ALBRECHT DÜRER AND THE VENETIAN RENAISSANCE

Albrecht Dürer and the Venetian Renaissance examines twenty-five paintings by
the German artist in an effort to reevaluate his relationship to contemporary
Italian art and his status as a painter. Providing a technical analysis of these
works, Katherine Crawford Luber explains how Dürer appropriated Venetian
techniques and suggests that the artist was engaged in the exploration of an
atmospheric, coloristic perspective. Luber also demonstrates how the Venetian
alternative to "scientific" perspective was integrated not only in Dürer's late
paintings but also in his later graphic oeuvre, which necessitates a reassessment
of the critical partition of his painted and graphic work. Emphasizing Dürer's
careful working methods, Luber argues that technique is an interpretable and
critically important aspect of artworks that should be integrated into main-
stream art historical studies.

Katherine Crawford Luber is a scholar of Northern Renaissance art. She has
contributed articles on aspects of Northern Renaissance art in *Master Drawings*.

Albrecht Dürer and the Venetian Renaissance

KATHERINE CRAWFORD LUBER

PUBLISHED BY THE PRESS SYNDICATE OF THE UNIVERSITY OF CAMBRIDGE
The Pitt Building, Trumpington Street, Cambridge, United Kingdom

CAMBRIDGE UNIVERSITY PRESS
The Edinburgh Building, Cambridge CB2 2RU, UK
40 West 20th Street, New York, NY 10011-4211, USA
477 Williamstown Road, Melbourne, VIC 3207, Australia
Ruiz de Alarcón 13, 28014 Madrid, Spain
Dock House, The Waterfront, Cape Town 8001, South Africa

http://www.cambridge.org

First published 2005

Printed in the United States of America

Typeface Janson Text 10.25/14.5 pt. *System* LATEX 2ε [TB]

A catalog record for this book is available from the British Library.

Library of Congress Cataloging in Publication Data
Luber, Katherine Crawford, 1961–
Albrecht Dürer and the Venetian Renaissance / Katherine Crawford Luber.
p. cm.
Includes bibliographical references.
ISBN 0-521-56288-0
1. Dürer, Albrecht 1471–1528 – Criticism and interpretation. 2. Painting, Renaissance –
Italy – Venice – Influence. 3. Painting – Technique. I. Dürer, Albrecht, 1471–1528.
II. Title.
ND588.D9 L73 2001
759.3–dc21
97-018153

ISBN 0 521 56288 0 hardback

MM Publication of this book has been aided by a grant from the
Millard Meiss Publication Fund of the College Art Association.

For Philip, Jacob, and Diana

Contents

List of Plates and Illustrations

Acknowledgments

I acknowledge the support and help of the institutions and individuals, too numerous to list, in the research and writing of this book, which began as my doctoral thesis at Bryn Mawr College. James Snyder encouraged me to embark on this study. Jeffrey Chipps Smith introduced me to the possibilities of Dürer scholarship. Maryan Ainsworth has provided an inspirational model for grappling with the burdens – both literal and figurative – of this kind of research.

A Fulbright Scholarship to Austria in 1988–9 allowed me to carry out abroad most of the primary research necessary. The curatorial faculty at the Kunsthistorisches Museum in Vienna has earned my perpetual gratitude. Karl Schütz, Sylvia Ferino, and Wolfgang Prohaska were all committed to helping me with my research and always willing to talk about the issues involved. The conservators at the Kunsthistorisches Museum – Hubert Dietrich, Gerald Kaspar, Elke Oberthaler, Friedl Rollé, Maria Ranacher, and Monica Strolz – also gave generously of their time and insights. At the Graphische Sammlung der Albertina, Fritz Koreny was both kind and helpful, as was Barbara Dossi. In Nuremberg, I was graciously received and assisted by Kurt Löcher, Thomas Brachert, Joseph Pröll, and numerous conservation students. Emil Bosshard, conservator of the Thyssen-Bornemisza Collection at Lugano, kindly allowed me access to equipment and shared his documentation with me. Karen Haas of the Isabella Stewart Gardner Museum and Rhona MacBeth of the Boston Museum of Fine Arts were extremely helpful to me in Boston, and Frank Gunther Zehnder and Christa Steinbüchel deserve my thanks for their

kind assistance in Cologne. In London, Alastair Smith, Martin Wyld, David Bomford, and Susan Foister have always been extremely generous with their time and photographs. John Hand and Catherine Metzger at the National Gallery of Art in Washington, D.C., have given me time to examine the paintings in their collection over and over again.

A Whiting Fellowship in the Humanities allowed me the time to write the thesis. A brief version of Chapter 5 was delivered at the Annual Meeting of the College Art Association in Washington, D.C., in February 1991, and an early version of Chapter 6 was first presented at the Fiftieth Anniversary Symposium on the History of Art, The Frick Collection and the Institute of Fine Arts of New York University in April 1990. This paper was subsequently published in *Master Drawings* 29 (Spring 1991): 30–47. I presented a paper on the Venetian landscape watercolors at the symposium "Venice Reflected" held at the University of Michigan in October 1996 organized in part by Stephen Campbell. Elizabeth K. Allen provided a careful reading of an early version of the manuscript. Jennifer Vanim, Jane Oberwager, William Rudolph, and Adrienne Deitch helped me with the gathering of permissions for the numerous illustrations and plates in the book and getting the manuscript to press. A Millard Meiss award from the College Art Association supported the crucial inclusion of color plates in the book.

Special thanks to my parents for their support of my endeavors through many years. My husband, Philip, has been my most patient reader throughout this project. His love, support, and encouragement made this project possible.

ALBRECHT DÜRER AND THE VENETIAN RENAISSANCE

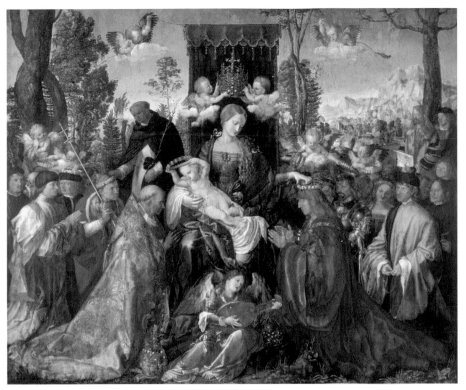

PLATE I. A. Dürer, *Feast of the Rose Garlands*, Prague

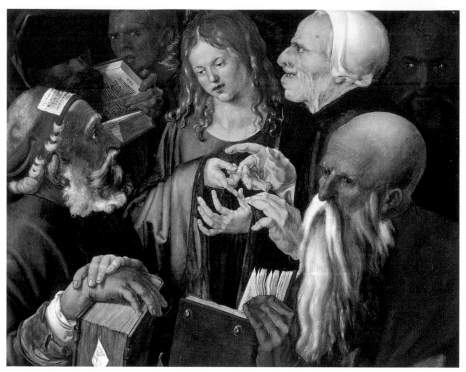

PLATE II. A. Dürer, *Christ among the Doctors*, Madrid, Fundacion Thyssen-Bornemisza

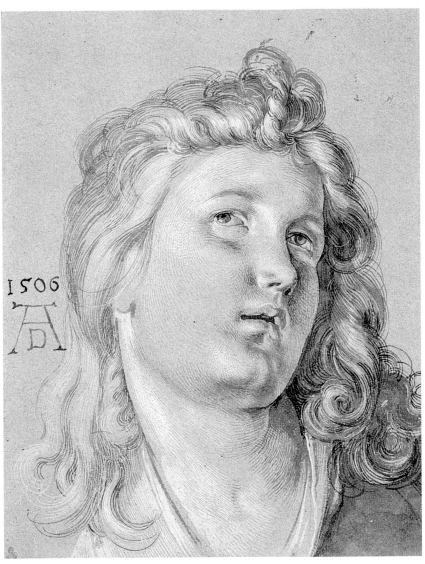

PLATE III. A. Dürer, *Head of an Angel*, drawing, Vienna,
Graphische Sammlung der Albertina

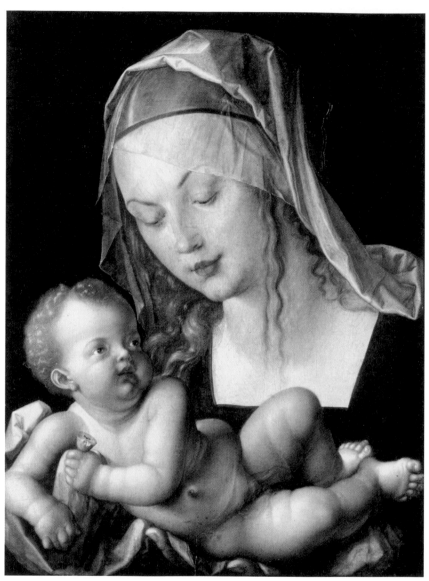

PLATE IV. A. Dürer, *Virgin with the Pear*, Vienna, Kunsthistorisches Museum

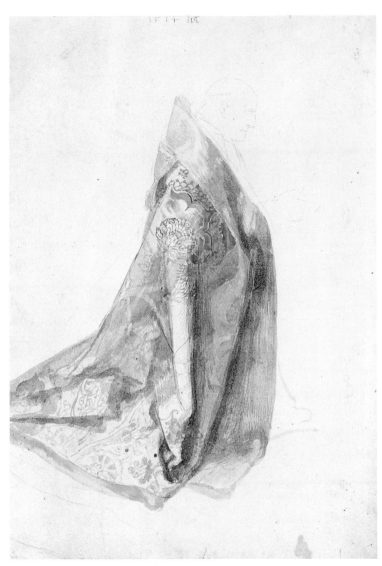

PLATE V. A. Dürer, *Pluviale*, drawing, Vienna

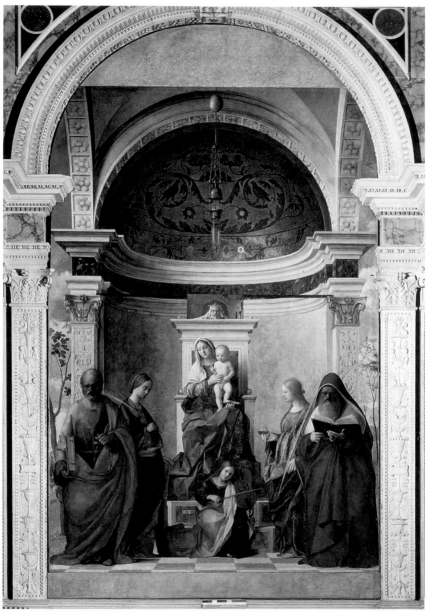

PLATE VI. Giovanni Bellini, *San Zaccaría Altarpiece*, Venice, Church of San Zaccaria
copyright Osvaldo Böhm

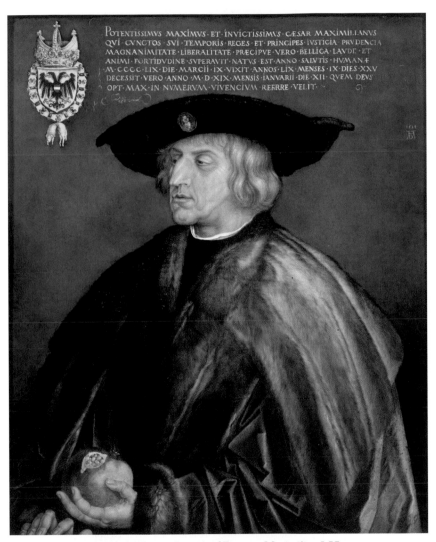

PLATE VII. A. Dürer, *Portrait of Emperor Maximilian I*, Vienna,
Kunsthistorisches Museum

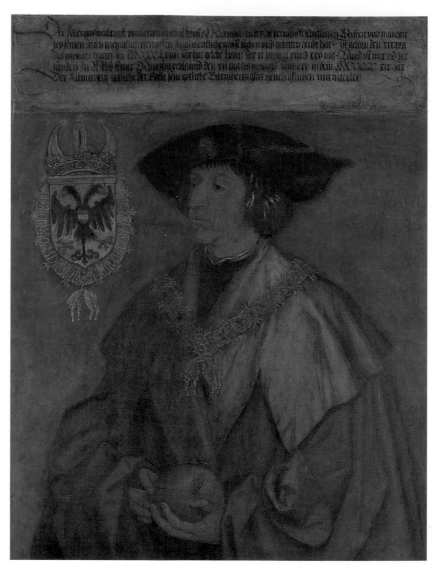

PLATE VIII. A. Dürer, *Portrait of Emperor Maximilian I,*
Germanisches National Museum

Introduction

ALBRECHT DÜRER (1471–1528) was celebrated in his own lifetime for his skill as both a painter and a draughtsman. Yet, his paintings have received significantly less critical attention than his graphic works, his theoretical writing, or his life as an exemplar of artistic genius. This critical imbalance is demonstrated by the fact that only one monograph dedicated to the study of his paintings has been written, whereas countless studies are devoted to the examination of his life, graphic works, and theoretical writings.[1] This has contributed, in turn, to the pervasive scholarly assumption that Dürer's paintings are inferior in quality to his graphic work, and that as a painter, Dürer was less accomplished (and less intriguing) than he was as a draughtsman.

The critical partition of Dürer's oeuvre into the graphic and the painterly occurred as early as the sixteenth century. In 1528, the year of the artist's death, Desiderius Erasmus described Dürer as the "Apelles of black lines."[2] Erasmus' description was written after Dürer had presented him with the engraved portrait of 1526, which Erasmus himself had requested Dürer to make. Although Erasmus' comments were intended as a broad humanist encomium about Dürer's skill as an artist, most modern scholars have interpreted his remarks as a critical judgment about the relative artistic merits of Dürer's paintings and prints. This comment, in turn, initiated the critical partition between Dürer's painted and graphic works. Any division between painted and graphic works reverberates by necessity with Giorgio Vasari's partitioning of Italian painting into "disegno" and "colore" in his book *Le vite de' più eccellenti pittori, scultori e architettori*.[3]

Vasari's distinction between "disegno" and "colore" helped to shape the critical history of the classification of Italian renaissance painting into regional schools. "Disegno" described the quality in painting that was representative of the highest aesthetic and intellectual achievement attainable by any artist.[4] "Disegno," in Vasari's view, was married to the idea of invention and formed an integral part of the Tuscan tradition of painting. "Colore," on the other hand, was regarded by Vasari as the forte of the Venetian painters of the sixteenth century. Although he admired the bravura color effects of Venetian painting, he regarded this school as a whole (and the quality of "colore" in particular) as less rigorous and intellectual than the paintings of the Florentine artists with whom he was so familiar.

Vasari's regional classifications of Italian art have had a tremendous impact upon the critical history of Renaissance painting. Even though Vasari did not devote an entire chapter to Dürer, his ideas about regional schools of art have shaped critical views of Dürer as a northern artist engaged with Italian art. Vasari lamented that Dürer would have been the best painter in Italy if he had only been exposed to the painterly traditions of Italy, particularly Tuscan ones. Vasari wrote that "[if] this man, so able, so diligent, and so versatile, had had Tuscany instead of Flanders [sic] for his country, and he had been able to study the treasures of Rome, . . . he would have been the best painter of our land, even as he was the rarest and most celebrated that has ever appeared among the Flemings."[5] Ironically, Dürer *was* exposed to the Italian painterly tradition, although his contact was with *Venetian* painting, and not the Tuscan tradition about which Vasari wrote so eloquently. Vasari's lament that Dürer was not exposed to the Tuscan artistic tradition provided the cornerstone for generations of arguments about the merits of Italian painting and the necessity for northern artists to study in Italy to achieve greatness.

Dürer's historical encounter with Venetian painting complicates the post-Vasarian critical division between "disegno" and "colore" within Dürer's oeuvre. Vasari's discussion of Dürer is included in the *Life of Marcantonio Raimondi*, which Vasari used to explicate the history of engraving, the graphic form for which Dürer remains best known. Besides Dürer, Vasari included short sketches of many artists significant for their

contribution to the graphic arts, including Martin Schongauer and Lucas van Leyden. Yet Vasari argued that Dürer was more gifted than any of his predecessors and credited him with the gifts specifically associated with the greatest Tuscan artists. Vasari compared Dürer to Martin Schongauer and wrote that "Albrecht Dürer began to give attention to prints . . . but with more design ["disegno"] and better judgment, and with more beautiful invention, seeking to imitate the life and draw near to the Italian manners, which he had always held in much account."[6] Ironically, Vasari's emphasis on Dürer's "disegno," coupled with judgment and invention, echoes the language Vasari used to describe the accomplishments of Michelangelo, Raphael, and the other artists for whom Vasari reserved his highest praise.[7]

In fact, because so much is known about Dürer's presence in Venice in the years 1505–7, the artist has become a figure of particular interest for scholars of the Renaissance. His life and work have been interpreted as the embodiment of the confrontation of two distinct cultures with distinct visual and intellectual traditions. Dürer's unique position as a northern artist who experienced the Renaissance in Italy firsthand has led scholars to view him as a living conduit for the exchange of artistic ideals and theories between the two cultures. His artistic production has been interpreted as reflective of the tensions between Italy and the North. It is surprising, therefore, that so little attention has been given to Dürer's painted works, not only as an indicator of his experiences in Venice but also as the primary source on which to base the critical study of artistic practice and experience.

Therefore, I have focused my investigation on the paintings executed by Dürer while in Venice during 1505–7 and those painted after his return to Nuremberg in the following years. I will discuss how Dürer's exposure to Venetian painting techniques in 1505–7 resonated throughout the rest of his career. I will argue that this exposure affected not only the way in which he painted but also the way in which he attempted to depict illusionistic space in all his artistic efforts. My arguments are based upon a study of twenty-five paintings attributed to Dürer and other paintings associated with his workshop, using infrared reflectography, microscopy, and X-radiography. Reconsideration of this group of paintings provides

an opportunity to reassess Dürer's reputation as an artist primarily gifted in the graphic arts. In the following pages, I will show that *how* Dürer chose to paint is as significant as, and often entwined with, *what* he chose to paint.

Now more than ever before, painting technique and the history of the use of different techniques can be studied because of the availability of advanced scientific tools adapted specifically for the investigation of the materials and procedures used in the production of paintings. The study of technique, encompassing the procedures utilized and adapted by artists at every step in the production of a work of art, has been largely overlooked as a source of material for the art historian committed to the reconstruction and interpretation of the past. Few successful explorations of the meaning inherent in the actual practice of painting have been made. Yet, there is widespread acceptance that paintings, as cultural images, are the source of a virtually endless stream of interpretations. I will demonstrate here that the study of technique – like the study of style, elements of form, or iconography – can augment our knowledge of artistic development and can also be used to form hypotheses about the meaning and importance of paintings.

Outside of a contextual and theoretical basis, technical information about paintings is ultimately of limited interest to art historians. The primary problem in the critical use of technical material has been the belief that the objective importance of the findings is so great that it stands on its own and demands little if any interpretation. Only, I believe, when the information derived from the laboratory is integrated into the interpretive discourses of the art-historical tradition can any richer meaning be derived from its existence. In this regard, my attempt to interpret the material I have collected here regarding the paintings of Albrecht Dürer is intended to contribute to our understanding of Dürer as a painter and an artist. More specifically, my investigations show that Dürer utilized particular elements of painterly technique to which he was exposed while in Venice in his paintings as well as in his later graphic works. This calls for a revision of the view ingrained in the history of the art of Dürer as an artist primarily gifted in, and ultimately limited to, the graphic realm of production.

To discuss the role of technique in Dürer's production of a painting with particular historical and iconographic meanings, I attempt to locate technique within precise historical contexts. Techniques are quite often tied specifically to particular geographic locations at particular times; identifying them makes it possible to trace regional influences. Dürer's primary source for learning about new, non-northern techniques as a mature artist was Italy, specifically Venice. In addition, I have discovered literary tropes to which Dürer may have been exposed that use painting technique as a metaphor to express the process of fulfillment promised by Christian sacrifice. This literary tradition strongly suggests that the practice of painting itself could be and was meant to be interpretable in its own right. Just as a Renaissance humanist might learn the form of iambic pentameter to express certain poetic ideas, I believe Dürer consciously appropriated specific Venetian techniques to express certain ideas in a work of art.[8]

My study of the paintings begins with the study of the techniques used by Dürer. My investigation of his later paintings, which includes those executed during his stay in Venice in 1505–7 and those completed after his return to Nuremberg in 1507, indicates that Dürer was profoundly affected by the traditions of Venetian painting. He did not merely absorb what he saw; he adapted elements of Venetian technique in conjunction with his own native traditions to refine the meanings in his own paintings. Therefore, I am interested in how and why the techniques specific to Venetian painters were appropriated and used by Dürer in his own productions. In Chapters 3–5, I explore the details of Dürer's utilization of Venetian techniques in the *Feast of the Rose Garlands* (Plate I) and the *Virgin with the Pear* (Plate IV).

A Brief Overview of the History of the Technical Investigation of Paintings

Interest in the study of the materials and techniques of paintings has gained a broader audience in the last thirty-five years due to the greater availability of investigative technology such as infrared reflectography and

X-radiography, even though curiosity about the sometimes mysterious power of artistic practice is far from being new.[9] Pliny the Elder first voiced his wonder at the painter's manipulation of technique in the first century A.D.:

> Another most curious fact and worthy of record is, that the latest works of artists, and the pictures left unfinished at their death are valued more than any of their finished paintings, for example, the *Iris* by Aristeides, the *Children of Tyndaros* by Nikomachus, the *Medeia* by Timomachus, and the *Aphrodite* by Apelles, mentioned above. The reason is that in these we see traces of the design and the original conception of the artists. . . .[10]

Interest in the otherwise inaccessible view into the "design and original conception of the artist" has remained constant over the course of two millennia, but our ability to investigate those aspects of an artist's production has changed with advanced technology. Sophisticated means to investigate the technical aspects of paintings (and other works of art) have been available only recently. Earlier art historians relied upon unfinished or damaged paintings and the record provided in treatises and manuals on painting for their discussions on techniques and processes involved in painting.[11]

In the years after World War I, parallel developments in the technical investigation of painting occurred at Harvard University's Fogg Art Gallery and at the Bayerischen Staatsgemaldesammlungen in Munich. At both institutions, the application of X-radiography for the investigation of technique was explored and fully integrated into the accepted methodology for examining paintings.[12] In 1938, Christian Wolters in Munich and Alan Burroughs at the Fogg published parallel books simultaneously about their study of paintings with X-radiography.[13] Burroughs described the results of X-radiography as "drawings" for paintings because of the way in which brushwork is made visible with this investigative technique. In 1936, the students of Paul Sachs' museum course at the Fogg organized an exhibition about the interrelationship of style and technique. This catalogue is one of the earliest expressions of the broader interest at the Fogg in exploring the effect of technique and

technical innovations upon style in its broadest sense. The students defined technique as

> the whole process that leads from an artist's mental concept to a final realization of that concept in a work of art. We include the materials and tools employed, the method of using both, and the shaping of the concept in the mind of the artist as it is revealed in preparatory work.[14]

Besides echoing Pliny, the essay and catalogue entries reflect the thinking and methodology of the Fogg method and is a monument to the integrated approach of teaching Fine Arts at Harvard at that time. The definition of technique, and its promised access to the mind of the artist, is here closely related to Pliny's expression of interest in the "original conception" of the artist. "Process" was perceived by the Fogg students and their teachers as an integral and significant part of the final artistic product.[15]

In contrast to this early synthetic and interpretive point of view, much of the recent art-historical literature that employs technical information, and particularly retrieved underdrawings, approaches it as concrete, minimally interpretable or even uninterpretable positivist data. As such, this information is often relegated to appendixes or given only a secondary importance in relationship to more traditional art-historical analyses.[16] Most technical research about paintings shares the assumption that the underdrawings revealed and the information produced by the scientific study of paintings is not subject to interpretation. This tendency within these technical studies is, in my view, due to the close connection such investigations have had to the scientific laboratory of the paintings' conservator. The recent increase in such studies by art historians has been nourished by investigations that originated in the conservation studio. The aims of conservators and art historians may be compatible, but they are motivated by very different goals. The conservator aims for the best possible understanding of painting technique to preserve the painting as object today. Although this information is often of interest to the art historian, the desire to use such information to reconstruct an understanding of the past is a distinctly unscientific and unobjective use of the material gathered in the laboratory. Furthermore, I believe that the

assumption of "scientific" objectivity may prevent scholars from exploring the possibilities of broader, more interpretive investigations based upon the technical findings generated in the laboratory.

When considered together, recent studies of underdrawings can be loosely divided into three groups, depending on their art-historical biases and the breadth of their interpretive goals. The first group is dedicated to the generation and presentation of raw technical data about paintings, including, for instance, the presence and degree of underdrawing, without organizing principles or interpretation to date.[17] The second group of studies uses this kind of data to resolve issues of attribution or to determine a more precise chronological dating within the oeuvre of an artist.[18] The third group of studies addresses issues related to attribution and chronology as a corollary to the study of the function of drawings and underdrawings and the reconstruction of artistic working practices and workshop organization.[19] A separate trend in this critical literature includes studies undertaken by art historians or curators in conjunction with conservators in which technical information retrieved from the paintings themselves is connected to contemporary treatises to examine the relationship between theory and practice.[20]

The Technical Literature about Dürer's Paintings

The earliest technical literature concerning Dürer's paintings consists of reports connected with unfinished paintings and the restoration of damaged paintings. Henry Wehle, for instance, reported extensively on the unfinished and damaged *Salvator Mundi* (Figure 1). In the tradition of Pliny, Wehle grasped the significance of the opportunity provided by the painting to catch a glimpse of Dürer's artistic working practices.[21] Other examples are the case report filed by Hertha Gross-Anders and the study by D. von Hampe on the occasion of the restoration of the *Dresden Altarpiece*.[22] Gross-Anders and von Hampe did not investigate the underdrawing in that painting because the technical means to do so was not available at that time. In addition, their studies, like other pure conservation reports, was written not for an audience of art historians and curators, but for an audience of conservators.[23]

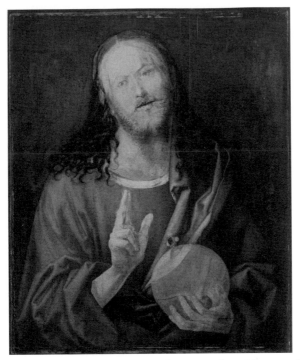

1. A. Dürer, *Salvator Mundi*, New York, Metropolitan Museum of Art

Despite the availability of some technical reports about specific paint-
ings, little attention has been directed to investigations of the physical
aspects of Dürer's paintings as a group. Fedja Anzelewsky included a short
section on Dürer's painterly technique in his 1971 monograph but noted
that there had been no extensive investigation of Dürer's painting tech-
nique. Anzelewsky's précis of Dürer's painting technique is based, liked
Wehle's, on the damaged *Salvator Mundi* (Figure 1) in the Metropolitan
Museum of Art.[24] Although the *Salvator Mundi* provides a unique op-
portunity to see the hand of Dürer at work, perusal of it alone as the
explicatory example of Dürer's painterly technique is problematic on at
least three counts. First, the painting is damaged; second, the surface is
drastically over-cleaned; and third, it is likely that the painting was left un-
finished by Dürer.[25] Together, these problems with the state of the paint-
ing preclude any reliable judgment of painting technique based upon it
alone.[26]

9

Christian Wolters used several Dürer paintings in his explication of the utilization of X-radiography for art history.[27] His analyses were limited to the important differentiation between various methods employed for the application of lead white by different artists in the North during the sixteenth century. Gisela Goldberg studied the *Four Apostles* in the Alte Pinakothek in Munich with infrared reflectography and with X-radiography to test the hypothesis put forward by Erwin Panofsky (based on observations made by Karl Voll) that the figure of St. Paul in the right panel was originally intended to be St. Philip.[28] Her investigation revealed this argument untenable. Technical investigation, including infrared reflectography and X-radiography of the head of St. Paul, shows that the head was executed as originally planned, with only a few pentimenti visible in either of the two Apostle panels. Goldberg's correction of Panofsky's theory about the *Four Apostles* is important because it demonstrates how technical investigations and the close study of the paintings themselves can lead to improved insights about the iconographic meaning of works of art.

Thomas and Adelheid Brachert published the results of several technical studies of paintings, including a thorough investigation of the paintings of *Emperors Sigismund* and *Charlemagne* in the Germanisches Nationalmuseum in Nuremberg.[29] The Bracherts further argued that, in addition to the primary versions of *Emperors Sigismund* and *Charlemagne* in the Germanisches Nationalmuseum, Dürer painted another pair of bust-length portraits located in a Swiss private collection. They note the existence of an extensive underdrawing in these bust-length portraits and assume that a copyist would not execute any underdrawing at all, much less such an elaborate underdrawing. Therefore, they argue that these two portraits must be by Dürer himself. The fallacy in this approach is the assumption that the existence of underdrawing in a composition is indicative of originality and, therefore, excludes the possibility that a composition might be a clever imitation by a copyist.[30] Furthermore the dense and rapid parallel hatching used in the two Swiss paintings does not resemble the underdrawing in other paintings by Dürer. Unfortunately, I was unable to examine the underdrawing in the *Emperors Sigismund* and *Charlemagne* myself.[31]

2. A. Dürer, *Christ Among the Doctors*, infrared reflectogram detail, head of man on left, Madrid, Thyssen-Bornemisza Collection

Thomas Brachert has also made several analyses, in conjunction with the Bayerisches Landeskriminalamt, of fingerprints within Dürer's paintings. Brachert hoped, to establish that Dürer's fingerprints were distinctly identifiable, and that they would provide an index with which to establish and secure attributions.[32] In my examination of paintings by Dürer, I have found, like Brachert, that Dürer frequently used his fingers to blend pigments.[33] Unfortunately, no complete set of Dürer's fingerprints exists with which to compare the fragments found and analyzed by Brachert and his collaborators. It may one day be possible to positively identify all of Dürer's fingerprints, but until then, the body of knowledge is too insignificant to form the basis from which to draw any solid conclusions.

Isolde Lübbeke included technical information about the *Christ Among the Doctors* (Plate II) in the Thyssen-Bornemisza Collection in her recent catalogue of that collection.[34] She noted a change in the underdrawn form of the man behind and to the left of Christ in the upper left corner of the painting (Figure 2). She suggested that Dürer altered this figure in the underdrawing from a woman to a man, and that this indicated that Dürer originally planned to show Christ flanked by the Virgin Mary and St. Joseph. Perusal of the infrared reflectogram detail of this area, however, does not support Lübbeke's interpretation of a change of sex for

this figure. This change shows only, I believe, a shift in the position of the figure.

Two recent catalogues from German collections present a great deal of new technical information about paintings by Dürer. Six paintings attributed to Dürer are included in the catalogue of sixteenth-century German and Netherlandish paintings in the Germanisches National-museum in Nuremberg.[35] The entry for each painting in the catalogue includes a technical description of the materials used as well as a description of other pertinent technical investigations, including the existence and extent of underdrawing. In particularly striking cases, detail photographs of infrared reflectograms are also reproduced. Löcher does not use the technical information to make new arguments or to support his attributions. For instance, he attributes the *Holzschuher Lamentation* to Dürer (despite the long critical arguments for and against its inclusion in the authentic oeuvre of Dürer). Although Löcher includes a single detail of an infrared reflectogram from the *Holzschuher Lamentation*, he does not refer to the comparisons made possible by the recovery of the underdrawing, in particular to the closely related *Glimm Lamentation*.[36] In contrast, Gisela Goldberg and her co-authors took the opportunity provided by the publication of their catalogue, *Albrecht Dürer: Die Gemälde der Alten Pinakothek*, to present comprehensive technical information about every painting attributed to Dürer in Bavarian collections including the *Holzschuher Lamentation* in Nuremberg, which is identified as a product of Dürer's workshop because of the style and manner of the underdrawing.[37] The consideration of the *Holzschuher Lamentation* in these two separate publications points to the inherent subjectivity involved in the use of underdrawing as a tool for attribution, especially when used without considerable comparative material.

Investigative Methods Used

The paintings of Albrecht Dürer, like early Flemish and Dutch paintings, are particularly receptive to investigation with infrared reflectography because of the traditional techniques of their construction. Typically, an underdrawing in a black or dark pigment – in any one (or more) of a variety

of media – is executed directly on the panel (prepared with a white, usually chalk, ground) in lieu of a preparatory drawing on paper.[38] The paint layers, which usually consist of pigments suspended in an oily medium, are applied to the panel on top of the underdrawing. In infrared reflectography, the dark pigmentation of the underdrawing forms a contrast with the reflective white of the ground. The result (an infrared reflectogram) is a dark pattern on a light ground, much like a drawing in dark ink on light paper. Like his drawings, Dürer's underdrawings were executed in a variety of media. At times, he used different inks and paints, including a dry, crumbly material (either black chalk or charcoal), and applied them with a variety of different tools, such as brushes, pens (quill and reed), or charcoal sticks.[39]

To determine the existence, quality, type, and extent of underdrawing made by Dürer in the paintings associated with his oeuvre included in my investigation, I examined the paintings with infrared reflectography when possible. Unfortunately, it is sometimes impossible to identify with certainty either the medium or the tool with which the underdrawing was made. For instance, the lines created by a brush and a pen may be difficult to distinguish.[40] Sometimes it is possible to distinguish between pen and brush lines with the aid of a microscope. Lines made with a pen often have blunt ends, are fairly uniform in width, and may show a gap in the center running parallel to the long edges that is the result of a split in the nib of the pen. Brush lines, on the other hand, often have tapering or pointed ends, and may vary considerably in width.

The infrared reflectography systems I employed consisted of a camera installed with an infrared vidicon responsive to a range of infrared light from 900 up to 2,000 nanometers and connected to a closed-circuit video monitor. A Kodak Wratten filter placed over the lens aperture of the camera blocks out all visible light; only the infrared light reflected from the surface of the painting passes through this filter and is transmitted into the vidicon tube. This reflected light is read by a laser that recognizes various heat intensities. The relative heat-absorptive tendencies of the different pigments used create the image made visible on the video monitor. White reflects the most light and is visible on the closed-circuit monitor as white or light areas, and black absorbs the most heat and is visible on the

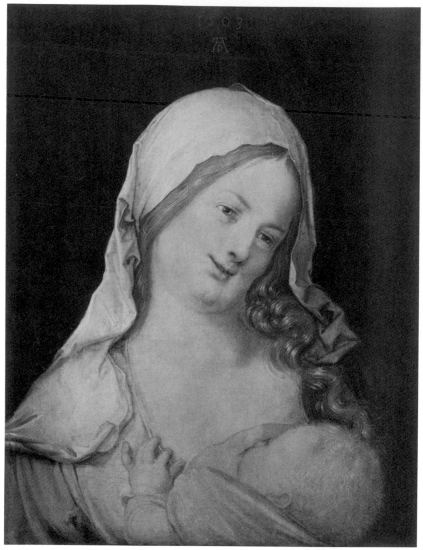

3. A. Dürer, *Small Virgin*, Vienna, Kunsthistorisches Museum

closed-circuit monitor as black or dark areas. Other pigments absorb heat at different rates than white and black. Pigments that absorb virtually no heat, like most organic red pigments, often appear completely transparent on the video monitor. Some blues, on the other hand, absorb so much

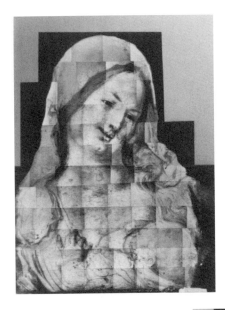

4. A. Dürer, *Small Virgin*, IRR assembly, Vienna, Kunsthistorisches Museum

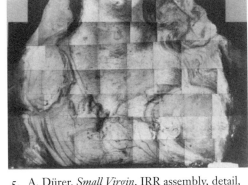

5. A. Dürer, *Small Virgin*, IRR assembly, detail, suckling Christ Child, Vienna, Kunsthistorisches Museum

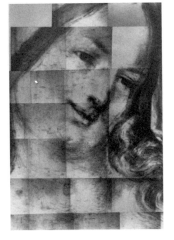

6. A. Dürer, *Small Virgin*, IRR assembly, detail, face of Virgin, Vienna, Kunsthistorisches Museum

heat that they appear to be as dark, or impenetrable, as blacks.[41] Several factors have a role in the determination of whether underdrawing is readily visible with infrared reflectography. These include the relative thickness of the paint, the covering power of the pigment used, and the relative visibility and strength of the underdrawing material used. (If, for instance, the underdrawing is very lightly and delicately sketched on the prepared surface, and the covering power of the pigment is very strong and the paint is applied very thickly, the underdrawing may not be visible with infrared reflectography.)[42]

I documented the underdrawing in the paintings by photographing small segments of each painting from the video-monitor in a gridlike pattern. These photographs of the underdrawing were then custom developed and printed to ensure an even gray-tone and to minimize the contrast. They were subsequently trimmed and assembled to make a mosaic-like image. This mosaic was then photographed to replicate the entire underdrawing beneath the surface of the painting for the purposes of documentation and comparison.[43] The distinctive "quilted" appearance of these reflectogram assemblies is due to this process.

To investigate further the layering of paints, especially the dispersal of pigments opaque to X-rays, I also examined X-radiographs of the paintings. X-radiographs can reveal in what order the different parts of a painting were created and show pentimenti not visible to either the naked eye or infrared reflectography. In X-radiography, a sheet of film sensitive to X-rays is placed on top of a painting while it is exposed to an X-ray emission. Lead, due to its heavy anatomical structure, absorbs X-rays. Therefore, pigments made with lead absorb the X-rays as they pass through the painting, leaving a resultant pattern on the film that corresponds to the relative density and dispersal of the lead pigments on the surface of the painting.[44]

Examination of the surface of the painting with the microscope aided in the determination of paint layer construction and in the identification of the pigments used by Dürer. Close examination with the microscope also helped to interpret the evidence gathered with infrared reflectography and X-radiography. In the process of collecting this body of technical material from almost one third of Dürer's paintings, I came to some general conclusions about the presence, type, and role of underdrawing in

Albrecht Dürer's paintings. Based on a limited, although carefully selected and significant, sampling of paintings attributed to Dürer from all phases of his career, I reached the following hypotheses.

1. In the earlier part of his career, by which I mean those years before his travel to Venice as a mature artist in 1505, Dürer commonly depended on the execution of a fully worked-up underdrawing in his paintings. This underdrawing articulated the form and volume of the subjects depicted with a dense internal network of hatching and cross-hatching. One example is the drawing in Berlin that establishes the design of the *Virgin with the Seven Sorrows* in the collections of the Alte Pinakothek in Munich and the Dresden Kunstsammlungen. This drawing establishes the basic idea of the composition, including the large central motif of the Virgin surrounded by smaller narrative scenes of the seven sorrows. However, the completed paintings differ in many respects from the drawing. In this regard, I view this drawing as an earlier design step in Dürer's invention of the composition. It is not truly preparatory to painting but established the idea of the composition. Examples of this kind of work include the *Small Virgin* (Figure 3; underdrawing, Figures 4–6) in Vienna and the *Salvator Mundi* (Figure 1; underdrawing, Figures 7–8) in the Metropolitan Museum of Art. In some early paintings, Dürer executed the final details on the surface of the painting in a highly graphic mode, as in the *Two Musicians* (Figure 9, underdrawing, Figures 10–11) in Cologne, the *Job and His Wife* (Figure 12) in Frankfurt, the *Jabach Altar Wings* in Munich, and the *Paumgartner Altarpiece* (Figure 13) in Munich. This technique of "drawing" linear details on the surface of the painting with the brush is also found in the *Ober St. Veit Altar* in Vienna (which was completed by Hans Schäufelein in Dürer's workshop after Dürer departed for Venice in 1505).[45] Recent investigations of larger narrative paintings support my hypotheses. The *Virgin of the Seven Sorrows* in Munich, the *Adam and Eve* in the Prado, and the *Paumgartner Altarpiece* (Figure 13) in Munich reveal densely worked-up, precise underdrawings.[46] However, in some (but not all) portraits, no underdrawing seems to be detectable whatsoever, including the 1498 *Self-Portrait* in the Prado and the *Portrait of Oswolt Krel* in the Alte Pinakothek in Munich. It may be that Dürer used a material not visible to present methods of investigation, or that he did not always

depend on underdrawings for his paintings. Few prepatory drawings on paper survive for these paintings.[47]

2. The first clearly discernible technical innovation in Dürer's utilization of underdrawing coincides with his journey to Venice in 1505–7. In many of the paintings from the year 1505 and after, underdrawing as an element of design and invention is minimized and appears not to have been a significant contributing feature of his technique. In some cases, underdrawing is limited to the indication of forms with mere contour lines, whereas in others, it seems to be completely absent. Apparently, Dürer did not make an underdrawing in the *Portrait of a Young Venetian* (Figure 14) or in the double-sided *Portrait of a Young Man* (Figure 15) with a portrait of *Avarice* (Figure 16) on the verso.[47] In the major Venetian paintings, the *Feast of the Rose Garlands* (Plate I; underdrawing, Figures 17–21) and the *Christ Among the Doctors* (Plate II; underdrawing Figure 2), underdrawing is, for the most part, limited to the depiction of contours. Little internal modeling is executed in the underdrawing in these paintings. The underdrawing in these two paintings is significantly looser, and the lines themselves are wider and less finely executed than in the earlier examples, such as the *Small Virgin* (Figures 3–6) or the *Salvator Mundi* (Figures 7 and 8). Dürer's decreasing dependency on underdrawing is matched by his simultaneous – and sudden – utilization of preparatory drawings on carta azzurra, a blue-dyed Venetian paper. The preparatory drawings on blue-dyed paper for the *Feast of the Rose Garlands* (Figures 22–27) are well known, as are those on green-prepared paper for the destroyed *Heller Altarpiece*.

3. Later paintings in Dürer's oeuvre do not correspond as neatly as the Venetian and pre-Venetian paintings to general rules about the presence and dependence upon underdrawing and preparatory drawings. Some later paintings by Dürer show no detectable underdrawing at all, for instance, the *Portrait of Michael Wolgemut* (Figure 28) in Nuremberg, the badly damaged *Portrait of a Man* (Figure 29) in Boston, or the *Portrait of a Clergyman (Johann Dorsch?)* (Figure 30) in Washington, D.C.[48] Yet at times late in his career, Dürer also made use of an underdrawing reminiscent of his earliest labors, as in the 1526 *Portrait of Johann Kleberger* (Figure 31; underdrawing, Figure 32) in the Kunsthistorisches Museum,

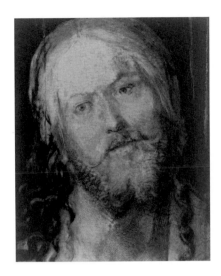

7. A. Dürer, *Salvator Mundi*, infrared photograph, detail of face, New York, Metropolitan Museum of Art

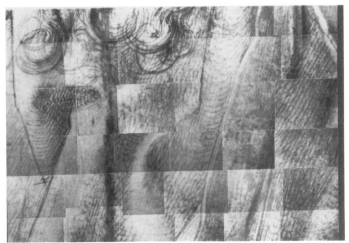

8. A. Dürer, *Salvator Mundi*, IRR assembly, detail of drapery, New York, Metropolitan Museum of Art

Vienna. On occasion, Dürer made use of preparatory drawings in the later paintings, most obviously for the *Heller Altarpiece*, unfortunately destroyed by fire, but also for the *Adoration of the Trinity and the All Saints* (Figures 33–34) and the later *Portraits of Maximilian I* (Plates VII and VIII) (discussed in detail in Chapter 6). However, the most interesting paintings from late in Dürer's career show his unique combination of different

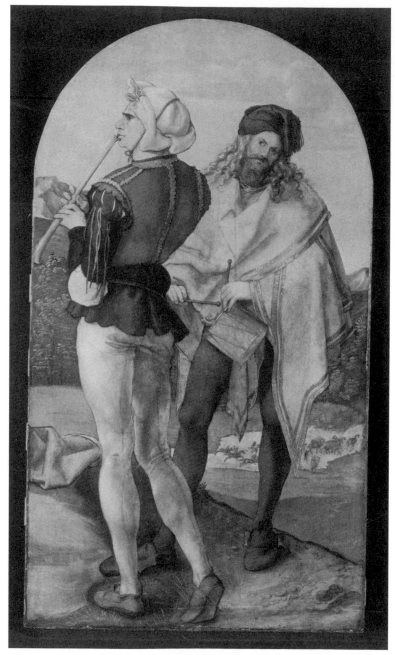

9. A. Dürer, *Two Musicians*, Cologne, Wallraf-Richartz Museum

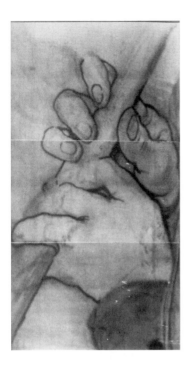

10. A. Dürer, *Two Musicians*, IRR assembly, detail, hands of piper, Cologne, Wallraf-Richartz Museum

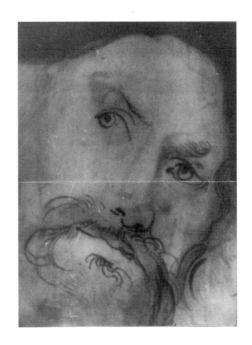

11. A. Dürer, *Two Musicians*, IRR assembly, detail, face of drummer, Cologne, Wallraf-Richartz Museum

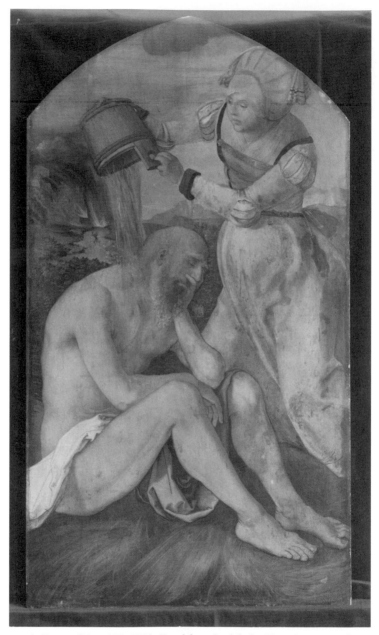

12. A. Dürer, *Job and His Wife*, Frankfurt, Städelsche Kunstinstitut und Städtische Galerie

13. A. Dürer, *Paumgartner Altarpiece*, Munich, Bayerische Staatsgemäldesammlung

techniques. For instance, in the *Virgin with the Pear* (Plate IV) (examined in depth in Chapter 5), the *Martyrdom of the 10,000* (Figure 35), and the *Adoration of the Trinity and the All Saints*, all in Vienna, Dürer explicitly combined the type of detailed underdrawing found in the pre-Venetian paintings with a minimal underdrawing similar to that found in the Venetian paintings, the *Feast of the Rose Garlands* and the *Christ Among the Doctors*.

4. Dürer's portraits must be considered as a group unto themselves. Many of them (although not all) seem to have been executed without dependence on much, if any, underdrawing. This may indicate that Dürer relied heavily upon portrait sketches on paper, as he did in the case of the *Portraits of Emperor Maximilian*.[49] Dürer was famed in his lifetime for his portrait likenesses, and he may have found that a drawing on paper was simply easier to make from life than a painted portrait, which would require multiple, repeated sittings from the subject. My own investigations, together with recent publications, support this view for most portraits. The following portraits reveal no trace of underdrawing when investigated with infrared reflectography: the *Portrait of Oswolt Krel*, the *Portrait of a Young Man*, and the *Portrait of Jacob Fugger the Rich*, all in the Altepinakothek in Munich; the *Portrait of Michael Wolgemut* in the Germanisches Nationalmuseum in Nuremberg; the *Portrait of a Young*

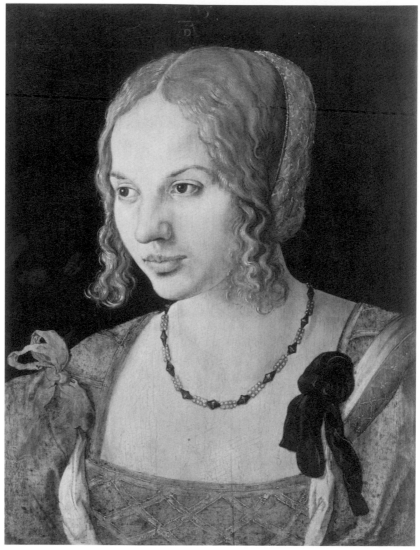

14. A. Dürer, *Portrait of a Young Venetian*, Vienna, Kunsthistorisches Museum

Venetian (Figure 14) and the *Portrait of a Young Man* (Figure 15) with *Avarice* on the verso in Vienna (Figures 15–16); the *Portrait of a Clergyman* (*Johann Dorsch?*) (Figure 30) in the National Gallery, Washington, D.C.; and the 1498 *Self-Portrait* in the Prado in Madrid. On the other hand, several portraits reveal extensive fully worked-up underdrawing.

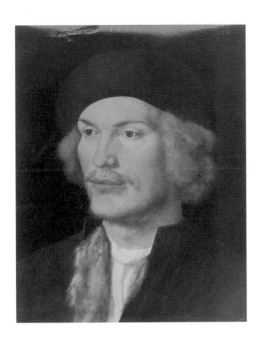

15. A. Dürer, *Portrait of a Young Man*, Vienna, Kunsthistorisches Museum

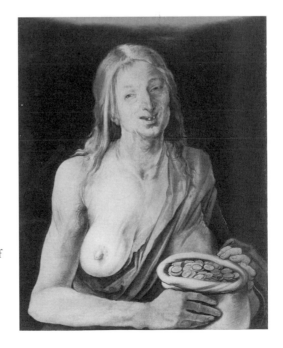

16. A. Dürer, *Avarice* (verso of Figure 15), Vienna, Kunsthistorisches Museum

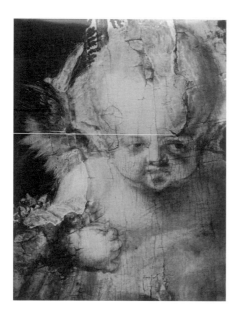

17. A. Dürer, *Feast of the Rose Garlands*, infrared photograph, detail, putto, Prague, Narodní Galerie

18. A. Dürer, *Feast of the Rose Garlands*, IRR assembly, detail, kneeling donor, Prague, Narodní Galerie

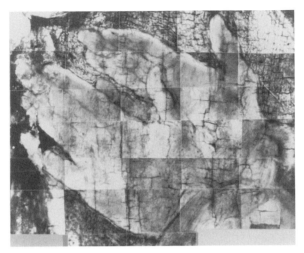

19. A. Dürer, *Feast of the Rose Garlands*, IRR assembly, detail, hands of Maximilian, Prague, Narodní Galerie

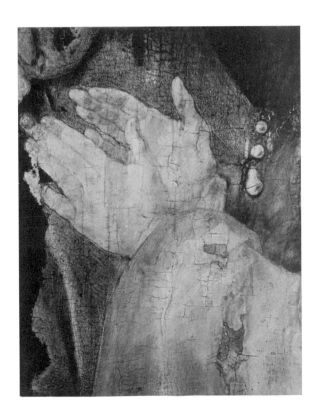

20. A. Dürer, *Feast of the Rose Garlands*, infrared photograph, detail, hands of Maximilian, Prague, Narodní Galerie

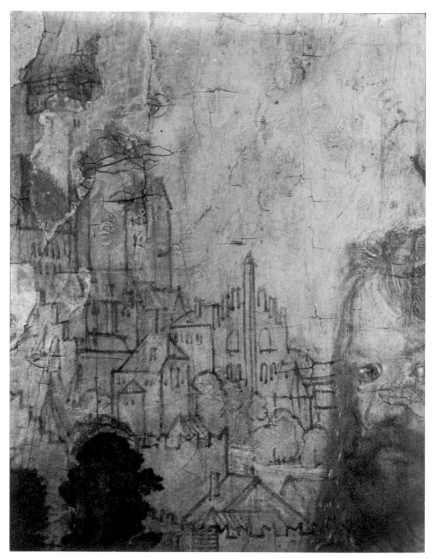

21. A. Dürer, *Feast of the Rose Garlands*, infrared photograph, detail, city vista, Prague, Narodní Galerie

These include the 1500 *Self-Portrait* in Munich and the late *Portrait of Johann Kleberger* in Vienna (Figure 31–32). The chronology of the pictures does not seem to have any relevance to Dürer's method in these portraits. Both early and late portraits contain fully executed underdrawings, and,

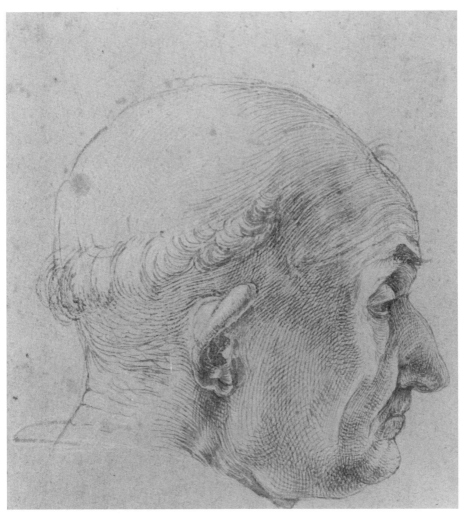

22. A. Dürer, *Head of the Pope*, drawing, Berlin, Kupferstich Kabinett, Staatliche Museen zu Berlin – Preußischer Kulturbesitz

likewise, both early and late portraits were executed without dependence on underdrawing.

Without further investigation of other late portraits by Dürer, it is still impossible to ascertain whether chronological distinctions could be made on the basis of these more complete, fully worked-up, underdrawings alone. However, the underdrawing found in the 1526 *Portrait of Johann*

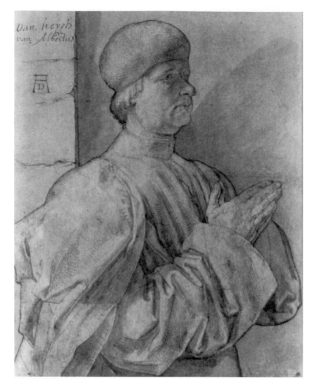

23. A. Dürer, *Praying Man*, drawing, Vienna, Graphische
Sammlung der Albertina

24. A. Dürer, *Hands of the Virgin*, drawing, Vienna,
Graphische Sammlung der Albertina

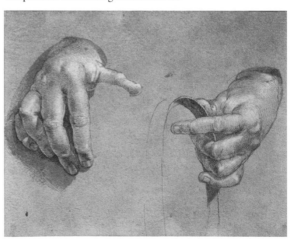

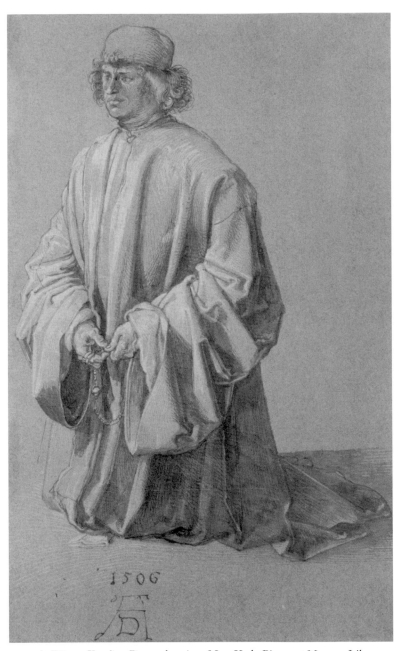

25. A. Dürer, *Kneeling Donor*, drawing, New York, Pierpont Morgan Library

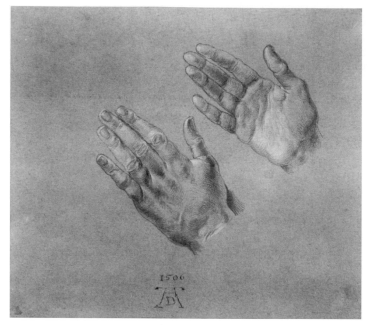

26. A. Dürer, *Hands of Maximilian*, drawing, Vienna, Graphische Sammlung der Albertina

27. A. Dürer, *Infant Christ Child*, drawing, Paris, Musée de Louvre

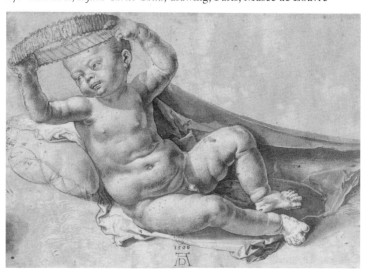

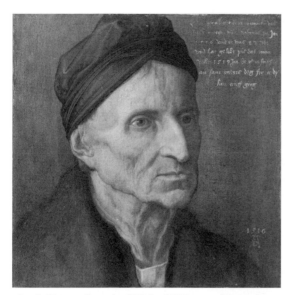

28. A. Dürer, *Portrait of Michael Wolgemut*, Nuremberg,
Germanisches Nationalmuseum

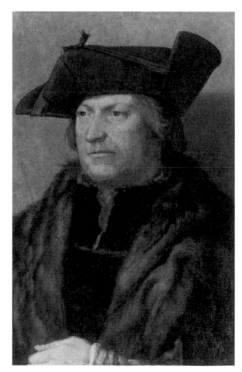

29. A. Dürer, *Portrait of a Man*,
Boston, Isabella Stewart Gardner
Museum

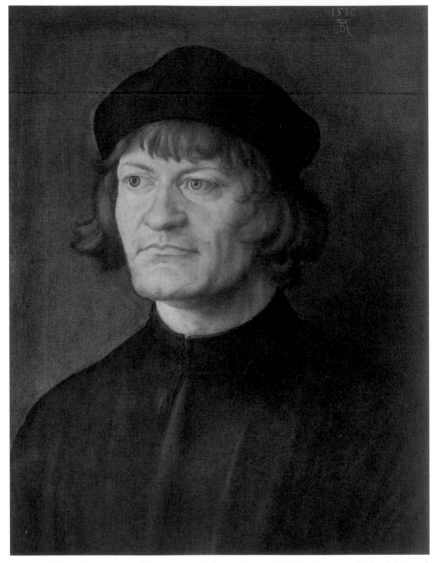

30. A. Dürer, *Portrait of a Clergyman*, (Johann Dorsch?) Washington, D.C., National Gallery of Art

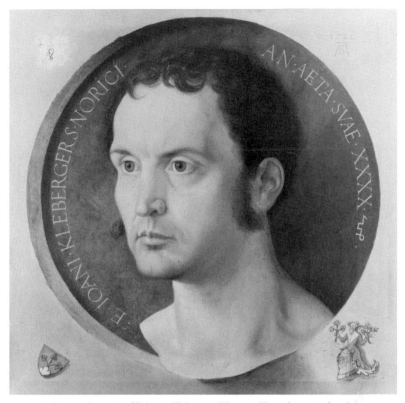

31. A. Dürer, *Portrait of Johann Kleberger*, Vienna, Kunsthistorisches Museum

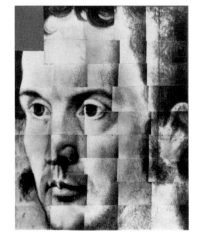

32. A. Dürer, *Portrait of Johann Kleberger*, IRR assembly, detail, face, Vienna, Kunsthistorisches Museum

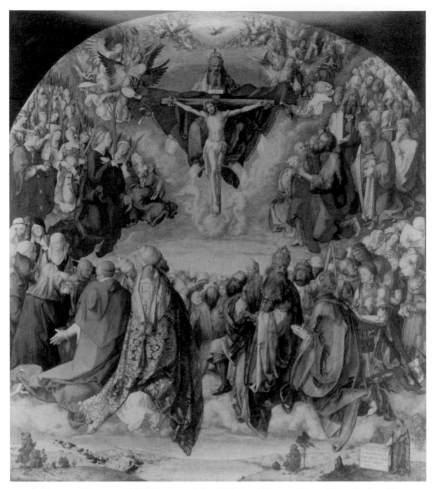

33. A. Dürer, *Adoration of the Trinity and the All Saints*, Vienna, Kunsthistorisches Museum

Kleberger shares some graphic characteristics with the later engraved portraits like the 1524 *Portrait of Frederick the Wise* (B. 104); the 1524 *Portrait of Willibald Pirckheimer* (B. 106); the 1526 *Portrait of Philip Melancthon* (B. 105); and the 1526 *Portrait of Erasmus* (B. 107). In all of these late portraits, Dürer combined curving, very densely hatched and cross-hatched areas with areas completely lacking in graphic articulation. The result is a pattern of contrasting dark and light areas that play across the surface of the faces and forms. This seems to me to be different from Dürer's earlier

34. A. Dürer, *Study for the Adoration of the Trinity and the All Saints*, watercolor, Chantilly, Musée Condé

use of hatches and cross-hatches in the articulation of forms, for example in the *Salvator Mundi* when he more uniformly described (and covered) the surface of the form with lines.

My technical investigations of almost one-third of Dürer's entire corpus of paintings reveal the significant alterations that occurred in his painterly technique while he was in Venice during 1505–7, as well as his selective incorporation of some of those same innovations into his later works, both

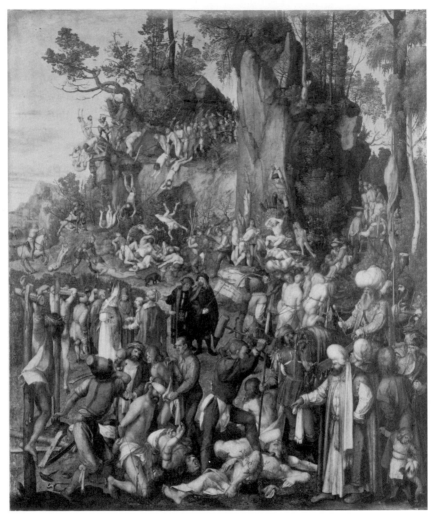

35. A. Dürer, *Martyrdom of the 10,000*, Vienna, Kunsthistorisches Museum

painted and graphic. In Chapters 3–6, I demonstrate the details as well as the breadth of Dürer's conspicuous adoption and adaptation of Venetian techniques. I also explain how his use of these techniques yields new insights into the meaning of the paintings and about Dürer's activity as a painter. This evidence is in striking contrast to the complete lack of any visual or technical evidence showing an awareness on Dürer's part of any Italianate or Venetian painterly techniques before 1505. Taken together,

this information invites a reappraisal of Dürer's relationship to Italian, and specifically Venetian, painting and casts doubt on the widely held assumption that Dürer was in Italy early in his career in 1494 where he was exposed to Italian art. In the next chapter, I examine the evidence used by earlier art historians to argue, I believe incorrectly, for two trips by Dürer to Italy, as well as the critical history that surrounds those arguments.

Dürer's Mythic and Real Presence in Italy

An Argument against Two Separate Journeys

D ÜRER'S HISTORICAL POSITION as one of the foremost artists of the
Northern Renaissance engaged with the Renaissance in Italy has
caused his life and works of art to become a template for scholars intent
upon explicating the course of the expansion of the Renaissance and hu-
manist ideals from Italy to Northern Europe.[1] For this reason, the details
of Dürer's relationship with Italy have commanded a tremendous amount
of attention from scholars. With few exceptions, art historians have ar-
gued, despite the lack of any strong visual evidence, that Dürer traveled
twice to Italy during the course of his lifetime. In this chapter, I will argue
that the artist made only one journey to Venice, the well-documented trip
of 1505–7. I will examine the documentary evidence that has been used to
advance an earlier trip, demonstrate how unreliable it is, as evidence, and
briefly recount the – at times peculiar – arguments made by generations
of art historians to explain the lack of any visual evidence within Dürer's
oeuvre to support this alleged trip.

The insistence in the Dürer literature upon a pair of trips to Italy –
largely formulated by German scholars of the late nineteenth century –
is strikingly reminiscent of Goethe's well-documented two visits to sunny
Italy. In 1786, at the time of Goethe's first trip to Italy, he traveled, like
Dürer, to Innsbruck, through the Brenner pass and then on to Venice
(as almost all German travelers through the middle of the nineteenth cen-
tury had done). His experience, recorded both in the travel diary he mailed
home to Charlotte von Stein in Weimar and in the famous *Italienishe Reise*,

published many years later, was utterly transformative and the *Italienische Reise* is perhaps the clearest expression of longing for the culture, art, and civilization of Italy ever written. When Goethe returned to Venice a few years later, he was disappointed to discover that his emotions and senses were not excited in the same way they had been the first time around. Goethe's expression of the yearning of the northern soul for the sunlit south, and for Italy, was transferred backward onto Germans of earlier centuries and became the template of choice for understanding Dürer's response to Italy and Venice.

My investigations of Dürer's paintings indicate that Dürer's response to the stimulus of newly discovered works of art and techniques was fervent, especially while in Venice in 1505–7. In the paintings executed in Venice during those years, he adopted a particularly Venetian idiom. The *Feast of the Rose Garlands* (Plate I), the central commission of Dürer's Venetian sojourn, reflects Dürer's awareness and emulation of a distinctly Venetian manner of painting. The outdoor setting is typically Venetian, as is the general iconographic format, which is a modification of the typically Venetian *Sacra Conversazione*.[2] A similar, strongly Venetian idiom is found in the *Virgin with the Siskin* (Figure 36) – a reprise of sorts of the *Feast* – as well as in the portraits associated with Dürer's Venetian sojourn, the *Portrait of a Young Venetian* (Figure 14) in Vienna and the *Portrait of Burkard von Speyer* (Figure 37) in the Queen's Collection at Hampton Court. These works betray specific Venetian influences, recalling the portraits of Giovanni Bellini in both form and lighting. Conversely, paintings similarly informed by Italian motifs and themes are distinctly lacking from Dürer's early career, specifically from 1494 to 1497.

The technical evidence I have derived from the paintings calls into question Dürer's presumed early presence in Italy. My investigations also show that Dürer was not limited to the recitation of Venetian forms and iconographic motifs in the paintings he made while in Venice in 1505–7. He adopted specifically Venetian techniques in the paintings that he executed in Venice and reused those techniques later in his career. Dürer incorporated these painterly innovations not only into his later paintings

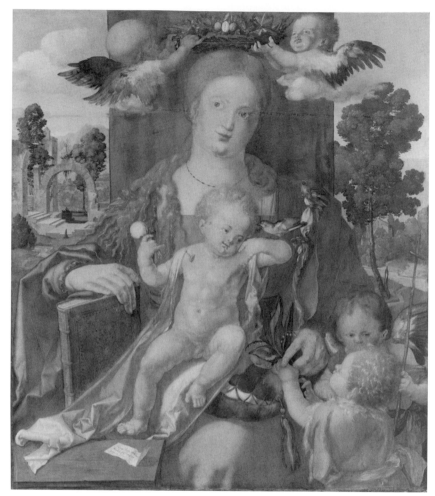

36. A. Dürer, *Virgin with the Siskin*, Berlin, Staatliche Museen zu Berlin-Preußischer Kulturbesitz

but also into his later graphic works. The very visible impact of Venetian painting on Dürer's work alone during this period suggests that the observations he made at that time were fresh and absolutely new to him. Earlier paintings reveal no evidence of any such significant alteration in technique or the introduction of a new technique that would be the result of an earlier exposure to Venetian or Italian art.

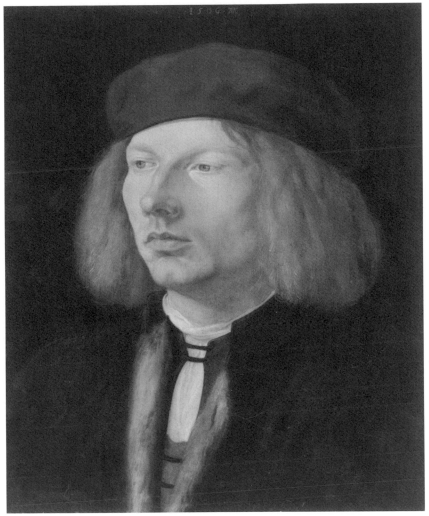

37. A. Dürer, *Portrait of Burkard von Speyer*, London, The Royal Collections

The Visual Evidence

Dürer's presence in Venice from 1505 to 1507 is unquestioned; the documentary and visual evidence converges to form a striking portrait of an artist active in a foreign country. In contrast to this evidence, there is no incontestable written record of his presence in Italy in 1494–5, nor

does the visual record support this conjecture. Most art historians have focused their energies on identifying drawings and paintings that reveal some aspect of Dürer's knowledge of Italian life that he could only have acquired in Italy. Yet the so-called Venetian elements in all of these works can, I believe, be explained by the traffic of prints and drawings throughout Europe. Furthermore, the commercial ties between Nuremberg and Venice were exceptionally well developed. More attention has been directed toward the presence of Germans in Italy than vice versa, but it would not be surprising to find that a significant number of Venetians visited Nuremberg on at least an occasional, if not a frequent, basis.[3]

Paintings

Four paintings in particular have been cited frequently as evidence of Dürer's presence in Venice in 1494. The four paintings include the *Madonna Before a Landscape* (Figures 38–39) in the Sammlung Georg Schäfer in Schweinfurt; the *Madonna del Patrocinio* (Figure 40) in the Fondazione Magnani-Rocca in Parma, Italy; the double-sided *Haller Madonna* (Figures 41–42) in the National Gallery of Art, Washington, D.C.; and the *St. Jerome* (Figure 44) in the National Gallery, London. All four were discovered or newly attributed to the early part of Dürer's career within the last century, after the theory was first presented that Dürer had traveled to Italy during the 1490s. Yet none of the four is so strikingly Italianate in style, iconography, or technique that it can offer any conclusive or convincing evidence of Dürer's presence in Venice or even Italy. This suggests that the desire to establish Dürer's presence in Italy has affected the process of attribution and dating; scholars have sought evidence in the form of newly attributed paintings to support and justify their views. Further, the critical understanding of Dürer's early painted production is still so poorly understood that it is difficult to convincingly attribute any painting to the early parts of his career in the absence of specific documentary evidence. This difficulty is compounded by the rather weak understanding of the painterly activities of Dürer's contemporaries. Much would be gained by further studies of figures like Wilhelm Pleydenwurff.

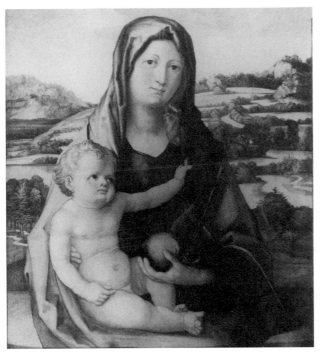

38. A. Dürer?, *Madonna Before a Landscape*, Schweinfurt,
Sammlung Georg Schäfer

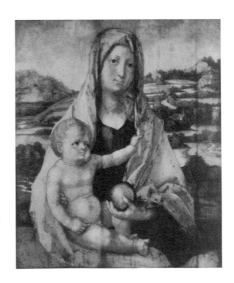

39. A. Dürer?, *Madonna Before a
Landscape*, Schweinfurt, Sammlung
Georg Schäfer infrared photograph 25

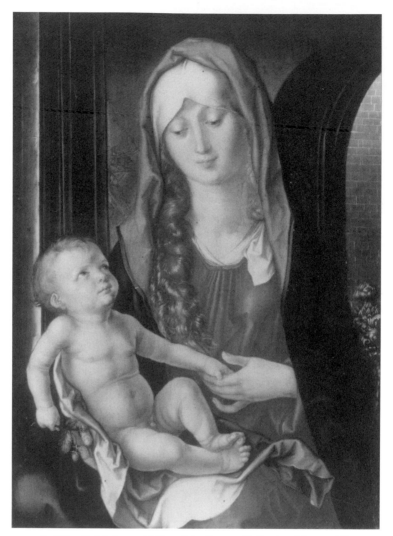

40. A. Dürer?, *Madonna del Patrocinio*, Parma, Collection Magnani-Rocca

The *Madonna Before a Landscape* in the Sammlung Georg Schäfer in Schweinfurt[4] (Figures 38 and 39), attributed to Dürer by Longhi as recently as 1961, is often cited as proof of Dürer's exposure to Italian, and specifically Venetian, painting primarily because it contains a pomegranate, which was an iconographic element frequently associated with Venetian painting and because the form of the Virgin looks vaguely Venetian.

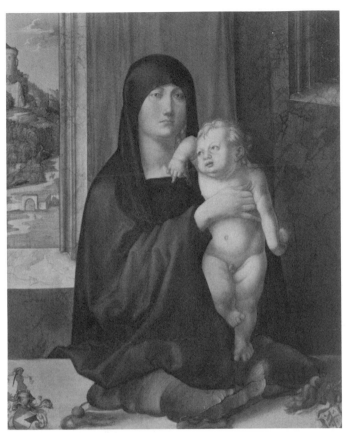

41. A. Dürer?, *Haller Madonna* (Virgin and
Child), Washington, D.C., National Gallery
of Art

42. A. Dürer?, *Haller Madonna* (Virgin and
Child), IRR assembly, detail of Christ Child,
Washington, D.C., National Gallery of Art

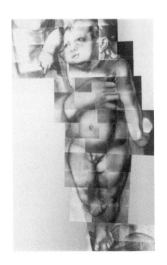

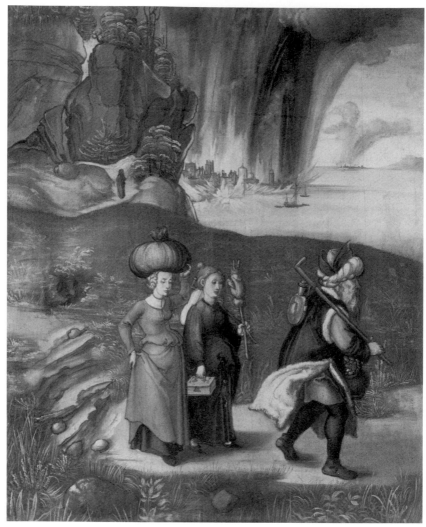

43. A. Dürer?, *Lot and his Daughters* (verso), Washington, D.C., National Gallery of Art

Anzelewsky observed that the inclusion of the pomegranate within representations of the Virgin and Child was unknown in Northern Renaissance painting prior to its occurrence in this work, and that the pomegranate does not commonly appear in paintings and prints as an iconographic motif before the late sixteenth century. However, Anzelewsky's identification of the fruit as a pomegranate is questionable; it could as easily represent an

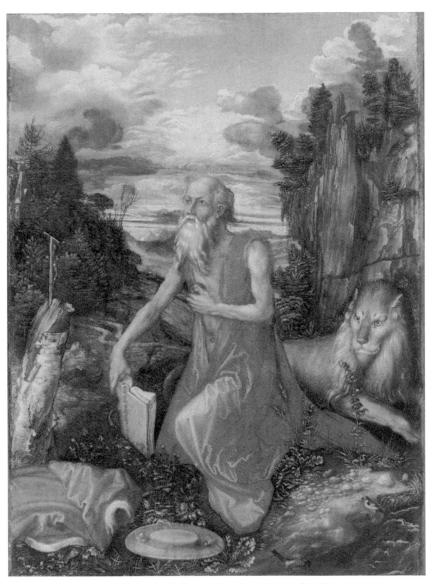

44. A. Dürer?, *St. Jerome*, London, National Gallery

apple or a pear. Further, the motif of the pomegranate occurs in both of Dürer's painted portraits of Emperor Maximilian I (discussed in Chapter 6).

Anzelewsky noted several other irregularities in the composition as well. He noted that the purplish-red color of the Virgin's mantle is unusual within Dürer's oeuvre and asserted that the placement of the Virgin before a landscape was rare in Dürer's work. The damaged and abraded condition of the *Madonna Before a Landscape* clouds judgment of the surface of the painting. Yet the formal qualities of the painting demonstrate a number of weaknesses in the execution of the pictorial space and relationship of forms to one another. For instance, the individual landscape elements are not unified with one another or with the figures of the Virgin and Child in the foreground. Likewise, the spatial relationship of the Christ Child to the Virgin's lap is confusing. The Virgin's robe sweeps around Christ as if he were seated on her lap, but she herself seems to be standing behind him. Anzelewsky suggested that, to resolve this compositional discrepancy, Dürer placed the low wall behind the figures over which the Virgin drapes her robe and upon which the Christ Child sits.[5] Anzelewsky implied that the unusual qualities of the painting reinforce the attribution to Dürer, revealing the artist's strengths in terms of iconographic invention. I would argue, in contrast, that Dürer's great strength lies in his ability to invent compositions that are particularly powerful and unified. Individual and idiosyncratic iconographic elements were important to Dürer, but within the context of fully realized compositions.

The underdrawing is visible to the naked eye in many areas of the painting, mostly because the paint layers have become transparent with age (Figure 39).[6] Although this increase in the transparency of paint layers with age is common in northern Renaissance painting in general, it is not common in works by Dürer, probably because of his method of painting. Moreover, the visible underdrawing is different from that in other paintings by Dürer that I have investigated. The infrared photograph of the painting shows how the artist depended upon relatively widely spaced, straight or slightly curved, parallel hatching to indicate the modeling. In the faces and drapery both, the long slashing strokes of the pen are bunched densely together and reveal a relatively planar approach

to the depiction of forms, especially when contrasted with the sensitive approach to curving volumetric surfaces found in the underdrawing in other paintings by Dürer, such as the *Salvator Mundi* (Figures 7–8) or the *Small Virgin* (Figures 3–6). These differences in the underdrawings, along with the unusual iconography and the awkward formal elements of the composition, suggest that the painting should be attributed, perhaps, to a follower of Dürer. It is also possible that the Schäfer Collection *Madonna Before a Landscape* is a product of the Dürer Renaissance and should be dated somewhat later in the sixteenth century. The J. Paul Getty Museum recently acquired a Dürer Renaissance painting of a *Rabbit* by Hans Hoffmann, one of the most well-known and documented artists of this later sixteenth-century period.

The *Madonna del Patrocinio* in the Fondazione Magnani-Rocca in Parma, Italy (Figure 40), was, like the Schäfer Collection *Madonna Before a Landscape*, attributed to Dürer by Longhi in 1961.[7] The Christ Child and the Virgin in *Madonna del Patrocinio* are remarkably similar to and may be derived from Schongauer's earlier engraving, the *Madonna with the Parrot* (B.29). In both representations (as well as the *Madonna Before a Landscape*), the Virgin is an idealized beauty with a high forehead, arching eyebrows, long straight nose, and small but full mouth above a rounded chin. This facial type is unlike most of Dürer's portrayals of the Virgin, which are usually highly individualized and often almost ugly characterizations of female physiognomy.

Anzelewsky argued that the presentation of the Virgin in knee-length was unusual north of the Alps but fairly common in Florentine examples.[8] As with the *Madonna Before a Landscape* (Figure 38), Anzelewsky used the iconographic anomalies to strengthen his attribution of the painting to Dürer. Significantly, it is more like the *Madonna Before a Landscape* than any other work ascribed to Dürer. A thorough and detailed technical examination of this painting would assist in understanding the relationship to Dürer and sixteenth-century German painting. Similar underdrawing is found in the *Virgin with the Iris* in the National Gallery, London, which has close ties to Dürer too, in terms of models and technique. The understanding is that painting, like the Schäfer Collection *Madonna Before a Landscape*, is in the Dürer style, but somewhat looser and less volumetric.[9]

The *Haller Madonna* in the National Gallery of Art, Washington, D.C.[10] (Figures 38–40), is painted on both sides, but the recto and verso are of very different quality. The painting of the Virgin and Child (Figure 41) on the recto is of extremely high quality; it is an example of the kind of problem of attribution not easily solved by technical investigation. Examination of the *Haller* Virgin and Child with infrared reflectography was not conclusive because penetration of all paint layers was not possible, possibly because of a large percentage of lead white in some of the paints used, particularly the blue of the Virgin's robe. However, it was possible to find and record underdrawing in the face of the Virgin, in the body of the Christ Child, (Figure 43) and in the pillow the Christ Child stands upon.[11] As I will show in subsequent chapters, I have found that Dürer used many different kinds of underdrawing. The underdrawing found in the figure of the Christ Child is somewhat similar to examples found in the *Adoration of the Trinity and the All Saints* as well as the *Virgin with the Pear*, both in Vienna. However, the broad, washlike strokes that define the shadowed side of the Virgin's face are unlike any other underdrawing I have seen.[12]

A representation of *Lot and His Daughters* (Figure 43) appears on the verso, which is much more crudely painted than the *Virgin and Child* on the recto. Many of Dürer's paintings are painted on both sides, frequently with representations of astronomical observations, like shooting stars, and sometimes with wild men. Wild men occur on the shutters of the *Portrait of Oswolt Krel* in Munich and on the outside of the *Jabach Altarpiece*, also in Munich. These verso representations, less finely wrought than the rectos of the panels and the *Lot and His Daughters*, should be understood in this context. For example, the burning city on the horizon of the *Lot and His Daughters* is a quotation of the burning city that appears in the *Whore of Babylon* from the *Apocalypse*, and the monogram on the *Lot and His Daughters* bears little resemblance to other examples that appear in Dürer's works.[13] I believe it likely that this painting reflects a collaboration between Dürer and another artist, possibly a member of his workshop, or that another artist painted the verso after Dürer had completed the recto. Such a collabration could explain the high quality of the recto as well as the cruder quality of the verso, the problematic presence of the

monogram, and the derivative quality of the burning city in the *Lot and His Daughters*.

Dürer mentioned a painting of a Madonna for which he hoped to find a buyer in his letter to Jacob Heller of August 24, 1508, and said that he would accept 25 to 30 florins for it. Some months later, on November 4, 1508, he wrote to Heller that the Bishop of Breslau had purchased the picture and paid 72 florins for the picture, significantly more than Dürer had indicated to Heller that he would accept. Perhaps the *Haller Madonna* is the Madonna picture bought by the Bishop of Breslau in the autumn of 1508. If this were the case, Dürer could have painted the figure of the Virgin after his return from Venice and then had the verso executed by someone in his shop after the Bishop expressed interest in the picture. Shop participation would have been necessary at this time because Dürer was very busy painting the *Heller Altarpiece* (for which he also had workshop assistance). This might explain as well how Dürer came to be paid 72 florins for the painting, significantly more than he had asked of Jacob Heller. Although only speculation, this – or another similar circumstance – would explain the difference in quality between recto and verso.[14]

The last of the four paintings attributed to the early part of Dürer's career and cited as possible evidence of Dürer's direct knowledge of Venetian art is the *St. Jerome* (Figure 44), recently acquired by the National Gallery in London.[15] Before David Carritt attributed this painting to Dürer in 1957, the English owners had attributed it to Giovanni Francesco Caroto, a painter active in Verona.[16] Carritt believed it to be the first representation of St. Jerome in German painting and iconographically advanced as such.[17] I would argue that the *St. Jerome*, like the *Lot and His Daughters* on the verso of the *Haller Madonna*, may be dependent on graphic sources for some of its compositional elements, and indeed the similarity of the lion in the painting to the *Lion* in Hamburg was central to Carritt's original attribution of the painting to Dürer. Close comparison of the two lions shows that the painted version is simplified in comparison to the Hamburg watercolor. The position of the eyes and ears on the head are not so well understood in the painting as in the watercolor, and the mane is simplified as well, reduced to single ruffs on each side of the jowls.

Further, the Hamburg *Lion* is not so securely datable to 1495–6, nor is it universally attributed to Dürer. The painting is also extremely close in composition to Dürer's 1496 engraving of the same subject, *St. Jerome in the Wilderness* (B. 61).

Little technical information is available about this painting, and initial investigations of the painting with infrared reflectography reveal little underdrawing.[18] The verso of the little panel is very beautifully painted with an astronomical image: possibly a shooting star, and is similar to the verso of the so-called *Portrait of Dürer's mother* in Nuremberg. The modeling of the arms and face of Jerome appear to be particularly soft and not clearly delineated, atypical of Dürer's handling. The earliest painting clearly attributable to Dürer that I have had occasion to examine closely (although without technical means of investigation) is the 1498–9 *Christ in the Sepulcher* in Karlsruhe. The handling of the paint and modeling of the forms is quite different in the two paintings.

Aside from these four works – whose authorship and dates are uncertain – no paintings can be identified that attest to Dürer's presence in Italy in 1494–5. Even if all four of these paintings are in fact by Dürer, they do not demonstrate firsthand knowledge of Italianate painting or painting techniques, since the motifs could have been translated from Italy to the North via the medium of graphic works. In sum, no conclusive evidence can be derived from Dürer's paintings that shows that the artist was in Italy before 1505. On the other hand, Dürer's striking and monumental self-portraits are particularly useful in thinking about his relationship to Italianate models. Even the earliest of the self-portraits, the 1493 *Self-Portrait with Eryngium* in the Louvre, conveys a quality of self-conscious assurance, monumentality, and direct confrontation with the viewer that is more often associated with the achievements of Raphael and Italian Renaissance portraiture of the sixteenth-century. Yet Dürer's self-portraits predate those masterpieces of portraiture by decades. The 1498 *Self-Portrait* in the Prado and the 1500 *Self-Portrait* in Munich are even more dazzling examples of portraiture, yet they, like the 1493 *Self-Portrait with Eryngium*, spring directly out of Dürer's northern, gothic sensibility *without* recourse to typically Italian prototypes.

Drawings and Watercolors

Drawings have been cited more often than paintings to buttress the argument that Dürer was in Venice in 1494. However, the dissension in the literature about the dating of Dürer's drawings makes it difficult to use them as positive proof of Dürer's activities and location at any given time. The landscape watercolors, frequently used by scholars as evidence of Dürer's presence in Italy, and to reconstruct a travel diary – paralleling Goethe's travel diary of the same type – provide a case in point.

The problems involved with using the landscape watercolors as proof of Dürer's travels to Venice in 1494–5 are manifold.[19] The dating of the watercolors has always been problematic. Dürer did not date them himself, and the physical evidence provided by the papers used and the presence of watermarks is inconclusive. Additionally, the watercolors as a group have never been, to my mind, convincingly ordered on the basis of style or technique. The lasting impression of Dürer as a primarily graphic artist, dedicated to the representation of visual reality in purely linear as opposed to painterly terms reverberates throughout the critical literature. The bias in the scholarly literature against Dürer as a painter is striking. Countless studies have been devoted to the life of the artist, his theoretical works, and especially his graphic achievements, both printed and drawn, but only a single monograph has been written about his paintings. Hans and Erica Tietze wrote that the watercolors lack the signs of internal growth that allowed them to classify Dürer's other works. Heinrich Wölfflin, for instance, introduced his 1914 monograph *Albrecht Dürer: Handzeichnungen* as follows: "The historical significance of Dürer as a draftsman lies in his construction of a purely linear style on the foundation of the modern three-dimensional representation of the real world." Yet Wölfflin included the landscape watercolors among the graphic works, even as he relegated them to the painterly, archaic, pre-modern realm of the fifteenth century, which in his words, did not possess the "graphic style."[20] Likewise, Kristina Herrmann-Fiore has shown that despite multiple and serious scholarly attempts to disentangle the chronological relationship of these watercolor drawings to one another and to the rest of Dürer's oeuvre, no single convincing dating has emerged.

45. A. Dürer, *Pond with Mill*, watercolor, Paris, Bibliothèque Nationale

Herrmann-Fiore also pointed out that the landscape watercolors have been measured against Dürer's other graphic production for dating purposes and that no comparisons of the watercolors to Dürer's paintings have been made. I would add that they have never been studied in relationship to Dürer's painting technique. Herrmann-Fiore noted that Dürer continued to paint landscapes until at least as late as 1511, when he painted the vista beneath the cosmic vision that appears in the *Adoration of the Trinity and the All Saints* (Figure 33) in Vienna. Furthermore, she suggested that drawings that have traditionally been dated to before the turn of the century, such as the *Tree* in the Ambrosiana in Milan or the *Pond with Mill* (Figure 45) in Paris, are more convincingly dated to 1506 or after, as they share formal and stylistic traits with the depictions of trees found in the paintings from this time and after, significantly, the *Feast of the Rose Garlands* (Plate I) and the *Virgin with the Siskin* (Figure 36) in Berlin. I will show in Chapter 3 that the watercolor landscapes reveal a profound change in Dürer's depiction of pictorial space that is directly related to his experience in Venice in 1505–7. This relationship, in turn, suggests that the landscape watercolors so often used to prove Dürer's presence in

Venice in the 1490s should be dated to 1505–7 and even later. Finally, it is possible to distinguish a real change in the way that landscape was perceived and depicted by Dürer after his experiences in Venice in 1505–7. This change, in conjunction with the securely datable watercolors of the environs of Nuremberg painted by Dürer early in his career, make it possible to consider a reordering of the landscape watercolors. As I will argue further in Chapter 3, Dürer became passionately interested in the depiction of space and aerial perspective during and after his Venetian journey of 1505–7 and continued to experiment with the depiction of landscape for the rest of his life.

Nonetheless, a reevaluation of the dating of *all* of Dürer's landscape watercolors is beyond the scope of this investigation. However, in the next chapter I discuss the chronology of a few of these watercolor landscapes in relationship to the *Feast of the Rose Garlands*. Given the uncertainties involved in dating these watercolors as well as the Tietzes' failure to organize them on the basis of signs of stylistic development, they cannot be used to establish Dürer's location at a given moment in time, and should not be depended upon for proof of his presence in Italy in 1494.

Scholars have cited other drawings as well to demonstrate that Dürer was in Italy, mostly because forms or motifs are reproduced in them that Dürer could only have seen in Italy. The drawing of the *Three Orientals* in the British Museum, which reproduces a segment of Gentile Bellini's painting, *the Corpus Christi Procession* of 1496 in the Accademia in Venice, is an example of this type of argument.[21] Walter Strauss has argued that the *Three Orientals* (and other drawings) bear watermarks that prove he was in Venice during these early years. However, the paper trade in Europe in the late fifteenth century was well developed and Dürer mentioned in a letter to Willibald Pirckheimer that there were no finer papers available in Venice than were easily obtained in Nuremberg.[22]

Rowlands, Anzelewsky, and others have assumed that Dürer would have had access to Gentile Bellini's studio or to preparatory drawings before the completion of the *Corpus Christi Procession*, and that he was so struck by this particular detail that he drew a copy of it on the spot. Yet as Rowlands points out, the figures in the drawing do not correspond exactly with the detail in Gentile's painting.[23] Such differences hardly convince

that Dürer was closely copying the original in situ. Even if Dürer had been in Venice in 1494–5 (before Gentile's painting was completed), he would have had to gain access to his studio in order to see this detail, either in the painting itself or in the preparatory drawing for it. There is no documentary evidence whatsoever that Dürer had any contact with Gentile Bellini, and it would be extraordinary if he had achieved an entrée into his workshop and this were the only record of that encounter. This and other drawings of oriental types attributed to Dürer are often derivative and might have their origins in pattern books. Oriental figure types with turbans and exotic dress frequently occur in prints and books made in Germany and the north well before Dürer's activity as a mature artist. Turbaned figures appear in Hartman Schedel's *Weltchronik* as well as in Bernhard von Breydenbach's 1483 *Die Reise ins Heilige Land*.[24]

The other drawings most often used to assert Dürer's presence in Venice in 1494–5 are the costume studies of Venetian and Nuremberg ladies, and particularly the *Lady in Venetian Costume* in the Albertina in Vienna. Dürer reused this figure for the *Whore of Bethlehem* in the Apocalypse woodcuts, and most scholars have seen this as proof that he saw such a costume in Venice. Yet, a woman dressed in a strikingly similar costume was published in the frontispiece of Bernhard von Breydenbach's 1483 *Die Reise ins Heilige Land*. It is remarkable that no scholar has suggested that Dürer might have seen a Venetian lady on the streets of Nuremberg or Basel or in the Low Countries (or even a picture of a lady in Venetian costume), despite the fact that Italians traveled and traded throughout Europe. This is yet another signal of the scholarly entrenchment of the notion that Dürer must have traveled to Italy early in his career.

Animal studies are likewise cited as proof of Dürer's presence in Venice. The studies of the *Lion*, *Lobster*, and *Crab* are frequently presented as proof of Dürer's first-hand knowledge of these animals.[25] All three drawings are too damaged and abraded to allow any serious discussion of attribution, however, Dürer had traveled up the Rhine during his *Wanderjahre*, and marine delicacies like lobsters and crabs would have been more widely available closer to the North Sea Ports, even if they were not available in Nuremberg. Further, many bronze casts of crabs and other exotic sea

animals were made at the end of the fifteenth century, and must have been rather popular collectibles for sophisticated collectors throughout Europe at the end of the fifteenth century and well into the sixteenth century.[26] Similarly, if the Hamburg *Lion* is indeed by Dürer, there is no reason to suppose that he must have been in Venice to see such an animal. Collections of exotic animals were prized in northern Europe. For instance, in the diary kept during his 1521 journey to the Low Countries, Dürer commented on the lions he saw in Ghent.[27] He also visited the zoo in Brussels where he saw lions, a lynx, monkeys, and a goat. The lions in particular caught his attention; he made five different sketches of them altogether, and the Hamburg *Lion* is enormous. This suggests that the Hamburg *Lion* may well have been an "imaginary" study, one based either on descriptions or drawings by other artists. Similarly, Dürer's *Rhinocerus* (B.136) is assumed to be a work from the imagination. No scholar has supposed that Dürer traveled to sub-Saharan Africa to see such a creature. Lobsters, crabs, and even lions were no less subject to the imagination.[28]

Printed Works

As with the paintings and drawings, scholars have mined Dürer's printed corpus of works for evidence of an early sojourn in Italy. The single most significant set of prints for this enterprise should be the *Apocalypse* woodcuts, since they were largely completed between 1496 and 1498. Surprisingly, scholars concerned with Dürer's putative sojourn in Italy in 1494–5 have ignored these woodcuts in their discussions. It is generally accepted that Dürer was influenced by Mantegnesque sources in only half of the *Apocalypse* woodcuts, and especially those considered to be the later, stylistically more advanced ones.[29] Since all the woodcuts were executed after 1496, the emergence of Mantegnesque influences in *only* the latter half of the series is difficult to explain if Dürer was in fact in Italy before 1496. Further, the scope of the *Apocalypse* project was so enormous that it is difficult to imagine that Dürer would have had time to travel to Venice in 1495, return to Nuremberg in 1496, and still complete the woodcuts. I would argue, instead, on the basis of the visual evidence

provided by the *Apocalypse* woodcuts, that Dürer was made aware of these Italianate motifs only *after* 1496, which would preclude a previous journey to Italy. Therefore, the circulation of printed matter, and not direct observation of original works of art, was the likely means by which he became aware of the Italianate motifs adapted in the *Apocalypse* to such a striking effect. This argument is supported by Dürer's well-known copying of Mantegna's *Bacchanal with Silenus* (Figure 46) and *Battle of the Sea Monsters* (Figure 47) in 1494.

The other printed work most often cited as proof of Dürer's knowledge of the Italian landscape is the 1503 engraving *The Great Nemesis* (B. 77). Ludwig Grote identified the town in the valley beneath "Fatima" as Klausen in Eisacktal and argued that the representation of the landscape was so precise that Dürer must have been there himself.[30] Relatively rigorous map-making and picturing of specific locales had been codified by 1503, and this representation is not so much specific of Dürer's firsthand knowledge of the site as it is a manifestation of his extraordinary ability to re-represent the unseen, known only from descriptions and the traditions of representing city-scapes from such sources as the *Liber cronicarum*, written by Hartman Schedel and published by Anton Koberger in 1493.

In short, the manifestations of Italianate motives that occur in Dürer's oeuvre before 1506 can be explained by the widespread availability of prints, drawings, books, and bronzes throughout Europe in the fifteenth century.[31] Further, Dürer was very well traveled by 1494. During his *Wanderjahre* he spent four years visiting other places in Europe, including Basel, close enough to the Alps to explain any knowledge of the mountainous, Alpine landscape.[32] It is even possible, perhaps likely, that Dürer went as far as Innsbruck in 1494. This city was well established as Maximilian I's primary residence by 1494, and it is not unreasonable to imagine that Dürer would have been interested at that early moment in his career in seeing Innsbruck, the home of the emperor. This would also explain the very gothic, even wooden, appearance of the two watercolors Dürer made of the courtyards of Innsbruck Castle.[33] During this *Wanderjahre*, Dürer would have been open, even eager, to see and experience the most unusual sights, artworks, and places available to him. In fine, the lack of

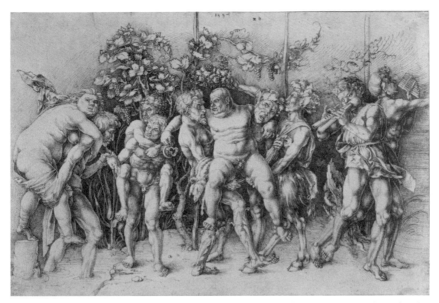

46. A. Dürer, *Copy of Mantegna's Bacchanal with Silenus*, drawing, Vienna, Graphische Sammlung der Albertina

47. A. Dürer, *Copy of Mantegna's Battle of the Sea Monsters*, drawing, Vienna, Graphische Sammlung der Albertina

any unassailable visual evidence supporting Dürer's presence in Italy in 1494–5 calls for a reexamination of the documentary evidence so often cited.

The Documentary Evidence

The primary documentary evidence, the foundation for the "first journey" of 1494–5, is extremely slight and consists of two vague, even obscure, literary references that place Dürer in Venice before the turn of the sixteenth century. My intention is to draw attention to the difficulties inherent in any interpretation of these texts. Whatever meaning is extracted and interpreted from them should be weighed against other forms of evidence. As I have signaled earlier, technical investigations stand in opposition to the previously accepted interpretations of the documentary evidence. The paintings themselves show that Dürer had little, if any, familiarity with Italianate painting techniques before 1506.

The first of the two texts is found in a letter written by Dürer while he was in Venice to Pirckheimer on 7 February 1506. It reads:

Und daz ding, daz mir vor eilff joren so woll hatt gefallen, daz gefelt mir jcz nüt mer. Und wen ich nit selbs sech so hatt ichs kein anderen gelawbt awch las ich ewch wissen daz vil pesser moler hy sind weder dawssen meister Jacob ist, aber Anthoni Kolb schwer ein eyt es lebte kein pessrer moler awff erden den Jacob. Du anderen spotten sein sprechen wer er gut belib er hie.[34]

William Conway translated this passage as:

And that which so well pleased me eleven years ago pleases me no longer; if I had not seen it for myself I should not have believed anyone who told me. You must know too, that there are many better painters here than Master Jacob (Jacopo de Barbari) is abroad, yet Anton Kolb would swear an oath that no better painter lives than Jacob. Others sneer at him, saying if he were good he would stay here and so forth.[35]

These sentences occur in a passage where Dürer expresses his delight at his discoveries of Venetian art and his reception by Venetian artists. Moritz Thausing believed that "Daz Ding" referred collectively

to artworks, and Eduard Flechsig documented this with a comparison of other similar usages in Dürer's writings.[36] Daniel Burkhardt understood it more broadly as "Kunstweise or Kunstrichtung."[37] However, the etymological history of "Ding" is quite complex. Prior to the Kantian philosophical attention to "das Ding an sich," the word "Ding" already had a wide range and variety of possible meanings, similar to "thing" in the English language. Although "Ding" was applied to matters of taste and affinity, it also often implied a belittling or derogatory regard for the object described.[38]

Due to its location in the passage, most scholars have interpreted the first sentence in this passage ("And that which so well pleased me eleven years ago, pleases me no longer") as referring to something that Dürer had seen before *in Venice*, the same place from which he was writing. However, one can argue that Dürer's descriptions of the place betray no previous familiarity with the city at all. He did not write in this letter of a city with which he was already intimate nor about artists with whom he was already acquainted. Equally, it is possible that Dürer's sense of disbelief at the discovery of a change in his taste ("if I had not seen it for myself, I would not have believed anyone else") had not to do with what he was seeing again, but with something he witnessed in 1506 for the first time.

Approximately eleven years earlier, Dürer had only just returned to Nuremberg from his *Wanderjahre*.[39] It is likely that upon his return he saw a new collection of Italian (or even more specifically Venetian) prints and drawings. These works must have had a special significance for him – the Mantegna prints he so assiduously traced and internally reworked remain the only physical record of this early contact with North Italian works of art; surely there were others.[40] It is not implausible to suppose that Pirckheimer, who spent a number of years in Padua and Bologna, would have acquired some memento of Italian art to bring back to Nuremberg with him on his return. Prints (and small bronzes like the box in the form of a crab noted earlier) would have been the least expensive and most easily transportable objects of this kind. If Pirckheimer himself did not bring prints from northern Italy back to Nuremberg, there were many other possible candidates for the task.[41] The mercantile relationship

between Nuremberg and Venice was well developed by the end of the fifteenth century; it was fashionable for prosperous patrician families from Nuremberg to send the scions of their families to study in the university towns of northern Italy or to spend time working in Venice.[42] Jacopo de Barbari was another certain contact between Nuremberg and Venice; his interpretation of Italian art and presentation of that to Nuremberg artistic circles might be the intermediary with which Dürer was later so disillusioned.[43]

I believe that the sentiment expressed by Dürer in this letter reflects two different things. First, he had expected to be excited by the forms of Italian art to which he had been previously exposed to in the form of prints. Second, he was more excited by the paintings, most likely those associated with the Bellini school, than he had expected. Although we will never know exactly what Dürer meant by "daz ding" in his letter to Pirckheimer, I believe that he was referring to his own taste for art as a young man and not to specific artworks. The works of art he had admired earlier in his career – prints, drawings, and works of art associated with Jacopo de Barbari, all of which had come to Nuremberg from abroad – were viewed by Dürer with distaste at the time he wrote this letter in 1506. This shift in taste was the result, I believe, of Dürer's exposure to Venetian painting, which he witnessed for the first time in 1505–7. In that case, the derogatory aspect of "Ding" noted by Grimm and Grimm would correspond to his denigration of his earlier taste. Therefore, it is possible to understand the disappointment expressed in the letter as a result of the disparity he perceived between his previous and current models.

My reading is supported by another part of that passage in the same letter written to Pirckheimer. Here, Dürer refers to Giovanni Bellini as "sehr alt, aber noch der Best in Gemäl." Many scholars have found in this statement a confirmation of the earlier journey and have assumed that Dürer, if not acquainted with Bellini himself, was at least familiar with his paintings and works before his presence in Venice in 1505–7. I believe, however, that this passage could be interpreted to mean that Dürer saw that Bellini was very old, indeed (he was probably about 70 years old in 1506), but that despite his age he was still the single best painter within the large community of painters active in Venice. Rather than a reference to a

past event or meeting, Dürer's remark can be understood and interpreted as a sign of respect for the much older painter Bellini. The closeness of the relationship between the elderly Bellini and Dürer is attested to in a letter recently reintroduced and reinterpreted by Giovanni Maria Fara. In this letter, known since the fifteenth century, but inaccessible because it was in a family archive, Bellini's deep affection for Dürer is reported.[44]

The other document used to buttress a 1494–5 journey to Venice by Dürer is found in the humanist Christoph Scheurl's *Libellus de laudibus Germaniae et ducum Saxoniae* of 1508. Scheurl, from a family of Nuremberg merchants, studied in Heidelberg between 1496 and 1498 and then studied law in Bologna from 1498 to 1507. After 1507 he became a professor of law at Wittenberg. Scheurl's passage about Dürer in the *Libellus* begins as follows:

> Ceterum quid dicam de Alberto Durero Nurimbergensi? Cui consensu omnium et in pictura et in fictura aetate nostra principatus defertur. Qui quum nuper in Italiam rediiset, tum a Venetis, tum a Bononiensibus artificibus, me saepe interprete consalutatus est alter Apelles.[45]

Matthiäs Mende translated this passage into English as:

> What else should I say about Albrecht Dürer of Nuremberg, whom all in our country acknowledge to be of the first rank both in painting and sculpture? Not long ago, when he traveled once again to Italy, he was greeted in Venice and in Bologna as a second Apelles; at which occasions I often served him as an interpreter.[46]

Scholars have used this passage, and particularly the phrase that reads "Qui quum nuper in Italiam rediiset," to support the argument that Dürer's visit to Venice in 1505 was not his first. I believe that Scheurl's statement that Dürer "returned to Italy" ("Qui cum nuper in Italiam rediiset") should be interpreted within the context of his other writings about Dürer's life and travels. Besides the passage cited here from the *Libellus*, Scheurl wrote about Dürer on two other occasions. In his 1509 *Oratio . . . Ecclesie Collegiate Vittenburgensis*, Scheurl again praised Dürer as the German Apelles, described the *Martyrdom of the 10,000* (at that time in Frederick the Wise's Collegiate Church in Wittenberg), and wrote that not in Venice, Rome, or Naples could one see such an outstanding

example of excellence in painting.[47] As in the 1508 *Libellus*, Scheurl compared Dürer and Dürer's works of art to the artists and art of Italy in a paradigmatic relationship. In a third book, *Vita Reverendi patris Domini Anthonii Kressen*, written some years later in 1515, Scheurl describes in detail the places visited by Dürer during his *Wanderjahre* and notes the names of the significant artists with whom Dürer came into contact on that journey.[48] In this document, Scheurl makes no mention of an early, 1494–5 journey to Italy, despite his otherwise thorough knowledge of the events of Dürer's life.[49]

As Michael Baxandall has shown in an investigation of Bartholomeus Facius' *De Viris Illustribus*, written in 1456, humanist descriptions of artists' lives and work were often densely structured allusive texts intended to make a point about the relative ranking of the arts, whether by media or geography, and were not necessarily meant as biographically accurate, or true accounts.[50] Facius' manuscript is also significant for my argument because it reveals a comparative paradigm that contrasts the painters of northern Europe with those of Italy, and specifically Venice.[51] Facius links the northern artists Jan van Eyck and Rogier van der Weyden to the Venetians Gentile da Fabriano and Pisanello and calls them all the best of their time. Scheurl's comparison of Dürer to Apelles parallels Facius' accounts of famous artists. For Scheurl to compare Dürer to Apelles was to locate Dürer within the pantheon of the greatest artists of all time. I believe Scheurl's vision of Dürer's presence in Italy could be interpreted as a rhetorical device meant to further the allusion to Dürer's equality to Apelles, as well as his stature as a German artist.

The range of meaning attached to the Latin verb "redire" lends credibility to this view. "Redire" may indeed mean to come or go back to a place from which one has set out or to return. This is the meaning clung to by those art historians arguing for Dürer's early presence in Italy, but "redire" can also signify to go to a place to which one is thought of as particularly belonging.[52] Later in the same passage, Scheurl makes use of complex allusive structures in the description of Dürer's life, mostly pertaining to the Apelles myth. Since Italy was viewed by the German humanists (like Scheurl) as the locus for the rebirth of classical antiquity,

Scheurl's rhetorical location of Dürer in Italy strengthens his mythical connection to Apelles, the greatest artist of Antiquity.

The Scholarly Response to the Evidence

Nineteenth-Century Scholarship

The arguments put forward that locate Dürer in Italy before the turn of the sixteenth century were first formulated in the decade after the publication of Jacob Burckhardt's *The Civilization of the Renaissance in Italy* in 1860.[53] Intellectual interest in Italy was already at least a century old when Burckhardt published his study, although he was the first of the great nineteenth-century historians to identify Italy as the locus of the Renaissance.[54] Burckhardt's book became popular and his ideas gained widespread acceptance. It is striking that in 1865, only five years after it was published, Hermann Grimm suggested that Dürer had made a journey to Venice in the autumn of 1494, a few weeks after his marriage to Agnes Frey in July of that year.[55] The art historian G. F. Waagen concurred with Grimm's theory in 1866.[56]

In his monographic account of Dürer's life, Moritz Thausing accepted the arguments of Waagen and Grimm without reservation.[57]

Thausing cited the copies Dürer made of Mantegna's engravings, the drawing of a *Lion* in Hamburg, and the landscape watercolors as proof of Dürer's presence in Venice in 1494. For Thausing, Mantegna, as the source of the Venetian Renaissance, was of particular importance to Dürer in 1494 because Mantegna had already combined the observation of nature with intellectual learning.[58] Those were the very qualities that Thausing believed would project Dürer into the forefront of artistic activity within a few years. In Thausing's view, since Mantegna's interests and achievements paralleled those of Dürer, it was logical that Dürer would be drawn to the older Paduan artist.[59] Ironically, for Thausing, the very lack of evidence attesting to Dürer's attraction to Mantegna revealed Dürer's innate engagement with the theoretical aspects of the Renaissance as well as his still nascent intellectual state. Although he was drawn to the artistic

and theoretical advances made by Mantegna, Dürer, in Thausing's view, simply was not developed enough theoretically to utilize them.[60]

Yet Thausing recognized the circumstantial nature of this evidence and went to extreme lengths to explain that it was a rather "indefinite" quality to which Dürer was attracted in 1494.[61] He also blamed the technical achievements of the Venetians, specifically in the arena of color, to explain the dearth of visual evidence connecting Dürer to Venice. Thausing wrote that color principles, and the coloristic handling of oil paint in Venetian art, were incomprehensible to Dürer, since he was limited, as a young artist from the North, to the graphic, linear expression of artistic ideas.[62] Thausing's attempts to explain the *lack* of visual evidence supporting Dürer's firsthand contact with Italy are indeed striking, especially since Thausing was usually so meticulous in his gathering and interpretation of facts. Thausing's machinations are surprising given the overwhelming evidence against the early trip. His view was nonetheless accepted by the next generations of scholars concerned with Dürer's relationship to Italy.

Charles Ephrussi and Daniel Burckhardt stand out as lone voices in the history of early Dürer criticism. Both explicitly questioned Thausing's arguments for Dürer's presence in Venice in 1494.[63] Ephrussi countered Thausing's contention by asserting that Dürer could not have had the time to travel to Venice after his return from his *Wanderjahre*. Ephrussi also dismissed Thausing's view that the landscape drawings proved Dürer's presence in Italy because of the great stylistic variation apparent in them. He proposed instead that Dürer left Venice in the summer and early autumn months of 1506, traveled to the mountains north of the Adriatic, and executed the mountain landscapes during this time. According to Ephrussi, a trip by Dürer north from Venice in 1506 also explained the Christoph Scheurl document in which Scheurl wrote of Dürer's return to Venice. Ephrussi argued that Dürer had simply left Venice and come back again, all within the year 1506.[64] The difference of opinion between Thausing and Ephrussi seems to have extended well beyond scholarly rivalry. Thausing later referred to Ephrussi, the editor of the *Gazette Des Beaux-Arts* in Paris as a "Landesmann aus dem Osten," a seeming slur on Ephrussi's racial and ethnic heritage.[65] This episode is striking because Ephrussi's conceptualization of and conclusions about Dürer's

activities and artistic life were different from Thausing's throughout. Thausing's virulent ad hominem attacks seem to me to be reflective of something greater than a mere difference of opinion and may be indicative of Thausing's desire to establish his idea of Dürer's pure germanic qualities.

Daniel Burckhardt followed closely in Ephrussi's tracks but focused his research on determining where Dürer traveled during the earliest part of his career, and then between 1492 and 1494.[66] He referred to Thausing's arguments about Dürer's early presence in Italy as "Dürer dogma."

Modern Scholarship

Almost uniformly, scholars of the twentieth century have ignored Ephrussi's argument in favor of Thausing's and continued to find presentiments of Goethe's preoccupation with Italy. For Heinrich Wölfflin, Dürer's presence in Italy attested to his familiarity with the classical tradition and the forms of the Italian Renaissance, and defined that scholar's understanding of Dürer as an artistic personality.[67] Like Thausing, Wölfflin explained Dürer's seeming lack of response to the artistic vibrancy of Venice in 1494 to the shock of the new. He strayed even further from the visual evidence by explaining that Italy served to wake Dürer's consciousness, if nothing else, at this early date in his career.[68]

Joseph Meder wrote extensively about Dürer's putative first journey to Italy and concluded that, despite Dürer's presence in Venice at this moment of extreme and rich artistic productivity, Dürer was only interested in the graphic elements of Italian art. Yet, as if in disbelief of his own thesis, Meder described at length the extraordinary wealth of activity occurring in Venice during the last decade of the fifteenth century. Instead of wondering if perhaps Dürer were not in Venice at this time, Meder reasoned (like Thausing and Wölfflin before him) that Dürer was too undeveloped as an artist to understand or benefit from the painted and sculptural production of artists active in Venice and the Veneto during that time.[69]

In an excursus appended to their multivolume catalogue devoted to Dürer's complete oeuvre, the Tietzes asserted that Dürer was in Italy in

1494–5. They criticized the stylistic evidence offered by previous scholars in support of Dürer's early presence in Venice as circumstantial, yet relied upon Dürer's letter to Pirckheimer and the Christoph Scheurl books for their position. The Tietzes argued that Dürer's artistic consciousness and maturity were brought to fruition only through the medium of the strange and new elements of the Renaissance available to him in Italy.[70] They concluded their excursus about Dürer's relationship to Italy by comparing the incentives for his journey to those of Goethe's first journey to Italy in 1786–8. In both cases, they asserted, the drive to grasp the advances of a foreign (and implicitly more advanced) cultural and artistic milieu colored the relationship, in addition to enhancing the artist's self-recognition through that very contact.[71] Although I can readily agree with the Tietzes' assertion that Italy was of crucial and critical importance for Dürer as an artist, I disagree with their view that he must have traveled there on *two* separate occasions to discover his own artistic potential.

Other scholars wrote contemporaneously with the Tietzes about Dürer's relationship with Italy. Eduard Flechsig, unlike the Tietzes, questioned the documentary sources that placed Dürer in Italy but accepted the stylistic evidence.[72] Flechsig suggested that an outbreak of the plague in the autumn of 1494 in Nuremberg that eventually killed more than eight thousand people in the city was the prime motivation for Dürer's travel to Italy in 1494–5. It is striking that Flechsig explained the supposed first journey by a desire to escape the plague, and that little convincing stylistic evidence was found by him to support this conclusion. This is the more striking given that Flechsig's primary organizational impetus was to trace the development of Dürer's style using the most scientific and exacting criteria possible. Like Meder, Flechsig accounted for the lack of visible evidence in Dürer's artistic production of his presence in Italy by suggesting that Dürer did not know exactly what he was interested in while there.[73]

Panofsky's Response to the Evidence

Erwin Panofsky's portrait of Albrecht Dürer, in which the German thinker prevails over the artist, has dominated the scholarly discourse about Dürer

for more than fifty years now.[74] For Panofsky in 1943, Dürer's relationship to Italy and to Italian art was not of importance for the artistic inspiration it might have provided Dürer. In fact, Panofsky dismissed entirely the significance of Dürer's painterly production. He wrote, "It can be said without exaggeration that the history of painting would remain unchanged had Dürer never touched a brush and palette...."[75] Instead, Panofsky wanted to believe that Dürer was in Italy in 1494 because it furthered his argument that Dürer's primary interest in Italy had not to do with works of art but with the rediscovery of classical antiquity and the pursuit of theoretical artistic knowledge. Further, Panofsky maintained that the lure of Italy and Venice would have been doubly strong for Dürer in 1494. At that time Dürer could have witnessed the rebirth of classical antiquity as well as take advantage of the presence there of his friend Pirckheimer, who could have provided an appropriately scholarly introduction to the rediscovered wonders of Greek and Roman civilization. The life of the mind, in Panofsky's account, would have far outweighed any interest Dürer might have had in the visual arts.[76]

Dürer's ongoing relationship with Italy was so important in Panofsky's conceptualization of Dürer's life that the artistic significance of the 1505–7 journey was minimized in his rendering of the artist's career. Panofsky asserted that Venice in 1506 held no artistic surprises for Dürer, despite his mention of the sudden appearance of a new type of drawing in Dürer's work: studies in black ink with white heightening on a Venetian blue-dyed paper known as *carta azzurra*.[77]

Contemporary Scholarship

The contributions of most other scholars have augmented the information assembled by Panofsky; no one has significantly challenged Panofsky's view of Dürer the man or Dürer the artist. Alastair Smith is the only modern scholar who has questioned the historical validity of placing Dürer in Italy in 1494–5.[78] Smith argued that any congruences with Italian art that appear in the imagery, style, or form of Dürer's works can be understood by recognizing the extent of his familiarity with Italian drawings

and prints that circulated in Germany. However, Smith did not consider the documentary evidence.

The 500th anniversary of Dürer's birth in 1971 generated a great deal of scholarship. The catalogue for the Nuremberg exhibition focused on the social and historical milieu in which Dürer lived and worked.[79] His contemporaries, both patrons and friends, as well as the social history of the Reformation were all considered as being of greater importance than any monographic or aesthetic concerns about the works displayed. In the same year, several smaller exhibitions were held in America. The most important of these, *Dürer in America* at the National Gallery of Art in Washington, D.C., collected and examined the graphic works by Dürer in American collections.[80] An exhibition held at the University of Michigan focused on Dürer's relationship to Venice.[81] Egon Verheyen argued in the Michigan catalogue that Dürer first gained access to and copied Mantegna's *Bacchanal with Silenus* (Figure 46) and *Battle of the Sea Monsters* (Figure 47) while in Venice in 1495. Verheyen also said that Dürer was absorbing Italian art, "but instead of looking at paintings, was preoccupied with prints."[82]

Much of the recent writing about Dürer's painting and his relationship to Italy that is not related to exhibitions has been monographic. These recent monographs are essentially reformulations of the same information first codified by the Tietzes and that reached its culmination in Panofsky's work. For instance, Fedja Anzelewsky accepted the first journey to Venice in 1494–5 as irrefutable in his 1971 monograph on Dürer's paintings. He found proof of Dürer's presence there in the four paintings I addressed at the beginning of this chapter, none of which can be easily accepted as representative of Dürer or his work at that time. Anzelewsky also endorsed Flechsig's explanation that the plague drove Dürer out of Nuremberg in the autumn of 1494. He posed the further question of how Dürer could have afforded such a journey, since in 1505, eleven years later, he was forced to borrow money from Pirckheimer to finance the journey. Anzelewsky answered his own query with the speculation that Dürer financed this journey with the money he earned selling prints while in Venice.[83] On the other hand, while Peter

Strieder accepted Dürer's presence in Venice in 1494–5 as historically accurate, he also noted the problems that go along with such an interpretation, such as the lack of a tradition among northern artists of making such journeys as well as the lack of an identifiable motive for the journey.[84]

Jan Białostocki praised Panofsky, and by extension, his monograph, as being "free of ideological burdens"; he called the book itself "perfectly balanced" and declared it the "*Summa* of Dürerology for three decades."[85] Even if Białostocki's judgments are not precise in fact, they capture the essence of the history of Dürer scholarship. Białostocki considered the history of the scholarship about Dürer and Italy from a number of different points of view, including the reception of his work in Italy, the contemporary comparison of him as artist to Apelles, and even to the traditions of scholarship that have linked him to Italy. Yet Białostocki never questioned the interpretation of the evidence leading to the common assumption that Dürer was in Italy in the middle of the last decade of the fifteenth century.

Jane Hutchison closely examined the documents pertaining to Dürer's family and background but accepted the argument of Dürer's journey to Italy without question in her recent critical biography of the artist.[86] Hutchison excludes none of the previous explanations of Dürer's presence in Italy, or any of the possible motivations that would have spurred his journey there in the first place. For instance, she accepted as adequate documentation of the 1494–5 trip the drawings and watercolors "of north Italian motives," Dürer's letter to Pirckheimer, and the passage in Scheurl's Laudatio. Furthermore, she believed it possible that Dürer fled Nuremberg because of the outbreak of the plague in the autumn of 1494, that his itinerary can be reconstructed on the basis of the surviving alpine watercolors, that he was fascinated by the works of North Italian Renaissance artists, especially Mantegna, and that he traveled to Venice to come into contact with classical antiquity. Dürer's relationship with Italy and Italian art is not so significant for her; her vision of Dürer is less that of Renaissance master than of Nuremberg craftsman drawn into the circle of his humanist friends.

Conclusion

Attention to the blind spots and distortions in the work of previous scholars can lead to new insights about otherwise well-documented and thoroughly researched works of art and artists. As I have shown, the arguments used by Dürer scholars to explain the lack of any visual evidence to support Dürer's presence in Italy in 1494 have ranged from the merely unfeasible to the implausible and illogical. When considered as a group, it is apparent that these arguments share in the assumption that the problem with the lack of visual evidence lies with Dürer as an artist. As a northerner in Italy, the artist lacked the maturity that would otherwise have made his experience in Venice readily apparent in the work of this period.

To reiterate the outlines of these often implausible arguments, Thausing contended that Dürer, as a northerner, was limited to the graphic expression of his artistic ideas and that the painterly techniques of the Venetians were incomprehensible to him. Wölfflin suggested that the shock of all that was new to Dürer in Venice simply overwhelmed him and limited his capacity to absorb anything at all from the Venetians. The Tietzes favored the view that Dürer's consciousness was awakened in Italy, but that this did not affect his artistic production until later in his career. Meder followed Wölfflin in suggesting that Dürer was too undeveloped as an artist at that time to understand or benefit from the Venetians, and further, that he was only interested in prints anyway. Flechsig, like the Tietzes, thought Dürer to be unformed and argued that he simply did not know what was of interest to him early in his career. Panofsky, who has had the most profound impact on modern scholarship, argued that for Dürer in Italy in 1494, intellectual pursuits took precedence over artistic ones. According to these views, Dürer was, because of his German origins and training, predisposed to graphic works of art, unable to comprehend Italian painting, and more concerned with the intellect than with painting. I believe that all of these rationalizations are caricatures of a larger anxiety about the meaning of the Germanic identity in relationship to the renascence of classical culture in Italy.

Although I cannot demonstrate a factual explanation for this tendency within the Dürer literature with any certainty, it is possible to speculate

about the possible reasons and meanings of this bias. Dürer was a product of the German craft tradition but also lived and was active on the cusp of the Renaissance in the North. He was highly regarded at home, a member of humanist circles, but nonetheless wrote to his friend Pirckheimer from Italy in 1506 that he would miss the sun of Italy, that in Venice he was a gentleman, while at home in Nuremberg, only a parasite.[87] Dürer's preeminence abroad, together with his ambivalent feelings about his home, must have had strong reverberations for the generations of scholars writing about Dürer. Italy was perceived by scholars from Vasari onward as the birthplace of modern civilization, the result of the rebirth of classical, Mediterranean traditions confronting the barbarism of central European medievalism.[88] Germany, on the other hand, occupied a more ambiguous position in the history of civilization. It was perceived as the homeland of the barbaric Goths who contributed to the fall of classical civilization, and, indeed, German culture came to be synonymously identified as "Gothic." Yet in contrast to this "barbaric" history, German civilization was also recognized as the apogee of achievement in that it nurtured the highest accomplishments in literature and music, as well as rigorous intellectual, historical, and philosophical investigations.

For the German scholars of the eighteenth and nineteenth centuries, Italy, and the study of the Renaissance in Italy, promised a form of redemption through which the barbarism of Germany's medieval past could be repudiated and the classical past regained. Dürer's recognition that his achievements were more valued in Venice than in Nuremberg was paralleled by the valorization of Italy over Germany by scholars like Thausing, Wölfflin, and Meder. At the same time, Dürer's positive response to Italy provided a precursor and justification for their own interests in the Renaissance in Italy and may have lead them to exaggerate Dürer's purported contact with Italy. The emphasis on two purported journeys simultaneously achieved two different goals. The first journey tied Dürer more closely to classical civilization in Italy but also underlined his distance from it. His inability to absorb the progressive innovations of the Renaissance in Venice separated him from the Renaissance and emphasized his position as a "German" outsider. In a similar fashion, Dürer's ambivalence about his native Nuremberg and his voluntary "migrations"

must have had strong reverberations for Jewish scholars like Panofsky and the Tietzes, who were forced to flee Germany in the 1930s during the Nazi regime. For these scholars, Dürer's expressed ambivalence about returning to Nuremberg paralleled their own ambivalence about German culture.

It is important to recognize that the historical constructions about Dürer's early presence in Italy are colored by the desire of art historians to find historical reinforcement of contemporary political beliefs and situations. Without the discovery of some further documentary evidence, I do not believe that any scholar will be able to prove that Dürer was or was not in Venice during 1494–5. However, my study of the paintings, particularly the close attention to the role of technique and technical innovation as an aspect of Dürer's relationship with Italian art, supports the position that, on the basis of the available evidence, it is highly unlikely that Dürer was in Venice before the turn of the sixteenth century. Dürer was profoundly affected, indeed, by his exposure to Venetian painting, but only after his journey to Venice in 1505–7. I will demonstrate in Chapters 3 and 4 some of the ways in which Venetian painting, specifically the techniques used by Giovanni Bellini and other Venetian painters, unambiguously affected Dürer's own production of paintings, first in the *Feast of the Rose Garlands* and later in the *Virgin with the Pear*.

CHAPTER THREE

The *Feast of the Rose Garlands* I

Dürer's Appropriation of Venetian Painterly Techniques

I N CONTRAST TO THE LACK of any convincing evidence attesting to Dürer's presence in Italy in 1494–5, there is a great deal of evidence that survives about Dürer's stay in Venice from 1505 to 1507. Art historians have accepted that Dürer was influenced by Giovanni Bellini and Venetian painting in the *Feast of the Rose Garlands* (Plate I) in the National Gallery of Art in Prague, the central commission of Dürer's Venetian sojourn, but have limited their explorations of the painting to Dürer's formal and iconographic imitation of Venetian models. In this chapter, I will explore Dürer's appropriation of Venetian painting techniques and the way in which they illuminate his use of color and light as an alternative to mathematical perspective in the construction of pictorial space. This requires a reappraisal of the entrenched scholarly view of Dürer as an artist absorbed in the study of artificial, mathematical perspective.

Dürer's strategy in the production of the *Feast of the Rose Garlands* (Plate I) is unlike that in any other painting by him before 1506 that I have examined. My investigation of this badly damaged painting with infrared reflectography and X-radiography shows that Dürer appropriated aspects of Italianate technique in different phases of production, including the preparation of the panel, the design of the composition, and the handling of the color and tonal harmonies.[1] Comparison of the preparatory drawings and the underdrawing for the *Feast of the Rose Garlands* reveals that Dürer experimented with a kind of chiaroscuro, the effect of light and shade on the perception and representation of color and three-dimensional space. Dürer also wrote about the practice of painting in the

years after his return to Nuremberg from Venice. His ideas about the relationship of color and spatial representation are compatible both with his practices in the *Feast of the Rose Garlands*, as revealed by my technical investigations, and with a few, but significant – and frequently overlooked – sixteenth-century Italian theoretical writings on art.[2] Through the comparison of Dürer's practices, his painterly theory, and the Italian sources, I will demonstrate that the impact of Venetian techniques and theories on Dürer in 1505–7 fundamentally altered his conception and presentation of pictorial space from a primarily graphic one to a painterly one.

Preparation of the Panel

My investigation of the X-radiographs of the *Feast of the Rose Garlands* and the identification of the substances used to make the ground preparation show that Dürer himself combined elements typical of Italian and Northern practices in the basic support structure of the altarpiece. Dürer described how he prepared the panel for the *Feast of the Rose Garlands* in his letters to Pirckheimer.[3] In the letter of January 6, 1506, he mentioned that he had a commission to paint an altarpiece for the German expatriate community in Venice. He described the preparation of the panel as follows: "Dy wird jch noch jn acht dagen ferfertigen mit weissen und schaben." I translate this as: "I will complete it [the panel] in eight more days with whitening and polishing."[4] His description shows that Dürer prepared the panel himself in a complex process that involved separate steps over a number of days. After the grounding material was spread on the panel and allowed to dry (often in several coats over a period of several days), it too was scraped to create a polished and smooth surface ready for the application of paints. Dürer's preparation of the panel himself seems to be somewhat unusual, since the only other evidence about the preparation of his own panels shows that he did not always do so. In the August 28, 1507, letter to Heller regarding the commission of the *Heller Altarpiece*, Dürer indicated that he had bought those panels from a joiner and would have them prepared, grounded, and gilded by someone else.[5]

The most clearly Italianate aspect of the preparation of the panel for the *Feast of the Rose Garlands* is the presence of linen or canvas strips of cloth placed on top of the panel but beneath the ground preparation. The weave pattern of these linen or fine canvas strips of cloth are visible in the X-radiograph (Figure 48) of the painting.[6] The inclusion of linen or canvas strips beneath the ground preparation on the face of the panel was a relatively common practice in Italian fifteenth-century panel painting and in Tirolean painting, but not in German or Northern European painting.[7] In Italian practice, these cloth strips were used to strengthen the structural support and to provide a stronger, more secure, and elastic support to which the paint could adhere.[8] It is possible that because of the large format of the panel Dürer chose to strengthen the joints with linen. However, he did not include linen strips in the preparation of the panel for the *Adoration of the Trinity and the All Saints* in Vienna, his other large altarpiece. The *Martyrdom of the 10,000*, also in Vienna, was transferred from panel to canvas, so it is impossible to determine whether Dürer strengthened that panel with cloth strips. Dürer's inclusion of cloth strips into his otherwise traditionally northern preparation of the panel for the *Feast of the Rose Garlands* points to his close observation of Italian techniques and may indicate that he employed Italian assistants who would have known typical Venetian practices.

The chemical composition of the ground preparation itself consists of a mixture of naturally occurring gypsum ($CaSO_4$, calcium sulfite); a small amount of calcium carbonate ($CaCO_3$) commonly found in a number of different forms, including chalk or ground-up seashells); and "size," more commonly known as glue.[9] In Italy, chalk does not occur naturally, but gypsum does. For this reason, gesso, the mixture of calcium sulfite and size, was commonly used in Italy as a grounding material. The ground preparation of a panel is often regarded as an indicator of the location in which a panel was painted, since the availability of materials directly affected whether a gesso or chalk and glue ground preparation was used.[10] Therefore, one would expect to find a gesso ground in the *Feast of the Rose Garlands*, since it was made in Italy.[11] The presence of even a small admixture of chalk into the preparation is unusual and raises the question of its origin. Did Dürer bring chalk to Venice to mix into

48. A. Dürer, *Feast of the Rose
Garlands*, X-radiograph, detail,
center of panel, Prague, Narodní
Galerie

the ground preparation? Although the possibility seems remote today,
Dürer's attention to the construction of the panel in all other ways makes
it an intriguing question of an intriguing moment in his career. A similar
combination of Italianate and northern materials and techniques is found
as well in Dürer's use of preparatory drawings on carta azzurra and under-
drawings for the design of the altarpiece. Carta azzurra was a blue-dyed
paper available to Dürer only in Venice, and the utilization of preparatory
drawings was a specifically Italianate practice. The use of underdrawing
in lieu of preparatory drawings was, on the other hand, a more specifically
northern practice.[12]

The Relationship of Preparatory Drawings, Underdrawing, and Artistic Theory in the *Feast of the Rose Garlands*

My investigation of the *Feast of the Rose Garlands* with infrared reflectogra-
phy makes it possible to compare closely Dürer's preparatory drawings for

the *Feast of the Rose Garlands* to the underdrawings for that painting. The comparison of preparatory drawing, underdrawing, and painted version allows glimpses into Dürer's invention and production of the painting. In most areas of the painting, including the figures of the putti and the hands of Maximilian, for example, Dürer progressed seamlessly from the preparatory drawing to the underdrawing to the final painted rendition. These areas, which are typical of the execution of the *Feast of the Rose Garlands*, demonstrate Dürer's mastery of the study of light. In other areas, however, Dürer deviated from this clear path of execution and either made corrections to the underdrawing or did not follow the practice that served him so well with the hands of Maximilian and the putti. Two areas of the *Feast of the Rose Garlands* to which I will draw particular attention are the figure of the kneeling donor in a lilac robe holding a rosary on the right side of the painting, and the view of a city just adjacent to Dürer's profile self-portrait. Close examination of these two areas provides evidence of how he wrestled with specific technical problems of spatial and volumetric depiction.

The Preparatory Drawings for the *Feast of the Rose Garlands*

As far as we know, before his Venetian journey in 1505–7, Dürer did not make preparatory drawings prior to painting, since none have survived. The watercolor drawing for the woodcut *Virgin with a Multitude of Animals* of about 1503 in the Albertina in Vienna provides the only prototype for preparatory work in Dürer's entire oeuvre. In contrast to that drawing, which presents a schematic organization for the entire composition, the carta azzurra studies examine single figures or elements from the greater composition. In contrast, he made numerous preparatory drawings for the *Feast of the Rose Garlands*.[13] In all of Dürer's preparatory drawings on carta azzurra for the *Feast of the Rose Garlands*, the lighting is consistent and falls strongly and dramatically on the studied figures from the upper left. This is apparent in the carta azzurra study *Head of the Pope* (Figure 22), the *Pluviale* (Plate V), the *Praying Man* (Figure 23), and the *Hands of the Virgin* (Figure 24). In these examples, the lighting is almost exaggerated; for example, the back of the Pope's

head is illuminated while his face is left in shadow. In the painting, the lighting is somewhat modulated and softened; it falls more evenly on the figures from a more centralized position. The iconographic implications of leaving the face of the Pope in darkness might have prompted Dürer to alter the light source in the painting. It is also possible that Dürer reconsidered the lighting conditions in the painting because of his study of the intended location for the painting in the Church of San Bartolommeo.

There is an extensive literature about the numerous preparatory drawings for the *Feast of the Rose Garlands*.[14] Most investigations of the drawings focus on Dürer's immediate and striking adoption upon his arrival in Venice of the Venetian technique of executing figure studies in black inks with extensive white highlighting on the blue-dyed paper called carta azzurra. Meder argued that the use of blue-dyed paper as a drawing support was an invention of the Venetian painters of either the last years of the fifteenth century, or possibly the early years of the sixteenth, and was uncommon in Venice or anywhere else in Italy before the first decade of the sixteenth century.[15] Meder also maintained that Dürer merely adopted a method of drawing in common use in Venice when he traveled there. The execution of Dürer's carta azzurra drawings shares an unmistakable similarity with the surviving Venetian examples from the early years of the sixteenth century. Yet, I will suggest that they are functionally different from their Venetian counterparts.

The Tietzes asserted that the function of all Venetian drawings, including those executed on carta azzurra, was related to the production of paintings in the workshop.[16] The Tietzes' definition is very broad. It includes Venetian drawings from all the studios throughout the course of the sixteenth century, not only, for example, those from Giovanni Bellini's shop in the very early years of the century when Dürer was in Venice. At the turn of the sixteenth century, Bellini was the undisputed leader of the major Venetian school of painting. However, there is no surviving physical evidence that Bellini made preparatory drawings on blue-dyed paper in connection with paintings. Felton Gibbons noted that only one drawing attributed to Bellini corresponds to a painting from his oeuvre and the attribution of that painting is frequently doubted.[17] Gibbons argued, in

contrast to the Tietzes, that such a drawing could be called functional only if it were identified as a simile to be used by another artist or workshop member for the reproduction of the specific motif.[18]

Most surviving early Venetian drawings on carta azzurra do not correspond to known paintings; when they do, they are generally related to secondary figures only, and not to the central figures or the entire composition.[19] Although these drawings may have preserved figure types or patterns for general use in the shop, they were not directly related to the production of specific paintings.[20] If drawings on blue-dyed paper were indeed an innovation of the late fifteenth or even early years of the sixteenth century, as Meder argued, it seems unlikely that they could have played a central role in the activities of the Venetian painting studio. It seems to me unlikely that Bellini would embrace a new technique related to the production of paintings during the last years of his life, at the end of an extremely productive career. I believe, instead, that for an artist of Bellini's age and stature, such drawings would have been a novelty of sorts. It is likely that he experimented with such a technique, but it would not have been central to his workshop practices. Dürer's precise and exact studies on blue paper of the individual figures for the *Feast of the Rose Garlands* stands in direct opposition to this practice.[21]

Following Gibbons, I would argue that the early Venetian examples of carta azzurra drawings are not functional in the same way that Dürer's drawings are. I agree with Meder that Dürer borrowed this type of drawing from the Venetians, but more specifically, that he appropriated the form and materials of the drawings but altered the function of the drawings to meet his own needs in the preparation of the *Feast of the Rose Garlands*. Like the Venetian artists, Dürer explored both the volumetric structure of the form and the light falling on those forms in these drawings, but his purpose was to prepare individual figures for their inclusion in a specific lighting situation, rather than to record standard types for subsequent use. It was only *after* Dürer was in Venice in 1505–7 that drawings on carta azzurra, executed in black ink with white heightening, were used in this manner, beginning with Giorgione and Titian, and continuing through the course of the sixteenth century with Veronese,

Palma, Sebastiano, and Tintoretto.[22] The evidence I have discovered suggests that Dürer learned to use blue paper for the study of lighting effects from the early sixteenth-century Venetian painters. In turn, later Venetian painters learned from Dürer how blue paper could be employed for the study and preparation of discrete figures in paintings. This is a specific example of the mutual interplay and influence of northern and southern traditions through the vehicle of Dürer.

The Underdrawing in the Feast of the Rose Garlands

In comparison to earlier works from Dürer's oeuvre, investigation of the *Feast of the Rose Garlands* with infrared reflectography and infrared photography reveals relatively little underdrawing.[23] In most areas of the painting, the underdrawing reproduces the contour lines of the forms studied in the preparatory drawings and is probably executed in brush.[24] It functions mostly as a placeholder and suggests that Dürer relied heavily upon the preparatory drawings and began work on the panel itself only after he had worked out the design of the individual figures in the preparatory drawings.[25]

Most underdrawing found in the *Feast of the Rose Garlands* is similar to that found in the figure of the putto holding a rose garland to the right of the Virgin (Figure 17). The underdrawing loosely defines the contour of the jaw and chin, yet internal modeling is completely absent. In contrast, the underdrawing in earlier painted works from Dürer's oeuvre – for example, the unfinished *Salvator Mundi* (Figures 7 and 8) and the *Small Virgin* (Figures 4–6) – is more detailed, and includes not only contours, but hatching and cross-hatching to describe the forms.[26]

Dürer's careful study of light in the preparatory drawings precluded the need for such extensive underdrawing. The hands of Emperor Maximilian as they appear in the preparatory drawing (Figure 26), the underdrawing (Figures 19–20), and the painting itself (Plate I) are paradigmatic of Dürer's working practices in the *Feast of the Rose Garlands*. In the preparatory drawing (Figure 26), Dürer carefully studied the volume and location of the hands in isolation within the pictorial space through the modulation of light and shadow. The contour lines in the underdrawing

(Figure 19–20) correspond to the contours of the preparatory drawing, even though Dürer shifted the hands closer together in the painting, where the thumb of Maximilian's left hand overlaps the palm of his right. Examination of the underdrawing shows how Dürer manipulated the contours of Maximilian's left hand – the lower and nearer one to the viewer – in the painting to achieve a more reverent expression. In both the infrared reflectogram assembly and the infrared photograph, two contour lines that define the top edge of the left thumb are visible. The higher of the drawn lines corresponds to the final painted hand. Dürer's reworking of the edge of the thumb simultaneously broadened the hand and drew the two hands closer together spatially. Dürer's adjustment of the contours of the hands helps to transmit an attitude of prayer. In this case, Dürer's attention to the symbolic and religious aspects of the narrative of the painting took precedence over his desire to capture and portray nature through close observation and imitation.

The underdrawing marks the location for the insertion in paint of the studied form. In this sense, the relationship between the preparatory drawing and the painted hands is more important than the relationship of the preparatory drawing to the underdrawing, or the underdrawing to the painting.[27] Even though executed in paint, and not with purely graphic means, Dürer preserves an almost identical rendition of the hands in space because of his close attention to and repetition of the play of light on the surfaces of the hands already explored in the preparatory drawing. Yet, Dürer's version of the hands in paint reveals a conceptual shift in representation as well. In the drawings, the forms of the hands are strictly graphic, whereas in paint they appear smooth and painterly, not dependent on linear description. This indicates Dürer's successful execution of his goal in the careful study of light in the preparatory drawings.

Although Dürer successfully incorporated his prior study of volumetric forms with light by means of preparatory drawings into some of the figures and details in the *Feast of the Rose Garlands*, he had more difficulty integrating light and form in other areas of the painting. Unlike the hands of Maximilian, the underdrawing in the figure of the kneeling donor is fully worked up and substantially altered from the design

of the corresponding preparatory study. In the preparatory drawing, *Kneeling Donor* (Figure 25), the man kneels, facing left, in a position of quiet attention.[28] The strong light that falls on him from the upper left brilliantly illuminates his hat and face and bathes the front of his coat. The depths of the exterior folds of the sleeves of his coat and the fall of the drapery behind him are thrown into deep shadow. No light penetrates the large interior hollow of the man's loose right sleeve at all, whereas the interior lining of his left sleeve is picked out in bright light.

In the painting (Plate I), Dürer modulated and softened the lighting so that it is more evenly dispersed than in the drawing. The sharp shadow beneath the kneeling donor's chin in the preparatory drawing is barely found in the painting. The part most dramatically altered by the change in lighting is found in the interior hollows formed by his long, loose sleeves. In the painting, both hanging sleeves are partially illuminated, and the interior area of the right sleeve is much more luminous than the left.

The underdrawing of the hands, rosary, and sleeves of this figure (Figure 18) consists of simple contour lines, similar to the underdrawing found in the putto (Figure 17) and in the hands of Maximilian (Figures 19–20). Yet Dürer reworked the interior of the man's right sleeve with a series of long, parallel brush strokes similar in graphic form to the lines used to describe the interior of the proper left sleeve in the preparatory drawing. I believe this indicates that, in the course of the alteration of the light source, Dürer found it necessary to recast this area, since the change in lighting affected his execution of the form and color of the cloth. Some alteration in the underdrawing of some of the figures, as with the kneeling donor, might have been necessary; without it, the figures on the left side of the painting would have been illuminated only from the rear, their faces and hands left in shadow.[29]

Preparatory Drawings as Light and Color Studies

Dürer's preparatory drawings themselves and their relationship to the completed *Feast of the Rose Garlands* show that Dürer's working procedures

were highly dependent upon the observation of light and light sources. Since Dürer never worked in this manner prior to his presence in Venice in 1505–7, I believe his interest in light and color can be traced to his exposure to parallel Venetian practices during his stay in that city. The theoretical study of the effects of light on form and color in the depiction of space were broadly reflected in contemporary practical and theoretical treatises. Giorgio Vasari described the technique of drawing with white highlights on colored paper in his book *On Technique* in the chapter devoted to different types of preparatory drawings and the various uses to which painters put them. Yet Vasari's passage has gone virtually unnoticed in the literature on Renaissance drawings.[30] Neither the circumstances that led to the appearance of this drawing technique in Venice nor their functional connection to the preparatory procedures of painting have been fully investigated.

Vasari's description reads as follows:

> Drawings in light and shade are executed on tinted paper which gives a middle shade; the pen marks the outlines, that is, the contour or profile, and afterwards half-tone or shadow is given with ink mixed with a little water which produces a delicate tint: further, with a fine brush dipped in white lead mixed with gum, the high lights are added. This method is very pictorial and best shows the scheme of coloring.[31]

Dürer's drawings study specific lighting effects for the *Feast of the Rose Garlands* and correspond exactly to Vasari's passage. Vasari's assertion that this "method of drawing is very pictorial and best shows the scheme of coloring" is related to Dürer's ability in the *Feast of the Rose Garlands* to shift from a completely graphic depiction of form to a very painterly one. Vasari's description also raises the question of the relationship of these studies of light to the use of color. The study of color is closely related to the study of light. Without a specific and exact understanding of the fall of light upon a given form, color becomes only a marker of a local quality and is not tonal.[32] Without the close observation of the interrelationships of different tonalities in hues, and their reaction to the intensity of light, paints as colors only describe the surface color of an object and contribute nothing to the perception and location of that object within pictorial space.[33] For example, Giovanni Bellini's reputation

for glowing color harmonies was a result of his perception and exploitation of light – and not due to his use of a specific palette with accompanying connotations of symbolic beauty.[34]

Dürer's Color Theory

Some of Dürer's theoretical ideas about painting and color survive in two outlines and a single draft of a passage on color written for his planned, but never completed nor published, instructional manual for young painters. Dürer worked on this manual (which was called in different places "Unterricht der Malerei," "Unterweisung der Lehrjungen in der Malerei," and "Ein Speis der Malerknaben") for a number of years after his return from Venice in 1507, perhaps until as late as 1512. Two outlines written by Dürer for this planned manual survive in the collection of the British Museum Library.[35] Much of Dürer's projected program for the education of young painters concerns the broadest material and spiritual needs of the apprentice. The middle section of the outline presents the practical, craft aspects of painting itself. According to Dürer's plan, the first half of this section was to be devoted to the art of measurement, and the second half to perspective, light and shadow, and color.

A single draft survives for the section on color, which Dürer titled "*Von Farben.*"[36] *Von Farben* begins as an address to the painter who "erhabn willt molen" (in English, wants to paint in an exalted way or wants to paint sublimely).[37] According to Dürer's passage, an "erhaben" painting is achieved through the play of light and shadow on the forms and colors of all the objects depicted in the pictorial space. To be "erhaben," a painting must deceive the eye of the viewer; that is, it must present a convincing rendition of illusionistic space. The alternative to "erhaben" painting was, according to Dürer, painting that lacked that variation of light and shade, without which everything would look flat, like a checkerboard of colors. Dürer wrote: "There is light and shadow on all things, wherever the surface folds or bends away from the eye. If this were not so, every thing would look flat, and then one could distinguish nothing save only a checkerboard of colors."[38] Painting that was not "erhaben" according to Dürer's definition can best be understood as dependent upon

local coloring, the opposite of the type of tonal or chiaroscuro painting most often associated with Leonardo da Vinci.

Before he wrote his fragment *Von Farben*, Dürer used the word "erhaben" to describe his achievement with color in the *Feast of the Rose Garlands*. As far as I know, no one has previously noted Dürer's complementary usage of "erhaben" in these two places, nor connected them.[39] Dürer wanted the Venetians to recognize his ability in painterly color and wrote proudly to Pirckheimer on September 8, 1506, that they had done so:

> und jch hab awch dy moler all geschtilt, dy do sagten, jm stechen war jch gut, aber jm molen west jch nit mit farben um zw gen. Jtz spricht jeder man, sy haben schoner farben nie gesehen.[40]

Conway translated this passage as follows: "And I have stopped the mouths of all the painters who used to say that I was good at engraving but, as to painting, I did not know how to handle my colors. Now everyone says that better coloring they have never seen."[41] In his next letter, dated September 23, 1506, he wrote that the Venetian painters had praised his painting and that they had described it as "erhaben" (my emphasis). The Venetians remarked "daz sy erhabner leblicher gemell nie gesehenn haben;" in English, "that they had never before seen such a sublime, lovely painting."[42]

Conway translated Dürer's use of "erhaben" in "*Von Farben*" differently than he did the same word in Dürer's letter to Pirckheimer. In the letter he translated "erhabner" as "nobler,"[43] although in the passage on color, he assumed that Dürer referred to modeling, and translated "so du erhaben willt molen," as "If thou wishest to model well in painting."[44] Dürer's concern with modeling with colors is implicit in the passage, but I believe Conway was mistaken in his translation of "erhaben" in that circumstance. It seems to me that Dürer's hortatory usage of the word "erhaben" was likely learned in Venice from the Venetians. I would suggest that Dürer's desire to impress the Venetians with his color, together with his pride that the painting was "erhaben," reflected Dürer's understanding of an Italian and perhaps particularly Venetian quality of painting akin to "grazia," to which he was exposed while in Venice. Blunt

has shown that "grazia" was used interchangeably with "beauty," but also in the description of the handling of color in painting.[45]

Scholars have neglected this passage for two reasons. First, the passage is only a draft and does not present a clearly defined color theory.[46] As John Shearman noted, color has always been perceived as too subjective to be the focus of critical investigation.[47] I would argue that Dürer's passage is significant because it reveals his interest in alternatives to mathematical perspective. Second, and more importantly, the content of this passage does not fit into the common art-historical vision of the "scientific" Dürer, committed to the exploration of mathematical and geometric solutions to the depiction of perspectival pictorial space. Dürer's struggle to depict color in relation to specific lighting conditions is revealed in the relationship between the preparatory study of Pope Julius II's *Pluviale* (Plate V) and the very different rendition of it in the painted *Feast of the Rose Garlands* (Plate I).

The Watercolor *Pluviale*

Scrutiny of the watercolor *Pluviale* (Plate V) helps us understand Dürer's technical means of implementing the study of light and its effect on color in the *Feast of the Rose Garlands*. Painted on white paper, it is the only one of the surviving preparatory drawings for the *Feast of the Rose Garlands* not executed on carta azzurra. The Tietzes argued that the *Pluviale* reveals Dürer's preparatory technique before his arrival in Venice, and that when he saw the drawings on blue paper being created in the workshops of Bellini and of Carpaccio, he immediately began to work in that technique.[48]

The only other extant watercolor in Dürer's oeuvre that is a study for a specific painting is the compositional study for the *Adoration of the Trinity and the All Saints* in Chantilly (Figure 34). This study, different in both technique and intention from the *Pluviale* (Plate V), is datable to 1508, after Dürer's return from Venice. It is a compositional study for the entire painting, not just a detail, and was probably intended as a presentation drawing of the projected composition for Matthäus Landauer, who commissioned the painting from Dürer. The watercolor parts of this drawing

are added in discrete washes that fill in the areas defined by the pen drawing and are indicative of local color. The emulation of tonalities as they
are affected by modulations of light and shadow is the aim of neither
the Chantilly watercolor study nor the earlier *Virgin in the Multitude of
Animals*.

Dürer's handling of the medium in the study of the *Pluviale* is what
makes it so different from the other surviving watercolors in his oeuvre.
Meder noted that the contours of the *Pluviale* were traced, implying the
existence of another earlier and similar drawing.[49] Although Meder does
not pursue the ramifications of this observation, it seems possible that
the study of the *Pluviale* is related to the drawings on blue paper; perhaps there was even a study of the Pope in his pluviale worked out in this
technique. If so, after Dürer had worked out the folds of the robe as they
were affected by the fall of light, he could have traced the contours from
the blue-paper study onto the white sheet used for the watercolor study.
Thus, he would have a clean, blank page on which to carry out an experimental rendering of the colors as they had been affected by the lighting
conditions.

In the watercolor *Pluviale*, Dürer executed the floral pattern of the
brocade in a cool lilac-purple. The border and base of the fabric itself
are executed in a light yellowish-brown. This is quite different from the
way that the pluviale was eventually painted in the altarpiece. The cool
lilac tint used in the drawing was warmed up significantly in the painting,
where the base color of the robe is a warm, rosy pink. Dürer's balance
of the cooler blue tones and the warmer reds is one reason that this
painting, unlike other paintings by Dürer, has been cited as showing his
mastery of Venetian color harmony. The watercolor rendition shows a
much less precise regard for the exact capturing of the form than found
in the painting, where a highly believable form occupies space. I believe
Dürer used the carta azzurra studies and the watercolor study of color
in a complementary fashion. The drawings on blue paper would have so
precisely captured the form of the figure studied through the fall of light
that subsequently, in a watercolor study like the *Pluviale*, Dürer could
have focused on the tonal balance of the color in relationship to that
well-understood form.

49. A. Dürer, *Italian Mountains*, watercolor, Oxford, Ashmolean Museum

Dürer was a master of watercolor, as is attested by his numerous landscape studies, including, among many others, the *Italian Mountains* (Figure 49) in the Ashmolean Museum in Oxford and the *Pond with Mill* in Paris (Figure 45). The landscape watercolors are similar to the *Pluviale* (Plate V) in that they carefully study natural lighting conditions and color, but they are different in that they are not preparatory studies: they are completed works of art in their own right. Yet Dürer's achievement in both types of watercolor is related to his concerns with an atmospheric, coloristic perspective.

On the basis of the study of the *Pluviale*, it is possible to speculate that the careful execution of the color tonalities in this watercolor is evidence of the pains Dürer took to practice what he asserted in his letters to Pirckheimer, namely that he had proven to the Venetian painters that he "knew his way around colors."[50] The emphasis placed in Dürer's letters to Pirckheimer on color and the painterly qualities of the finished *Feast of the Rose Garlands* provides further evidence for the execution of this painting according to Italian, and specifically Venetian, color principles. I believe that Dürer's close study of light and color while in

Venice dramatically altered his vision and practice of the depiction of space.

Dürer's Shift from a Graphic to a Painterly Vision of Space

Dürer's shift from a primarily graphic vision of pictorial space to a more painterly one can be demonstrated by comparing the underdrawing of the distant cityscape in the *Feast of the Rose Garlands* (Figure 21) to similar depictions of that same view in an earlier drawing, the *Pupila Augusta*[51] (Figures 50–51), and in the significantly later, reversed engraving of 1519, *St. Anthony Before a City*[52] (Figure 52). This shift, marked by Dürer's engagement with atmospheric perspective, is paralleled in his landscape watercolors as well and provides a clear rationale for dating them to the time of the 1505–7 journey rather than earlier in the artist's career. I will briefly discuss a few of these landscape watercolors in relationship to the cityscape in the *Feast of the Rose Garlands*.

As with the figure of the kneeling donor in the *Feast of the Rose Garlands*, Dürer's use of preparatory drawings and underdrawing varies in the distant cityscape area from the method employed in the rest of the painting. All the city views are essentially identical, and portray at least three common elements: a high central tower connected to a large, many windowed building; a second, lower tower; and a gabled building with stepped crenellations and two large windows. In the painting and the drawing the three shared structures slope down toward the right, while in the engraving, they descend toward the left.[53] Although all four renditions – drawing, underdrawing, painting, and engraving – include the same formal elements, they are quite different as depictions of pictorial space.

In the *Pupila Augusta*, the cityscape (detail, Figure 51) is executed in pen and consists of a gridlike network of intersecting lines. The distance between foreground figures, middleground figures, and the city is implied only by diminution of scale. To indicate volume in the buildings represented, Dürer included horizontal hatching on the frontal planes of the buildings. These hatch marks are essentially schematic; they are not

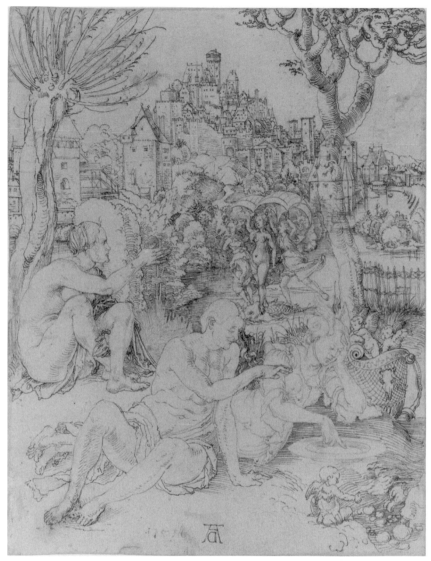

50. A. Dürer, *Pupila Augusta*, drawing, Windsor Castle, The Royal Collections

differentiated one from another except by frequency of occurrence, and all of them lie in the same horizontal direction.

Investigation of the city vista in the *Feast of the Rose Garlands* with IR photography (Figure 21) reveals that Dürer's underdrawing in this area of

51. A. Dürer, *Pupila Augusta*, drawing, detail, Windsor Castle, The Royal Collections

52. A. Dürer, *St. Anthony Before a City*, engraving, B. 58

the composition is remarkably similar in execution and form to the corresponding area in the *Pupila Augusta*. Like the rest of the underdrawing in the *Feast* it is drawn freely, and not traced or reproduced with some other mechanical means.[54] However, the drawing is more precise than the other

areas, and like the *Pupila Augusta*, seems to have been executed with a pen rather than a brush. The lines are regular in width and have blunt endings. The underdrawing, like the drawing, is so flat and two-dimensional that it is almost antiillusionistic. This flatness is emphasized in the infrared photograph because the vista of the city, located in the background of the pictorial space, literally abuts the contour profile of Dürer's face, which is located in the foreground of the painting. Dürer completely shifted the graphic representation of this cityscape to a painterly representation of coloristic and atmospheric perspective with the application of the paint layers. Only after the addition of paints to the underdrawn representation does the city vista recede away from Dürer's self-portrait and appear to extend into a much deeper, distant plane. In the finished painting, Dürer's exploration of the modulation of the value of the color in the landscape through the study of light and shadow creates an atmospheric, as opposed to a mathematical, perspective.

With the application of paint to the underdrawn gridwork of lines in the *Feast of the Rose Garlands*, Dürer transformed the vista of the distant city from a flat, abstract, aggregate of lines into a sensitive rendition of receding spatial volumes. As painted, this vista recedes deep into the pictorial space and has an internal coherence of spatial volume that was completely lacking in the drawn and underdrawn versions. The subtle modulations of light, shadow, and color help Dürer to achieve the illusion of a distant vista within the plane of the picture, and to create three-dimensional volumes out of the representations of the individual buildings.

As a single occurrence within the oeuvre of a painter, such a striking transformation from graphic description to a painterly achievement of space and volume might not be so significant. However, Dürer used the image of this city vista again in his career, in the 1519 engraving *St. Anthony Before a City* (Figure 52). Panofsky described this engraving as "a cubistic phenomenon." The rendition of spatial volumes was identified by him as the raison d'être of the composition.[55] While the engraving presents the same view of the city as the drawing *Pupila Augusta* and the underdrawing in the *Feast of the Rose Garlands*, it could not be more different. As Panofsky implied, the representation of the volume of space itself seems to be the

motivating force behind Dürer's execution of the engraving. It shares with the *painted* version of this view found in the *Feast of the Rose Garlands* an acute sense of volumetric form and spatial perception. Metaphorically, the *Pupila Augusta* drawing (Figures 48–49) and the underdrawing of the city vista in the *Feast of the Rose Garlands* (Figure 21) exhibit a "graphic" vision of pictorial space, whereas the finished painted version in the *Feast of the Rose Garlands*, and the engraving *St. Anthony Before a City* (Figure 52) exhibit a "painterly" vision of pictorial space. The latter two encapsulate a reference to the sensitivity to spatial effects and techniques the artist learned while in Venice.[56]

Dürer's exact repetition of forms and motifs was rare and is an indicator that the repeated form carried a significant meaning for him. It appears that Dürer was so pleased with the progression of his cityscape from a flat two-dimensional rendering to an illusion of volumetric buildings in the distance of his painted composition that he was moved to revise the *Pupila Augusta* (Figure 50) sometime after he completed the painting. The two trees at the right and left margins are drawn on top of the already completed city vista, and the foreground figures were added as well. Dürer's reworking of the drawing, and in particular the addition of the foreground figures, helps to explain the somewhat discordant appearance of the drawing. These additions transformed the preparatory drawing into a work of art in its own right and furthermore attest to Dürer's continued interest in this particular motif.

Remarkably, Giovanni Bellini, the artist whom Dürer most admired in Venice, also used elements of this particular cityscape within a landscape in his ravishing *Lamentation* in the Accademia. Although not dated by Bellini himself, it is usually dated to 1505. Bellini, of course, frequently included cityscapes in his landscapes; yet in the *Lamentation*, Bellini seems to make reference to Dürer and the *Feast of the Rose Garlands* through the inclusion of the building with stepped crenelation turned perpendicular to the picture plane. I see this as an overt, if playful acknowledgment of Dürer's struggle to get the spatial effects correct in the *Feast of the Rose Garlands*.

In comparison to the landscape in the *Feast of the Rose Garlands*, the landscapes depicted in paintings executed before 1505 are of a strikingly

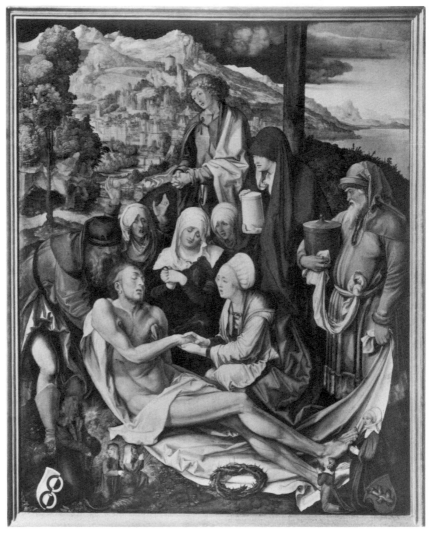

53. A. Dürer, *Glimm Lamentation*, Munich, Bayerische Staatsgemaldesammlungen

different nature. For instance, the beautiful landscape in the (now seriously damaged) *Glimm Lamentation* (Figure 53) of 1503 consists of an aggregate of masses of equal sharpness piled one atop the other. The softening of detail and atmospheric haze so clearly achieved in the *Feast of the Rose Garlands* is not present in this painting. There are many more examples of landscapes in paintings by Dürer painted before he went to

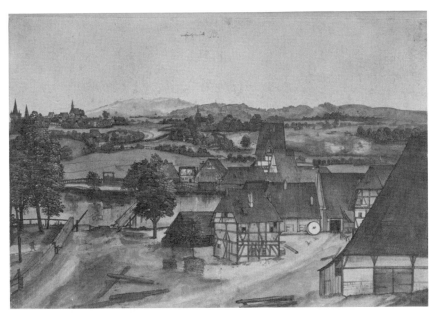

54. A. Dürer, *Wire Pulling Mill*, watercolor, Berlin, Kupferstich Kabinett, Staatliche Museen Zu Berlin, Preussischer Kulturbesitz

55. A. Dürer, *Innsbruck from the North*, watercolor, Vienna, Graphische Sammlung der Albertina

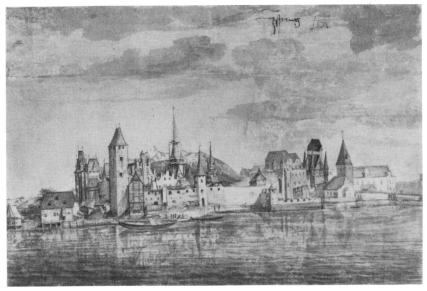

Venice in 1505 that share similar features, such as the slivers of landscape found in the *Haller Madonna* in the National Gallery of Art in Washington, D.C., or in the beautiful Prado *Self-Portrait*. Yet in paintings completed after his return from Venice, Dürer continued to make use of the subtly modulated, atmospheric, coloristic perspective he had learned there. This is especially apparent in the 1511 *Adoration of the Trinity and the All Saints* (Figure 33) where Dürer alone occupies the vast cosmic landscape beneath his vision of the celestial inhabitants of heaven.

The watercolor landscapes can be similarly divided into depictions that predate Dürer's exposure to Venetian techniques and those that follow it. In the watercolor *Wire Pulling Mill* (Figure 54) executed by Dürer in the environs of Nuremberg early in his career (perhaps as early as 1490), the landscape is constructed of masses piled atop one another so that the recession of space is not so much into depth as upward into the pictorial frame. This landscape structure became a formula, often repeated in Dürer's pre-Venetian paintings like the *Glimm Lamentation*. In the *Glimm Lamentation*, the distant mountains are sharply delineated, and the trees are stylized rounds reminiscent of lollipops dotted across the landscape. (Jane Hutchison poetically described this kind of representation of trees as a "string of pearls." This tradition of townscape representation has a long history in Franconia (it was certainly not an invention of Dürer's) and topographically accurate depictions of cities and towns were widely published and known. Wolfgang Katzheimer's *View of Bamberg* from about 1470 provides a model to which Dürer could have looked in his earliest watercolors. Likewise, the townscapes found in Hartman Schedel's *Weltchronik*, published in 1493, would have been well known to Dürer. The *Weltchronik* was published by Anton Koberg, Dürer's godfather. Michael Wolgemut, Dürer's teacher, provided the woodcut illustrations for the book. Some scholars have argued that the young Dürer contributed to the *Weltchronik* and have attempted to identify his works among the various illustrations and cityviews.

Dürer's view of *Innsbruck from the North* (Figure 55) is one of the more problematic watercolors, often cited as one of those landscapes that must have been painted early in his career and as such, definitive proof of Dürer's engagement with Italy early in his career. Yet, this watercolor is

much more sophisticated than the early *Wire Pulling Mill* (Figure 54). By 1505 Dürer was an incredibly accomplished painter, master print maker, and a master of watercolor technique. His ability to capture intimate views that depended upon close observation of meteorological conditions and the natural world was unparalleled. His maturity and sophistication are evident in the watercolor *Little House on the Pond*, or *Das Weiherhaus* in Paris (Figure 56), which has often been dated to about 1498. *Innsbruck from the North* (Figure 55) shares many formal elements established in the *Das Weiherhaus*. Dürer lowered the horizon in both, and set the city, the focal point of the composition, deeper into space, just as he did in the *Das Weiherhaus*. And despite Dürer's enormous sophistication at this point, in the Innsbruck watercolor he still clings to some pictorial conventions associated with earlier topographical vistas. For example, the mountain behind the town is still sharply defined, much like the mountain rising behind St. John in the *Glimm Lamentation* (Figure 53). The conceptualization of the view has much in common with similar woodcut views of cities found in Koberger's *Weltchronik*, such as the *View of Ulm*. Both the woodcut and the watercolor present the city seen as a complete composition; each occupies the space of the page completely. Both share the conceit of viewing the town across a river, which is depicted by a dense network of parallel lines in the woodcut, and by an equally dense application of small, independent brushstrokes in the watercolor. A boat floats on the river before the town in both as well, suggesting a formula for representation as opposed to an accurate portrayal of a moment. I do not mean to suggest that Dürer was copying the *View of Ulm*, or indeed any of the numerous similar townscapes found in Koberger's *Weltchronik*, but I would propose that Dürer's vision of *how* to paint a townscape was closely informed by such an example. In sum, I would argue that this watercolor was painted before Dürer went to Venice.

Evidence for dating *Innsbruck from the North* more precisely, to before 1505, can be detected in the particular view Dürer chose, and his later reuse of it in the *Feast of the Rose Garlands*. In the Innsbruck watercolor, Dürer captured two crenelated and gabled buildings similar to the one he later incorporated into the *Pupila Augusta* drawing (Figure 50), the *Feast of the Rose Garlands* (Plate I), and the *St. Anthony Before a City*

(Figure 52). Indeed, many scholars, including the drawing connoisseur Friedrich Winkler, believed this view to be the one that Dürer used for the landscape in the *Feast of the Rose Garlands*. Yet the Innsbruck townscape is not identical to that used in the *Feast of the Rose Garlands*, and I would like to suggest that his preoccupation with this view, coupled with the way he changed it slightly, makes a compelling argument for the watercolor being fresh in his mind when he arrived in Venice.

After he completed the *Feast of the Rose Garlands*, Dürer continued to make landscape watercolors. Whether he made these on his home-ward journey, or on a separate trip form Venice to the countryside, or both, is impossible to determine. No firm record of such a journey outside of Venice exists; however, Dürer did write to his friend Willibald Pirckheimer from Venice that he hoped to visit Bologna to learn about perspective before he returned home I believe it possible that the *View of Trent* (Figure 57), the *Italian Mountains*, and the *Italian Castle* were all painted after Dürer had been in Venice some time, and perhaps after the completion of the *Feast of the Rose Garlands*. We know that Dürer completed the *Feast* in the early autumn and did not return to Nuremberg until after the new year. No adequate accounting for Dürer's activities during those months has ever been proposed. It is possible that Dürer traveled out of Venice during this period of months and that several of the landscape watercolors often used to place Dürer in Italy early in his career may have been executed at this time.

The *View of Trent* (figure 57) refers again to the townscape used by Dürer in the *Feast of the Rose Garlands*. Although the crenelated and gabled building itself is not particularly close to the one used in the painting, the configuration of the buildings slope down to the right, and three towers of different shapes are placed side by side. Even though this depiction of the city connects the watercolor to the Venetian pictures, the differences reveal the change in Dürer's method of painting landscape vistas. The landscape itself is no longer a totality executed with equal degrees of clarity. The details of the hill sloping down in front of the castle dissolve into an atmospheric blur, and the houses on the right seem about to slide off the page. The *Wehlsches Pirg* (*Italian Mountains*) (figure 49) and the *Wehlsch Schloss* (*Italian Castle*), which I believe were executed

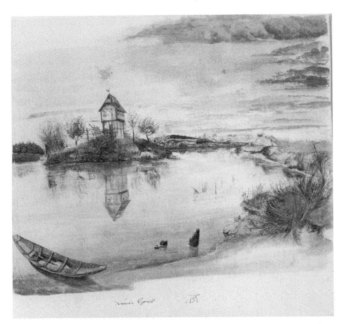

56. A. Dürer, *Das Weiherhaus* (*Little House on the Pond*), watercolor
London, The British Museum

57. A. Dürer, *View of Trent*, watercolor, London, British Museum

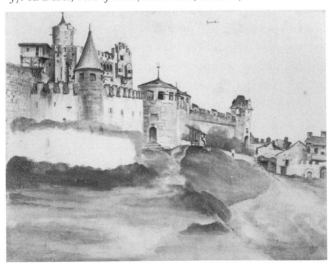

about the same time as the *View of Trent* are even more atmospheric and soft. The mountains are not constructed of sharply defined lines, planes and masses, but are suggested by broad, soft, translucent washes of color. The whiteness of the page upon which the landscapes are painted begins to suggest the space. Even though the landscapes do not fill up the pages upon which they are painted, they are not unfinished works. Dürer wrote descriptive titles upon both of them in his beautiful hand, suggesting a finished record.

Dürer did not cease to utilize the techniques he had developed while in Venice in his later landscape watercolors. In fact, some of these are so fresh and atmospheric that they could easily be confused with nineteenth-century *plein-air* watercolors. One example is the watercolor *View of Kalchreuth*, a town and valley near Nuremberg that Dürer painted late in his life, probably around 1520 or 1521.[57]

North Italian Treatises on Coloristic Perspective

My discussion of the use of color as an integral part of atmospheric perspective here supplements a small literature that has focused on the existence of an atmospheric, coloristic perspective in Venetian artistic circles during the Renaissance. The technical evidence requires a reevaluation of the traditional view of Dürer, codified by Panofsky, as an artist primarily engaged with geometric and mathematical solutions to the depiction of pictorial space. This view should be expanded to include Dürer's interest in atmospheric perspective achieved through the modulation of light and color.

Vasari again sheds light on the significance of the use of color in the depiction of objects receding into space, volumetric form, and atmospheric perspective. Just a few sentences after his discussion of drawings on colored papers in dark and light inks, Vasari wrote:

> The painter must take care to make [perspectives] diminish in proportion by means of delicate gradations of color. . . . The need of this is shown in the difficulty of the many confused lines gathered from the plan . . . but when covered with color everything becomes clear."[58]

Vasari's injunction to the artist that he use "delicate gradations of color" to make perspectives diminish properly shows that he recognized the importance of using tonal values to suggest different light effects and the resultant perception of color in the creation of a perspectival space.

Vasari's description, written almost fifty years after Dürer was in Venice, cannot be interpreted as a treatise that describes the intellectual and theoretical concerns of artists in Venice at the turn of the sixteenth century, but Vasari's precise knowledge of the technique itself and his description of the function of the drawings suggests an accepted tradition with which he was familiar. Vasari's description of the need for "delicate gradations of colors" to clarify the "confused lines gathered from the plan," is akin to the visual evidence found in Dürer's reworking of the city vista and also to Dürer's own writing about color in *Von Farben*. Dürer wrote there that without the variation of light and dark on all things and colors, everything would look flat.

G. M. Canova has shown that during the fifteenth century a discourse about the depiction of space and diminution of objects in two-dimensional works of art was shared by Paduan and Venetian scientists and intellectuals. These discussions focused on a form of perspectival construction achieved not through linear means, but through the modulation of color and illumination.[59] The innovations of Jacopo Bellini were central to this; his experimentation with light and color substantially affected the Venetian school of painting, leading them to a non-Tuscan conception of pictorial space, based on variations in value and hue rather than mathematical principles. The atmospheric perspective achieved with color stands in opposition to the Tuscan notions of the development of perspective as well as to our modern notions of the overarching importance of the development of a "scientific" perspective in the course of the fifteenth and sixteenth centuries.

As evidence, Canova presented a document dedicated to Jacopo Bellini regarding his use of color for perspectival means, written by a fifteenth-century, Venetian-educated, Paduan physician named Giovanni da Fontana.[60] Da Fontana's dedication to Jacopo Bellini is a declaration

of a northern Italian alternative to the more linear, Tuscan perspectival depiction of space:

> From this natural experience, the art of painting derived excellent canons, as I described in a pamphlet [dedicated] to the prominent Venetian painter, Jacopo Bellini, so that he might know by which means dark and light colors are to be applied, with such method that not only are parts of a single painting in relief on the pictorial plane, but also that the hand or foot of a man believably stretches out into space; likewise, on the very same surface, men, animals and mountains should appear distant by some miles. Indeed this art of painting teaches that near things must be painted with light colors, distant ones with dark colors, and those in the middle with a mixture of [dark and light] colors.[61]

The passages written by Vasari and da Fontana are analogous to Dürer's *Von Farben*. All three stress the importance of color and value in the construction of space.

Da Fontana's description of the depiction of objects in space, that "a hand or a foot of a man believably stretches out into space," is strikingly congruent to Dürer's adoption of the Venetian practice of making drawings on blue paper with dark and white inks. It also mirrors Dürer's discussion of light and shadow on objects in space in his discussion of colors.[62] As Vasari observed about drawings using contrasts of light and shade, the color of the paper itself acts as the middle or median tone. Vasari emphasized that drawings in this technique were very pictorial, and showed the scheme of coloring. Da Fontana, writing about Jacopo Bellini, suggested that a range of tones of color best show the forms of objects in space. I believe that these two passages are related, and that each describes a crucial aspect of Venetian, and indeed Renaissance, technical innovation. The placement of form and color were intimately united in both the theory and actual construction of illusionistic space in the *Feast of the Rose Garlands*.[63]

The likelihood of Dürer's knowledge of these theoretical currents is demonstrated by a comment in G. P. Lomazzo's 1585 *Trattato*.[64] Lomazzo claimed in this work that he intended to publish a treatise written by Vincenzo Foppa containing "a number of sketches done with the pen," of which Dürer later made considerable use in his own

treatise. Lomazzo described Foppa as one of the few artists who had both understood and written about the principle of aerial perspective. He also eulogized Foppa's treatment of color and light. Unfortunately, no historical record of Foppa's treatise exists, nor is it clear to which of Dürer's treatises Lomazzo referred, although *Von Farben* is a likely candidate.[65]

Da Fontana's declaration of the importance of color for atmospheric perspective is, from the viewpoint of modern scholarship, out of the mainstream of Renaissance thought and artistic theory, because in studies of perspective, much more attention has been given to the mathematic or geometric methods of spatial construction.[66] Yet, the consideration of light and color as integral aspects of the science of the painter's art was widespread.[67] Alberti himself described the first book of his treatise *On Painting* as "all mathematics."[68] Yet, in the midst of his discourse on geometric measurement, he reminds the reader of the centrality of color and light to his discussion.[69] Alberti's treatise is by no means revolutionary; rather, it presents common practices and widely held theoretical beliefs.[70] Alberti contributed to the development of the idea of tonal harmony and its role in the depiction of a unified pictorial space. According to Albertian theory, this was achieved with colors ranging from the lightest to the darkest through the addition of either white or black. Alberti's theory is similar in its broadest outlines to the descriptions of Vasari, da Fontana, and Dürer, all of whom recommend a full range of light and dark colors to create the illusion of pictorial space.[71]

Conclusion: The Impact of Venetian Color Theory on Dürer's Later Paintings

The information gathered from the technical investigation of the *Feast of the Rose Garlands*, interpreted within the context of Dürer's own theoretical writings and contemporary Italian theory, shows how Dürer struggled to adapt and selectively utilize specific Italianate techniques in this painting. Dürer incorporated Italianate elements and techniques into every phase of its production, from the construction of the ground preparation to his use of preparatory drawings on blue-dyed paper,

the subsequent minimization of underdrawing, and his study of color and light in the mastery of pictorial three-dimensional space. However, Dürer never uncritically adopted the techniques he discovered in Venice; instead, he synthesized them in relation to his own native traditions.

Like the construction of the panel, the preparatory drawings, and the modified use of underdrawing, Dürer's handling of paint in the *Feast of the Rose Garlands* reveals lasting changes that occurred in his painting technique while he was in Venice from 1505 to 1507. Before this journey, much of his construction of details in the paint layers was dependent upon a particularly graphic vision.[72] For the first time in Venice, in the *Feast of the Rose Garlands*, Dürer significantly altered the essentially graphic characterization of forms in pictorial space. In this painting and in related and subsequent works, both graphic and painted, he utilized a more painterly approach to spatial representation. This is not only apparent in a work like the *St. Anthony Before a City* (Figure 52) but is also central to his achievements in the three Master Engravings from 1514 to 1515, the *St. Jerome*, the *Knight, Death and the Devil*, and the *Melancholia*.

After his return from Venice, Dürer continued to exploit the technical innovations he had adopted there. For instance, he executed preparatory drawings for the *Heller Altarpiece* on green-prepared paper, similar to carta azzurra, to work out the value and color relationships of the forms before painting as he had done with the *Feast of the Rose Garlands*.[73] Technical investigation of paintings executed in Nuremberg after the completion of the *Feast of the Rose Garlands* in Italy in late 1506 shows that Dürer painted the later paintings differently from the "pre-Venetian" ones. Rather than a highly graphic handling of form in the execution of details, the *Martyrdom of the 10,000* (Figure 35), the *Adoration of the Trinity and the All Saints* (Figure 33), and the *Virgin with the Pear* (Plate IV), all demonstrate a more painterly understanding of objects in pictorial space. However, in these three later paintings, the technical innovations adopted by Dürer while he was in Venice coexist with the traditions of his Northern, gothic training and traditions. My findings about Dürer's utilization of painterly techniques in graphic works suggest a new reading for Erasmus' description of Dürer as the "Apelles of black lines." Instead of seeing Dürer as

an artist who could draw better than he could paint, perhaps we should think of him as an artist who drew as if he were painting.

Dürer's painterly achievements, including the incorporation of painterly techniques in the representation of color and light in the depiction of space without geometric perspectival constructions, have been greatly undervalued. Scholars, in particular Panofsky, have so consistently labeled Dürer a graphic, nonpainterly artist dedicated to the "scientific," "rational" construction of space, that they have underestimated the impact that Venetian painterly techniques in terms of color, light, and perspective had upon his conception of form and volume in his mature works of art, painted and graphic. Dürer's explorations of and achievements in the mathematical investigation of perspective should not be discarded. However, the historical vision of Dürer as a painter as well as a graphic artist should be broadened.

The *Feast of the Rose Garlands* II

Dürer, Giovanni Bellini, and Eristic Imitation in the Renaissance

A S I DEMONSTRATED in the last chapter, Dürer imitated the Venetian technique of drawing on *carta azzurra* and appropriated a specifically Venetian theoretical conceptualization of space in his production of the *Feast of the Rose Garlands* (Plate I). In this chapter, I will argue that Dürer was stimulated by his emulation of Giovanni Bellini to incorporate Venetian techniques into his own work and will demonstrate that a central focus of his interest was Giovanni Bellini's 1505 *San Zaccaría Altarpiece* (Plate VI). Besides the formal, iconographic, and technical aspects of his emulation of Bellini, I believe Dürer introduced a number of color quotations from the *San Zaccaría Altarpiece* into the *Feast of the Rose Garlands*. Dürer's relationship to Bellini can best be understood within the context of a Renaissance tradition of imitation in which the eristic, or competitive, component of the relationship between two artists influenced the outcome of their artistic productions.[1] Viewed within this context, Dürer's claim to have executed the *Feast of the Rose Garlands* in only five months, a significantly shorter time period than the evidence found in his letters to Pirckheimer suggests, can be understood as a manifestation of this competitive impulse. Dürer revealed his desire to be as good as or even to surpass Bellini through a combination of imitation and bravado displays of his technical, painterly virtuosity.

Dürer's imitation of Venetian painting in the *Feast of the Rose Garlands* has been widely accepted by art historians, who have agreed on the

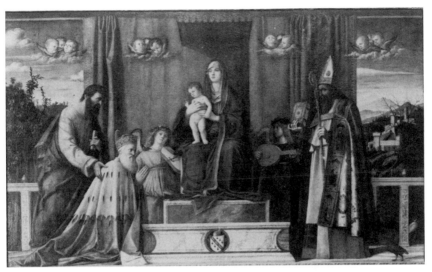

58. G. Bellini, *Votive Picture of Doge Agostino Barbarigo*, Murano, San Pietro di Musano

Venetian source of formal quotations and the "Venetian" tonality of the painting but have not agreed upon Dürer's specific sources. For instance, Thausing argued that the angel in Dürer's painting was like a Bellini angel.[2] Wölfflin disagreed and contended instead that the angel could not be a direct quotation from Bellini because it did not correspond exactly to any single one of Bellini's angels and was closer in type to the angels painted by Palma.[3] Wölfflin also maintained that the small floating putti in the *Feast* resembled a general Venetian type. The Tietzes argued that Dürer's prototype was Bellini's 1488 *Votive Picture of Doge Agostino Barbarigo* in the church of San Pietro Martire in Murano (Figure 58).[4] Panofsky asserted that the *Feast of the Rose Garlands* would not have been possible without Dürer's general study of Bellini's style and the form of Venetian *Sacra Conversazioni*, but he did not identify any particular source.[5] More recently, Terisio Pignatti wrote that a number of Venetian features were prominent in the *Feast of the Rose Garlands*. Further, like the Tietzes, Pignatti asserted that Dürer modeled the painting after Bellini's earlier *Votive Picture of Doge Agostino Barbarigo* because it "represented a more solid Bellini, a strongly graphic approach to painting which someone like Dürer would turn to most

naturally."[6] André Chastel contended that the formal elements of the *Feast of the Rose Garlands* were a critique of "static" Venetian forms, but that Dürer's use of color was the result of his exposure to the Venetian artistic milieu.[7]

It is true that the *Feast of the Rose Garlands* depended upon Dürer's close observation of the multiple facets of Venetian painting. I would like here to draw attention to specific details in his execution of the painting that have been overlooked in the literature. These details strongly suggest that Dürer was particularly drawn to the works of Giovanni Bellini. In addition to the formal quotations he took from the *Votive Picture of Doge Agostino Barbarigo* (Figure 58) (including the floating putti and the pose of the robed figure of the Doge himself), Dürer made numerous specific quotations of the *San Zaccaría Altarpiece* (Plate VI).

Dürer displayed a notable concern that the painterly and coloristic qualities of the *Feast of the Rose Garlands* be accepted and recognized as superior by the artists of Venice. As noted before, on September 8, 1506, Dürer wrote to Pirckheimer:

> My picture, you must know, says it would give a ducat for you to see it, it is well painted and beautifully colored.... I have stopped the mouths of all the painters who used to say that I was good at engraving, but as to painting I did not know how to handle my colors. Now everyone says that better coloring they have never seen.[8]

Two weeks later, on September 23, he wrote: "the artists praise it... they say they have never seen a more sublime nor lovely painting."[9] Dürer stated his respect for Bellini in the letter to Pirckheimer of February 7, 1506, where he wrote: "Er [Bellini] ist sehr alt vnd jst noch der pest jm gemoll."[10] As I showed in the previous chapter, I believe Dürer's description of Bellini should be understood as "Bellini is very old, indeed, but is nonetheless the best painter [in Venice]." Bellini had just completed the *San Zaccaria Altarpiece* when Dürer arrived in Venice in 1505. His praise of Bellini occurred just one month after he reported to Pirckheimer that he had received the commission for the *Feast of the Rose Garlands* from the German expatriate community in Venice.[11] Dürer had already absorbed enough of the Venetian painting scene in

February of 1506 to declare to Pirckheimer that Bellini was the best painter there.[12]

Dürer's Quotations from the *San Zaccaria Altarpiece*

Both Dürer's *Feast of the Rose Garlands* and Bellini's *San Zaccaría Altarpiece* (Plate VII) are painted as if illuminated by natural light, facilitated by the inclusion of outdoor settings. Bellini combined elements of the natural and sacred through the inclusion of two slender trees in the narrow vistas at the left and right margins of his altarpiece. These trees frame the sacred, indoor space. Dürer also used two trees to frame his scene but changed the quotation slightly by enlarging the trees and eliminating the church architecture (more like Bellini's *Votive Picture of Doge Agostino Barbarigo*).[13]

The inclusion of slivers of landscape allowed Bellini to illuminate the *San Zaccaria Altarpiece* strongly and dramatically with "natural" light from the left side.[14] Dürer likewise illuminated the *Feast of the Rose Garlands* from the left, although not with such dramatic intensity. Bellini, known for his masterful and subtle use of light and shading in the modeling of forms, captured the heads of the individual saints in his altarpiece with a smoky chiaroscuro and located those heads within an almost tangible space. Dürer followed Bellini's model closely in the floating, winged putti heads. Like the heads of St. Jerome, St. Paul, and St. Catherine in Bellini's *San Zaccaria Altarpiece*, the heads of these little cherubs are exquisitely rounded and modeled with a high degree of sensitivity to the fall of the shadows and light.

Dürer's imitation of Bellini is further attested to by the method he used to claim authorship of the *Feast of the Rose Garlands* (Plate I) and the *Christ Among the Doctors* (Plate II). Bellini often painted his name and date of execution on illusionistic slips of paper that seem to be attached to an object or surface depicted in the pictorial space.[15] Similarly, in both the *Feast of the Rose Garlands* and the *Christ Among the Doctors*, Dürer used painted scraps of paper to declare his authorship.[16] Before he went to Venice, Dürer's inscriptions either floated freely on the background of

the painting or looked as if they were carved on stone tablets incorporated into the image.[17]

Dürer's Color Quotations

Scholars such as Panofsky and Chastel have remarked on Dürer's "Venetian" color sensibility in the *Feast of the Rose Garlands* but have identified neither the specific aspects nor his Venetian sources.[18] In fact, the Venetian quality of the *Feast* is due to a large extent to Dürer's close observation and quotation of the *San Zaccaría Altarpiece*.[19] In the *Feast*, Dürer borrowed Bellini's color combinations and in several instances placed these combinations in analogous locations to Bellini's altarpiece.

The rich, scarlet red of Emperor Maximilian's cape in the *Feast of the Rose Garlands* is found in Saint Jerome's robe in Bellini's altarpiece. Like Jerome, Maximilian is located at the right in the altarpiece. Dürer also imitated the gray accents in the red lining of Jerome's robe in the gloves and in the red and gray costume of the cardinal situated between the pope and Burkard of Speyer at the left. The combination of lilac and salmon-orange that comprises the costume of Bellini's Saint Peter was repeated by Dürer in the costume of the man to the left of Burkard von Speyer, the last figure in the left foreground in the *Feast*.[20] He occupies the same position in the composition that Saint Peter occupies in the *San Zaccaría Altarpiece*; both are located in the left foreground. Another striking coloristic motif shared by the two paintings is lilac modeled with blue and purple. This opalescent color combination occurs in the robe of Saint Peter in the *San Zaccaría Altarpiece* and is found twice in the *Feast of the Rose Garlands*: in the costume of the man to the right of Burkard von Speyer and in the man holding a rosary at the right in the painting. This particular combination of lilacs, blues, and purples occurs nowhere else in Dürer's oeuvre.

Another parallel in color usage between the two paintings is discernible only through the comparison of the preparatory watercolor study for the Pope's *Pluviale* (Plate V) in the Albertina to Bellini's altarpiece (Plate VI). The *Pluviale*, widely recognized as a tour de force of coloristic

experimentation and expression, corresponds almost exactly in color scheme and tonality, and closely in pattern, to the tunic worn by Saint Lucy at the right in the *San Zaccaría Altarpiece*. However, the colors in the *Pluviale* do not correspond to those in the painted garment in the *Feast*. I believe that Dürer's watercolor study of the *Pluviale* was an overt gesture of imitation on his part, and that his deviation from the careful examination of color in the preparatory study shows that he did not want to appear to imitate Bellini too slavishly in the *Feast*, particularly since his imitation of Bellini was already transparent in that the position of the pope echoed the figure of the Doge in the *Votive Picture of Doge Agostino Barbarigo* (Figure 58). Dürer's painted rendition of the pluviale is warmer and brighter than any comparable area of drapery in the *San Zaccaria Altarpiece*. For Dürer to include this exact study after Bellini in the painting itself would have been uncharacteristic. Dürer's imitation of Bellini was not outright copying, but it was a virtuoso demonstration of his artistic ability. Moreover, imitation carried many meanings in the Renaissance, and the grossest form of it – mechanical copying – although central to the artistic process, did not demonstrate artistic virtuosity and was the least respected in theoretical discussions of the sixteenth century.

The Renaissance Theory of Imitation

In sixteenth-century artistic and literary theory, imitation was accepted as an intrinsic and inevitable part of the production of works of art.[21] Imitation in the Renaissance always implied a relationship, either to nature, to other works of art, or to other artists. The specific relationship involved affected the nuance of the meaning carried by "imitation." For writers like Vasari, the imitation of nature, the illusionistic reproduction of the visible world, was regarded as central to the rebirth of the art of painting in the Renaissance.[22] The imitation of nature remains central to modern assessments of Renaissance painting as well.[23]

The second most common meaning attached to imitation is related to the existence of artistic models, some of which were copied over and over again. David Summers pointed out that Renaissance writers did not question whether the artist should or should not imitate something or

someone, but how he should go about the inevitable task of recapitulating the accomplishments of his artistic or literary predecessors.[24] This type of imitation had different connotations of meaning, dependent upon context. It could indicate either the relatively straightforward task of directly copying a model, or it could indicate a neoplatonic form of copying in which the process of imitation was in itself transformative. Following this definition, imitation corrected the deficiencies of the model that was copied, making it more perfect.

In his 1567 treatise, *Il primo libro del trattato delle perfette proporzioni*, Vincenzo Danti distinguished between the more mundane copying or reproduction, for which he used the verb "ritrarre," and the neoplatonic ideal of transformative imitation, for which he used the verb "imitare." Danti expressed the difference between the two as follows:

> By the term ritrarre, I mean to make something exactly as another thing is seen to be; and by the term imitare I similarly understand that it is to make a thing not only as another has seen the thing to be (when that thing is imperfect) but to make it as it would have to be in order to be a complete perfection."[25]

"Imitare" was related to the ability of the artist to fashion the typical from his observation of the particular.[26] Nineteenth- and twentieth-century art historians have taken the position that the Italians, as artists, had a greater ability to transform observed reality into the ideal through imitation, whereas Dürer, like most Northern artists, was acclaimed for his ability to capture observable nature in the everyday sense of the particular. Roger Fry, for example, suggested that Dürer had unified observation and transformation, the Northern and Italian types of imitation in the *Feast of the Rose Garlands*, and that he came nearer then than at any other moment of his life to penetrating the mysteries of Italian design.[27] I would argue that Dürer's imitation of Bellini and the Venetians had a particular competitive edge because of his need to prove he was not just a lesser, Northern, copyist of the particular but rather was a painter in the same way that the Venetians were painters. As I discussed in Chapter 3, Dürer himself expressed a wish to rectify the common perception that he was

good at engraving but not able to "handle" colors in the Venetian manner in his letter to Pirckheimer of September 8, 1506.[28]

This type of competitive imitation is emphasized in Renaissance literary theory. Eristic imitation is the imitative relationship of an artist with other artists.[29] The relevance of eristic imitation to artists, and particularly to painters in the Renaissance, has not, to my knowledge, been explored. The identification of formal quotations by artists, the first kind of imitation, is central to the history of art, but personal artistic relationships, and particularly competitive relationships, are frequently overlooked if not completely ignored.[30] Roger Fry, for example, characterized Dürer's relationship with Bellini as "amiable."[31] The evidence from my technical investigation of the *Feast of the Rose Garlands* and the comparison of the painting to the *San Zaccaría Altarpiece* suggests that Dürer's relationship to Bellini was more complex than that, even if at heart he admired Bellini and their interaction was "amiable."

In literary theory, eristic imitation frequently described the relationship between generations of poets and writers. A younger poet demonstrated his mastery of the forms, motifs, and structures of previous poets' work while proving, by his transformation of those elements as they appeared in his own work, that he had surpassed the very model he imitated.[32] Plato's imitation and improvement of the Homeric and Hesiodic models was the classical source for this Renaissance definition of imitation. Plato paid both Homer and Hesiod the homage of flattery in the act of imitation, but, at the same time, he improved upon the forms he imitated and thereby surpassed the masters.[33] Classical prototypes for eristic imitation also existed for the art of painting.

Pliny's description of the rivalry between Apelles and Protogenes demonstrates that eristic imitation was not limited to literary relationships.[34] The competitive aspect of the relationship between Apelles and Protogenes is central to Pliny's account, as are the details of their competition: each tried to surpass the other in displays of virtuoso technique. I find it surprising that Dürer's relationship to Bellini has not been discussed in these terms since Pliny's account was well known in the Renaissance, and Dürer was so frequently compared to Apelles, even in

his own lifetime.[35] As the following passage shows, Pliny believed that evidence of artistic ability was to be found in the exhibition of great technical skill:

> An amusing exchange took place between Protogenes and Apelles. The former lived in Rhodes and Apelles sailed there, eager to acquaint himself with Protogenes' work – for he was known to him only by reputation. He made at once for his fellow artist's studio, but the latter was not at home. An old woman was looking after a large board resting on an easel. She announced that Protogenes was not in and asked who was looking for him. Apelles said, "This person," as he took up a brush and painted an extremely fine line in color across the board.
>
> On Protogenes' return the old woman showed him what Apelles had done. The story goes that after a close inspection of the line, Protogenes said that the visitor had been Apelles since such a line could not be the work of anyone else. Protogenes, using another color, superimposed an even finer line on the first one. As he left his studio, he told the old woman to show this to Apelles if he returned, and to add that he was the person for whom Apelles was searching. So it happened. For Apelles came back and, red-faced at being beaten, divided the lines with a third colour, leaving no room for any finer line.
>
> So Protogenes admitted defeat and rushed down to the harbour in search of his visitor. He decided that the board should be preserved for posterity to be wondered at by all, but particularly by artists.[36]

Artistic genius is defined here by the ability to recognize, imitate, and surpass the technical skill of another great artist. Proof of the excellence of Apelles and Protogenes as painters is not demonstrated by their ability to paint specific images or to recreate space illusionistically but by their facility with the paintbrush in the rendition of a single, abstract, perfect line. Furthermore, Pliny maintains, future artists would recognize the greatness of the techniques exhibited by Apelles and Protogenes in the lines limned upon the otherwise blank board.

Speed of Execution

Speed of execution was integral to the evaluation of virtuoso technique in Renaissance art theory, as it was in the classical roots of that theory.[37] Pliny praised Nichomachus as a rapid painter.[38] Alberti, closely following

Pliny, wrote in his 1435–6 treatise on painting, *Della pittura*, that when the artist uses his mental abilities combined with a great deal of practice, he "will become a much faster painter than Aesclepiodorus, who ... was the most rapid of all ancient painters."[39] Alberti stated on several occasions that the speed of the hand was a reflection of the power of the mind. He wrote that the mind of the artist, after it is "warmed by exercise, gives itself with greater promptness [pronto] and dispatch to the work," and that "the hand will proceed most rapidly which is well-guided by a certain rule of the mind."[40] Speed of execution was the primary aspect of technique that allowed the master to demonstrate his ability; what was difficult for the average artist was *not* difficult for him.

The notion of the difficult being achieved with ease, or with the absence of the *appearance* of difficulty, was codified by Castiglione's use of the word "sprezzatura" in *Il libro del Cortegiano*, published in Venice in 1528, but written before that date.[41] Summers pointed out that the notion of "sprezzatura" was grounded in the contrasting yet complementary ideals of "difficultà" and "facilità," which coupled artistic solution with inspiration.[42] "Facilità" was regarded as a synonym for virtuosity and was connected, as Barasch pointed out, to two related notions about the ability of the artist. The first of these is the ability to imitate nature so well that the senses are deceived; the second, the ability to produce complex, intricate works of art rapidly and without effort.[43] Barasch also noted that the demonstration of speed in execution was specific to the Venetian belief in the innate gift of the artist, especially as connected to color. This was sometimes expressed by the word "prontezza," which meant quickness, or promptness.[44] The sixteenth-century theorist Lodovico Dolce said that "facility is the basis of the excellence of any art,"[45] and his contemporary Cristoforo Sorte connected it to the "sureness of the hand of the artist."[46] The more conservative Paolo Pino voiced some ambivalence about the virtues of "prontezza," yet reflected the importance and timeliness of the issue by his very discussion of it.[47] Vasari, too, voiced a prohibition against the display of too much effort, especially in the length of time taken to complete a painting. He wrote: "[P]aintings want to be done with ease ... lingering too long over them takes away all the good that facility and grace ... might do."[48]

Dürer's Claims About Speed of Execution in the *Feast of the Rose Garlands* and the *Christ Among the Doctors*

In Latin inscriptions found on illusionistically painted scraps of paper included in each composition, Dürer claimed to have executed the *Feast of the Rose Garlands* (Plate I) in five months and the *Christ Among the Doctors* (Plate II) in five days. Other forms of available evidence discredit the veracity of these contentions. Dürer's letters to Pirckheimer directly contradict his allegation in the *Feast,* and the existence of preparatory drawings for the *Christ Among the Doctors* that were executed in the spring of 1506, months before September when he claimed to have produced that painting in five days, undermines the second claim. I believe that Dürer's repeated boasting about his speed of execution in these two paintings reveals his wish to exhibit his technical expertise, "facilità," and demonstrate his "sprezzatura."[49]

The Latin inscription on the slip of paper held by Dürer in the *Feast of the Rose Garlands* proclaims: "Exegit quinquemestri spatio Albertus Dürer Germanus" or "Albrecht Dürer of Germany executed [this] in the space of five months."[50] This inscription is paralleled in form and content by the one found in the *Christ Among the Doctors.*[51] Dürer's inclusion of similar inscriptions in the two paintings suggests that he intended them to be compared, and scholars have consistently related the two paintings to one another.[52]

These matching inscriptions must have been intended for a very specific audience, one that could appreciate the artistry involved in the manufacture of a work of art, and especially the length of time expended in that production. In his letter of February 7, 1506, Dürer described the visit made by Giovanni Bellini to his studio in Venice and reported that Bellini had not only admired his work but wanted to commission something from him and would pay well for it.[53] It is plausible that this work was the *Christ Among the Doctors.*[54] Bellini would have been familiar, of course, with the *Feast of the Rose Garlands* and would have appreciated, as no other peer of Dürer's could, the conceit involved in comparing a monumental public altarpiece to a highly personal, even idiosyncratic work of art intended for his own private consumption.

The Evidence Against the Claims

Scholars have noted the disparity between the epistolary evidence and the statement made by the inscription in the *Feast of the Rose Garlands* itself, but they have excused this inconsistency on the grounds of artistic license. I will argue that these letters reveal that Dürer was deeply concerned with completing the altarpiece according to a rather strict, and seemingly self-imposed, time schedule. Likewise, the claim that the *Christ Among the Doctors* was completed in five days does not stand up when the evidence of the preparatory drawings is scrutinized.

In the letter to Pirckheimer on January 6, 1506, Dürer informed his friend about the commission of the *Feast of the Rose Garlands* from the Fondaco dei Tedeschi, which he referred to as "the Germans."[55] He wrote optimistically of the timeframe for completion of the project and said that it should be standing on the altar a month after Easter.[56] Almost two months later, on February 28, Dürer reported to Pirckheimer that he was working quickly but would not be finished according to his initial schedule.[57] He betrayed his anxiety about the completion of the commission again by mentioning twice in the letter of April 2 that he would not finish according to schedule. In that same letter, he complained of the financial hardship that the commission was causing him.[58] It is likely that Dürer wrote Pirckheimer more letters during the course of the spring and summer, but none survive between April 25 and August 18. In the letters written on those dates, Dürer made no reference to the *Feast*. It is likely that he was hard at work on the painting, but that since the Easter deadline had passed, his anxiety about completion had also somewhat diminished.[59]

Dürer next mentioned the altarpiece on September 8, 1506, at which time the painting must have been completed, but possibly not yet installed on the altar. In this letter, he exulted in the response of the Venetian public to the painting and noted that both the Doge and the Patriarch had seen it.[60] Two weeks later, on September 23 in the penultimate surviving letter to Pirckheimer, Dürer wrote that the altarpiece was finished:

> You must know that my picture is finished as well as another painting the like of which I have never painted before.... [L]et me tell you there is

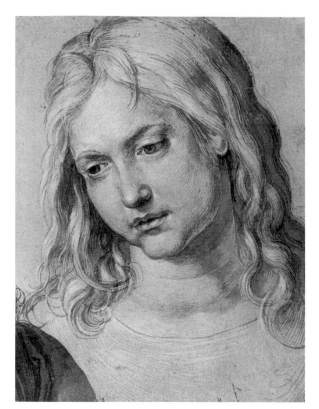

59. A. Dürer, *Head of Christ*, drawing, Vienna, Graphische Sammlung der Albertina

60. A. Dürer, *Hands Holding a Book*, drawing, Nuremberg, Germanisches Nationalmuseum

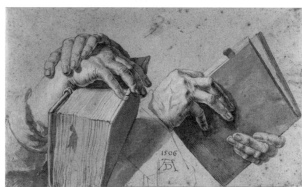

no better Madonna picture in the land than mine; for all the painters praise it. . . . They say that they have never seen a nobler, more charming painting.[61]

Thus, from Dürer's initial mention of the commission on January 6 until his statement to Pirckheimer on September 23 that the *Feast of the Rose Garlands* was finished, it can be reckoned that a little more than eight months had elapsed. It is impossible to reconcile the documentary evidence found in the Pirckheimer letters with the claim of rapidity expressed in the inscription. Since Pirckheimer was Dürer's friend and close confidante, the information found in the letters would seem to be reliable, guileless statements of Dürer's concerns at the time of writing. The inscription on the painting, on the other hand, communicated a calculated message about Dürer's genius to a much broader public. Therefore, it is likely that Dürer's letters to Pirckheimer come nearer to expressing the duration of Dürer's involvement with the *Feast of the Rose Garlands* than the inscription does.

Likewise, Dürer's claim that he completed the *Christ Among the Doctors* in a period of five days is undermined by the trail of physical evidence related to his production of the painting. Preparatory drawings for the *Christ Among the Doctors* were executed on the same sheets that Dürer used for the *Feast of the Rose Garlands*. Koschatzky and Strobl demonstrated that in at least two cases one study from each of these two paintings was executed on a single, large folio sheet of *carta azzurra*, and only later cut in two.[62] The *Head of Christ* (Figure 59), a study for the *Christ Among the Doctors*, occupies the same sheet as the *Head of an Angel* (Plate III), studied for the *Feast*.[63] The left shoulder of the angel is clearly discernible in the lower left corner in the sheet with the *Head of Christ*. Likewise, the *Hands of Maximilian* (Figure 26), a study for the *Feast*, was originally joined to the *Hands Holding a Book* (Figure 60), a study for the *Christ Among the Doctors*.

Koschatzky and Strobl argued that the occurrence of studies for the two paintings on single sheets of paper indicates that Dürer used the studies from the *Feast of the Rose Garlands* for the *Christ Among the Doctors* as well, or that he worked on both paintings at the same time.[64] It is

likely that Dürer's preparatory study, the *Head of Christ* for the *Christ Among the Doctors*, was executed at approximately the same time as the preparatory study for the *Head of an Angel* for the *Feast*, long before August or September of 1506. This evidence directly undermines the veracity of the inscription, which professes that the painting was the work of only five days.

Conclusion

Dürer's eristic imitation of Giovanni Bellini and the *San Zaccaria Altarpiece* pushed him to new heights of painterly achievement but also ultimately limited his success in the *Feast of the Rose Garlands*. Dürer's preparatory drawings on carta azzurra for the *Feast* (Plate I, Figures 22–27) demonstrate his ability to observe and to mimic Bellini's Venetian use of light to maximum dramatic and volumetric effect. Likewise, the watercolor *Pluviale* (Plate V) shows Dürer's ability to study the tonal harmonies of color that were the acknowledged domain of Giovanni Bellini.

Yet Dürer vitiated these effects in the painting, perhaps because he was afraid that his nontransformative, open imitation of Bellini would not be well received critically. For instance, the light in the painting falls more gently upon the assembled figures than in the preparatory drawings. This deemphasizes the dramatic monumentality of the figures as captured in the preparatory studies. Dürer's hesitation to execute in paint what he had mastered in his drawings on *carta azzurra* is especially apparent when the individual figures in the two paintings are compared. Bellini painted many fewer figures in a larger space than Dürer did and fully exercised his understanding of the modulations of light and color in the creation of pictorial space. In contrast, Dürer massed together the heads of the Christian community surrounding the Virgin and Christ Child in the frontal plane of the painting. There, the heads of the most important figures, including Maximilian, the pope, and some other patrons, are fully modeled and worked up. However, in contrast to the way that Bellini's figures fully occupy the space in which they are depicted, Dürer surrounded the principal figures with less important, less fully worked-up figures. This foreground crowding of the figures stands apart from Dürer's otherwise careful

emulation of Bellini and vitiates the effects of his study of light and spatial relationships successfully worked out in the preparatory drawings.

For these reasons, I believe Dürer's imitation of Bellini's *San Zaccaria Altarpiece* is only a qualified success. This view contrasts with Panofsky's assertion that in "one propitious moment [Dürer] succeeded in synthesizing the force and accuracy of his design with the rich glow of Venetian color" in the *Feast of the Rose Garlands*.[65] Panofsky argued that Dürer closely observed and assimilated the essential quality of Venetian painterly achievement. He limited the importance of Dürer's relationship to Venetian painting to this single monument. I would argue instead that even though Dürer's exposure to Venetian painting, and especially to the works of Giovanni Bellini, had a profound effect on the *Feast of the Rose Garlands*, this painting was only the first step in a longer process. It was only after his return from Venice that he successfully synthesized these painterly techniques into his work.

CHAPTER FIVE

After Venice

Concordance of Technique and Meaning

A FTER HIS RETURN TO Nuremberg from Venice in 1507, Dürer
continued to experiment with Venetian painting techniques, in-
geniously combining elements of learned Venetian techniques with his
native Germanic ones. As early as 1508, in the *Martyrdom of the 10,000*,
Dürer combined these two distinct techniques. He continued to experi-
ment in the *Adoration of the Trinity and the All Saints* of 1511 (Figure 33),
but Dürer achieved his fullest synthesis of Venetian and Northern paint-
ing techniques in the *Virgin with the Pear* (Plate IV) of 1512. My technical
investigation of this painting shows that Dürer utilized two significantly
different techniques in the painting, one for the Virgin and one for the
Christ Child. I will argue that this fusion of different techniques was not
merely an idiosyncratic accident but was intended to mirror the essen-
tial difference between the Virgin's human flesh and Christ's divine flesh.
Further, this allowed Dürer to express the essential iconographic mean-
ing of the depiction of the Virgin and Christ Child in an imaginative and
new way.

The two techniques that Dürer combined in the *Virgin with the
Pear* are the two major techniques known and used for the depiction
of painted flesh during the Renaissance. The Virgin corresponds to
Northern Renaissance practices, the Christ Child to Italo-Byzantine
practices.[1] The substantial difference between the human Virgin and her
divine child is central to the iconography of the Virgin and Child and
penetrates to the core of Christian salvation. An analog to the icono-
graphic and technical differences in the painting is found in a medieval

126

exegetical tradition that interprets the abrogation of the Old Testament by the New in terms of painting technique.

The critical history of the painting is remarkably limited, although split in the assessment of Dürer's aesthetic accomplishment in the painting.[2] The combination of opposites seems to have provoked either strongly positive or strongly negative assessments of the painting. Thausing, for instance, remarked on the beauty of the painting, but Ernst Heidrich wrote that Dürer had appropriated the worst of Italian mannerism in the painting.[3] Heidrich noted elsewhere that the composition of the *Virgin with the Pear* was influenced by Dürer's Venetian sojourn.[4] Yet Panofsky alone pointed out that the Virgin and Christ Child are stylistically at odds, that the Virgin depends upon Northern sources whereas the Christ Child seems to stem from Italianate ones. Of the painting he wrote: "[in] . . . the *Virgin with the Pear*, . . . a Virgin Mary reminiscent of the sweet, smiling maidens of Nicholas Gerhaert von Leyden is combined with an almost Michelangelesque Infant Jesus."[5] Panofsky did not elaborate upon these differences nor did he wonder if they might hold a clue to understanding Dürer's production of this particular painting.

In fact, the figure of the Christ Child derives from a marble putto commissioned by Matthias Corvinus, King of Hungary, from Andrea del Verrocchio for a fountain dedicated to the city of Florence. The fountain was never completed, due to Verrocchio's death in the summer of 1488. Whether Dürer saw the marble putto, a terra-cotta copy of it made by Francesco de Simone, or a drawing of it (by either Francesco de Simone or Lorenzo de Credi, Verrocchio's friend, pupil, and the executor of his estate) is unclear.[6] However, it is likely that Dürer's exposure to this putto (in whatever form) is recorded in the drawing of the *Infant Christ* Child on carta azzurra (Figure 27) in Paris. This drawing was made in Venice at the time the other studies on blue paper were made for the *Feast of the Rose Garlands*. The connection between the carta azzurra study of the *Christ Child* and the *Virgin with the Pear* (Plate IV) provides further proof of the lasting significance of Dürer's technical experiments in Venice on his subsequent artistic production.[7] Further corroboration of Dürer's reliance upon Venetian techniques is found in the fragment of a pear held by the Christ Child. This sliver of fruit is not merely an iconographic

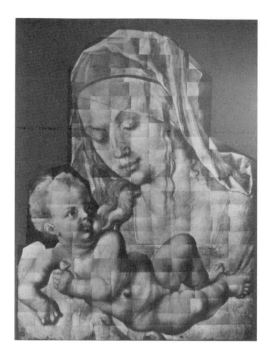

61. A. Dürer, *Virgin with the Pear*, IRR assembly, Vienna, Kunsthistorisches Museum

62. A. Dürer, *Virgin with the Pear*, IRR assembly, detail, eyes and nose of Virgin, Vienna, Kunsthistorisches Museum

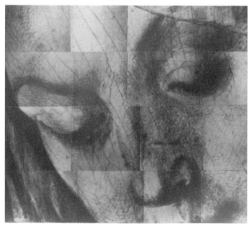

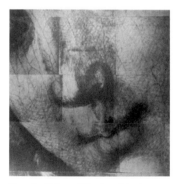

63. A. Dürer, *Virgin with the Pear*, IRR assembly, detail, nose and mouth of Virgin, Vienna, Kunsthistorisches Museum

symbol representing the Passion and Resurrection but also a subtle and witty memento of Dürer's appropriation of techniques and painterly practices related to Venice. It is specifically a reference to Giovanni Bellini, who used the pear as an attribute of the Christ Child on many occasions.[8]

Despite the elegance of Dürer's conception, the union of mother and child is uneasy, and underscores the unsettling quality of the painting that is the consequence of the combination of opposites in the composition. The angular line of the Virgin's falling veil connects her formally to the Christ Child. Yet this line and the square neckline of the Virgin's dress contrast with the opulent curves of the contours of Christ's body. The Virgin's form is relatively flat and two dimensional, contrasting strongly with the sculptural quality of the Christ Child, who emphatically occupies three-dimensional space.

Technical investigation of the painting shows that the formal and stylistic disparities between the figures of the Virgin and the Christ Child are congruent with significant differences in painterly technique.[9] Infrared reflectography reveals how Dürer actually applied paint to the panel and establishes the type and extent of underdrawing used in the preparatory phases of the painting. The infrared reflectogram assembly of the painting (Figure 61) accentuates the different techniques employed for each figure.

The face of the Virgin provides a good example of the techniques that Dürer would have learned both in Wolgemut's workshop and during the course of his *Wanderjahre*. Thinly layered oil glazes cover a panel prepared with a white chalk ground and a detailed, precise brush underdrawing. The IRR assembly of details of the Virgin's face (Figures 62 and 63) looks like a drawing on paper because the paint layers do not absorb infrared light; instead, they allow it to pass through to the white ground of the panel, where the dark underdrawing, by contrast, absorbs the infrared light. This is especially evident because the form and details are as fully worked out and legible in the underdrawing as they are in the painted surface. In contrast to the transparently painted figure of the Virgin, infrared reflectography of the Christ Child (Figure 64) does not show a multitude of transparent glazes. The infrared reflectogram assembly of this figure looks less like a drawing than does that of the Virgin because

the gray pigments that were applied absorb the infrared light and prevent penetration to the ground of the painting.[10]

The way in which paint layers are added to the prepared and under-drawn panel is related to the function and quantity of its underdrawing. Dürer mapped out the three-dimensional features of the Virgin's face with an extensive network of lines that includes contour lines, hatching, and cross-hatching (Figures 62 and 63). The very detail of the underdrawing suggests that Dürer did not plan to alter the form captured with this graphic means when adding the paint layers. The underdrawing would have been only partially obscured in the successive stages of painting, al-lowing the painter to follow the underdrawn form exactly through to the completion of the work. The same technique is observed in Dürer's un-finished and drastically over-cleaned *Salvator Mundi* (Figures 1, 7, and 8) of 1503–5 in The Metropolitan Museum of Art. Only a few areas of the *Salvator Mundi* are brought to a high degree of finish, such as the blue drapery to the left of the orb. Other areas of drapery are at an intermediate level of completion, as is evident in the red drapery on Christ's left shoul-der (Figure 1). The very first glazes of the painting process were applied directly on top of the underdrawing and are clearly visible in Christ's right hand and in the orb, where the paint layers cover but do not obscure the drawing beneath.

The technique used for the Christ Child in the *Virgin with the Pear* (Plate IV) contrasts strongly with the technique used in the face of the Virgin. In the infrared reflectogram assembly of the head of the Christ Child (Figure 65), only a few underdrawn lines are visible. They appear in the loop that identifies his mouth, in the scant details of his ear, and in the simplified curl on his forehead. Unlike the descriptive lines in the face of the Virgin, these marks merely note for reference the location and approximate size of the form to be painted.[11] Examination of the painting with the microscope revealed that the modeling of the figure is not constructed with graphic means followed closely in the paint layers above but with painterly means. Many fewer, but thickly applied layers of paint containing a gray pigment perform the function of the dense underdrawing in the figure of the Virgin.

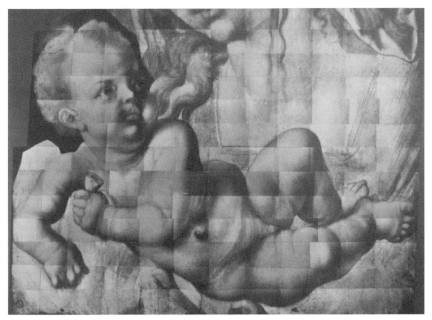

64. A. Dürer, *Virgin with the Pear*, IRR assembly, detail, Christ Child, Vienna, Kunsthistorisches Museum

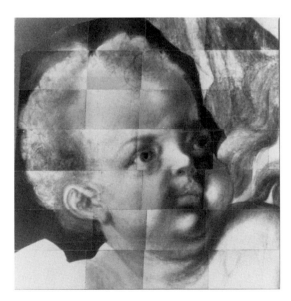

65. A. Dürer, *Virgin with the Pear*, IRR assembly, head of Christ, Vienna, Kunsthistorisches Museum

The *Infant Christ* Child on *carta azzurra* (Figure 27), executed by Dürer in Venice during 1506 in preparation for the *Feast of the Rose Garlands*, corresponds closely, though not exactly, with the painted figure of the Infant Christ in the *Virgin with the Pear*.[12] The pelvis and legs of the Christ Child in the painting are similar to those in the drawing. As I demonstrated in Chapters 3 and 4, the use of preparatory drawings on paper prior to painting was, for Dürer, an essentially Italianate practice that he adapted for his own purposes. The use of such preparatory drawings represented to him the successful incorporation of specifically Italian qualities of painting into his own native techniques. The sparse underdrawing found in the figure of Christ in the *Virgin with the Pear* is entirely consistent with Dürer's practices during his Venetian sojourn. As in the *Feast of the Rose Garlands*, the detailed preparatory drawing seems to have precluded the need for a complex, fully worked out underdrawing on the panel itself.

The use of a gray pigment in the depiction of certain kinds of flesh, specifically in the representation of figures of great sanctity, occurred in two other post-Venetian paintings in Dürer's oeuvre as well. In these paintings, the *Martyrdom of the 10,000* (Figure 66) and the *Adoration of the Trinity and the All Saints* (Figure 33), both completed *before* the *Virgin with the Pear*, Dürer combined two different techniques. The *Martyrdom of the 10,000*, commissioned by Frederick the Wise, was completed in 1508.[13] Investigation with infrared reflectography reveals that most of the figures are underdrawn and painted in a typically Northern technique and include a thorough, complete underdrawing. Examples of this type of work are found in the figure of the small boy at the bottom right (Figure 66) and in many of the figures in the group surrounding Christ, including the two crucified men (Figure 67) and the man who assists with disrobing those martyrs about to be beheaded (Figure 68).

These figures form a striking contrast to the two men about to be beheaded, both with wrists bound, and one blindfolded (Figure 68). Unlike the other underdrawn figures, the bodies of these two men are not defined with underdrawing but are rendered with deep gray pigments that give them a solidity of form and presence. The martyrs depicted with gray paint are sacred figures, related to Christ by their proximity to him and by their imminent sacrifice.[14]

A second, even more explicit precursor to Dürer's contrast of tech-
niques in the *Virgin with the Pear* is found in the *Adoration of the Trinity
and the All Saints* (Figure 69). *The Adoration of the Trinity and the All Saints*
was commissioned by Matthäus Landauer for the Zwölfbruderhaus in
Nuremberg and completed in 1511, three years after the *Martyrdom of
the 10,000* and the year before the *Virgin with the Pear* was painted.[15] Inves-
tigation with infrared reflectography reveals that all of the major figures,
with the exception of Christ, were fully worked up with a complex and
extremely finished underdrawing.[16] For instance, extensive underdraw-
ing defines the internal modeling and fall of light and shadow on the
robe of the king kneeling at the right center of the lower tier (Figure 70).
Similarly explicit underdrawing is found in the group of female martyrs
at the upper left (Figure 73), and in the figure of King David (Figure 74)
in the upper right tier.[17]

Some scholars have argued that Dürer included many portraits of lead-
ing Nuremberg citizens in the *Adoration of the Trinity and the All Saints*.
Alfred Gümbel identified both Matthäus Landauer (on the left side of
the painting) and his son-in-law, Wilhelm Haller (in golden armour
on the right side of the painting) on the basis of a description of the
Zwölfbruderhaus by a Nuremberg resident in the middle of the sixteenth
century. My investigation of the painting with infrared reflectography
supports the identification of the man on the left as Landauer, and also
shows that the figure that Gümbel identified as Wilhelm Haller was like-
wise probably intended as a portrait. The spot on the painting in which
the figure of Landauer was painted was not underdrawn, unlike the rest
of the painting (Figure 69), nor did Dürer leave a discernable negative
space empty for the portrait. Landauer's head was painted on top of paint,
which suggests that Dürer only completed the portrait of the donor late
in the process of completing the painting. Since a portrait drawing of
Landauer survives, it is possible to surmise that Dürer painted the por-
trait after Landauer sat for him, but possibly on top of a less satisfactory,
preliminary attempt.

Investigation of the figure in the splendid golden armor with X-
radiography and infrared reflectography shows that Dürer planned this
figure all along but changed the execution and the features substantially in

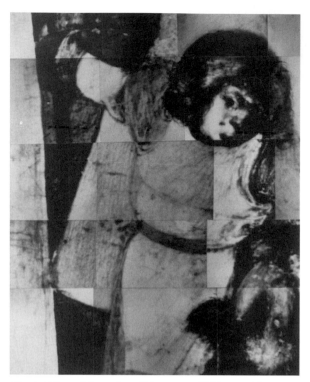

66. A. Dürer, *Martyrdom of the 10,000*, IRR assembly, detail, small boy, Vienna, Kunsthistorisches Museum

the paint layers after the underdrawing was complete. In the X-radiograph (Figure 70) it is possible to see the negative space left for the portrait. This space was significantly larger than the space ultimately used by Dürer for the portrait. The infrared reflectogram assembly (Figure 71) shows that in the underdrawing stage Dürer planned to represent a man with an abundance of curly hair extending over his forehead as well as a lavish and curled handlebar moustache! The lack of a portrait drawing on paper for this figure, together with the differences in the underdrawn and painted versions suggest to me that either Dürer had such an easy familiarity with this figure that he did not need to make a drawing, or that the identification of the figure as Haller is not entirely secure. It seems more likely that what we are witnessing here is a sort of joke between friends; a teasing, perhaps mocking, or more likely fond, representation of one of Dürer's patrons and a leader of Nuremberg society.

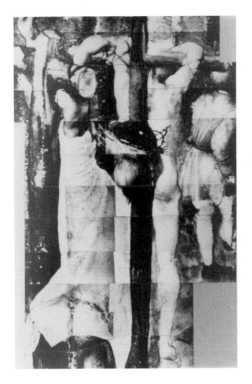

67. A. Dürer, *Martyrdom of the 10,000*, IRR assembly, detail, crucified men, Vienna, Kunsthistorisches Museum

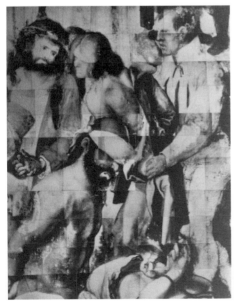

68. A. Dürer, *Martyrdom of the 10,000*, IRR assembly, detail of bound martyrs, Vienna, Kunsthistorisches Museum

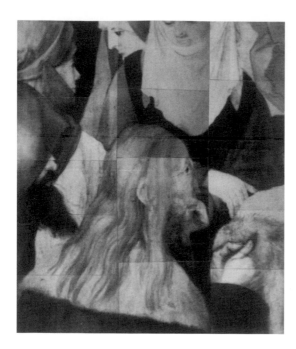

69. A. Dürer, *Adoration of the Trinity and the All Saints*, IRR assembly, detail, Matthäus Landauer, Vienna, Kunsthistorisches Museum

70. A. Dürer, *Adoration of the Trinity and the All Saints*, X-radiograph, detail, lower right tier, Vienna, Kunsthistorisches Museum

71. A. Dürer, *Adoration of the Trinity and the All Saints*, IRR assembly, detail, portrait of Haller, Vienna, Kunsthistorisches Museum

72. A. Dürer, *Adoration of the Trinity and the All Saints*, IRR assembly, detail, king's robe, Vienna, Kunsthistorisches Museum

73. A. Dürer, *Adoration of the Trinity and the All Saints*, IRR assembly, detail, virgin martyrs, Vienna, Kunsthistorisches Museum

74. A. Dürer, *Adoration of the Trinity and the All Saints*, IRR assembly, detail, King David, Vienna, Kunsthistorisches Museum

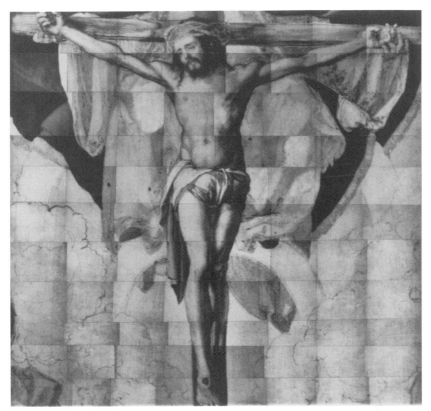

75. A. Dürer, *Adoration of the Trinity and the All Saints*, IRR assembly, detail, Christ, Vienna, Kunsthistorisches Museum

In comparison with the rest of the painting, executed using traditional painting techniques, only the central figure of the crucified Christ was painted using an entirely different technique. Dürer briefly indicated only the contour lines of the figure of Christ to mark his place in the picture and used gray paint to model His body. This is clearly visible in the infrared reflectogram assembly (Figure 75) where the contour lines that define Christ's arms and body are visible, but all graphic internal modeling is lacking and replaced by the more plastic qualities conveyed by gray pigments. The similarities in the infrared reflectogram assemblies between the body of the crucified Christ in the *Adoration of the Trinity and the All Saints* (Figures 73, 74 and 75) and the Infant Christ in the *Virgin with the*

Pear (Figures 64 and 65) are striking. If it were not for the congruences found in all three of these paintings – the *Martyrdom of the 10,000*, the *Adoration of the Trinity and the All Saints*, and the *Virgin with the Pear* – the use of a different technique for the execution of Christ and related figures might seem to be a coincidence or even an anomaly.[18] The similarities found in these three, however, suggest that the technique itself bore a significant valence of meaning for Dürer. This is not, I believe, mere coincidence.

To understand what that valence of meaning might be for Dürer, it is necessary to look at the history and origins of the different techniques. The use of transparent oil glazes over a white ground is the technique traditionally associated with Northern, gothic Europe, whereas the use of dark pigments in the painting of flesh is typically Italo-Byzantine.[19] The cultural and artistic exchange between Italy and Greece has a long and complex history; the fifteenth and sixteenth centuries saw a resurgence, credited to Cretan-Venetian painters active in Venice, of the Italo-Byzantine technique.[20] Thus, Cretan-Venetian icons were popular in Venice when Dürer was there in 1505–7. Prominent among such icons was the type sometimes referred to as the *Madonna mora o nera* (Figure 76), so called because of the distinctive dark, almost black pigmentation of the flesh.[21] Further, these *Madonne more o nere* were associated with the portrait of the Virgin, or "vera effigies" painted by St. Luke, and were therefore believed to be particularly sacred; every household in Venice was said to have possessed one because of its apotropaic powers.[22] On the evidence of the *Virgin with the Pear*, we can speculate that Dürer took notice of these icons, which offered both a new means to paint flesh and a technique traditionally associated with sacred themes.

Even if Dürer never saw a single example of a Venetian-Cretan *Madonna mora o nera* (which is unlikely), he could have learned of the Italo-Byzantine technique from its dissemination in the works of Italian Renaissance painters. Although most students of these painters' technique think of Cennino Cennini's discussion of the use of "verdaccio," a dark greenish or brownish pigment for the modeling of flesh areas, in fact, gray and even black pigments were used in the preparatory phases of paintings

around the turn of the sixteenth century, especially in Venice and north-ern Italy.[23] Vincenzo Foppa's "leaden" *Madonna and Child* (Figure 77) in the Metropolitan Museum of Art in New York of about 1480 is a strik-ing example of the inclusion of gray, even blackish underpaint in specific areas of flesh.[24] Plesters' technical investigation of the structure of the paint layers in Giovanni Bellini's 1514 *Feast of the Gods* (Figure 78) shows that the flesh of the Nymph Lotos is modeled with gray underpaint.[25] It is possible that Dürer saw paintings similar to Foppa's or Bellini's while in Venice and was led to explore the possibilities of using dark and gray pigments, instead of underdrawing, to model form. Dürer's exposure to and use of the more painterly Italo-Byzantine technique of depicting flesh may have allowed him to reevaluate the expressive possibilities of his own more draughstmanly technique.

Dürer made a similar, and possibly related, drawing in 1520: the un-usual *Head of a Woman* (Figure 79) in the British Museum.[26] The tech-nique of this drawing has drawn no attention, despite the fact that it is strikingly different, in both construction and appearance, from any other in his oeuvre. The correspondences between the technique Dürer used in this sheet and that used by Foppa in his paintings are so striking that mere coincidence seems unlikely.[27] I believe that the *Head of a Woman* provides further proof of Dürer's awareness of Foppa's technique and that Dürer consciously emulated that technique in this drawing. The technique employed by Foppa and Dürer is the antithesis to the tradi-tional Northern painting method in which colored pigments were ap-plied to a white ground. Both Foppa's *Madonna and Child* (Figure 77) and Dürer's *Head of a Woman* (Figure 79) are prepared with a dark founda-tion of solid, uniform dark gray paint. This gray paint acts as the un-derlying flesh color. The details are defined with black and white paint, which create shadows or highlights. The visual result is an almost metallic gleam.

Unlike Foppa and the Cretan-Venetian icon painters, Dürer reserved the application of this new (to him) technique of painting flesh for por-trayals of the nude Christ, the divine "new Adam," or to figures closely related to him – for example, the sacrificial figures in the *Martyrdom of the 10,000* (Figure 68). The culmination of this trope occurs in the

76. Angelos, *Virgin Kardiotissa*, Athens, Byzantine Museum

77. Vincenzo Foppa, *Madonna and Child*, New York, Metropolitan Museum of Art

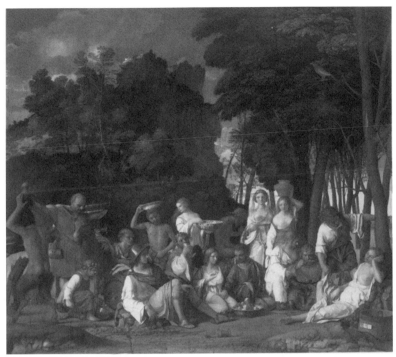

78. Giovanni Bellini, *Feast of the Gods*, Washington, D.C., National Gallery of Art

79. A. Dürer, *Head of a Woman*, London, British Museum

Virgin with the Pear. Dürer expresses the essential difference between the divine Christ and his human mother through the material creation of their simulated substance. Dürer's choice to realize, first, the Virgin with extensive underdrawing (figures 62 and 63) and the Christ Child with relatively little and, second, the Virgin with translucent oil glazes and the Christ Child with thickly applied gray pigments corresponds to a metaphorical expression of the fulfillment of the Old by the New in medieval exegesis. Medieval glosses equate the Old Testament and its Laws with the underdrawing of a painting and the New Testament with the paint that covers the underdrawing. Dürer's painting, obviously, does not simply copy this trope but suggests an awareness of the metaphor of prophecy and fulfillment. This representation of the special relationship between human mother and divine child conveys an extraordinary amount of condensed typological meaning relating to the achievement of the Old Testament promises through the sacrifice of Christ, which was only possible through the human conduit of the Virgin.

The verse that generated the various glosses appears in the anonymous Epistle to the Hebrews 10:1:

> For the law, having a shadow of good things to come and not the very image of the things, can never with those sacrifices which they offered year by year continually make those who come to it perfect.[28]

This verse specifically contrasts the "shadow of good things," which relates to the Old dispensation, to "the very image of things," or the realization of the Old Testament in the New. The visual content of the language of the verse, in which the experience of looking at the shadow of an image is contrasted with the experience of looking at a real image, is the essence of this metaphorical tradition. Gerhard Ladner and Herbert Kessler have demonstrated how John Chrysostom, Cyril of Alexandria, and John of Damascus, among others, elucidated Hebrews 10:1 with a complementary metaphor taken from painting, which compares the Old Testament to the preparatory underdrawing of a painting and the New Testament to a completed painting.[29] As in the practice of painting, the rough outlines of the figure are sketched onto a panel, subsequently to

be covered over with paints, or colors. Therefore, in the New Testament, the human incarnation of Christ "fleshed out" the promises only "drawn" in the Old Testament.

John Chrysostom, perhaps the earliest to use this metaphor, related the necessity of faith for the Christian seeking salvation to the necessity of colors for the painter creating an image. He wrote:

> as long as somebody traces the outlines as in a drawing, there results [only] a sort of shadow; but when he paints over it brilliant tints and lays on colors, then an image emerges.[30]

John Chrysostom was one of the most influential of the early Byzantine church fathers; his works were well-known in the West, and they influenced almost all Western theologians.[31] In this gloss, John's description of the painterly process reveals a remarkably thorough knowledge of the technical aspects of making a painting. His elucidation of the verse makes use of his understanding of the necessity of color in the production of a painting to explicate the necessity of belief in the New Order as a means to achieving grace.

Cyril of Alexandria employed the trope to explain typological method. He explicitly compared the process of fulfillment through salvation to the achievement of beauty in a painting through the addition of colors to the underdrawing. Cyril used this exegesis to explain typological method to Acacius. He glossed the Hebrews verse with the following paragraph:

> For the examples are very much less than the truth and are incomplete indications of the things signified. But we say that the law was a shadow and a type, and like unto a picture set as a thing to be viewed before those watching reality. But the underdrawing of artists' skill are the first elements of the lines in pictures, and, if the brightness of the colors is added to these, the beauty of the picture flashes forth.[32]

John of Damascus, claiming to quote Chrysostom, wrote:

> As the Law and Melchisedek are the preliminary drawing ["proskía-grama"] of the colored picture, so Grace and Truth are the colored picture, and so is that which is the world to come, reality.[33]

The practice of painting, that is, the application of colors to a figure is equivalent in Damascus's metaphor to the achievement of grace and truth in the New Order. His discussion of painted images in relationship to the orders of the world also concerns the illusory quality of images. A drawing, or the underdrawing of a painting, is only the initial stage in portrayal and illusion. But when the colors are applied to it, then that image becomes reality. The end result of the practice of painting is a "figure of real things," not an illusory "figure of a figure." The "figure of real things" is equivalent to the succession of a New Order on earth. Similar exegesis of the Hebrew text was not limited to Byzantine patristic writers but was also common in the West.[34] In fact, it was appropriated virtually word for word, although translated from the Greek to Latin, by at least three major Carolingian theologians: Alcuin, Rabanus Maurus, and Walafrid Strabo.[35] During the late fifteenth century, Strabo was believed to have been the compiler of the "glossa ordinaria" and many editions of the Vulgate were published with his textual glosses inserted into the margins.[36] It is possible that Dürer was familiar with the metaphor in some form since it remained intact in exegetical writings through both the span of centuries and the transcription from Greek to Latin. I have discovered that Anton Koberger, the noted Nuremberg printer and publisher, and significantly, Dürer's godfather, published an edition of the Vulgate in Straßburg that included Strabo's glosses, and specifically the gloss on Hebrews 1:10.[37]

Peter Lombard, Bishop of Paris in the twelfth century, also utilized this metaphor in his exegetical writings.[38] From one of these sources, most likely the *"glossa ordinaria,"* the metaphor could have found its way into homilies that would have been accessible to a man like Dürer.[39] Dürer's friend Pirckheimer, noted for his love of Greek texts and very active in the publication of translations of both classical and religious works, might have been a more direct conduit of knowledge of this medieval trope about painting. Pirckheimer published a translation of the writings of John of Damascus in 1536, admittedly some years after Dürer's death. However, it is probable that he possessed the original text before that time and was familiar with its contents.[40] Surely, he would have found a passage that explicates the fulfillment of the Old Testament by the New in

terms of painting technique of interest to Dürer and would have shared it with him.

Further, the similarity between the language used in these glosses and Vasari's description of preparatory drawings, as discussed in Chapter 3, is remarkable. Vasari wrote:

> Drawings in light and shade are executed on tinted paper which gives a middle shade; the pen marks the outlines, that is, the contour or profile, and afterwards half-tone or shadow is given with ink mixed with a little water which produces a delicate tint: further, with a fine brush dipped in white lead mixed with gum, the high lights are added. This method is very pictorial and best shows the scheme of coloring.[41]

Although Vasari does not explicitly refer to the coming of the New Order, his suggestion that drawings made in this way can demonstrate color schemes (as opposed to purely graphic depictions of objects) echoes these Church Fathers. Likewise, Giovanni da Fontana's passage about Jacopo Bellini's ability to depict space closely echoes these writings, further strengthening the possibility that the discussion of the metaphor was known in artistic theoretical circles and centers. This is particularly true for Venice, which was the locus for much of the introduction of Greek and Byzantine patristic texts into the West.

The discovery that Dürer combined two different techniques in the *Virgin with the Pear* (Plate IV), each representative of a distinct tradition for the painting of flesh, reveals previously unrecognized facets of the visual meaning of the painting. My technical investigation demonstrates that Dürer incorporated techniques learned in Italy into his own method of painting. His use of gray underpainting rather than fine underdrawing to model the figure of the Christ Child reveals his keen artistic sensibility and attentiveness to the profound religious meaning of the image. Dürer enriched the inherent message of the *Virgin with the Pear* with actual, perceptible, yet not readily identifiable differences in the construction and creation of the Virgin's and Christ's flesh. While it is impossible to prove that Dürer knew of the specific texts I have adduced here, it is plausible that the general metaphor of underdrawing and paint standing respectively for the Old and New Testaments was accessible to him in

the early sixteenth century. Even if Dürer did not know of the specific metaphor, that it existed at all provides a significant analog for the interpretation of painting technique during the Renaissance as well as an impetus to reconsider the meanings attached to the actual techniques involved in painting. The trope of the fulfillment of the Old Testament by the New suffuses every aspect of the *Virgin with the Pear*; the practices of painting converge with religious tradition and metaphor to create a remarkable marriage of piety and painterly virtuosity.

CHAPTER SIX

Repetition and the Manipulation of Meaning

Drawings and Paintings after 1512

A FTER 1512, Dürer continued to utilize elements of painting tech- niques he had learned and adapted while in Venice in 1505–7. Most significant of these practices was Dürer's continued utilization of prepara- tory drawings in lieu of pure underdrawing in the production of paintings, a practice he first explored in the *Feast of the Rose Garlands*. Several exam- ples exist of later paintings from Dürer's painted oeuvre in which he uti- lized a similar preparatory technique, depending primarily on preparatory drawings rather than on underdrawings to study the forms to be depicted in paint.[1] The portraits of Maximilian I merit special attention, however, because of their subject: Dürer first painted the Emperor Maximilian I, *not* from life, in the *Feast of the Rose Garlands*. Furthermore, the Maximilian portraits provide the only example of multiple versions of a single sub- ject based on a single preparatory cartoon within Dürer's corpus of paintings.

The art-historical literature about the portraits – a drawing (Figure 80), a woodcut (Figure 81), and two paintings, one in Vienna (Plate VII) and one in Nuremberg (Plate VIII) – has focused on dating and the rela- tionship between the images. The following discussion investigates this unique episode in Dürer's career: what it meant to the artist to draw the Emperor's portrait from life and how this drawing was used to make sub- sequent versions. The related questions of function and dating of the portraits are reconsidered as well. The data from my technical investiga- tions of the paintings and drawing, including infrared reflectography, are used to support my arguments.

149

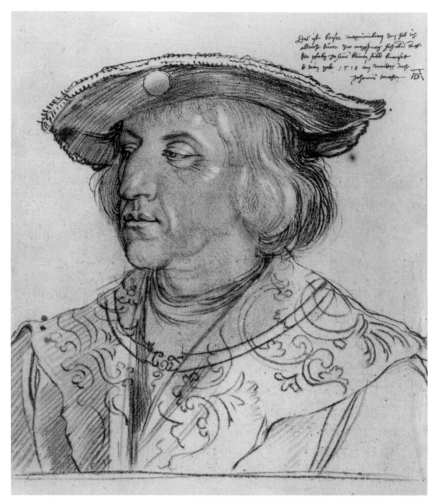

80. A. Dürer, *Portrait of Emperor Maximilian I*, drawing, Vienna, Graphische Sammlung der Albertina

Those facts definitively known about the portraits are relatively few: the charcoal drawing of Maximilian's head in the Albertina (Figure 80), made during the Imperial Diet in Augsburg in June of 1518, bears an inscription in Dürer's hand stating that he made the sketch in that city on June 28, 1518, "high up in the palace in his [Maximilian's] tiny little cabinet."[2] Seven months later, in January of 1519, Maximilian died; the portrait of the Emperor in Vienna on panel (Plate VII) is signed with a

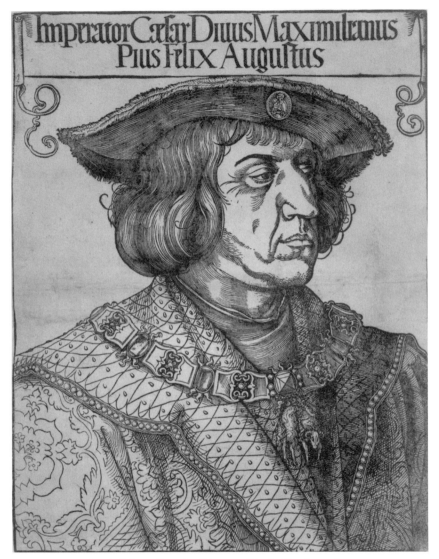

Imperator Cæsar Diuus Maximilianus
Pius Felix Augustus

81. A. Dürer, *Portrait of Emperor Maximilian I*, woodcut

monogram and dated 1519. Neither the version in Nuremberg, on canvas
(Plate VIII), nor the woodcut bears a monogram or date. We know, too,
from Dürer's diary, which he kept during his trip to the Netherlands in
1520–1, that he offered a portrait of Maximilian to Margaret of Austria,
Maximilian's daughter and Regent of the Netherlands. Which of the

portraits he offered her, and why she rejected it, remains unknown. Dürer recorded his disappointment at her rejection of the portrait in his diary and mentioned as well that he later traded the same work to a Genoese merchant for some white English linen.[3] Dürer's use of linen seems to coincide with his two journeys to the Low Countries and the Rhineland: the first, early in his career, and the second, the 1520–1 journey just mentioned. The fact that the Nuremberg version is painted on linen and the Vienna version on panel is worthy of note; the use of linen was more common in the Lowlands than in Germany at the beginning of the sixteenth century.

The material qualities of the portraits, executed on panel, canvas, and paper, as well as the especially poor condition of the Nuremberg painting, have influenced the critical interpretation of the paintings. Specifically, the different materials of the two paintings led Hans Stegmann to view them as stages of a single project; he believed that the canvas version in Nuremberg was a preparatory stage, or what he called a "modello," of the design that reached its culmination in the Vienna version.[4] His arguments have influenced most subsequent investigation of the portraits. Despite Thausing's recognition of the very close relationship of the drawing and the woodcut more than one hundred years ago, the relative sizes of the images have remained open to debate.[5] To clarify the size relationships, I made a tracing of the painting in Nuremberg and compared it with the version in Vienna (Figure 82, and detail, Figure 83), with the drawing (Figure 84), as well as with the woodcut.[6] I discovered that the contours of the heads in all the images are not only the same size but the features are essentially identical, including eyes, nose, mouth, and hair. (The heavier black drawn lines in Figure 82–84 show the contours of the Nuremberg painting superimposed on the other versions.) In addition, the hands in the two paintings are identical. They differ only in that the position of the right hand in the Nuremberg painting has been rotated ninety degrees from that in the Vienna painting.

My investigation of the two paintings with infrared reflectography – which reveals the underdrawing that was made during the preparatory phases of the painting and that is normally not visible to the naked eye – suggests that the identical heads were created with the aid of a cartoon that

was transferred to each one. Not only is the underdrawing of the contours beneath each of the painted heads exactly congruent, as is shown in the underdrawing (Figure 85) in the painting on panel (Plate VII), but it is also executed in a style indicative of a traced cartoon.[7] An underdrawing produced with the aid of a cartoon often looks bold, as it does here, but is also very tightly controlled. The contour lines that define the right side of Maximilian's face are precise but inorganic in execution. The line defining Maximilian's cheek, for instance, is drawn in two unconnected strokes between the eye and the bulge of the jowl, interrupted only by the tip of the nose. The internal modeling lines reveal their traced origins in the short, halting strokes that show where the drawing instrument was lifted from the panel in the process of repeating the traced design. Such traced lines are apparent around the nostril, in the crease line between nostril and mouth, in the dimple on the chin, and in the contours of both eyes. The lines traced from the cartoon were augmented with some further details on the same sheet, produced perhaps with the chalk cartoon near at hand, but not traced. This second stage of preparatory drawing, though still not entirely free in its execution, is evident in the less controlled crow's-feet beneath the eye, in the indications for individual locks of hair in the bangs, and in the irregular, short strokes running from the bridge of the nose into the cheek.

Another seemingly unrelated and puzzling example of underdrawing also occurs in the panel painting. The lines of underdrawing beneath the Emperor's left sleeve (Figure 86) are irregularly drawn and bear no concrete relationship to the folds of velvet painted on top of them. Further, they are unconnected to the rest of the drawing in the cloak; the description of the folds of the material seems to be out of register with the rest of the drawn design. My examination of twenty-five other paintings by Dürer reveals no parallel to this technique, and the answers to the questions of how and why Dürer prepared this part of this painting must remain conjectural. However, if Dürer were looking at a cartoon, or perhaps at a live model while making the preparatory drawing, rather than at the panel itself, this would explain the dissimilarity between this part of the underdrawing and the painted surface. It would account for the unsteady quality of the drawing and its disjunction from the rest of

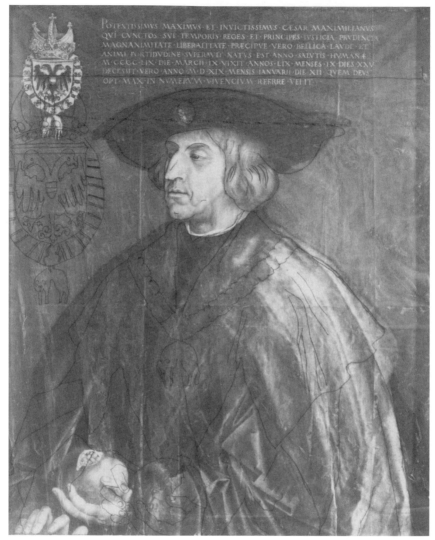

82. A. Dürer, *Portrait of Emperor Maximilian I*, photographed with tracing overlay from Nuremberg painting, Vienna, Kunsthistorisches Museum

the fluently executed design as well as the divergence of the painted layers from the underdrawing.

Close observation in raking light of the charcoal drawing of *Maximilian* in the Albertina (Figure 80) shows incised lines around the contours, in the details of the nose, eyes, eyebrows, mouth, chin, and hair in the same

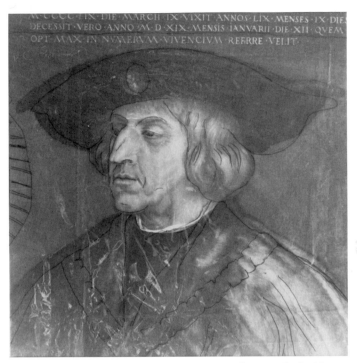

83. A. Dürer, *Portrait of Emperor Maximilian I*, photographed with tracing overlay from Nuremberg painting, detail, Vienna, Kunsthistorisches Museum

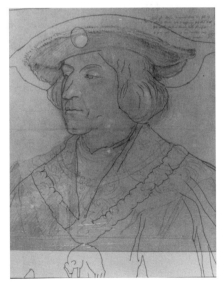

84. A. Dürer, *Portrait of Emperor Maximilian I*, drawing, photographed with tracing overlay from Nuremberg painting, Vienna, Graphische Sammlung der Albertina

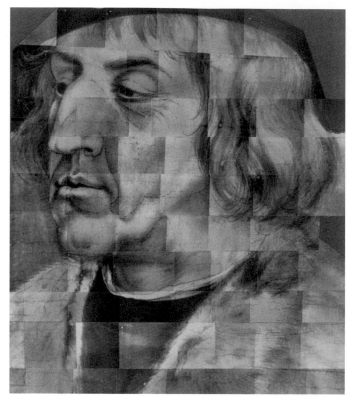

85. A. Dürer, *Portrait of Emperor Maximilian I*, IRR assembly, detail of head, Vienna, Kunsthistorisches Museum

86. A. Dürer, *Portrait of Emperor Maximilian I*, IRR assembly, detail of left sleeve, Vienna, Kunsthistorisches Museum

places that underdrawn lines appear in the paintings.[8] These lines, which are literally indented into the surface of the paper, reveal that this drawing was the actual cartoon used in the transfer process.[9] It is likely that the incised lines were made in the manner prescribed by Vasari in his manual on technique, where he instructs the artist to incise a drawing with a stylus over an interleaf of carbon-coated paper to transfer the design of the drawn image to the prepared surface of the painting support.[10]

The dissimilar effects that Dürer achieved through the manipulation of these traced images has been the source of the confusion in the literature about the relative sizes of the images. His formal manipulation of the elements of the portraits, combined with the slightly divergent dimensions of the painting supports gives the illusion of difference in the images. Because the panel in Vienna (Plate VII) is slightly smaller than the canvas in Nuremberg (Plate VIII), the ratio of head size to overall painting size is greater, making Maximilian appear larger in the panel painting.[11] Dürer emphasized Maximilian's age in the Vienna version by depicting him with gray hair, whereas in the Nuremberg painting, he portrayed a more youthful, dark-haired Emperor. In addition, Maximilian's body is positioned differently in each portrait. In the Vienna painting, he rests his hands on the lower left edge of the frame in a relaxed, informal, nonaxial position that makes his presence both immediate and near. In contrast, in the Nuremberg version, he is presented almost in half-length, removed from the pictorial plane with his head and hands lined up in an axial, hieratic position. Lastly, the symbols of Office and Rule receive different emphases. In the Nuremberg painting these symbols are large and prominently displayed, whereas in the Vienna painting they are minimized; Maximilian does not even wear a chain of the Order of the Golden Fleece in this version.

Investigation of the paintings using infrared reflectography also reveals that the chain of the Order of the Golden Fleece worn by Maximilian in the Nuremberg version is significantly altered from the underdrawn conception (Figure 87) to the painted version.[12] In the finished painting (Plate VIII), this chain is much larger than initially underdrawn. (To the eye not trained in the investigation of underdrawings, the underdrawn chain is not immediately apparent; it rests about two centimeters above

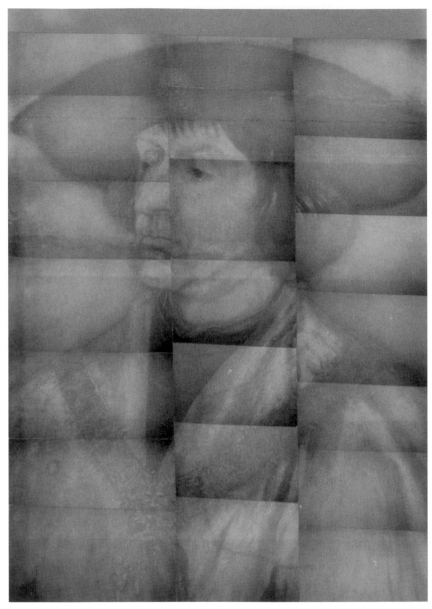

87. A. Dürer, *Portrait of Emperor Maximilian I*, IRR assembly, Nuremberg, Germanisches Nationalmuseum

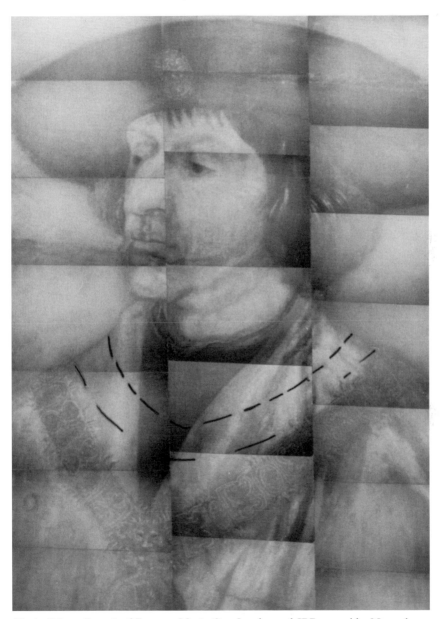

88. A. Dürer, *Portrait of Emperor Maximilian I*, enhanced IRR assembly, Nuremberg, Germanisches Nationalmuseum

the large painted chain, which is still visible in the infrared reflectogram document.) In the underdrawing (Figure 88, with markings to clarify the position of the underdrawn chain), the chain is much smaller, would have rested higher on Maximilian's shoulders, and was rounded instead of V-shaped. This underdrawn conception for the chain corresponds closely to the woodcut (Figure 81), the best known version of the Maximilian portraits. A similar indication for a chain is also found in the drawing (Figure 80). On the other hand, no chain at all is indicated in the Vienna version (Plate VII), either underdrawn or painted. I believe that Dürer's adaptation of the size of the chain in the Nuremberg painting indicates that he realized in the midst of production that the painting called for a stronger emphasis on the symbols identifying the sitter as Emperor, whereas such considerations were not prominent at any point during the production of the Vienna painting.

The differences in the two paintings that I have outlined above suggest strongly that it was Dürer's intent to create two different kinds of portraits. The Latin and German inscriptions on the paintings, identical in content but written in different languages, further endorse this view. The use of Latin for the inscription on the Vienna panel implies that Maximilian was a humanist scholar, while the vernacular German on the Nuremberg painting would have appealed to the populace of Maximilian's Empire. The Nuremberg painting, with its more formal presentation of the idealized, youthful figure of Maximilian and the overriding emphasis on the accoutrements of office, including the enlarged chain of the Order of the Golden Fleece and the enormous coat of arms to the left is an Imperial portrait. It presents Maximilian as Emperor and accentuates the office over the man. The Vienna painting, on the other hand, is a portrait first of Maximilian the individual. The intimacy of the presentation, combined with the lack of emphasis on the smaller coat of arms to the left, and the complete absence of the chain of the Golden Fleece, and Dürer's uncompromising focus on his sitter's aged demeanor makes this representation more a statement about the man than about the Emperor.

Dürer's creation of two functionally different portraits, one presenting the private, the other the public, man is not without precedent. Bernhard Strigel, Maximilian's court painter, made two distinct types of

portraits, one emphasizing the office of Emperor and the other accenting Maximilian as an individual. The Imperial type (Figure 89) presents Maximilian in the trappings of office; he is shown in three-quarter view, wears golden armor and the chain of the Order of the Golden Fleece, and holds both a scepter and a sword. In contrast, Strigel portrays Maximilian the private man (Figure 90) in strict profile wearing a fur-lined robe and holding a scroll instead of a sword in his left hand.

Why, then, if Dürer's two painted portraits look so different from one another, and fulfill different purposes, did he feel a need to trace the design for the two heads, repeating it exactly in every version? Certainly Dürer did not *need* to trace any design; why did he not employ Strigel's more typical solution to the problem of making functionally different portraits, which entailed distinct formulas for each portrait type, from start to finish? To make different portraits as Dürer did would seem to be more trouble than it was worth, unless there was some meaning attached to the drawing that was being traced.

I believe the answer to that question is found in the portrait drawing Dürer took of Maximilian from life during their meeting in Augsburg in 1518. Dürer had never made a portrait of Maximilian from life before this time; and although he had worked for Maximilian on various propagandistic projects, he was not a court painter like Strigel, who made many portraits of the Emperor and the Imperial family (Figure 91).[13] Further, the very status of the two men involved must have given that meeting a unique, almost mythical quality. Maximilian, the Holy Roman Emperor, was the most powerful man in Europe, and Dürer was the greatest artist in the North. Therefore, this portrait of Maximilian would have had a special significance: it was the product of a unique meeting, it was taken from life, and its verity was almost unimpeachable since it had been made by Dürer, arguably the greatest draughtsman alive.

In terms of the meaning of taking the Emperor's portrait from life, I would like to speculate on one further meaning connected to my arguments in previous chapters. I believe it is possible that, when Dürer took the portrait of Emperor Maximilian from life in Augsburg in 1518, he was reminded of the only other portrait of Maximilian he had made: the portrait of the Emperor included in the 1506 *Feast of the Rose Garlands*

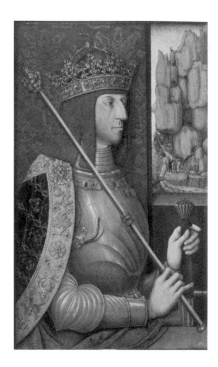

89. Bernhard Strigel, *Portrait of Emperor
Maximilian I*, Augsburg, Bayerisches
Staatsgemäldesammlungen

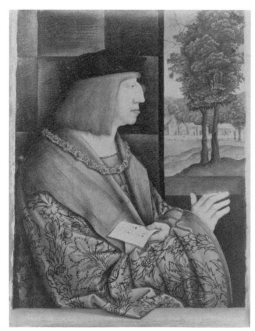

90. Bernhard Strigel, *Portrait of
Emperor Maximilian I*, Vienna,
Kunsthistorisches Museum

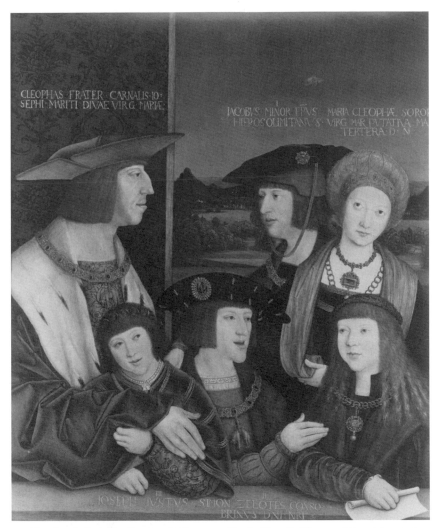

91. Bernhard Strigel, *Family of Emperor Maximilian I*, Vienna, Kunsthistorisches Museum

(Plate I). That earlier portrait was not taken from life; taking the Emperor's portrait from life twelve years later is likely to have revived memories of the time of his earlier portrait (i.e., his Venetian sojourn and the resultant exposure to Venetian painting techniques). My hypothesis gains credence from the reappearance of three distinctly "Venetian"

motifs and techniques in Dürer's work in the two years following his meeting with Maximilian in Augsburg.

The first of these reiterations is the 1519 engraving *St. Anthony Before a City* (Figure 52), which was, as I discussed in Chapter 3, a reworking of the city vista in the *Feast of the Rose Garlands* and demonstrated Dürer's mastery of an atmospheric, coloristic, perspective. In 1519, Dürer also executed another drawing, the *Virgin and Child with Angel* (Figure 92), that is a paraphrase of a Bellini-like motif of the Virgin with a musical angel at her feet. Interestingly, this drawing also includes a summary sketch of a landscape that seems to repeat the essential form of the city vista from the *Feast of the Rose Garlands*. This sketchy rendition of a city vista in the left side of the drawing includes – like the *Feast of the Rose Garlands*, the *Pupila Augusta* drawing (Figure 50), and the *St. Anthony Before a City* (Figure 52) – a high tower flanked by a building with stepped crenellations and a lower tower. As I discussed in Chapter 3, examination of the versions of this city vista shows Dürer's progressive mastery of Venetian lighting effects to achieve perspective and depth; the city vistas are intimately associated with his contact with Italy.

The third work following his meeting with Maximilian, which points to a recrudescence of Venetian themes in Dürer's late work, is the 1520 drawing *Head of a Woman* (Figure 79). This drawing demonstrates Dürer's revival of a Venetian technique rather than a Venetian motif. The technique used by Dürer in this drawing to depict flesh, a gray base layer to which details in black and white highlights are added, is similar to that found in the *Madonne more o nere* for example, the *Virgin Kardiotissa* (Figure 76) painted by the Cretan-Venetian painters active in Venice and to the "leaden" Madonnas (Figure 77) of Vincenzo Foppa. As I showed in Chapter 5 , Dürer would have first seen these techniques in Venice in 1505–7; he continued to experiment with this technique after he returned to Nuremberg, notably in the *Adoration of the Trinity and the All Saints* (Figure 33) and the *Virgin with the Pear* (Plate IV). Dürer's separate, but contiguous, revitalization of Venetian motifs and techniques, twelve years after his return from Venice to Nuremberg, shows the evolving importance of his trip to Venice throughout the span of his career.

92. A. Dürer, *Virgin and Child with Angel*, drawing, Windsor Castle, The Royal Collection

93. A. Dürer, *The Draughtsman Drawing a Portrait*, woodcut

The importance to Dürer of his June 1518 sitting with the Emperor is further testified to by what I believe is another, significantly later representation of it in Dürer's work. In *The Draughtsman Drawing a Portrait* (Figure 93), a woodcut illustration included in Dürer's 1525 edition of the *Unterweysung der Messung*, the artist, possibly a self-portrait of Dürer, draws the portrait of a man enthroned in a small bed chamber. The congruence between this depiction of portrait taking and Dürer's inscription on the charcoal drawing of Maximilian taken "high up in the palace in his tiny little cabinet" suggest that this image represents Dürer's initial intimate contact with Maximilian. The subject of the portrait cradles the orb on the finial of the throne in his right hand in a formal gesture similar to Maximilian cradling the pomegranate in Dürer's two painted versions of the portrait.

Although it is certainly only speculation, I believe that Dürer was pre-occupied with this portrait of the Emperor because, for him, that moment and that union of artist and Emperor had an allusive, almost transcendent aura. The significance of Dürer's single life drawing resonates with the commonly known tradition of sacred portraiture manifested in the legend of St. Luke's miraculous portrait of the Virgin. Many artists utilized the trope of representing themselves as St. Luke taking the portrait of Mary from life. Of course, Dürer does not explicitly represent Maximilian as divine, nor himself as St. Luke, but he did reuse, almost obsessively, the drawing that was the product of his meeting with the Emperor, just as St. Luke's portrait of the Virgin was copied and reused.

Bernhard Strigel again provides a parallel to Dürer's activity as Imperial portraitist, particularly in his conflation of religious and political realms. Strigel altered his painting *The Family of Emperor Maximilian I*, (Figure 91) in 1520, just after the death of Maximilian and after the completion of Dürer's Vienna portrait of Maximilian.[14] Strigel added to the original composition a representation of the Holy Family on the back of the panel and inscriptions on the front that identify Maximilian and his relatives as members of the Holy Family, explicitly proclaiming the divine nature of the royal family.[15]

Given the variations in the portraits that are indicative of different functions – made evident by the changes in the underdrawn chain in the Nuremberg painting and by Dürer's manipulation of the same image to serve distinct purposes – I would like to clarify the dating of the images. Since the Vienna painting is signed and dated 1519, the year Maximilian died, and is the more intimate of the two paintings, it was probably a commission from Maximilian himself; his sudden death in January would have interrupted delivery of the completed portrait. Still, it is impossible to determine whether the Vienna panel or the woodcut came first. I would suggest that they were commissioned by Maximilian more or less simultaneously; the one for his private use, the other for distribution in his Empire. Also, because of Dürer's relatively infrequent use of linen as a support earlier in his career, his interest in linen during his journey to the Netherlands in 1520–1, as well as the more common use of linen supports in the Netherlands in general, I would posit that the Nuremberg portrait

was made during that time, possibly as a processional banner associated with the coronation of Maximilian's grandson Charles V in 1520.

The significance of Dürer's Maximilian portraits cannot be divined from their surface appearances alone. An understanding of how Dürer made the versions, repeating a single image, but disguising the repetitions, is crucial to interpretation of the portraits. Dürer's ability to synthesize the representational, political, and anagogical aspects of portraiture in a single series of productions bears further testimony to his creative genius. In this unique group of portraits – drawing, woodcut, and two paintings – equivalence and variation converge within an unchanging structure as Dürer reveals and masters the complex task of Imperial portraiture.

Conclusion

D ÜRER WAS A PIVOTAL FIGURE in the interchange of artistic tech-
niques and theories between Italy and the North during the Re-
naissance. I have used the new evidence from my technical investigations
of twenty-five of his paintings, including infrared reflectography, to re-
assess his relationship to Italy and his status as a painter. My studies of
the techniques used by Dürer and of the visual evidence provided by
his painted and graphic works indicate that he traveled to Italy only once
during his lifetime. The Dürer literature, in contrast, depends too heavily
on two obscure, indeterminate literary references to contend that Dürer
made two separate trips to Italy. My examination of the paintings exe-
cuted in Venice during the 1505–7 sojourn shows that Dürer's response
to the art and artistic practices of the Venetian painters was extremely
acquisitive. It is hard to accept the proposition that this artist could have
been in Venice eleven years earlier and not had even a moderate response
to the stimuli that so absorbed him in 1505–7.

My investigation of the 1506 *Feast of the Rose Garlands* in Prague demon-
strates Dürer's extraordinary achievement in terms of the rapidity with
which he appropriated and utilized new Venetian techniques. This im-
portant painting provides a glimpse into Dürer's experimentation with
the Venetian theoretical and artistic approaches to the utilization of at-
mospheric and coloristic perspective. Dürer's engagement with the activ-
ities of the Venetian painters, and Giovanni Bellini in particular, can be
characterized as a competitive, eristic imitation, in which Dürer clearly
emulated the older artist, and did so with a demonstration of speed and

facility. However, I submit – in contrast to Panofsky's view – that the *Feast of the Rose Garlands* was not the culmination of Dürer's painterly synthesis of Italianate techniques and motifs but was only the first step in a process of experimentation that would continue throughout his artistic career.

Dürer's use of gray paint in the depiction of flesh is an example of his evolving integration of Italianate techniques. He first witnessed this technique while in Venice when he was exposed to the icons of the Cretan-Venetian "maddonneri" and the related "leaden Madonnas" of Vincenzo Foppa. He experimented with this technique, particularly in sacred figures, in the later *Martyrdom of the 10,000* and the *Adoration of the Trinity and the All Saints* and achieved his most brilliant expression of it in the *Virgin with the Pear* of 1512. In addition, the manifestation of the changes Dürer introduced into his artistic practices as a result of his exposure to Venetian painting were by no means limited to painted works but include graphic works as well. His new knowledge about the depiction of space with the manipulation of light, a direct result of his study of Venetian techniques, is perhaps more striking in his graphic works than in his paintings. This is demonstrated by Dürer's depiction of space in the *St. Anthony Before a City*, which was dependent upon Dürer's resolution of the problem of three-dimensional spatial depiction in the same detail in the *Feast of the Rose Garlands*. This suggests that the dominant view of the "scientific" Dürer, absorbed in the investigation of geometric and mathematical forms of perspective, should be expanded to take into account his interest in alternative forms of perspectival spatial constructions.

I have tried to be clear about which of my arguments are based on empirical evidence and which are more speculative. I think my main arguments gain credibility through the convergence of visual, technical, and historical evidence. Of course, my arguments need to be tested by further scholarship and technical studies of more of Dürer's paintings.[1] Investigation of paintings by Venetian and North Italian masters, including the works of Giovanni Bellini and others, would provide comparative material for my arguments.[2]

I think the evidence from my investigations shows that Dürer was an extremely careful artist; nothing in his execution of paintings was random. Even his choice of a particular technique for the depiction of the

holy flesh of the Infant Christ in the *Virgin with the Pear* facilitated the expression of the larger iconographic meanings of the work as a whole. Likewise, multiple copies of a specific motif in his works were not the result of the presence of a pattern or simile in his shop that was copied repeatedly for years. Instead, repetitions indicate Dürer's struggles with and ultimate triumph over specific artistic problems, whether in the depiction of pictorial space, as in the multiple occurrence of the city vista from the *Feast of the Rose Garlands*, or in the expression of the political significance of an Imperial portrait in the case of the four versions of the Maximilian portrait.

I hope my research is one step in the necessary integration of technical studies into "mainstream" art-historical investigations. Such studies should not be segregated into technical appendices but should occupy a central role where they can enrich and enhance our knowledge about artists and their activities. Dürer and his artistic production provide the example par excellence of how technique itself is interpretable and needs to be seen in relationship to other paths of critical inquiry, including studies of patronage, formal analysis, and iconography.

The History of the Condition of the *Feast of the Rose Garlands*

M ODERN SCHOLARS have invoked the ruined state of the *Feast of the Rose Garlands* repeatedly, almost as a leitmotif, to mourn the loss of the central monument of Dürer's relationship to Venetian art as well as the very brevity of that relationship.[1] The measures taken to save the "ruined" *Feast of the Rose Garlands* have become an essential part of the art-historical record of the painting. The accounts of various campaigns of restoration, as well as the notices in inventories about the ruined condition of the painting, reach as far back as the seventeenth century. Such remarks and records are rare in the twentieth century and were almost nonexistent in documentary records of the seventeenth, eighteenth, and nineteenth centuries.

It is likely that the initial damage to the painting was sustained at the turn of the seventeenth century, when Rudolf II acquired the painting and had it transported across the Alps. Joachim Sandrart recorded Rudolf II's acquisition of the altarpiece and described in detail the care with which Rudolf had the painting transported from Venice to Prague.[2] The elaborate precautions taken by Rudolf II were ultimately useless; the journey from Venice to Prague over the Alps must have been devastating to its structure and resulted in damages to the painted surface. The painting probably suffered even more damage in the 1630s, when the Imperial Habsburg collections were evacuated from Prague to Vienna and Linz to save them from the advancing Swedish forces.

Sandrart's record of these events, written in 1675, almost seventy years after the events described had happened, but also after the earliest

documented campaign of restoration to the much damaged painting, shows the high esteem in which the painting was held, and the importance it was granted both by Rudolf II and by Sandrart himself. The historical record of Rudolf's desire to obtain the painting, as well as the disastrous consequences of that desire, affirmed the romantic vision imposed on contact between Germany and Italy by late nineteenth and twentieth century art historians writing about Dürer and the *Feast of the Rose Garlands* as a monument of Dürer's ill-fated, but inevitable, contact with Italy.

The altarpiece was extensively restored at least as early as 1633.[3] It is not clear if this campaign of restoration was a result of the evacuation effort to salvage the collection from the Swedes, was meant to redress the problems that had arisen from the transport of the painting over the Alps thirty years earlier, or was the by-product of both. Regardless, large areas of the painting had been completely repainted by the end of the seventeenth century.[4]

In the Imperial Habsburg inventories of 1718 to 1763, the altarpiece was described as "ganz ruiniert."[5] The painting disappeared from the Imperial Habsburg collection sometime late in the eighteenth or early in the nineteenth century, probably because it had been identified as completely ruined and therefore materially worthless. It subsequently appeared in the collection of a Habsburg official named Fillbaum, whose heirs sold it to the Abbot of Strahow Monastery in Prague for twenty-two ducats, without the frame, which was later acquired for one hundred ducats.[6] That the frame was valued at more than four times the worth of the painting shows how the damage to the painting affected contemporary evaluations of it.

The present frame of the *Feast of the Rose Garlands* is not original, neither is it clear that the frame priced at one hundred ducats by the heirs of Oberpostdirektor Fillbaum was the original one. Although I do not have comparable figures for the relative prices of frames and paintings in the late eighteenth century, that the frame was valued at four times the worth of the painting is extreme by any standards. Even if it were the original frame, it would be surprising if it were valued at more than the set value of the painting itself, unless the cost of the materials alone was the basis

for the evaluation, and the panel was viewed as being worthless, whereas the timber in the frame was seen as having some material value.[7]

In the 1830s, some ten years after the founding of the Imperial Prussian Museum in Berlin, Graf Karl von Brühl[8] and Gustav Waagen[9] set out to acquire the *Feast of the Rose Garlands* from the Strahow Monastery. They wanted this painting in particular, since the Imperial Prussian Museum lacked a work by Dürer.[10] Despite the participants' keen awareness of the problematic state of the painting, all the experts who provided written evaluations of the monetary value of the painting (with the exception of the Conservator of the Berlin museum, Jacob Schlesinger) initially attested that the ruined state of the painting did not significantly interfere with the ultimate value of the painting and would not limit the prestige it would bring to the Berlin museum.[11] Yet lingering doubt over the extent of the damage led Graf Brühl to dispatch Waagen to Prague to see and report on the condition of the painting firsthand. Waagen's description was so dismal that the negotiations between the Berlin museum and the Abbot of Strahow Monastery were abruptly terminated, and the painting remained in Prague.[12]

After the rejection of the painting by the Imperial Prussian Museum in Berlin, the *Feast of the Rose Garlands* was restored between 1839 and 1841, reportedly "because the condition was so bad that the painting would have perished otherwise."[13] The painting was restored by the painter Johann Gruss of Leitmeritz. Gruss' son helped with the restoration and reported that the panel was severely damaged, especially in the area around the head of the Madonna, the Christ Child, and the lute-playing angel.[14]

My investigations of the painting suggest that there has been no major campaign of restoration since Benesch wrote his report. The restoration technique used in the present retouches on the painting, in which large areas of loss are inpainted in a lighter shade of pigment than the surrounding, original areas, was in vogue in the second decade of this century.[15]

After another ninety years of relative oblivion, the fate of the painting was again raised when the Strahow Monastery decided, in the face of a financial crisis, to sell the painting just before the 1929 exhibition in Nuremberg. Speculation about who would acquire the painting filled the German language art and news tabloids.[16] Again, as in the 1830s, the

cultural value of the painting was determined to outweigh the problematic condition of the painting. At issue was whether Germany, through the Berlin museum, should acquire the painting as a monument of German culture or whether it would go to a private collector from the United States of America, France, or Austria.[17] The Czechoslovak government, which had the right of first refusal in the sale of the altarpiece, determined to purchase the painting in 1932, and it entered the collection of the National Gallery of Art in Prague.

Since the onset of the Velvet Revolution in the former Czechoslovakia in 1989, and the attendant attempts at reclamation of private property, the Strahow Monastery in Prague has attempted to reclaim possession of the *Feast of the Rose Garlands* from the National Gallery in Prague.

Dürer's Theoretical Writing on Color

D ÜRER'S ESSAY ON COLOR, *Von farben*, which survives in a single draft in the British Museum, has not received a great deal of critical attention and has not been widely incorporated into the critical literature. Therefore, for ease of reference, I have reproduced Rupprich's transcription of the passage, as it appears in *Albrecht Dürer. Der Schriftlicher Nachlass*, Vol. II, pp. 393–4, followed, in sections, by my own translation of the passage. See also Conway's translation, in rather old-fashioned English, of this passage.

1. Item so du erhabn willt molen, so es daz gesicht betrigen söll, mustw der farben gar woll bericht sein und jm mollen fast aws ein ander scheiden, also zw versten.

1. If you would like to paint in a sublime manner, so that the eye is deceived and perceives relief, you must use your paint wisely, and know how to distinguish one color from another.

2. Item dw molst 2 röck oder mentell, ein weis, denn anderen rott. Und wen dw sie schettigst, do es sich pricht, wan an allen dingen ist lichts und finsters, was sich aws den awgen krumt oder pewgt.

2. For example, you paint two jackets or mantles, one white, the other red. And you must shade them, because they fold, since there is light and shade on all things which come forward or recede away from the eye.

3. Wo daz nicht wer, so wers als eben an zw sehen, und jn solicher gestalt wurd man nüt erkenen den als fill sich die blossen farben aws ein ander schiden.

3. If this were not so, everything would look flat, and in such forms one would recognize nothing except for that which the mere difference in colors distinguish from one another.

4. Dorum so dw den weissen mantell schettigst, mus er nit so mit einer schwartzen farb geschettigt sein als der rott. Wann es wer vnmüglich, daz ein weis ding so ein finstern schatten geb als daz rott, vnd wurt sich pey ein ander nit vergleichen. Aws genumen wo kein dag hin mag, jst alle ding schwartz, als in der finster kanstu kein farb erkenen. Dorum, obs die rechnung geb jn einem weissen ding, do einer mit recht zvm schatten gantz schwartz nützett, wer nit schtrefflich. Doch kumt es gar sellten.

4. Therefore when you shade the white mantle, it does not need to be shaded with so dark a color as the red. It would be impossible for a white thing to yield so dark a shadow as a red, and neither could they be compared to one another. The exception is the total absence of light, then everything is black, since in darkness you cannot recognize color. Therefore, in such a case, the rules allow one to use pure black for the shadows on a white object. However, this seldom occurs.

5. Awch soltu dich hüten, so du ettwas von einer farb moltzt, sy sey rot, plo, prawn oder vermischt farben, wie sÿ sein, daz du sÿ jm lichten nit zw fill licht machst, also daz sie aws jrer art schlach.

5. Also, beware, whenever you paint anything in one color – whether red, blue, brown or any mixed color – that you do not make it so bright that it is unrecognizable.

6. Peyspill: ein vngelerter besicht dein gemell, vnder dem ein rotten rock, spricht: "schaw, gut freunt, wie ist der rock awff eim teill so schön rott vnd awf dem anderen hatt er weis far oder pleich flecken."

6. For example, a man untrained in painting looks at a red coat in your painting, and says, "Look, good friend, in one area the coat is a beautiful red, but in another it is white or has pale spots on it."

7. Daz selb ist strefflich, vnd hast jm nit recht gethan. Du must jn sollicher gestalt mollen ein rott ding, daz es vberall rott sey, des geleichen mit allen farben, und doch erhaben sein. Awch mit dem schettigen des geleichen halten, daz man nit sprech, ein schon rott sey mit schwartz beschissen.

7. That is a mistake; you have not painted the coat correctly. In such a case you must paint a red object red all over and similarly with all colors in order for the painting to be sublime. The same must be done with shadows, so that no one says that a beautiful red is dirtied [literally, made shitty] by black.

8. Des halb hab acht, daz dw ein jetliche farb schettigst mit einer farb, dÿ sych dortzw fergeleich. Als jch setz ein gelle farb. Soll sy jn jrer art beleiben, so mustu sy mit einer gelben farb schettingen, die dunckeler seÿ weder die hawbt farb ist.

8. Therefore, be careful that you shade each color with a similar color. For example, a yellow, to remain yellow in appearance, must be shaded with another shade of yellow that is darker than the principal color.

9. Wen dw sy mit grün oder plob absetzt, so schlechtz aws der art vnd heist nÿmer gell, szunder es würd ein schilrette farb doraws, als man seyden gewant fint, die fan zweyen farben gebürgt sind, jtem von pran und plo, daz ander prawn und grün, etlichs dunckell gell und grün, awch kester prawn und dunckell gell, item plo und tzigell rott, awch zigell rott vnd feiell prawn, vnd der farben mencherley, daz man vor awgen sicht, so man dy selben molt.

9. If you shade [the yellow] with green or blue, it doesn't look yellow any longer, but becomes a shot color, like silk fabrics woven of threads of two colors, like brown and blue, brown and green, dark yellow and green, chestnut brown and dark yellow, blue and brick-red, brick-red and brown, and the many other colors one sees.

10. Vnd wo es sich pricht albeg am ab wenden, deylen sich die farben, daz man sie for ein ander erkent. Dem noch must du sy molen. Aber wo sy blatt awff ligen, sicht man nun ein farb. Aber nüt dest mÿnder so dw ein soliche seyden molst vnd mit einer farb duschirst, als ein prawn mit dem plo, so mustu daz plo noch mit eim setteren plo absettzen, wo es jm nott thut.

10. And where the surface bends and breaks in space, the colors divide themselves so that the two colors are distinguishable from one another. This is how they should be painted. But where the surface of the fabric lies flat, one sees only a single color. However, if you are painting such a silk and shade it with one color (as a brown with a blue) you must still shade the blue with a deeper blue where necessary.

11. Es kumt awch oft, daz dise seyden jn der dunkellen an der prawn farb gesehen wirt, als wen einer vor dem anderen stett, der ein sollix kleid an hatt. So mustu daz selbig prawn mit eim setteren prawn absetzen vnd nit mit dem plo.

11. It also often happens that the silks appear brown in the shadows, as when one person stands in front of another who wears clothing like that. So you must shade the same brown with a deeper brown and not with blue.

12. Es ge, wie es woll, so mus kein farb jm duschiren aws jrer art kumen.

12. So it goes as it will, no color needs to leave its family when it is used (in painting).

List of Abbreviations

AGNM Anzeiger des germanischen Nationalmuseums

Anzelewsky, 1971 Anzelewsky, Fedja. *Albrecht Dürer. Das Malerische Werk.* Berlin: Deutsche Verein für Kunstwissenschaft, 1971 (2nd ed., 1991).

Barrochi Vasari, Giorgio. *Le vite de più eccellenti pittore scultori e architettori nelle redazioni del 1550 e 1568.* Edited by Rosanna Bettarini, commentary by Paola Barrochi. Florence: Sansoni, 1966, 1971, 1976.

Białostocki Białostocki, Jan. *Dürer and His Critics 1500–1971: Chapters in the History of Ideas Including a Collection of Texts.* Baden-Baden: Valentin Koerner, 1986.

BM Burlington Magazine

Cennini Cennini, Cennino d'Andrea. *The Craftsman's Handbook "Il Libro dell' Arte".* Translated by Daniel V. Thompson, Jr. New York: Dover, 1960.

Conway Conway, William Martin. *Literary Remains of Albrecht Dürer.* Cambridge: Cambridge University Press, 1889.

JWCI Journal of the Warburg and Courtauld Institutes

KV Tietze, Hans, and Erica Tietze-Conrat. *Kritisches Verzeichnis der Werk Albrecht Dürers.* Volume I: *Der junge Dürer.* Augsburg: Dr. Benno Filser, 1928; Volume II: *Der reife Dürer.* Basel & Leipzig: Holbein AG, 1937.

Panofsky, 1943 Panofsky, Erwin. *The Life and Art of Albrecht Dürer (with Handlist)* 1st ed. Princeton: Princeton University Press, 1943.

Panofsky, *ENP* Erwin Panofsky. *Early Netherlandish Painting.* Cambridge: Harvard University Press, 1953.

Pr.Jb Jahrbuch der königlich preuszischen Kunstsammlungen

Rep Repertorium für Kunstwissenschaft

Rupprich, *Nachlass* Rupprich, Hans, ed. *Albrecht Dürer. Der Schriftlicher Nachlass*. Berlin: Deutscher Verein für Kunstwissenschaft, 1956–1969.

Thausing Thausing, Moritz. *Dürer: Geschichte seines Lebens und seiner Kunst.* Leipzig: E. A. Seemann, 1884 (1st ed. 1876).

Wölfflin, 1905 Wölfflin, Heinrich. *Die Kunst Albrecht Dürers*. Munich: F. Bruckmann, 1905.

ZdVK *Zeitschrift des deutschen Vereins für Kunstwissenschaft*

ZfbK *Zeitschrift für bildende Kunst*

ZfKg *Zeitschrift für Kunstgeschichte*

ZfKw *Zeitschrift für Kunstwissenschaft*

Glossary

Abrasion The condition of the surface of a painting that has suffered from harsh handling, usually in the process of cleaning. The surface of the paint is literally abraded, with resultant losses overall.

Condition The relative damage or lack of damage sustained by the painting. "State" is often used interchangeably with "condition" in discussions of the surface of a painting.

Execution The handling of materials in the completion of the painting.

Free brushwork Term used in the context of underdrawing to denote drawing that is made without the aid of devices like cartoons.

Infrared photograph A record of a painting's underdrawing made through infrared photography. These photographs are made with an ordinary camera and photographic lamps, but a special film sensitive to infrared radiation is required.

Infrared reflectogram A record of a painting's underdrawing made through infrared reflectography. An infrared reflectogram is made by photographing images from the video monitor, which is hooked up to the infrared vidicon camera. The reflectogram may document a relatively large or small area of a painting. If a large area is documented, then individual reflectograms are combined to form an infrared reflectogram assembly.

Infrared reflectogram assembly Final result of the investigation of a painting with infrared reflectography, if the underdrawing is documented. This is literally a collection of photographs of small discrete areas of the underdrawing that are reassembled to closely approximate the layout and distribution of the underdrawing in the painting.

Infrared reflectography The technological means used to investigate the underdrawing in a painting. There exist a variety of combinations of cameras, video monitors, and lenses with which to conduct such investigations. I employed both Grundig and Hamamatsu cameras. (A Grundig camera contains a Hamamatsu vidicon.) Which camera I used was dependent upon the equipment available at a particular collection or museum. Infrared reflectography is abbreviated as IRR.

Penetration The relative ability of the infrared vidicon to make the underdrawing visible. A paint layer through which the infrared light easily passes is more penetrable than one through which less infrared light passes, therefore making the underdrawing more visible.

Preparatory drawing A drawing made prior to and specifically in relationship to the production of a painting. These include drawings that study individual figures and overall composition, as well as lighting and color.

Production The combination of various techniques used in the process of making a painting.

Support The surface upon which a painting or drawing is executed. The support may be panel, canvas, or paper.

Technical investigation The investigation of the techniques used by artists in the production of paintings. Technical investigation is usually based on the use of research tools like the infrared vidicon, microscope, and X-radiography, all of which originated in the scientific laboratory.

Technique The specific procedures that a painter uses to create an image. This includes the different ways in which underdrawings are executed, as well as the ways in which paint is applied to the surface of the painting.

Tüchlein A fine canvas support usually made of linen. Paintings on tüchlein (often called tüchlein paintings) were often executed with a water-soluble, or tempera, medium rather than an oil medium.

Underdrawing The initial design for a painting located on top of the ground preparation but beneath the paint layers. Underdrawing may be executed in a variety of media, such as paint, ink, or charcoal. It may also be executed with a variety of tools, including, but not limited to, pens and brushes. Underdrawing can be made visible with infrared reflectography.

Notes

Chapter 1. Introduction

1. Fedja Anzelewsky has written the only monographic treatment of Dürer's paintings. See F. Anzelewsky, *Albrecht Dürer: Das Malerische Werk* (Berlin: Deutsche Verein für Kunstwissenschaft, 1971). A second edition of his monograph was published in 1991. Except for the study of the paintings, investigation of Dürer's life and complete oeuvre has been exhaustive. The earliest complete study of Dürer's life and works was written by M. Thausing, *Dürer: Geschichte seines Lebens und seiner Kunst* (Leipzig: F. A. Seemann, 1876). Thausing was followed by, among others, H. Wölfflin, *Die Kunst Albrecht Dürers* (Munich: F. Bruckmann, 1905); H. Tietze & E. Tietze-Conrat, *Kritisches Verzeichnis der Werk Albrecht Dürers* (Augsburg: Dr. Benno Filser, 1928–38); E. Flechsig, *Albrecht Dürer: Sein Leben und Sein Künstlerische Entwicklung* (Berlin: G. Grote'sche, 1928); and E. Panofsky, *The Life and Art of Albrecht Dürer (with Handlist)* (Princeton: Princeton University Press, 1943). More recent are P. Strieder, *Albrecht Dürer: Paintings, Prints, Drawings*, trans. N. M. Gordon and W. L. Strauss (New York: Abaris Books, 1982); F. Anzelewsky, *Dürer: His Art and Life* (London: Alpine, 1982); and Joseph Leo Koerner, *The Moment of Self-Portraiture in German Renaissance Art* (Chicago: University of Chicago Press, 1993).

Likewise, many studies are devoted purely to Dürer's drawings and graphic production, including, among many others, H. Wölfflin, *Albrecht Dürer: Handzeichnungen* (Munich: R. Piper, 1914); F. Winkler, *Die Zeichnungen Albrecht Dürers* (Berlin: Deutscher Verein für Kunstwissenshaft, 1936–9); H. Tietze, *Dürer als Zeichner und Aquarellist* (Vienna: Anton Schroll, 1951); K.-A. Knappe, *Dürer: Das graphische Werk* (Vienna, Munich: Anton Schroll, 1964); and W. L. Strauss, *The Complete Drawings of Albrecht Dürer* (New York: Abaris Books, 1974).

2. See J. Bialostocki, *Dürer and His Critics 1500–1971: Chapters in the History of Ideas Including a Collection of Texts* (Baden-Baden: Valentin Koerner, 1986), 31 and 43. Bialostocki reproduced the text found in Desiderius Erasmus, *Dialogus de recta latina graecique sermonis pronunciatione* (Rotterdam: n.p., 1528). Bialostocki noted that Erasmus' *laudatio* is a "genuine humanistic appreciation of

an artist, since it is composed of Classical topoi . . . borrowed from Pliny and other sources."

3. Vasari published his *Vite* (Lives) in two editions, the first in 1550 and a later one in 1568. Many editions and excerpts have been published. For the most complete modern edition of the *Vite*, see G. Vasari, *Le vite de' più eccellenti pittori, scultori e architettori nelle redazioni del 1550 e 1568*, ed. R. Bettarini, commentary by P. Barocchi (Florence: Sansoni, 1966–76).

4. The literature on the topic of *disegno e colore* is enormous. For a useful and in-depth introduction to the issues involved, see David Summers, *Michelangelo and the Language of Art* (Princeton: Princeton University Press, 1981).

5. Bialostocki reprinted the entire "Life of Dürer," as it appears in Vasari's "Life of Marcantonio Raimondi," translated by G. Du C. de Vere, pp. 37–51. Bialostocki (p. 51) also pointed out that Vasari focused on Dürer's graphic production and did not know much about his painted production.

6. For this translation, see, G. Vasari, "Life of Marc' Antonio Bolognese and of Other Engravers of Prints," *Lives of the Most Eminent Painters, Sculptors and Architects*, trans. G. du C. de Vere, Vol. 6 (London: The Medici Society, 1913), 92. For the original Italian text, see Giorgio Vasari, *Le vite de' più eccellenti pittori, scultori e architettori*, Vol. 5, ed. Gaetano Milanese (Florence: Sansoni, 1981), 398: "cominciò Alberto Duro . . . con più disegno e miglior giudizio e con più belle invenzioni, a dare opera alle medesima stampe, cercando d'imitar il vivo e d'accostarsi alle manieri italiane, le quali egli sempre apprezzò assai."

7. See Summers for a thorough discussion of the interpretation of "disegno," "invenzione," and "giudizia."

8. There is an extensive literature about imitation and emulation in Renaissance literary theory and practice. For an introduction to the different forms and meanings of literary imitation in the Renaissance, as well as an exhaustive bibliography on the topic, see G. W. Pigman, III, "Versions of Imitation in the Renaissance," *Renaissance Quarterly* 33 (1980): 1–32. I explore imitation as an aspect of Dürer's artistic productivity in Chapter 4.

9. Van Asperen de Boer initiated the retrieval of underdrawings with infrared reflectography in the late 1960s in Holland and continues to work in the field today. His work has revolutionized the study of Early Netherlandish paintings. Van Asperen de Boer published a thorough introduction to the development, uses, and limitations of infrared photography and infrared reflectography in J. R. J. van Asperen de Boer, "Examination by Infrared Radiation," *Scientific Examination of Easel Paintings, Published on the Occasion of the Xth Anniversary Meeting of the Pact Group at Louvain-la-Neuve*, ed. R. Van Schoute and H. Verougstraete-Marcq (Strasbourg: Council of Europe, 1986), 109–130 [Pact, 13, 1986]. A biannual colloquium is held at the Catholic University at Leuven and Louvain-la-Neuve under the title "Le dessin sous-jacent dans la peinture," organized by R. van Schoute and H. Verougstraete-Marcq. Extensive bibliography on the technical investigation of paintings are available in the proceedings published from these colloquia.

10. *Natural History. The Elder Pliny's Chapters on the History of Art*, trans. K. Jex-Blake, intro. E. Sellers (Chicago: Argonaut, 1968), Chapter XXXV, line 145, p. 169.

J. J. Pollitt translated this passage as "the last works of artists and their unfinished pictures... are held in greater admiration than [their?] finished works, because in these the sketch lines remain and the actual thought processes of the artists are visible," in *The Ancient View of Greek Art: Criticism, History, and Terminology* (New Haven: Yale University Press, 1974), 393–4.

11. There is an extensive literature about this question. The treatises of Theophilus, Cennino Cennini, Vasari, and Armenini, as well as the fifteenth century manuscript on painting from Straßburg have received particular attention. For discussion of treatises and recipes of medieval and Renaissance painting technique, see particularly, M. P. Merrifield, *Original Treatises on the Art of Painting* (London, 1849; repr. New York: Dover, 1967); Sir C. L. Eastlake, *Methods and Materials of Painting of the Great Schools and Masters* (London, 1847; repr. New York: Dover, 1960); E. Berger, *Beiträge zur Entwicklungs-Geschichte der Maltechnik: Quellen für Maltechnik während der Renaissance und deren Folgezeit* (Munich: Georg D. W. Callwey, 1901); D. V. Thompson, *The Materials of Medieval Painting* (New Haven: Yale University Press, 1936).

12. For a brief history of the discovery and early use of X-radiography in Munich, see A. Burmester, "Dürer durchleuchtet," *Albrecht Dürer: Die Gemälde der Alten Pinakothek*, eds. G. Goldberg, B. Heimberg, and M. Schawe (Munich: Braus, 1998), 120. For the history of conservation at the Fogg, see R. Spronk, "The Early Years of Conservation at the Fogg Art Museum: Four Pioneers," *Harvard University Art Museums Review* 6, no. 1 (Fall 1996), 1–12, esp. p. 5. Ron Spronk is preparing a book about the history of conservation at the Fogg with Francesca Bewer.

13. See C. Wolters, *Die Bedeutung der Gemäldedurchleuchtung mit Röntgenstrahlen für die Kunstgeschichte* (Frankfurt am Main: Prestel, 1938). Wolters collaborated with Röntgen, who was a faculty member of the University of Munich during these years. See also A. Burroughs, *Art Criticism from a Laboratory* (Boston: Little, Brown and Co., 1938).

14. Fogg Art Museum, *Style and Technique: Their Interrelationship in Western European Painting* (Cambridge: Harvard University Press, 1936), 5.

15. Other early and important publications that incorporate the information derived from technical investigations of paintings into art-historical studies include such later publications as P. B. Coremans, *L'agneau mystique au laboratoire, examen et traitement sous la direction de Paul Coremans* (Antwerp: De Sikkel, 1953) and H. Aulmann, *Gemäldeuntersuchungen mit Röntgen-, Ultraviolett- und Infrarotstrahlen zum Werk des Konrad Witz* (Basel: Holbein Verlag, 1958).

16. Newer catalogues of museum collections include technical material. See, for instance, J. O. Hand and M. Wolff, *Early Netherlandish Painting. The Collections of the National Gallery of Art Systematic Catalogue* (Washington, D.C.: National Gallery of Art, 1986); J. O. Hand, *German Paintings of the Fifteenth Through Seventeenth Centuries* (Washington D.C., Cambridge: National Gallery of Art, 1993); J. Sander, *Niederländische Gemälde im Städel 1400–1550* (Mainz am Rhein: Philipp von Zabern, 1993); J. Chapuis, introd. by M. Faries, *German and French Paintings: Fifteenth and Sixteenth Centuries* (Rotterdam: Museum Boymans-van Beuningen, 1995); and K. Löcher, ed. *Germanisches Nationalmuseum, Nürnberg: Die Gemälde des*

16. Jahrhunderts (Nuremberg: Gerd Hatje, 1997). In the aftermath of the acid attack on four paintings in the Alte Pinakothek in Munich, Gisela Goldberg et al. organized an exhibition about the paintings of Dürer in the collections of the Bayerisches Staatsgemäldesammlung in which they presented the extensive documentation of all technical aspects of the paintings. See G. Goldberg, B. Heimberg, and M. Schawe, *Albrecht Dürer: Die Gemälde der Alten Pinakothek* (Munich: Braus, 1998). Carl Brandon Strehlke is presently completing the first volume of his catalogue of the Italian paintings in the Philadelphia Museum of Art, provisionally titled *Italian Paintings in the John G. Johnson Collection and the Philadelphia Museum of Art*. The wealth of technical information to be included in this catalogue reflects Strehlke's close collaboration with the paintings' conservators at the Philadelphia Museum of Art, particularly Mark Tucker. The first volume should appear in 2004.

17. Many of the earlier publications concerned with the exciting new information coming out of the conservation laboratories and much of the early work presented at the Biannual Colloquia in Louvain-la-Neuve were of this type. See, for instance, M. Garrido and D. Hollanders-Favart, "The Paintings of the Memling-Group in the Prado – The Underlying Design and Other Technical Aspects," *Boletín del Museo del Prado* 5, no. 15 (1984): 151–71. The intent of this type of investigation is to present the material to a wider audience for perusal; however, the release of raw, technical data without clear parameters provided for interpretive reasons can be problematic. Without immediate access to both the paintings and the technical documentation, the material can be neither easily read nor persuasively interpreted.

18. See, among many others, M. Comblen-Sonkes, "Le dessin sous-jacent chez Roger van der Weyden et le problème de la personnalité du Maître de Flémalle," *Bulletin de l'Institute royal du Patrimoine artistique* 13 (1971–2): 161–206; also, see R. van Schoute, "Le dessin de peintre chez Hugo van der Goes," *Revue des Archéologues et Historiens d'Art de Louvain* 5 (1972): 59–66; and J. P. Filedt-Kok, "Underdrawing and Drawing in the Work of Hieronymus Bosch: A Provisional Survey in Connection with the Paintings by Him in Rotterdam," *Simiolus* 6 (1973–4): 133–62. W. A. Real makes suggestions about the applications of infrared reflectography to art history in "Exploring New Applications for Infrared Reflectography, "*Bulletin of the Cleveland Museum of Art* (December 1985): 389–412; his suggestions are not limited to the investigation of northern Renaissance panel paintings, but include sculpture and Asian paintings as well. Van Asperen de Boer has published his exhaustive study of the underdrawings in work by Rogier van der Weyden and the Master of Flémalle. See "Underdrawings in Paintings of the Rogier van der Weyden and Master of Flémalle Groups," *Nederlands Kunsthistorisch Jaarboek* 41 (1990): 7–328. Likewise, R. van Schoute and M. Garrido plan a publication detailing their technical findings about the Bosch circle.

19. The joint publication of M. Ainsworth and M. Faries, "Northern Renaissance Paintings: The Discovery of Invention," *The Saint Louis Art Museum Bulletin* 18, no. 1 (Summer 1986), follows the development outlined earlier. Ainsworth and Faries first present the underdrawing itself as a new work of art. This section is followed by a reconstruction of workshop practices based upon this material. Other pertinent works include, M. Faries, "Underdrawings in the Workshop Production

of Jan van Scorel – A Study with Infrared Reflectography," *Nederlands Kunsthistorisch Jaarboek* 26 (1975): 98–228; and J. P. Filedt-Kok, "Underdrawings and Other Technical Aspects in the Paintings of Lucas van Leyden," *Nederlands Kunsthistorisch Jaarboek* 29 (1978): 1–184. For an examination of preparatory drawings and underdrawings in Holbein's workshop, see M. Ainsworth, " 'Paternes for Phiosioneamyes': Holbein's Portraiture Reconsidered," *BM* 132, no. 1044 (March 1990): 173–86.

Ainsworth suggested a method for the study of underdrawings retrieved from northern Renaissance paintings, following the classification of Italian drawings according to workshop practices. Ainsworth suggested the classification of underdrawings in terms of function and comparison to drawings on paper. Her approach is similar to Ames-Lewis' study of Italian drawings. See M. Ainsworth, "Northern Renaissance Drawings and Underdrawings: A Proposed Method of Study," *Master Drawings*, 27, no. 1 (Spring 1989), 5–38; and F. Ames-Lewis, *Drawing in Early Renaissance Italy* (New Haven: Yale University Press, 1981). Ainsworth's investigations of the working methods of Petrus Christus are detailed in *Petrus Christus: Renaissance Master of Bruges* (New York: Metropolitan Museum of Art, 1994). Most recently, Ainsworth has presented her findings about Gerard David and his workshop, *Gerard David: Purity of Vision in an Age of Transition* (New York: Metropolitan Museum of Art and Ludion Press, 1998). Her David book was published in conjunction with the catalogue of the exhibition *Van Eyck to Breughel: Early Netherlandish Paintings in the Metropolitan Museum of Art* (New York: Metropolitan Museum of Art, 1998).

20. G. McKim-Smith, G. Andersen-Bergdoll, and R. Newman, *Examining Velazquez* (New Haven: Yale University Press, 1988). A similar investigation of the relationship between theory and practice was undertaken by M. K. Talley and K. Green in their investigation of the little-known English painter Thomas Bardwell. See M. K. Talley and K. Green, "Thomas Bardwell and His Practice of Painting: A Comparative Investigation Between Described and Actual Painting Technique," *Studies in Conservation* 20, no. 2 (1975): 44–108. Talley and Green came to the conclusion that Bardwell, better known as the author of a painter's manual, did not follow his own technical advice.

For further examples of art historians working closely with conservators, see C. B. Strehlke and M. Tucker, "The *Santa Maria Maggiore Altarpiece*: New Observations," *Arte Cristiana* 75, no. 719 (March–April 1987): 105–24; J. Sander, *Hugo van der Goes: Stilentwicklung und Chronologie* (Mainz: P. von Zabern, 1992); and R. Spronk, "More Than Meets the Eye: An Introduction to Technical Examination of Early Netherlandish Paintings at the Fogg Art Museum," *Harvard University Art Museums Bulletin* 5, no. 1 (Fall 1996).

21. H. B. Wehle, "Preparatory Drawing on a Panel by Dürer," *The Metropolitan Museum of Art Bulletin* N.S. 1, no. 4 (1942–3): 156–64.

22. H. Gross-Anders, "Dürer's Dresdner Altar und seine Rettung," *Maltechnik* 67 (1961): 68–81; and D. von Hampe, "Beobachtungen und Erfahrungen bei den Restaurierungsarbeiten am Dresdner Dürer Altar," *Forschungen und Berichte* 3/4 (1961): 109. After the restoration of the Portrait of Katharina Fürlegerin in Berlin, Gerhard Pieh also published a report outlining his findings from the course of investigation and treatment. Painted on tuchlein, a thin linen, this painting had

suffered extreme damage when Pieh undertook the restoration. Little of Dürer's original execution of the face and hands remains intact, and therefore its usefulness as a comparative work for other Dürer portraits or tuchlein paintings is minimal. See G. Pieh, "Aspekte einer Dürer-Restaurierung," *Maltechnik Restauro* 2 (April 1985): 22–33. See also S. Urbach, "Ein Burgkmairbildnis von Albrecht Dürer?" *Anzeiger des germanischen Nationalmuseums* (1985): 73–90.

23. The recent reports on the damage sustained by the acid attacks on Dürer paintings in the Alte Pinakothek in Munich are similarly directed toward conservators. For this information, see B. Heimberg and H. von Sonnenburg, "Säureanschlag auf drei Dürer-Werke in der Alten Pinakothek in München," *Restauro* 1 (January 1990): 13–21; and A. Burmester and J. Koller, "Säureanschlag auf drei Dürer-Werke in der Alten Pinakothek München. Schadenbeschreibung und Wege zur Konservierung aus naturwissenschaftlicher Sicht," *Restauro* 2 (April 1990): 89–95. See also P. Diemer, "Zur Restaurierung der beschädigten Münchner Dürer-Gemälde," *Kunstchronik* 43, no. 4 (April 1990): 147–8.

24. Anzelewsky, 1971, 89, 185. Anzelewsky's revised entry does not depend so exclusively on the *Salvator Mundi* but is not greatly expanded.

25. The answer to why the *Salvator Mundi* was left unfinished must remain speculative. However, it has been suggested repeatedly that work on the painting was interrupted by Dürer's trip to Venice in 1505–7, and that he never completed it upon his return. This supposition, while factually insupportable, is likely to be true. Further, I believe it is possible that Dürer did not finish the *Salvator Mundi* because he was so profoundly affected by paintings seen and techniques discovered in Venice, that he discarded the *Salvator Mundi* as an "old-fashioned" or recherché work of art upon his return. The unfinished *St. Barbara* by Jan van Eyck presents a similar problem. That painting, like the *Salvator Mundi*, was left unfinished by the artist. The opportunity to examine this painting closely at the Philadelphia Museum of Art during the exhibition *Recognizing van Eyck* has left me more strongly convinced of this than ever before. The blue and buff paint in the sky, long dismissed by scholars following Panofsky as "The work of a clumsy follower" is no such thing. In particular, the buff portions of the sky have been distorted and greatly altered by disfiguring repaints. Examination with the stereo microscope reveals that the overpaint was added to these areas to conceal clumps of black paint, perhaps a workshop accident. For the most recent investigation of this painting, undertaken during the exhibition *Recognizing van Eyck* at the National Gallery, London, see Rachel Billinge et al., "The Saint Barbara," *Investigating van Eyck* (Turnhout: Bhepols, 2000).

26. See Wehle, "Prepatory Drawing on a Panel by Dürer," for a complete discussion of the problematic state of the painting. The painting was completely restored sometime in the eighteenth or nineteenth century. A reproduction of the painting in this completely restored "finished" state is found in V. Scherer, *Klassiker der Kunst in Gesamtausgaben, Vol. 4, Dürer: Des Meisters Gemälde, Kupferstiche, und Holzschnitte* (Stuttgart: Deutsche Verlags-Anstalt, 1908).

27. Wolters, *Die Bedeutung der Gemäldedurchleuchtung*, 46–51.

28. G. Goldberg, "A Technical Analysis of Albrecht Dürer's 'Four Apostles,' *Albrecht Dürer, Paintings, Prints, Drawings*, ed. P. Strieder, trans. N. M. Gordon

and W. L. Strauss (New York: Abaris, 1982), 333–46. See also E. Panofsky, "Zwei Dürerprobleme (Der sogenannte 'Traum des Doktors' und die sogenannten 'vier Aposteln')." *Münchner Jahrbuch der Bildenden Kunst* N.S. 8 (1931): 18–48; and K. Voll, "Zur Enstehungsgeschichte von Dürers vier Aposteln." *Süddeutsche Monatshefte* 3 (1906): 73–80.

29. T. Brachert and A. Brachert, "Neues zu Dürer's Kaiserbildern," *Restauro* 1 (January 1989): 22–39. See the Bracherts' article for an enumeration of the previous literature surrounding the two Emperor panels. More recently, these two paintings have been discussed in Kurt Löcher, ed., *Germanisches Nationalmuseum, Nürnberg: Die Gemälde des 16. Jahrhunderts* (Ostfildern-Ruit: Gerd Hatje, 1997) 203–19.

30. Another example of the reasoning that the presence of elaborate and complex underdrawing is grounds for an attribution is found in Isolde Lübbecke's attribution to Dürer of the *Virgin and Child* in the Georg Schäfer Collection in Schweinfurt. See B. Bushart, ed., in collaboration with I. Lübbeke, *Altdeutsche Bilder der Sammlung Georg Schäfer Schweinfurt* (Schweinfurt: Weppert GmbH, 1985), 80–83.

31. In the course of my research I have had the opportunity to look at many paintings executed during the later sixteenth and seventeenth centuries associated with the Dürer Renaissance. These paintings often show an elaborate underdrawing that is similar in kind to the underdrawing style of Dürer. Examples include copies of the *Adoration of the Trinity and the All Saints* and the *Martyrdom of the 10,000* in the Kunshistorisches Museum in Vienna. The *Virgin with the Iris*, in the National Gallery in London, was attributed to Dürer by Flechsig as late as 1928, and is, I believe, an exemplar of the Dürer Renaissance. Investigation of the painting with IRR revealed a fully worked up underdrawing that reveals an artist very familiar with Dürer's style and technique. See the recent article by Paul Ackroyd, Susan Foister et al., "A Virgin and Child from the Workshop of Albrecht Dürer?" *National Gallery Technical Bulletin* 21 (2000): 28–42. Similarly, some drawings from the Dürer Renaissance show a keen understanding of Dürer's graphic form. For a discussion of the Dürer Renaissance, including issues of problematic attribution, see F. Koreny, *Albrecht Dürer und die Tier- und Pflanzenstudien der Renaissance* (Munich: Prestel, 1985).

32. T. Brachert, "Neues zu Dürer's Madrider Selbst Porträt," *Restauro* 3 (September 1990): 175. Brachert has also analyzed the fingerprints in the Prado *Self-Portrait* and asserts that it is the earliest painting by Dürer in which he used his fingers to blend the paint layers.

33. Dürer frequently used his fingers to blend the topmost paint layers. I have found this in many of the paintings that I have investigated, including the *Adoration of the Trinity and the Feast of the All Saints*, the *Martyrdom of the 10,000*, and the *Virgin with the Pear* (all three in the Kunsthistorisches Museum in Vienna), as well as in the *St. Anna Selbdritt* in the Metropolitan Museum of Art. Goldberg et al., *Albrecht Dürer*, note the presence of fingerprints where Dürer blended the paint layers in the *Holzschuher Lamentation*, p. 289; the *Glimm Lamentation*, p. 262; and the *Suicide of Lucretia*, p. 442.

34. I. Lübbeke, *Early German Painting: 1350–1550. The Thyssen-Bornemisza Collection*, trans. M. T. Will (London: Sotheby's Publications, 1991), 218–41.

35. K. Löcher, *Germanisches Nationalmuseums, Nürnberg: Die Gemälde des 16. Jahrhunderts*, (Nuremberg: Gerd Hatje, 1997), esp. 192–222; and Gisela Goldberg et al., *Albrecht Dürer*.

36. Löcher, *Germanisches Nationalmuseum, Nürnberg*, 192–7.

37. Goldberg, "A Technical Analysis," 289–313, esp. 298–302.

38. For a general discussion of grounds in paintings, see Spronk, "More Than Meets the Eye," 18–22. See also B. Heimberg, "Zur Maltechnik Albrecht Dürers," *Albrecht Dürer: Die Gemälde der Alten Pinakothek* (Munich: Braus, 1998), p. 34–6.

39. For a thorough discussion of the materials and methods used in Dürer's paintings in the collections of the Alten Pinakothek in Munich, see Heimberg, "Zur Maltechnik Albrecht Dürers," p. 36–42.

40. Even though it is not always possible to determine whether an underdrawn design executed on a panel preparatory to painting was executed with a pen or with a brush, this design is nonetheless generally referred to in the literature as "underdrawing" in the same sense that drawings on paper are considered drawings whether they are executed with brush, pen, or another tool. "Underpainting," on the other hand, is the term generally used in the technical literature to refer to the application of broader areas of pigment by the painter to block in or define an all-over tone or color.

41. Van Asperen de Boer provides a discussion of the relative transparencies of various pigments in his doctoral thesis. Nonetheless, there remains a great deal of confusion in the literature about just what materials can be "seen," or are made visible, with infrared reflectography. Black pigments, which often consist of carbon compounds (such as lamp-black, charcoal, or even chalk) absorb more heat than any other pigments. One common assumption is, then, that only carbon-bearing pigments are visible using this technique. Shelly Fletcher demonstrated that iron-gall ink, which contains no trace of carbon, could be made visible with the addition of visible light into the infrared vidicon system at the 1984 ICOM meetings. See S. Fletcher, "A Preliminary Study of the Use of IRR in the Examination of Works of Art on Paper," preprint, *ICOM Committee for Conservation, 7th Triennial Meeting, September 10–14, 1984* (1984), 84.14.24–25. Therefore, as van Asperen de Boer established in his 1970 doctoral thesis, the traditional techniques of northern Renaissance artists, where an underdrawing in a black pigment is executed on top of a white ground, provide the optimal circumstances for investigation with infrared reflectography. However, many other pigments and elements absorb some infrared heat as well.

42. Catherine Metzger at the National Gallery of Art in Washington, D.C., together with Maryan Ainsworth and Jeffrey Jennings of the Metropolitan Museum of Art, has initiated an investigation of the degree to which different materials are rendered visible or invisible with the heat-sensitive technology of infrared reflectography. The initial findings of that investigation definitively show that many different pigments, including soft metals such as lead and silver as well as a variety of gall inks are heat absorptive and made visible with infrared reflectography. See J. Jennings, "Infrared Visibility of Underdrawing Techniques and Media," *Le Dessin sous-jacent dans la peinture*, collected papers, *Colloque IX, Louvain-la-Neuve, September 1991*, (1993): 241–52.

43. Filedt-Kok provides a lively discussion of the history of the processes involved in the investigation of underdrawings with infrared reflectography and of the methods he used both initially and after some amount of experimentation. See Filedt-Kok, "Lucas van Leyden," 2–4, 153 n. 4, 154 n. 9.

In the years since I made my reflectogram assemblies, the field has changed entirely, due to the accessibility of computer programs like Adobe's *PhotoShop*. The most recent investigations of underdrawing are made *without* a single lens reflex camera. Instead, the individual segments to be documented are digitized instantaneously by the computer, after which they are assembled on the computer, eliminating the patchwork quality of the reproduced images. See Burmester, "Dürer Durchleuchtet," 124–5, for a history of recent advances in the retrieval of underdrawings with infrared reflectography. Burmester illustrates the differences in appearance made possible by the recent advances in the handling and manipulation of digitized images with computers.

44. For a more specific discussion of the historical development, technical aspects, and further bibliography on the uses of X-radiography in the investigation of panel paintings, see R. Van Schoute and H. Verougstraete-Marcq, "Radiography," *Scientific Examination of Easel Paintings, Published on the occasion of the Xth Anniversary meeting of the Pact Group at Louvain-la-Neuve*, ed. R. Van Schoute and H. Verougstraete-Marcq (Strasbourg: Council of Europe, 1986), 131–54. [Pact, 13, 1986]. For a history of X-radiography of paintings by Dürer, see Burmester, "Dürer Durchleuchtet," 120–5.

45. M. Ainsworth, "Schäufelein as Painter and Graphic Artist in the *Visitation*," *Metropolitan Museum Journal* 22 (1987): 139. Ainsworth noted a similar graphic strengthening of details in the Schäufelein's *Visitation* in Vaduz, Liechtenstein. She called this reinforcement of contours in black paint "overdrawing" and contrasted it with the underdrawing.

46. See Goldberg et al., *Albrecht Dürer*, 138–415, as well as Carmen Garrido, "Albert Dürer: Deux manières différentes de travailler," *Le dessin sous-jacent et la technologie dans la peinture "perspectives,"* Colloque XI, Louvain-la-Neuve (1997), 61–6.

47. It is possible that Dürer used an underdrawing material in these paintings that is not detectable with modern technical means of investigation.

48. Alternate methods of transferring the design were investigated in regards to these paintings, but no evidence was found to support such a possibility. For instance, no incisions were visible on the surface of the paintings that would suggest that they had been traced. Likewise, no evidence was found that the underdrawing was covered up or concealed by painted contour lines on the surface, as Maryan Ainsworth has found frequently to be the case in Holbein portraits. See Ainsworth, "'Paternes for Phiosioneamyes,'" 173–86.

49. See Chapter 6 for a discussion of this group of portraits.

Chapter 2. Dürer's Mythic and Real Presence in Italy

1. Erwin Panofsky commented on Dürer's seminal role in bringing the Renaissance to Flanders in his book, *Early Netherlandish Painting* (Cambridge: Harvard

University Press, 1953), 8–9. He wrote there, "It was, with but a few and well-motivated exceptions, not until the very end of the fifteenth century that Flemish painting came to be drawn into the orbit of the Italian Renaissance . . . and it took the spirit of a new century, the rise of new artistic centers and even the help of a German, Albrecht Dürer, to open Netherlandish eyes to the more basic values of the Italian rinascimento." Panofsky titled the introduction to his book on Early Netherlandish Painting the "Polarization of European Fifteenth-Century Painting in Italy and the Lowlands." For a further elaboration of Panofsky's view of the polarization of art in Italy and northern Europe during the Renaissance, see his book, *Renaissance and Renascences in Western Art* (Stockholm: Almquist & Wiksell, 1960), 162–8. I presented a paper on Panofsky's conceptualization of the polarization of northern Europe and Italy and the influence of his views on subsequent scholarship at the 1993 CAA Annual Meeting held in New York City in the Session chaired by Craig Harbison called "Panofsky's Early Netherlandish Painting: Forty Years Later."

2. For the most recent discussion of the Venetian aspects of the painting, see P. Humfrey, "Dürer's *Feast of the Rose Garlands*: A Venetian Altarpiece," *Bulletin of the National Gallery in Prague* 1 (1991): 21–33.

3. The major scholarly work on the presence of Germans in Venice during the Renaissance remains H. Simonsfeld, *Der Fondaco dei Tedeschi in Venedig und die deutsch-venetianischen Handelsbeziehungen Vols. 1–2* (Stuttgart: J. G. Cotta, 1887). See also G. Ludwig, "Antonello da Messina und deutsche und niederländische Künstler in Venedig," *Pr.Jb* 23 (1902): 43; and N. Lieb, *Die Fugger und die Kunst im Zeitalter der Spätgotik und frühen Renaissance, Studien zur Fuggergeschichte, Vol. 10* (Munich: Schnell and Steiner, 1952); G. Fedalto, "Stranieri a Venezia e a Padova," *Storia della Cultura Veneta: Dal primo Quattrocento al Concilio di Trento*, eds. G. Arnaldi and M. P. Stocchi, (Vicenza: Neri Pozza Editore, 1980): 499–535. For more general discussions of the interrelationships between Italian and northern artists, see *Italienische Frührenaissance und nordeuropäisches Spätmittelalter: Kunst der frühen Neuzeit im europäischen Zusammenhang*, ed. J. Poeschke, (Munich: Hirmer, 1993).

Little scholarly attention has been directed to the question of foreigners in Nuremberg in the fifteenth and sixteenth centuries, although undoubtedly there were many, given the importance of Nuremberg as a trade city. For a short summation of foreign visits to Nuremberg in the fifteenth century, see O. Anders, "Nürnberg um die Mitte des 15. Jahrhunderts im Spiegel ausländischer Betrachtung," *Mitteilungen des Vereins für Geschichte der Stadt Nürnberg* 50 (1960): 100–12. For a discussion of the activity of Netherlandish artists in Nuremberg in the sixteenth century, see J. C. Smith, "Netherlandish Artists and Art in Renaissance Nuremberg," *Simiolus* 20, no. 2/3 (1990–1): 153–67. Smith notes that Netherlandish and Italian paintings were both widely collected in Nuremberg. Dürer could easily have seen Italian – and specifically Venetian paintings – in his hometown.

Finally, see S. Ozment's *Magdalena and Balthasar: An Intimate Portrait of Life in 16th Century Germany Revealed in the Letters of a Nuremberg Husband and Wife* (New Haven, London: Yale University Press, 1989; and S. Ozment, *Three Behaim Boys: Growing Up in Early Modern Germany: A Chronicle of Their Lives* (New Haven,

London: Yale University Press, 1990). Both books are based on personal letters preserved in the Behaim family archive housed at the Germanisches Nationalmuseum in Nuremberg and provide a vivid picture of life in Nuremberg in the early sixteenth century. These letters also bear witness to the extensive travel throughout Europe undertaken by merchants in the early years of the sixteenth century.

4. According to Smith and Chiesa, the painting appeared on the art market unpublished; see A. Smith and A. O. della Chiesa, eds., *The Complete Paintings of Dürer* (New York: Abrams, 1968), 105. Longhi attributed this painting to Dürer in 1961, along with the *Madonna del Patrocinio*, see Longhi, R., "Una Madonna del Dürer a Bagnacavallo," *Paragone* 139 (July 1961): 3–9. Shortly after Longhi published it as a Dürer, it made its way into the Schäfer Collection. See B. Bushart, ed., with I. Lübbecke, *Altdeutsche Bilder der Sammlung Georg Schäfer* (Schweinfurt: Weppert, 1985), 80–3.

5. Anzelewsky, 1971, 130. Bushart and Lübbecke, *Altdeutsche Bilder der Sammlung Georg Schäfer*, 181, concur with Anzelewsky's identification with only a slight reservation, identifying the fruit as being similar to a pomegranate.

6. Anzelewsky, 1971, published infrared photographs of the painting in his monograph, plates 18, 20, and 22.

7. See R. Longhi, "Una Madonna del Dürer a Bagnacavallo." The painting was in the Capucin monastery in Bagnacavallo since it was founded in 1774, but nothing is known of the painting before then. See, V. Sgarbi, *Fondazione Magnani-Rocca: Capolavori della pittura antica* (Milan: Mondadori, 1984), 71–5; and S. T. Pizzetti, ed. *Masterpieces from the Magnani-Rocca Foundation Collection* (Bologna: Nuova Alfa Editoriale, 1990), 15.

8. Anzelewsky, 1971, 124. See too B. Aikema and B. Brown, eds. *Renaissance Venice and the North Crosscurrents in the Time of Bellini, Dürer, and Titian* (Milan: Bompiani, 1999) p. 282.

9. P. Ackroyd, S. Foister, et al., "A Virgin and Child from the Workshop of Albrecht Dürer," *National Gallery Technical Bulletin* 21 (2000): 28–42.

10. John Hand of the National Gallery of Art in Washington, D.C., generously shared a great deal of information about the provenance of the painting with me prior to his publication of the material in the National Gallery's Systematic Catalogue. See Hand and Wolff, *Early Netherlandish Painting*. Hand noted that the painting was unknown before 1932, when it was sold, as a Bellini, at Christie's in London, at the sale on April 29, 1932, lot no. 51. Baron Heinrich von Thyssen-Bornemisza bought the painting on the German art market later in 1932 as a Dürer. He put it on consignment at M. Knoedler & Co. in New York in 1950, and the painting was acquired by the National Gallery of Art in Washington, D.C., in that year.

11. John Hand and Catherine Metzger graciously allowed me to examine this painting on numerous occasions. A reproduction of my reflectogram assembly of this painting is included in Hand's systematic catalogue of the German paintings in the collections of the National Gallery, *German Paintings of the Fifteenth Through Seventeenth Centuries*.

12. The closest comparison I have been able to locate is found in a drawing of the *Head of the Virgin* attributed to Hans Seuss von Kulmbach in the

Universitätsbibliothek in Erlangen. This drawing is reproduced in E. Bock, *Die Zeichnungen in der Universitätsbibliothek Erlangen* (Frankfurt am Main: Prestel, 1929), cat. no. 237.

13. See Goldberg et al., *Albrecht Dürer: Die Gemälde der Alten Pinakothek*. C. Eisler interpreted these two joined letters as an early manifestation of Dürer's monogram, *Paintings from the Samuel H. Kress Collection: European Schools Excluding Italian* (Oxford: Phaidon Press for the Samuel H. Kress Foundation, 1977), 12. Anzelewsky, 1991, 143, presented a drawn representation of this combination of letters in order to support his attribution of the painting to Dürer. In his drawn facsimile of the monogram, Anzelewsky minimized the width of the lines that curve around the legs of the uppercase A. In fact, these lines are all uniform in width and cannot easily be read as an A combined with a D.

14. See Rupprich, *Nachlass* I: 66–7.

15. This painting was previously in the Bacon collection on loan to the Fitzwilliam Museum at Cambridge. See Carritt, "Dürer's St. Jerome in the Wilderness," *BM* 9 (1957): 363 ff. E. Schilling supported Carrit's attribution in two articles: E. Schilling, "Dürer's Täfelchen mit dem hl. Hieronymus," *ZfKw* 11 (1957): 175–84; and E. Schilling, "Additional Notes on Dürer's Painting *St. Jerome*," *BM* 100 (1958): 130. Other scholars, however, have not agreed with this attribution. See L. Koetser, "Dürer or not Dürer?" *The Connoisseur* 141 (1958): 567, who attributed the painting to Altdorfer; and M. Levey and C. White, "The German Exhibition at Manchester," *BM* 103, no. 705 (December 1961): 485–8. Levey and White questioned the attribution of the painting to either Dürer or Altdorfer but did not provide an alternative attribution.

16. Carritt, "Dürer's St. Jerome in the Wilderness," 363 ff.

17. Carritt, "Dürer's St. Jerome in the Wilderness," 363 ff.

18. I am most grateful to Susan Foister, Curator of Early Netherlandish, German and British Pictures at the National Gallery, London, who generously shared with me the information she had gathered about the painting. She reported that her investigation with infrared reflectography revealed very little underdrawing; of note were the drawn circles used to mark the position of the eyes. The investigation at the National Gallery also revealed that the panel is pear wood and that oil is included in the paint medium.

19. See, among others, B. Haendke, *Die Chronologie der Landschaften Albrecht Dürer's* (Straßburg: Heitz und Mündel, 1899); L. Klebs, "Dürers Landschaften. Ein Versuch, die uns erhaltenen Naturstudien Dürers, chronologisch zu ordnen," *Rep* 30 (1907): 399–420; M. Müller, "Bamberger Ansichten aus dem XV. Jahrhunderten," *Pr.Jb* 58 (1937): 241–57; A. M. Cetto, *Watercolours by Albrecht Dürer*, trans. G. T. Hughes (New York: MacMillan Co., 1954); K. Fiore-Herrmann, "Das Problem der Datierung bei Dürers Landschaftsaquarellen," *AGNM* (1971–2): 122–42; and K. Herrmann-Fiore, *Dürers Landschaftsaquarelle*, ed. E. Hubala (Frankfurt/M: Peter Lang, 1972), see particularly the excursus on the problem of dating the landscapes, 91–109. See also H. Leber, *Albrecht Dürers Landschaftsaquarelle: Topographie und Genese* (Hildesheim, Zürich, New York: Georg Olms, 1988).

20. H. Wölfflin, *Albrecht Dürer: Handzeichnungen* (Munich: R. Piper, 1914).

21. This drawing is reproduced in J. Rowlands, with G. Bartrum, *The Age of Dürer and Holbein: German Drawings 1400–1550* (London: British Museum Publications, 1988), 65. For a discussion of the Ottoman costumes worn by these figures, see J. Raby, *Venice, Dürer and the Oriental Mode*, The Hans Huth Memorial Studies, 1 (London: Islamic Art Publications, 1982), 21–30.

22. Rupprich, *Nachlass* I: 53. The letter of August 18, 1506 reads as follows: "Jtem last mich wissen, was papirs jr meint, daz jch kawften soll, wann jch weis kein subtillers den als wir doheim kawft hand." See W. L. Strauss, *The Complete Drawings of Albrecht Dürer* (New York: Abaris Books, 1974). See also B. Hausmann, *Albrecht Dürer's Kupferstiche, Radirungen, Holzschnitte und Zeichnungen, unter besonderer Berücksichtigung der dazu verwandten Papiere und deren Wasserzeichen* (Würzburg: J. Frank, 1922). Hausmann noted that Dürer's use of paper was fairly consistent throughout the early years of his career, and that new papers were introduced only after his journey to Venice in 1505–7. See also A. Schulte, "Dürerforschung und Wasserzeichen," *Der Papier-Fabrikant* 13 (1938): 110.

23. Rowlands, *The Age of Dürer and Holbein*, 65, notes, "The three figures in [Gentile's painting] differ from those in Dürer's drawing, in that the man in the center has a beard and the one on the right is a European, and not a Negro slave, as Dürer depicted him. Dürer has also changed the position of the slave's left foot after an initial outline drawing of it in the same position as in Bellini's painting." The Tietzes, *KV* I: 87, considered this drawing a product of Dürer's workshop or of a follower.

24. H. Schedel, *Weltchronik*, B. von Breydenbach, *Die Reise ins Heilige Land*, published in 1483, ed. and trans. E. Geck (Wiesbaden: Guido Pressler, 1961). See the facsimile edition of the Weltchronik, 'Die Schedelsche Weltchronik von 1493' Kommentiert von Rudolf Pörtner Dortmund, Harenberg Kommunikation: 1978.

25. J. Ackerman, "Dürer's Crab," *Ars Auro Prior: Studien Joanni Bialostocki Sexagenaria Dicata* (Warszawa: Panstwowe Wydawnictwo Naukowe, 1981), 291–5.

26. Arthur Wheelock included a cast bronze crab in his exhibition and catalogue, *A Collector's Cabinet* (Washington, D.C.: National Gallery of Art, 1998), 41. This *Box in the Form of a Crab* (National Gallery of Art, Samuel H. Kress Collection) was made in Padua at the end of the fifteenth century and could have been the same type as the one that Dürer drew. Bronze casts from nature – especially of somewhat exotic species – were popular in Padua at the end of the century. It seems possible that casts of lobsters were also made. Dürer's friend Pirckheimer studied at the University of Padua early in the 1490s. He could have easily sent such casts home to Dürer.

27. Roger Fry, ed., *Dürer's Record of Journeys to Venice and the Low Countries* (New York: Dover, 1995).

28. D. Eichberger, "*Naturalia* and *Artefacts*: Dürer's Nature Drawings and Early Collecting," in D. Eichberger and C. Zike, eds., *Dürer and His Culture* (New York and Cambridge: Cambridge University Press, 1998), 13–37.

29. The literature about the *Apocalypse* is enormous. For a list of the pertinent literature about the series, see W. L. Strauss, ed., *Albrecht Dürer. Woodcuts*

and Woodblocks (New York: Abaris Books, 1980), 153–203. Further bibliography is collected in M. Mende, *Dürer Bibliographie* (Wiesbaden: O. Harrasowitz, 1971), 260–4.

30. L. Grote, *Albrecht Dürer: Reisen Nach Venedig* (Munich and New York: Prestel, 1998), 12.

31. Alastair Smith made this point cogently in an article questioning Dürer's presence in Italy earlier than 1506. See A. Smith, "Germania and Italia: Albrecht Dürer and Venetian Art," *Royal Society of Arts Journal* 28, no. 5273 (April 1979): 273–90.

32. D. Burkhardt, *Albrecht Dürer's Aufenthalt in Basel 1492–1494* (Munich and Leipzig: G. Hirth, 1892).

33. Both of these watercolors are in the Albertina in Vienna.

34. Rupprich, *Nachlass* I: 44.

35. W. M. Conway, *Literary Remains of Albrecht Dürer* (Cambridge: Cambridge University Press, 1889), 48.

36. Thausing, I: 104; E. Flechsig, *Albrect Dürer*, 158–60.

37. D. Burckhardt, *Albrecht Dürer*, 35. He argued that "daz ding" was probably the same thing as the "antikische art" or old-fashioned art that he referred to in the same letter.

38. J. Grimm and W. Grimm, *Deutsches Wörterbuch* (Leipzig: Verlag von S. Hirzel, 1860), 1166 definition nr. 16: "Das ist mein ding nicht; das ist meine Sache; nicht mein geschmack." Further, the Grimms' note in their entry on "Ding" (pp. 1158–66) that this derogatory usage was often applied to children, girls, small animals, and anything at all unusual.

39. For a close reconstruction of Dürer's activities and whereabouts during his *Wanderjahre*, see D. Burckhardt, *Albrecht Dürer's Aufenthalt in Basel 1492–1494* (Munich, Leipzig: G. Hirth, 1892). In 1892, Burckhardt had already noted the polemic surrounding Dürer's exposure to Italian art.

40. Whether Dürer copied these prints while in Italy or whether he did them while in Nuremberg has been endlessly argued. The Tietze's argued that he would not have wasted the time in Italy when they were most likely available to him in Nuremberg. See Tietze and Tietze-Conrat, *KV* I: 305–30.

41. D. Burckhardt suggests that Hartmann Schedel was an avid collector of printed materials and would have been an obvious source for Dürer. D. Burckhardt, *Albrecht Dürer's Aufenthalt in Basel 1492–1494*, 37.

42. For a discussion of the breadth of the connections between Nuremberg and Venice in the fifteenth and sixteenth centuries, see M. Lowry, "Venetian Capital, German Technology and Renaissance Culture in the Later Fifteenth Century," *Renaissance Studies* 2, no. 1 (March 1988): 1–13; and Anders, "Nürnberg um die Mitte Des 15. Jahrhunderts," 100–12.

43. Jacopo de Barbari's relationship with Dürer has provoked special interest among art historians, since that connection has been viewed as a key to the reconstruction of Dürer's relationship to Venetian and Italian art. However, the lack of a solid corpus of paintings and the problematic dating of many of the prints attributed to Jacopo have limited the usefulness of such reconstructions.

For various positions on these issues, see P. O. Kristeller, *Das Werk des Jacopo de Barbari* (Berlin: Internationale Chalcographische Gesellschaft, 1896); L. Justi, "Jacopo de Barbari und Albrecht Dürer," *Rep.* 21 (1898): 346–74; B. Haendke, "Dürer's Beziehungen zu Jacopo de' Barbari, Pollaiuolo und Bellini," *Pr.Jb* 19 (1898): 161–70; A. de Hevesy, *Jacopo de Barbari: Le maître au caducée*, ed. G. van Oest (Paris, Bruxelles: Libraire national d'art et d'histoire, 1925); and J. A. Levenson, *Jacopo De'Barbari and Northern Art of the Early 16th Century* (New York: Garland, 1978).

44. G. M. Fara, "Sul secondo soggiorno di Albrecht Dürer in Italia e sulla sua amicizia con Giovanni Bellini," *Prospettiva*, no. 85 (January 1997): 91–6.

45. Rupprich, I: 290–1, reproduced the Latin passage written by Scheurl about Dürer. Rupprich pointed out that Scheurl's first edition of the *Libellus*, published in Bologna on January 20, 1506, did not include the part about Dürer. This could be construed as further evidence for reading Scheurl's report of Dürer's activities as a rhetorical rather than a factual or historical account. For the original text, see C. Scheurl, *Libellus de laudibus Germaniae et ducum Saxoniae* (Leipzig: Martin Landsberg, 1508).

46. Mende's English translation is included in a compilation "From Writings about Dürer," found in Strieder's *Albrecht Dürer*, 1982, 366. The text is translated into German in *1471 Albrecht Dürer 1971* (Nuremburg: Germanisches National-museum, 1971), 40.

Mende's translation is rather free. For instance, it is not clear to me that "in pictura and in fictura" should be translated as "in painting and sculpture." Likewise, "me saepe interprete consalutatus est alter Apelles" cannot clearly be translated to read "he was greeted as the second Apelles . . . at which occasions I often served him as translator." This latter translation is especially problematic because it implies that Scheurl was with Dürer. If the translation is kept closer to the original Latin, it should read something like: "it was often made known to me that he was hailed as the second Apelles."

47. This text is reproduced in Rupprich, I: 292–3 and III: 461. The original text is found in C. Scheurl, *Oratio attingens litterarum prestantiam necnon laudem Ecclesie Collegiate Vittenburgensis* (Leipzig: Martin Landsberg, 1509).

Z. Z. Filipczak provides an illuminating discussion of the use of the Apelles simile to praise artists in Flanders later in the sixteenth and seventeenth centuries in her book, *Picturing Art in Antwerp 1550–1700* (Princeton: Princeton University Press, 1987). See also D. Cast, *The Calumny of Apelles: A Study in the Humanist Tradition* (New Haven, London: Yale University Press, 1981); and for the specific use of the Apelles metaphor in relationship to Dürer, see A. Smith, "Dürer and Bellini, Apelles and Protogenes," *BM* 114 (1972): 326–9.

John Rowlands pointed out that Holbein was lauded as a modern Apelles by the French poet Nicolas Bourbon, a client of Anne Boleyn at the court of Henry VIII. Bourbon referred to Holbein as "the royal painter, the Apelles of our time" in a letter of September 15, 1536. See J. Rowlands, *Holbein: The Paintings of Hans Holbein the Younger*, complete edition (Oxford: Phaidon, 1985), 90–1. Oskar Batschman and Pascal Griener have discussed the Apellian motif in relationship

to Holbein. See their book, *Hans Holbein* (Princeton: Princeton University Press, 1997).

48. Reproduced in Rupprich, I: 294. The original text is found in C. Scheurl, *Vita Reverendi patris Domini Anthonii Kressen. Nürnberg* (Nuremberg: Friedrich Peypus, 1515).

49. Charles Ephrussi mentioned this point in his refutation of Thausing's argument for Dürer's early presence in Italy. See C. Ephrussi, *Albert Dürer et ses dessins* (Paris: A. Quantin, 1882), 13. Daniel Burkhardt also emphasized that Scheurl's knowledge of Dürer's whereabouts was thorough, and that if Dürer had indeed traveled to Venice before the turn of the century Scheurl would have made the fact clear. See Burkhardt, *Albrecht Dürer's Aufenthalt in Basel 1492–1494*, 32–4.

50. M. Baxandall, "Bartholomeus Facius on Painting. A Fifteenth-Century Manuscript of the *De Viris Illustribus*" *JWCI* 27 (1964): 91–107.

51. The comparison of northern and Italian artists and painters is deeply embedded in both traditional and modern art-historical scholarship. See Panofsky, *ENP*, 2–3, for another paradigmatic discussion of Facius' comparison of northern and Italian artists.

52. P. G. W. Glare, ed., *Oxford Latin Dictionary* (Oxford: Clarendon Press, 1982), 1589. The first definition of "redire" reads: "To come or go back (to a place from which one has set out or to which one is thought of as particularly belonging), return, retire." Burkhardt makes this point cogently, *Albrecht Dürer's Aufenthalt in Basel 1492–1494*, 33–4.

53. J. Burckhardt, *The Civilization of the Renaissance in Italy*, intro. H. Holborn (New York: Random House/The Modern Library, 1954). In 1855, Burckhardt wrote a guide to the artistic monuments of Italy, called *The Cicerone*. He also wrote *The Altarpiece in Renaissance Italy*, ed. and trans. Peter Humfrey (Cambridge: Cambridge University Press, 1988), 9–10.

54. In 1855, Jules Michelet, in distinction to Burckhardt, wrote about the French origination of the Renaissance.

55. H. Grimm, *Über Künstler und Kunstwerke* (Berlin: Ferd. Dümmler's Verlagsbuchhandlung, 1865), 133–6. Grimm based his argument on the passage in Dürer's letter of February 7, 1506, to Willibald Pirckheimer, in which Dürer mentioned that the thing which pleased him eleven years before pleased him no longer.

56. G. F. Waagen, "Albrecht Dürer in Venedig." *ZfbK* 1 (1866): 112–17. The Tietzes wrongly attributed the initial observation to Wickhoff, who wrote an article that appeared in the *Mitteilungen des Instituts für österreichische Geschichtsforschung* (1880), 413 ff.

57. An English edition of Thausing's monograph was published in 1882. M. Thausing, *Dürer: Geschichte seines Lebens und seiner Kunst* (Leipzig: E. A. Seemann, 1875). See *The Life and Art of Albrecht Dürer* (London: John Murray, 1882). G. von Térey cited the same evidence as Thausing to argue that Dürer had traveled to Venice in 1494–5 in *Albrecht Dürer's Venetianischer Aufenthalt 1494–1995* (Straßburg: J. H. Ed. Heitz [Heitz und Mündel], 1892).

58. Thausing wrote of Mantegna in relationship to the Bellini and the Murano schools of painters in Venice: "Er allein ist der Schöpfer des großen paduanischen Renaissancestiles. . . ."

59. Comparisons of Dürer and Mantegna – following Thausing – are numerous, largely because of the view of Mantegna as an "ur-archaeologist." Max Friedländer, for instance, insisted upon a close connection between Dürer and Mantegna. See M. J. Friedländer, "Dürer's erste italienische Reise. Report on *Sitzung der Berliner kunstgeschichtlichen Gesellschaft* on 24 February 1893." *Kunstchronik* N. F. 4, no. 18 (March 16, 1892–3): 298. Friedländer repeated this assertion in his later Dürer monograph, *Albrecht Dürer* (Leipzig: Insel-Verlag, 1921), 39. See also H. Secker, "Beiträge zur Dürer-forschung. 1. Dürer and Mantegna's Fresken in Padua," *ZfbK* N. F. 29, 53 (1918): 133; E. Tietze-Conrat, "Two Dürer Woodcuts and an Italian Model," *BM* 62, no. 362 (1933): 241–2; E. Pogány-Balas, "On the Problems of an Antique Archetype of Mantegna's and Dürer's," *Acta Historiae Artium* XVII (1971–2): 77 ff. For the most recent study of Mantegna and his archaeologizing activities, including further bibliographic citations, see R. Lightbown, *Mantegna: With a Complete Catalogue of the Paintings, Drawings and Prints* (Oxford: Phaidon, 1986).

60. Thausing, 114–16.

61. Thausing, 110–11. Thausing wrote, "Dabei konnten aber die Eigenthümlichkeiten und die feineren Abweichungen einer Stilrichtung dem deutschen Wanderburschen damals nicht in dem Masse klar werden, wie wir heutzutage aus objektiver Ferne zu unterscheiden vermögen. Im ganzen war es doch wohl ein ziemlich unbestimmtes Etwas, was Dürer im Jahre 1494 als antik und ehrwürdig bewunderte."

62. Thausing, 110. Thausing wrote about Dürer's uneasiness with Venetian painting technique and his predilection for drawing as follows: "Die Zeichnung, weit entfernt, in deutscher Weise vorzuherrschen, verbarg sich hinter einer Malweise, deren Oeltechnik ihm neu, deren specisisches Farbengefühl ihm unverstandlich blieb."

63. C. Ephrussi, *Albert Dürer et ses dessins* (Paris: A. Quantin, 1882), 8–18. Ephrussi summed up his dismissal of Thausing's arguments on pages 17–18: "L'hypothèse d'un voyage d'Italie en 1494 nous paraît donc devoir être absolument écartée. Aussi renvoyons-nous à la date du voyage authentique de 1505–1506 l'examen des vues du Tyrol et d'Italie et des autres dessins gratuitement assignés à l'année 1494." This book is a collection of essays published by Ephrussi in the Gazette des Beaux-Arts between 1877 and 1880.

64. Ephrussi, *Albert Dürer et ses dessins*, 8–18.

65. The venue for Thausing's accusations was the *Zeitschrift für bildende Kunst*. In that journal, he wrote a negative review of Ephrussi's book, *Etude sur le Triptyque d'Albert Dürer dit le Tableau d'autel de Heller* (Nuremberg: Sigmund Soldan, 1877) and accused him of plagiarism. The review appeared in *Zfbk* XII, (1877): 283; Ephrussi responded in the same volume (pp. 339–45), and Thausing made another complaint in the same volume (p. 386). The tension between the two was not, however, laid to rest. Ephrussi rebutted again in *Zfbk* XIII (1878): 63–4; and Thausing wrote another bitter reply in *Zfbk* XIII (1878): 96. Thausing made the accusation again in the Introduction to the second German edition of his monograph in 1884 (p. xi) where he did not accuse Ephrussi by name but, instead, referred to him as a "Landesmann aus dem Osten."

66. D. Burckhardt, *Albrecht Dürer's Aufenthalt in Basel in 1492–1494* (Munich and Leipzig: G. Hirth, 1892).

67. Wölfflin, 1905. See H. Wölfflin, *The Art of Albrecht Dürer*, trans. A. Grieve and H. Grieve (London: Phaidon, 1971).

68. Wölfflin, 1905, 38. Wölfflin wrote here: "So ganz neu ist die Entwicklung, die sich hier vollzieht, daß man schon begreifen kann, daß Dürer zunächst an der bereits geprägten Form sich festhält: an den Italienischen Mustern hat sich das schlummernde Lebensgefühl zum wachen Bewußtsein emporgebildet."

69. J. Meder, "Neue Beiträge zur Dürer-Forschung II," 211. Meder, like Wölfflin and Thausing, identified Dürer's graphic accomplishments with his northern, intellectual heritage. Dürer's predilection for the graphic arts was, for Meder, the determining factor in Dürer's inability to absorb the artistic richness of Venice.

70. Tietze and Tietze-Conrat, "Excurse III. Zur ersten Italienischen Reise," *KV* I: 305–30, esp. 317–22. The methodological emphasis on rigorous connoisseurship that forms the basis for judgment criteria in the rest of the monograph failed the Tietze's here. "Was die italienische Kunst dem edelreifen und seines Weges sicheren jungen Dürer geben könnte, war jenes Werkzeug zur Erweckung eigener verborgener Kräfte, . . . es ist jene Erhöhung psychischen und physischen Daseins – in ihrer Wechselbedingtheit –, die die stärkste und echteste deutsche Begabung als Ergänzung eigenen Wesens seit jeher in der Antike und in Italien zu suchen pflegte. Diese Beschwörung eigenen Ichs aus fremder Form gelang ihm nicht durch Anschluß an einen der großen Meister . . . sondern durch gierige Aufnahme und Verarbeitung dieser ganzen noch einheitlich dünkenden Fremdmasse" (322).

71. Tietze and Tietze-Conrat, *KV* I: 330: "beidemal war der Sinn der italienischen Reise – wie bei der Goethes – daß sie den ringenden Künstler zu sich selbst führte. Im Spiegel fremder Kunst die eigene klarer erkennen ließ."

72. E. Flechsig, *Albrecht Dürer: Sein Leben und Sein Künstlerische Entwicklung* (Berlin: G. Grote'sche, 1928), 144. The same material is found in Flechsig's article, "Zu Dürer's erster Reise nach Venedig." *Cicerone Albrecht Dürer Festschrift der Internationalen Dürer-Forschungen*, ed. G. Biermann (Leipzig, Berlin: Klinkhardt & Biermann, 1928), 54–8. Flechsig wrote that despite the lack of a real literary record of the journey, there was no doubt that Dürer had traveled to Venice in 1494.

73. Flechsig, *Albrecht Dürer*, 36. Flechsig further accounts for the lack of visual evidence with the argument that only a fraction of Dürer's works from this time survive, and that the lost ones would provide the necessary evidence.

74. Panofsky, 1943.

75. Panofsky, 1943, 45–6.

76. Panofsky, 1943, 30–1. L. Seidel has reflected upon Panofsky's projection of his own immigrant status into his scholarship about Jan van Eyck's *Arnolfini Wedding Portrait*. See L. Seidel, *Jan van Eyck's Arnolfini Portrait: Stories of an Icon* (Cambridge: Cambridge University Press, 1993). See also L. Seidel, "Jan van Eyck's Arnolfini Portrait: Business As Usual?" *Critical Inquiry* 16, no. 1 (Autumn 1989): 54–86.

77. Panofsky, 1943, 118.

78. A. Smith, "Germania and Italia: Albrecht Dürer and Venetian Art," *Royal Society of Arts Journal* 28, no. 5273 (April 1979): 273–90.

79. Nürnberg, Germanisches Nationalmuseum, *1471 Albrecht Dürer 1971*, Exhibition Catalog (Nürnberg: Germanisches Nationalmuseum, 1971).

80. C. Talbot, ed., *Dürer in America. His Graphic Work* (Washington, D.C.: National Gallery of Art, 1971).

81. C. Olds, E. Verheyen, and W. Tresidder, *Dürer's Cities: Nuremberg and Venice*, ed. R. A. Yassin (Ann Arbor: The University of Michigan Museum of Art, 1971), 16–27.

82. Olds et al., *Dürer's Cities*, 23.

83. Anzelewsky, 1971, 23–5.

84. P. Strieder, *Albrecht Dürer: Paintings, Prints, Drawings*, trans. N. M. Gordon and W. L. Strauss (New York: Abaris Books, 1982), 100–1.

85. Białostocki, 361.

86. J. C. Hutchison, *Albrecht Dürer: A Biography* (Princeton: Princeton University Press, 1990), 40–7.

87. Rupprich, I: 59. Dürer wrote Pirckheimer: "O wy wirt mich noch dere sunen friren. Hÿ pin jch ein her, doheim ein schmarotzer."

88. See the first chapter of E. Panofsky's *Renaissance and Renascences in Western Art* (Stockholm: Almquist & Wiksell, 1960).

Chapter 3. The *Feast of the Rose Garlands* I

1. I thank Dr. Hana Seifertova, then Curator of Northern Renaissance Paintings, and Mojmír Hamsik, then Chief Conservator, at the Narodní Galerie for their kindness and willingness to let me undertake this investigation. Dr. Karl Schütz, Director of the Gemäldegalerie of the Kunsthistorisches Museum in Vienna also deserves special thanks; without his assistance this research would never have been undertaken. Dr. Schütz allowed me to borrow the infrared reflectography equipment of the Kunsthistorisches Museum and drove with me to Prague to facilitate my research endeavors. Elke Oberthaler, Conservator at the Kunsthistorisches Museum, also accompanied me to Prague and assisted in the investigation of the painting.

For a brief history of the condition of the painting, and how it came to be so damaged, see Appendix 2.

2. The formulation of my ideas about alternatives to artificial perspective are the result of an independent study I conducted under the direction of Gloria Pinney at Bryn Mawr College about ancient methods of the depiction of space. She was convinced, as I am, that the classical use of the word "skíagraphia" implied a type of spatial construction dependent upon cast shadows, and therefore the close observation of light. The meaning of "skíagraphia" has been contested in the literature; many scholars have argued that it is essentially the same as "skenographia," which is the classical forebear to artificial perspective and indicates the construction of space with geometric principles of recession. My theory about the construction of space by Dürer in the Renaissance is related to these arguments, in that I believe that there were alternative ways of studying the depiction of space that have been largely lost to us today.

3. Rupprich, *Nachlass* I: 42; Conway, 47.

4. Conway, 47 translated this passage as follows: "I shall have scraped it [the panel] and laid on the ground and made it ready within eight days." Rupprich, *Nachlass* I: 42 interpreted "weissen and schaben" to mean grounded and polished. The description of these processes in Cennini suggests that both of these ideas could be true; any irregularities in the surface of the panel were filled and then scraped to ensure an even surface for the application of the ground material itself. However, the context of Dürer's description, that in eight days he will have made it white and smoothed or polished, suggests that Rupprich's reading is correct.

For different discussions of the steps involved in ground preparations, see C. Cennini, *The Craftsman's Handbook "Il Libro dell' Arte"*, trans. D. V. Thompson, Jr. (New York: Dover, 1960), 69–74; D. V. Thompson, *The Materials of Medieval Painting* (New Haven: Yale University Press, 1936), 30–38; H. Kühn et al., *Reclams Handbuch der Künstlerischen Techniken, Vol. 1, Farbmittel, Buchmalerei, Tafel- und Leinwandmalerei,* (Stuttgart: Philipp, 1984): 300–6; R. J. Gettens and G. L. Stout, *Painting Materials: A Short Encyclopedia* (New York: D. van Nostrand, 1942), 221, 270; and K. Wehlte, *Werkstoffe und Techniken der Malerei: Ein Fachbuch* (Ravensburg: Otto Maier, 1967), 382–9.

5. Rupprich, *Nachlass* I: 64: "so hab ich sie doch vom schreiner gelöst und das geldt geben, so ihr mir geben habt. . . . Und hab sie zu ainem zubereiter gethan, der hat sie geweist, gerferbet, und wirdt sie die ander wochen vergulten." Conway, 64, translated the passage as follows: "I have got it from the joiner and have paid away for it the money you gave me. . . . I have given it [the panel] to a preparer who has whitened it and painted it and will put on the gilding next week."

6. I thank Mojmír Hamsík, Conservator of the National Gallery in Prague, for presenting me with photographs of the X-radiographs of the painting. The cusping of the linen is visible in the photograph in some areas with the aid of a magnifying glass. Hamsík also told me that a large piece of canvas covers the entire back of the panel. I was not able to see the back of the panel, as it was mounted on the wall, and thus could not ascertain whether this piece of canvas was original or a modern addition.

Further, because the back and sides of the panel could not be studied, I was not able to identify the wood of the panel. It has not yet, to my knowledge, been identified by anyone else. Two other paintings associated with Dürer's Venetian sojourn, the *Virgin with the Zeisig* in Berlin and the *Portrait of a Venetian* in Vienna are both painted on poplar, a typically Italian support. However, Dürer used poplar in Nuremberg, too, as well as linden, for painting supports.

7. Dunkerton et al. suggest that the inclusion of linen strips beneath the ground preparation became less and less common through the course of the fifteenth century. I believe this finding may be indicative primarily of Tuscan practices, since the collection of the National Gallery in London, on which their investigation was based, does not contain a large number of Venetian panel paintings from the late fifteenth and early sixteenth centuries. It is possible, therefore, that the practice was not relatively common in the Veneto until a later date than it was in Tuscany. See J. Dunkerton et al., *Giotto to Dürer: Early Renaissance Painting in the National Gallery*

(New Haven, London: Yale University Press, 1991), 162–3. For the use of linen
strips in the Tirol, see Kühn et al., *Reclams Handbuch*, 148. These authors report
that Michael Pacher included linen supports beneath the ground in the *St. Wolfgang
Altar*.

8. Kühn et al., *Reclams Handbuch*, 147–9. Cennini recommended the practice of
strengthening the panel with strips of linen after the size was applied, but before
the gesso; he wrote: "When you have done the sizing, take some canvas, that is,
some old thin linen cloth, white threaded, without a spot of any grease. Take your
best size; cut or tear large or small strips of this canvas; sop them in this size; spread
them out over the flats of these anconas with you hands . . . and let them dry for two
days." Cennini, 70.

9. Mojmír Hamsík tested the chemical composition of the ground and gener-
ously shared this information with me. See M. Hamsík, "Dürers Rosenkranzfest:
Zustand und Technik: Mit einer Laboruntersuchung von Jindřich Tomek als
Beilage," *Bulletin of the National Gallery in Prague* 2 (1992): 128–31. See too,
O. Kotková, "'The Feast of the Rose Garlands': What Remains of Dürer?" *Burling-
ton Magazine* 144, no. 1186 (2002): 4–13. For a general discussion of ground prepa-
rations, see P. Hendy and A. S. Lucas, (with J. Plesters), "The Ground in Pictures,"
Museum 21, no. 4 (1968): 245–76.

10. Maryan Ainsworth's discussion of the *Christ Bidding Farewell to His Mother*
in the Metropolitan Museum of Art in New York is a good example of this use of
this kind of evidence. In the case of this panel, which was traditionally attributed
to Rogier van der Weyden, the ground was sampled and shown to be gesso, and
not chalk. This evidence, in conjunction with a close comparison of the under-
drawing in this painting and the version in Berlin, pointed in Ainsworth's view,
to a Spanish origin for the panel. This corroboration, in turn suggested that it
was a product of a gifted copyist and, or follower of Rogier van der Weyden, and
not Rogier himself. See Ainsworth's article, "Implications of Revised Attributions
in Netherlandish Painting," *Journal of the Metropolitan Museum of Art* 27 (1992):
59–76. See also R. Merrill, "A Technical Study: Birth and Naming of St. John the
Baptist," *Bulletin of the Cleveland Museum of Art* 63, no. 5 (1976): 136–45; and R. J.
Gettens and M. E. Mrose, "Calcium Sulphate Minerals in the Grounds of Italian
Paintings," *Studies in Conservation* 1, 4 (1954): 174–89.

11. I thank MaryColette Hruskocy and Christopher McGlinchey, chemists in the
Department of Paintings Conservation at the Metropolitan Museum of Art, for their
patience in discussing with me the chemical compositions of ground preparations.
MaryColette Hruskocy has been pursuing an investigation of the inert materials in
ground preparations as a means of identifying the sources of the materials at the
Central Analytic Laboratories (CAL) of the Smithsonian Institution since autumn
of 1991. Hruskocy suggested that it would be possible to locate the origins of the
chalk used in the ground preparation of paintings through the identification of the
inert materials that naturally occur with chalk deposits. These materials could then
be matched to local European chalk deposits, and the origin of the chalk identified.

Information about the ground preparation in paintings related to the *Feast of the
Rose Garlands* is limited. The *Portrait of Burkard von Speyer* (Figure 37) in the Queen's

Collection at Hampton Court reportedly has an unusual ground preparation for a painting produced in Venice, as well as a pale-pink underpainting. More specific details, including whether the painting has a chalk or gesso ground are not included in the catalogue. See *Treasures from the Royal Collection* (London: The Queen's Gallery, Buckingham Palace, 1988), 58–9. Similarly, despite the recent technical investigation of the *Christ Among the Doctors* in the Thyssen Collection at Lugano-Castagnola by Emil Bosshard and Isolde Lübbeke, the ground preparation of that painting was neither discussed nor identified. See I. Lübbeke, *Early German Painting*, 218–34.

12. The utilization of preparatory drawings in the production of paintings was far more common in Italy than it was in Northern Europe. In fact, Jan van Eyck's preparatory drawing for the *Portrait of Cardinal Albergati* in Vienna has been considered the only definite example of this practice in Northern Renaissance painting. For discussions of the rarity of preparatory drawings in Northern Renaissance painting, see J. Hand et al., *The Age of Breughel: Netherlandish Drawings in the Sixteenth Century* (National Gallery of Art, Washington DC: Cambridge University Press, 1986), 26–9; M. Ainsworth, "Northern Renaissance Drawings and Underdrawings," 6–8. For discussion and examples of the prevalence of preparatory drawings in Italian painting practices, see F. Ames-Lewis, *Drawing in Early Renaissance Italy* (New Haven: Yale University Press, 1981), 32.

13. The exact number of preparatory drawings made by Dürer for the *Feast of the Rose Garlands* is disputed. The Tietzes (*KV* II: 30) attribute sixteen drawings to Dürer as preparatory to the *Feast of the Rose Garlands*. These include (the Tietzes' numbers): 293, 294, 297, 302, 304, 305, 306, 307, 308, 309, 310, 311, 312, 313, 314, and W. 56. Ludwig Grote, "Hier bin ich ein Herr," *Dürer in Venice* (Munich: Prestel, 1956) argued for twenty-two. Strauss, II: 914–49, recently attributed 23 drawings to Dürer as preparatory to the *Feast of the Rose Garlands*.

14. See J. Meder, *Die Handzeichnung: Ihre Technik und Entwicklung* (Vienna: Kunstverlag Anton Schroll, 1919) for comments about their place in the overall development of drawing. See also Ephrussi, *Albert Dürer et ses dessins*; F. Lippmann, *Zeichnungen von Albrecht Dürer in Nachbildungen* (Berlin: G. Grote, 1883–96); H. Wölfflin, *Albrecht Dürer Handzeichnungen* (Munich: R. Piper, 1914); F. Winkler, *Die Zeichnungen Albrecht Dürers* (Berlin: Deutscher Verein für Kunstwissenschaft, 1936–9); E. Panofsky, *The Life and Art of Albrecht Dürer (with Handlist)*, 1st ed. (Princeton: Princeton University Press, 1943), # 736–59, 80–1; H. Tietze, *Dürer als Zeichner und Aquarellist* (Vienna: Anton Schroll, 1951); and W. L. Strauss, *The Complete Drawings of Albrecht Dürer. Vol. 2. 1500–1509* (New York: Abaris Books, 1974).

15. See Meder, *Handzeichnung*, 125.

16. H. Tietze and E. Tietze-Conrat, *The Drawings of the Venetian Painters*, 2nd ed. (New York: J. J. Augustin, 1969). See also F. Clapp, "Review of H. Tietze and E. Tietze-Conrat: The Drawings of the Venetian Painters in the 15th and 16th centuries," *Art Bulletin* (June 1945): 152–3.

17. This drawing is the Madonna in the Boymans Museum, Rotterdam, and it corresponds to a panel in the Huntington Library in San Marino, California, which is usually attributed to a follower of Bellini.

18. See F. Gibbons, "Practices in Giovanni Bellini's Workshop," *Pantheon* 23 (1965): 151–5. The Tietze's argument that these drawings are functional is true in this sense, that some drawings may have been similes, or patterns that could be utilized by members of the workshop for the rapid production of set compositions. However, except for the possible example provided by the Rotterdam drawing, none of these similes seem to survive. Ames-Lewis, *Drawing in Early Renaissance Italy*, 87–8, argued that Gentile Bellini had a sketchbook containing patterns of oriental types that was widely accessible in Venetian artistic circles.

Simile drawings were employed in the north of Europe as well. Maryan Ainsworth has explored the wholesale repetition of motifs and compositions in the work and workshop of Gerard David. David's use of patterns and similes is covered exhaustively in her book, *Purity of Vision in an Age of Transformation* (New York: Metropolitan Museum of Art, 1998).

19. An example of the nebulous relationships between Venetian drawings and surviving paintings is found in the *Head of a Bearded Old Man*, attributed to Giovanni Bellini, in the Royal Collection. J. Roberts, *Master Drawings in the Royal Collection: From Leonardo da Vinci to the Present Day* (London: Collins Harvill, 1986), 26, notes that no direct relationship with any painting by Bellini can be ascertained, although the drawing shares some general similarities to the figure of St. Anthony Abbot from the St. Sebastian Triptych attributed to the Bellini school in the Accademia in Venice. Even when vague similarities exist, such as that found in the *Head of a Bearded Old Man*, it is unclear whether the similarity is due to the drawing predating the painting or vice versa.

20. See Ames-Lewis, *Drawing in Early Renaissance Italy*, 84–8, 140–4, for a discussion of simile drawings in the Italian Renaissance workshop.

21. In central Italy and Tuscany, preparatory drawings are directly related to the production of paintings. Later in the sixteenth century in Venice, drawings on blue-dyed paper were made and utilized preparatory to painting. Leonardo, Michelangelo, and Raphael were especially honored in their own lifetimes for their preparatory drawings. See J. A. Gere, *Drawings by Raphael and His Circle from British and North American Collections* (New York: Pierpont Morgan Library, 1987), 45–8, 56–63, 68–73, and 74–85; and M. Hirst, *Michelangelo Draftsman* (Milan: Olivetti, 1988), 40–50.

22. H. Tietze and E. Tietze-Conrat, *The Drawings of the Venetian Painters*, 2nd ed. (New York: J. J. Augustin, 1969).

23. Mojmír Hamsik, Chief Conservator (now retired) at the National Gallery of Art in Prague, made a number of infrared photographs, which he kindly shared with me. Because of the limitations of the reach of my tripod, I am including some of his photographs to augment my findings using the infrared vidicon. Since my investigation of the painting was conducted in the Galleries of the Narodní Galerie in Prague, I was not able to examine the surface of the painting with a microscope. Nonetheless, based on my examination by naked-eye, it did not appear that the paint was so thickly applied that the underdrawing was in any way obscured.

24. The lines in the underdrawing are of varying widths with tapering ends. However, in the brocaded mantle of the Pope, no underdrawing whatsoever can be seen, despite the good state of the painting and good penetration of the paint

layers with infrared reflectography. Further, the state of the painting must be taken into consideration; for instance, the entire figure of the Virgin is repainted and it is impossible to know whether or not underdrawing existed in these destroyed areas.

25. Even though no sketch for the design of the composition as a whole survives, this does not indicate that there was not one. There must have been some indication of the plan for the layout of the figures within the composition.

26. In the *Salvator Mundi* the underdrawing is so dense and complete that it has been likened to a drawing on paper. See H. B. Wehle, "Preparatory Drawing on a Panel by Dürer," 156–64. The underdrawing in the *Small Virgin* of 1503 in the Kunsthistorisches Museum in Vienna is likewise reminiscent of a drawing on paper.

27. The preparatory drawings are significantly smaller than the painted execution of the *Feast of the Rose Garlands*, precluding the possibility that Dürer traced them onto the panel.

28. P. Humfrey has tentatively identified this man as Johannes Wild. See his article, "Dürer's *Feast of the Rose Garlands:* A Venetian Altarpiece," *Bulletin of the National Gallery in Prague* 1 (1991): 21–33.

29. No underdrawing was found in either the figure of the Pope or in the figure of the monk on the left. It is possible that the condition of the painting was the reason for this. The head of the Pope, with the exception of a small area on the back of his head, has been repainted.

30. G. Vasari, *Vasari on Technique*, trans. L. S. Maclehose (New York: Dutton, 1907), 212–15. Vasari's chapter subheading reads: "Of Sketches, Drawings, Cartoons and Schemes of Perspective; how they are made, and to what use they are put by the Painters." Neither Meder, Watrous, nor Ames-Lewis mentioned Vasari's description of drawings on carta azzurra.

31. Vasari, *Vasari on Technique*, 213. The Italian text is found in Barocchi, I: 118: "altri, di chiaro e scuro, si conducono su fogli tinti, che fanno un mez[z]o, e la penna fa il lineamento cioè il dintorno o profilo, e l'inchiostro poi con un poco d'acqua fa un tinta dolce che lo vela et ombra; di poi, con un pennello sottile intinto nella biacca stemperata con la gomma si lumeggia il disegno; e questo modo e molto alla pittoresca e mostra più l'ordine del colorito. Moltri altri fanno con la penna sola, lasciando i lumi della carta, che è difficile, ma molto mastrevole; et infiniti altri modi ancora si costumano nel disegnare, de quali non accade fare menzione perché tutti rappresentano una cosa medessina."

J. Watrous, in *The Craft of Old-Master Drawings* (Madison: University of Wisconsin Press, 1957), 36, attributes the first mention of this type of drawing to Raffaello Borghini in 1564. According to Watrous, Borghini described this type of drawing as "Chiaro oscuro sopra fogli tinti, che fanno un mezzo." It seems likely that Borghini cribbed his notice directly from Vasari's treatise, first published in 1550. F. H. Jacobs noted that Cellini described contour drawings shaded with wash and heightened with white as the "Bellissimo modi di disegnare," in "An Assessment of Contour Lines: Vasari, Cellini and the *Paragone*," *Artibus et Historiae* 18 (1988): 140. This description is similar to Vasari's description of drawings on tinted paper and suggests to me that drawings of this type had achieved a certain fame in Renaissance artistic and theoretical circles by the middle of the sixteenth century.

32. J. Shearman, "Leonardo's Color and Chiaroscuro," *Zfkg* 25, no. 1 (1962): 13–47.

33. M. G. Poirier, *Studies in the Concepts of Disegno, Invenzione and Colore in 16th and 17th c. Italian Art and Theory*, Ph.D. thesis written under the direction of C. H. Smythe, New York University, New York, 1976 (Ann Arbor: UMI, 1977), noted that in sixteenth-century theoretical treatises, most discussions of light and shade are found in chapters devoted to the discussion of color. See also M. Kemp, *The Science of Art: Optical Themes in Western Art from Brunelleschi to Seurat* (New Haven, London: Yale University Press, 1990), 261–341. Kemp focuses on Tuscan, and not Venetian optical theories in the sixteenth century, but does discuss the relationship of color and perspective to the study of light, especially pertaining to Leonardo.

34. For a discussion of Giovanni Bellini's successful manipulation of equivalent tonal saturations in the construction of corporeal space in the *San Zaccaría Altarpiece*, see R. Wollheim, *Painting as an Art* (Princeton: Princeton University Press, 1987), 332–3.

35. The material in the two outlines differs in particulars but contains the same general information presented in slightly different formats. For the differences between the two versions, see Rupprich, *Nachlass* II: 83–96 and Conway, 167–81.

36. Rupprich, *Nachlass* II: 83–96, 392–394; Conway, 167–81.
Surprisingly, little critical attention has been devoted to the passage on color, "*Von Farben*," in particular. Panofsky did not mention it in *Dürer's Kunsttheorie, vornehmlich in ihrem Verhältnis zur Kunsttheorie der Italiener* (Berlin: G. Reimer, 1915). H. Rupprich, in "Die Kunsttheoretischen Schriften Leoni Battista Alberti's und ihre Nachwirkung bei Dürer," *Schweizer Beiträge zur allgemeinen Geschichte* 18/19 (1960–1): 219–39, mentioned Dürer's manual of painting instruction, but does not discuss the section devoted to color. W. J. Hoffmann, *Über Dürer's Farbe* (Nürnberg: Hans Carl, 1971) discussed parts of this passage in terms of aesthetic theory, but not in relationship to Dürer's practices as observed from close examination of the paintings. Likewise, E. Strauss, "Untersuchungen zur Kolorit der spätgotischen deutschen Malerei," *Koloritgeschichtliche Untersuchungen zur Malerei seit Giotto und andere Studien*, ed. L. Dittmann (Munich: Deutscher Kunstverlag, 1983), 309–11, discussed this passage in relationship to his aesthetic theory of the use of colors by German painters of the late fifteenth and early sixteenth centuries. Strauss argued that Dürer in no way reached any understanding of Venetian color theory in his works.
In Appendix 2, I contrast the original German of the passage titled "Von Farben" with my own translation of the passage for easy reference.

37. Rupprich, *Nachlass* II: 393. Grimm and Grimm, *Deutsches Wörterbuch*, 832–3, report that "erhaben," as an adjective meant "hoch, sublimis." The contemporary usage is nearly the same, as sublime or exalted.

38. Conway, *Literary Remains of Albrecht Dürer* (Cambridge: Cambridge University Press, 1889), 173.

39. Anzelewsky, 1971, 95–6, argued that Dürer's use of "erhaben" in "Von Farben" should be understood as plastic/spatial representation. He said "erhaben" was similar in meaning to the Italian word "rilievo" and related it to Dürer's writing

about perspective and proportion. He did not note that Dürer had used the same word to describe the *Feast of the Rose Garlands.*

40. Rupprich, *Nachlass* I: 55.

41. Conway, 55.

42. Rupprich, *Nachlass* I: 57.

43. Conway, 56.

44. Conway, 173.

45. A. Blunt, *Artistic Theory in Italy 1450–1600* (Oxford: Clarendon, 1940), 93–8.

46. For instance, almost the entire second half of the passage is devoted to a discussion of the color effects of shot silks, or *"changeant"* effects. As Rupprich, *Nachlass* I: 57, pointed out, Dürer did not make use of shot silks in his depiction of drapery. This shows, I believe, that Dürer was emulating another source (almost certainly an Italian one) in his discussion of color and the practical use of colors by painters. On *changeant* effects, see Kemp, *Science of Art*, 265–6.

47. See J. Shearman, "Leonardo's' Color and Chiaroscuro," 13.

48. Tietze and Tietze-Conrat, *KV* II: 9; W. Koschatzky and A. Strobl, *Die Dürer Zeichnungen der Albertina* (Vienna: Residenz, 1971), 224–7. Koschatzky and Strobl argued, like the Tietzes, that because the study of the *Pluviale* is so different in technique from the other surviving preparatory drawings, it must have been the first of the preparatory drawings made by Dürer upon his arrival in Venice. They also asserted that Dürer abandoned this technique upon seeing the Venetian carta azzurra drawings. See also H. Tietze, *Dürer als Zeichner und Aquarellist* (Vienna: Anton Schroll, 1951).

49. J. Meder, "Eine Dürer Zeichnungen," *Mitteilungen der Gesellschaft für vervielfältigende Kunst. Beilag der "Graphische Künste"* 52, no. 4 (1929): 66. Meder implicitly assumed that the drawing that provided the pattern that was traced for the watercolor study is lost.

50. Dürer wrote to Pirckheimer in his letter of September 8: "I have stopped the mouths of all the painters who used to say that I was good at engraving, but as to painting I did not know how to handle my colors." Conway, 55; and Rupprich, *Nachlass* I: 55.

51. Pen drawing, Collection her Majesty the Queen of England, Windsor Castle. See E. Schilling, "Dürer's 'Pupila Augusta'," *Zdvk* 22 (1968): 1–9.

52. Bartsch, 58. The city in this engraving has been identified variously by scholars: Hausmann thought it resembled the fortified city of Marburg, Flechsig said it was not Nuremberg, and the Tietzes' said it combined aspects of Dürer's drawings of Trient, Innsbruck, and Nuremberg. Anzelewsky thought it combined motifs from Innsbruck and Nuremberg and noted that the same vista appeared in the *Pupila Augusta* drawing. See Olds et al., *Dürer's Cities: Nuremberg and Venice.* The catalog entry notes that the vista appears in all three places and that the drawing for the *Pupila Augusta* must date to 1505. See also F. Anzelewsky, *Dürer Werk und Wirkung* (Stuttgart: Elekta, 1980), 65, 199.

53. Thausing, *The Life and Art of Albrecht Dürer* II: 194, identified this view in the engraving as Nuremberg. Many scholars have suggested that this cityscape is a sentimental reconstruction of a particular city or of elements from many cities and have

noted that the vista includes a specific building (the middle building with crenelations) that also occurs in the supposedly veristic watercolor view of Innsbruck.

54. It is possible, but unprovable, that the underdrawn lines apparent with infrared reflectography and with infrared photography go over another design, no longer visible, that was initially traced onto the prepared panel by Dürer. However, the *Pupila Augusta* drawing is smaller in size than the painted rendition of the city vista in the *Feast of the Rose Garlands*. Therefore, Dürer would have had to make an intermediate copy of the drawing to make a cartoon from which to trace the design. This laborious process seems to me to be unlikely.

55. Panofsky 1943, 201–2. Panofsky contrasted the three versions of the townscape and noted the varying spatial aspects in each of the three, but he did not attempt to connect them in any way or to suggest a developmental progression.

56. Jeffrey Chipps Smith once communicated to me that he felt that Dürer's great achievement in the three Master Engravings, and especially in the *St. Jerome*, was the illusion of representing color with the black and white lines of this most graphic medium.

57. This watercolor, W. 118, is in the Bremen Kunsthalle.

58. Vasari, *On Technique*, 214.

59. G. M. Canova, "Rifflessioni su Jacopo Bellini e sul libro dei disegni del Louvre," *Arte Veneta* 26 (1972): 9–30. I thank Keith Christiansen for bringing Canova's article to my attention. See K. Christiansen, "Venetian Painting of the Early Quattrocento," *Apollo* 75, no. 301 (March 1987): 166–77. Christiansen notes that though Jacopo Bellini was known for his use of a perspectival system approximating Alberti's in the *Annunciation* in the Church of San Alessandro in Brescia, datable to ca. 1444, his celebrity was based upon his skill as a painter and not his theoretical work. Further, Jacopo's perspectival constructions seem to have been related to the effects of atmospheric perspective achieved through color and not to a geometric system.

60. For a discussion of Giovanni da Fontana's life and works, with the exception of the previously cited passage, see L. Thorndike, *A History of Magic and Experimental Science, Vol. 4, Fourteenth and Fifteenth Centuries* (New York: Columbia University Press, 1934): 150–82.

61. Canova, "Rifflessioni su Jacopo Bellini," 22. Canova reproduces the Latin text as follows:

> Ab hac naturali experientia ars pictoria optimos canones, accepit ut in libello ad Iacobem bellinum venetum pictorem insignem certe descripsi, quibusque modis colores obscuros et claros apponere sciret, tali cum ratione, quod non solum unius imaginis partes relevatae viderentur in plano depictae, verum extra manum vel pedem porrigentes crederentur inspectae, et eorum, quae in eadem superficie hominum animalium vel montium equantur quaedam per miliaria distare apparerent atque eiusmodi. Ars quidem pingendi docet propinqua claris, remota obscuris mediaque permixtis sub coloribus tingi deberi.

62. Dürer wrote, "wan an allen dingen ist lichts und finsters, was sich aws den awgen krumt oder pewgt." Conway translated this as: "There is light and shadow

on all things, wherever the surface foldeth or bendeth away from the eye." See Appendix 2.

This passage is also of interest because it recalls Pliny's description of Pausias' ability to paint an ox so that it appeared in relief. I believe that this refers to the fall of the light on the body of the ox. This passage is of sufficient interest to reproduce here. It was translated by K. Jex-Blake in *The Elder Pliny's Chapters on the History of Art* (Chicago: Argonaut, 1968), 153 as follows: "[Pausias] devised an innovation which has often been imitated but never equaled. The most striking instance is that wishing to display an ox's length of body, he painted a front and not a side view of the animal, and yet continued to show its size. Again, while all others put in the highlights in white and paint the less salient parts in dark colour, he painted the whole ox black and gave substance to the shadow out of the shadow itself showing great art in giving all his figures full relief upon the flat surface."

See Pollitt, *The Ancient View of Greek Art*, 399–400, for a discussion of this passage and the Plinian and classical uses of *lumen et umbra*, "light and shade."

63. These are exactly the qualities for which Giovanni Bellini is celebrated: the subtle response of colors shimmering in light within fully organized and structured spatial environments. See the discussion of the *San Zaccaría Altarpiece* in Chapter 4.

64. For a discussion of the organizations and contents of Lomazzo's treatise, see G. M. Ackerman, "Lomazzo's Treatise on Painting," *Art Bulletin* 49, no. 4 (December 1967): 317–26. See also M. Kemp, "'Equal excellences': Lomazzo and the Explanation of Individual Style in the Visual Arts," *Renaissance Studies*, 1, no. 1 (March 1987): 1–26.

65. See C. J. Ffoulkes and R. Majocchi, *Vincenzo Foppa of Brescia, Founder of the Lombard School. His Life and Work* (London and New York: Lane, 1909), 243–4 and n. 5. For the most recent bibliography and collected documents about Foppa's life, see M. G. Balzarini, *Vincenzo Foppa*, (Milan: Jacca, 1997). For further discussion of Dürer's knowledge of the particular techniques associated with Foppa, see Chapter 5.

66. Titles about perspective, the rational construction of space according to mathematical means, are much too numerous to list here. Besides Panofsky, who was devoted to the rational explanation of pictorial space, J. White's, *The Birth and Rebirth of Pictorial Space* (London: Faber and Faber, 1957) is exemplary of this tendency in the art historical literature. For discussions of Panofsky's adherence to the philosophical idea first explored by Ernst Cassirer, that perspective was a symbolic form, see M. Podro, *The Critical Historians of Art* (New Haven: Yale University Press, 1982), 186–9; and M. A. Holly, *Panofsky and the Foundations of Art History* (Ithaca, N.Y.: Cornell University Press, 1984), 114–57. Two authors who take issue with the "scientism" and narrow mathematical focus of much recent writing about perspective are J. Elkins, *The Poetics of Perspective* (Ithaca, N.Y.: Cornell University Press, 1994) and N. K. Smith, *Here I Stand: Perspective from Another Point of View* (New York: Columbia University Press, 1994).

67. M. Kemp, *The Science of Art*, 261–73.

68. L. B. Alberti, *On Painting*, trans. J. R. Spencer (New Haven: Yale University Press, 1956), 40.

69. Alberti, *On Painting*, 49. See also Spencer's comments about Alberti's concern with visibility and light (p. 19). Alberti wrote: "This reminds me to speak of both color and light. It seems obvious to me that colors take their variations from light, because all colors put in the shade appear different from what they are in the light. Shade makes color dark; light, where it strikes, makes color bright. The philosophers say that nothing can be seen which is not illuminated and colored. Therefore, they assert that there is a close relationship between light and color in making each other visible. The importance of this is easily demonstrated for when light is lacking color is lacking and when light returns the colors return" (p. 40).

70. The literature on Albertian and post-Albertian perspective is enormous and widely varied. For the problems in Alberti's discussion of color theory, see S. Edgerton, Jr., "Alberti's Color Theory: A Medieval Bottle Without Renaissance Wine," *JWCI* 32 (1969): 109–134. As Edgerton pointed out, Alberti's discussion of the interrelationship of light and color is not particularly sophisticated; however, the details and origins of Alberti's theory are not critical to my argument. What is important is Alberti's assertion that color and light are an integral part of the construction of the perspectival space in pictures.

71. Edgerton, "Alberti's Color Theory," phrased Alberti's theory of tonal harmony as follows: "all colors should be held to a uniform scale by the proper manipulation of black and white, thus ordering a uniform atmosphere of balanced light and shade," 110. For Leonardo's dependence on the Albertian scheme of tonal unity, see Shearman, "Leonardo's Color," 13–47. See also J. Gavel, *Colour: A Study of Its Position in the Art Theory of the Quattro and Cinquecento, Stockholm Studies in the History of Art* (Stockholm: Almquist & Wiksell International, 1979); and P. Hills, *The Light of Early Italian Painting* (New Haven: Yale University Press, 1987), 139–41.

72. The two panels traditionally associated with the *Jabach Altarpiece*, the *Two Musicians in Cologne* and the *Job* in Frankfurt, show this graphic handling of paint unambiguously, especially in the construction of the features of the faces. Small brush strokes are individually handled in these areas to indicate the features. The final touches are actually applied in a dark brown or black paint. Details similarly executed are found in many other paintings by Dürer and associated with his workshop. The *Ober St. Veit Altarpiece*, traditionally attributed to Hans Schäufelein (working under Dürer's instruction in his workshop after Dürer had already departed for Italy), shares this graphic construction of details on the surface of the painting. See Ainsworth, "Schäufelein," 135–40. Similarly, the *Holzschuher Lamentation*, the *Glimm Lamentation*, and the *Paumgartner Altarpiece*, all traditionally associated with Dürer's workshop, show a similar dependence on graphic detail in the finishing of the forms and features.

73. It is possible that Dürer did not have access to *carta azzurra* when he was in Nuremberg.

Chapter 4. The *Feast of the Rose Garlands* II

1. Dürer's relationship to Bellini has never been in question since Bellini was the only Venetian artist that Dürer mentioned by name in his letters to Pirckheimer. Unlike the *Paragone*, about which a great deal has been written, less attention has been

paid to competition between artists for its own sake. See A. M. Kosegarten, "The Origins of Artistic Competitions in Italy (Forms of Competition Between Artists Before the Contest for the Florence Baptistry Doors Won by Ghiberti in 1401.)," *Lorenzo Ghiberti nel suo tempo. Atti del convegno internazionale di studi*, Florence: L. S. Olschki, 1980, pp. 167–86; and L. Wolk-Simon, "Fame, *Paragone*, and the Cartoon: The Case of Perino del Vaga," *Master Drawings* 1 (1992): 61–82.

2. Thausing, II: 111.

3. Wölfflin, 1905, 29, 148.

4. Tietzes, *KV* II: 29. See R. Goffen, *Giovanni Bellini* (New Haven and London: Yale University Press, 1989), 102, for a reproduction of the *Pala Barbarigo*.

5. Panofsky, 1943, 112.

6. T. Pignatti, "The Relationship Between German and Venetian Painting in the Late Quattrocento and Early Cinquecento," in *Renaissance Venice*, ed. J. P. Hale (London: Faber, 1973), 258.

7. A. Chastel, "Dürer à Venise en 1506," *Giorgione e l'umanesimo veneziano, Vol. 1, Giorgione e la Cultura Figurativa del Suo Tempo*, ed. R. Pallucchini (Florence: L. Olschki, 1981), 463.

8. Rupprich, *Nachlass* I: 55. "Jtem wist, daz mein thafell sagt, sy wolt ein dugaten drum geben, daz jrs secht, sy sey gut und schon fon farben. Jch hab gros lob dordurch über kumen, aber wenig nutz. Jch wolt woll 200 dugaten dÿ tzeit gwunen haben und hab gross erbett aws geschlagen, awff daz ich heim müg kumen, und ich hab awch dy moler all geschtilt, dy do sagten, jm stechen war jch gut, aber jm molen west ich nit mit farben um zu gen. Jtz spricht jder man, sy haben schoner farben nie gesehen."

9. Rupprich, *Nachlass*, I: 57. "wan all künstner loben daz. . . . Sÿ sagen, daz sy erhabner leblicher gemell nie gesehenn haben." For a discussion of the significance of Dürer's use of "erhaben," see Chapter 3.

10. Rupprich, *Nachlass* I: 44.

11. Rupprich, *Nachlass* I: 42. Dürer related the news of the commission in the letter of January 6, 1506.

12. Rupprich, *Nachlass* I: 43. Earlier in the letter of February 7, Dürer complained of the jealousy of the other Venetian painters and noted that he had been warned against eating and drinking with them. The implication was, I believe, that he feared they might be so envious of his success that he might be poisoned. The German text as it appears in Rupprich reads as follows: "Ich hab vill guter frewnd vnder den Walhen, dy mich warnen daz jch mit jren moleren nit es und trink."

13. Dürer's quotation of Bellini's paired trees is also found in the *Pupila Augusta* drawing (Figure 64). As I discussed in Chapter 3, Dürer added a pair of framing trees to the drawing of the distant city vista later repeated in the *Feast of the Rose Garlands*.

14. Goffen, *Giovanni Bellini*, 171–5, argues that the monumentality of Bellini's figures is due to his understanding of light and shadow.

15. Bellini used the illusionistic device of a scrap of paper pasted onto the painting to claim his authorship throughout the course of his life. Such illusionistic "tags" are found on the early *St. Jerome in the Wilderness* in the Barber Institute of Fine Arts in

Birmingham, England and the *Transfiguration of Christ* in the Civico Museo Correr in Venice, many of his Madonna and Child compositions, including the *Madonna and Child* in the John G. Johnson Collection, Philadelphia, the *Madonna and Child* in the Isabella Stewart Gardner Museum in Boston, the *Lochis Madonna* in the Galleria dell'Accademia Carrara in Bergamo, the *Contarini Madonna* in the Galleria dell'Accademia in Venice, and the *Madonna of the Pear* in the Galleria dell'Accademia Carrara in Bergamo. Illusionistic scraps also appear in the *St. Francis in Ecstasy* in the Frick Collection, New York; the *San Giobbe Altarpiece* in the Galleria dell'Accademia in Venice; the *San Zaccaria Altarpiece*, San Zaccaria, Venice, and many others, too numerous to list here.

16. Dürer used a greater variety of formats for the incorporation of his monogram into prints than paintings. In prints he used cartouches, carved tablets, and at times he allowed his monogram to float freely in the space of the image. Cartouches were included in, among others, the *Saint Christopher* (B. 104) of ca. 1500–2, the *Nemesis* (B. 77) of 1501–3, the *Death's Escutcheon* (B. 101) of 1503, the *Adam and Eve* (B. 1) of 1504, and the *Rest on the Flight into Egypt* (the fifteenth illustration of the woodcut *Life of the Virgin* first published in 1511) (B. 90) of ca. 1501–2. A carved tablet appears in the 1503 engraving *Virgin on a Grassy Bank* (B. 34) and the 1505 *Small Horse* (B. 96).

Dürer used an illusionistically conceived slip of paper to carry his monogram in four prints that are usually dated earlier than 1506, although these bear only Dürer's monogram and not a long inscription. Significantly, none of these examples show Dürer's firsthand experience with the Venetian, and specifically Belliniesque, practice of writing one's name out in full on a scrap of paper. Dürer seems to have appropriated this practice from Giovanni Bellini. Dürer's monogram is found on a piece of paper that is attached to the wall behind Sebastian in the 1498–9 *St. Sebastian* (B. 56). Karl-Adolf Knappe, *Dürer: Das graphische Werk* (Vienna and Munich: Anton Schroll, 1964), 10, noted that this engraving was dependent on Cima da Conegliano. Although the direct source for this motive is not known, it is possible that Dürer acquired the motif of both Sebastian and the attached piece of paper bearing his initials from the same source, either a print or a reproductive drawing. In the later 1500–2 *St. Sebastian on a Tree* (B. 55), the monogram is found on a slip of paper attached to the branch of a tree. In the 1502–3 *Apollo and Diana* (B. 68), his monogram is found on a slip of paper illusionistically attached to the surface of the paper, outside of the pictorial space. This occurrence may perhaps be explained by the close connection of this print to the works of Jacopo de Barbari, who was in Nuremberg from 1500. De Barbari could have learned of the practice in Venice. The last example of Dürer placing his monogram on a scrap of paper occurs in the 1500–2 *St. Eustachius* (B. 57), in which the scrap of paper appears to be attached to the surface of the print, similar to that found in the *Apollo and Diana*.

17. Dürer's signature floats freely in the 1493 *Self-Portrait* in the Louvre, in the later 1498 *Self-Portrait* in the Prado in Madrid, and in the 1500 *Self-Portrait* in the Alte Pinakothek in Munich. Stone tablets bearing the illusionistically carved date and monogram are used in the *Adoration of the Magi* of 1504 in the Uffizi in Florence. The *Adam and Eve* of 1507, in the Prado in Madrid, combines the earlier practice of

using a cartouche with the inscription on paper first used in Venice. In the cartouche that hangs to the left of Eve, the information about Dürer's authorship is written on a piece of paper that appears to be attached to the wooden support. Dürer continued to use a variety of different identifying methods in his later paintings, including the use of inscriptions on paper, in, for instance, the *Martyrdom of the 10,000* in Vienna. On the other hand, in *the Adoration of the Trinity and the All Saints*, Dürer painted a carved tablet to convey this information.

Deborah Pincus is preparing an article on the form of Giovanni Bellini's signature when attached to scraps of paper that will appear in the companion volume to Peter Humfrey's volume (2003) on Giovanni Bellini.

18. Panofsky, 1943, 110; and Chastel, "Dürer à Venise en 1506," 463.

19. Goffen, *Giovanni Bellini*, 175, asserts that the polychromatic sophistication of the *Altarpiece* is unequaled at this date. For other technical studies of Bellini's use of pigments, see D. Bull and J. Plesters, *The Feast of the Gods: Conservation, Examination, and Interpretation*, Studies in the History of Art Monograph Series II, Vol. 40 (1990); and G. N. Sciré, "La Pala Barbarigo e l' "attramentum" di Apelle," *Quaderni della Soprintendenza ai beni artistici e storici di Venezia*: 41–3.

20. Goffen, *Giovanni Bellini*, 175, n. 69, notes that the robe of St. Peter (on the left) in the *San Zaccaria Altarpiece* is particularly advanced in that Bellini used a combination of orpiment and realgar to achieve this orangey color, and that he was among the first painters to use this combination of pigments.

21. The literature on imitation in Renaissance painting and painting theory is large. For an introduction to the meaning of imitation to artists and especially painters in the Renaissance, see Blunt, *Artistic Theory*, 88–90. E. Gombrich discusses the variations and nuances of imitation throughout the essays included in his book *Art and Illusion: A Study in the Psychology of Pictorial Representation* (Princeton: Princeton University Press, 1969).

22. For a discussion of the variety of meanings attached to "imitation" by Vasari, see J. V. Mirollo, *Mannerism and Renaissance Poetry: Concept, Mode, Inner Design* (New Haven: Yale University Press, 1984), 11–15.

23. For a clear discussion of the centrality of the imitation of nature to the rebirth of the art of painting during the Renaissance, see Panofsky, *Renaissance and Renascences in Western Art*, 12–21.

24. Summers, *Michelangelo*, 193, noted that Petrarch based his interpretation of the necessity of imitation on Classical authors, particularly Seneca and Quintilian. He notes that "Quintilian considered imitation a blessing and a curse: a blessing because the arts had been founded and husbanded before us, a curse because the existence of literary models encourages laziness."

25. Summers, *Michelangelo*, 279, reproduced this critical passage.

26. Summers, *Michelangelo*, 280.

27. R. Fry, ed. *Records of Journeys to Venice and the Low Countries by Albrecht Dürer* (New York: Dover, 1995), xii–xx. It is interesting that Fry's criticism of Dürer's painting is based upon neoplatonic ideals formulated in the Renaissance. For a discussion of the neoplatonic differentiation between ordinary imitation and an idealizing imitation, see Blunt, *Artistic Theory*, 88–9.

28. See Rupprich, *Nachlass* I: 55.

29. There is an extensive literature on the importance of imitation in the study of Renaissance literary theory. For a discussion and comparison of the different forms of Renaissance imitation by humanist scholars and a complete bibliography, see Pigman, "Versions of Imitation," 1–32.

30. Thomas Crow has explored the artistic and personal relationship between David and his studio members in *Emulation*, 1994. Harold Bloom's *Anxiety of Influence* also provides a model for thinking about artistic and competitive relationships among artists.

31. Fry, *Dürer's Records*, xx.

32. Pigman, "Versions of Imitation," 16–32.

33. Pigman, "Versions of Imitation," 4, 16–32, discusses the etymology of eristic imitation in relationship to Plato's reuse of Homeric and Hesiodic texts. Pigman defines eristic imitation as "an open struggle for preeminence, a struggle in which the model must be recognized to assure . . . victory."

34. See Pliny the Elder, *Natural History: The Elder Pliny's Chapters on the History of Art*, trans. K. Jex-Blake, intro. by E. Sellers (Chicago: Argonaut, 1968), 123. A more recent translation of the Chapters on the History of Art is found in Pliny the Elder, *Natural History: A Selection*, trans. with intro. and notes by J. F. Healy (London and New York: Penguin Books, 1991).

35. For discussions of the comparison of Dürer to Apelles, see *Białostocki, Dürer and His Critics*, 15–36; and A. Smith, "Dürer and Bellini, Apelles and Protogenes," *BM* 114, no. 830 (1972): 326–9. For the meanings of the Apellian metaphor in relationship to painters of the later sixteenth and seventeenth centuries, see Z. Z. Filipczak, *Picturing Art in Antwerp 1550–1700* (Princeton: Princeton University Press, 1987). D. Cast discusses the Lucian account of envy in relationship to Apelles in *The Calumny of Apelles: A Study in the Humanist Tradition* (New Haven and London: Yale University Press, 1981).

36. Pliny, *Natural History*, trans J. F. Healy, 1991, 331–2. For a discussion of this text in relationship to seventeenth century art theory in Holland, see H. van de Waal, "The *Linae Summae Tenuitas* of Apelles; Pliny's Phrase and Its Interpreters," *Zeitschrift für Aesthetik und allgemeine Kunstwissenschaft* 12 (1967): 5–32.

37. See, among others, Blunt, *Artistic Theory*; and M. Barasch, *Theories of Art: From Plato to Winckelmann* (New York: New York University Press, 1985).

38. Pliny, *Natural History*, 1968, 141.

39. Alberti, *On Painting*, 95, 134 n.14. Spencer points out that since Pliny mentions Nichomachus in a passage following a discussion of Aesclepiodorus, Alberti either misread Pliny or had an edition of Pliny that had a lapsus at the passage concerning Nichomachus.

40. M. Barasch, *Light and Color in the Italian Renaissance Theory of Art* (New York: New York University Press, 1978), n. 30, 126. See also Alberti, *On Painting*, 95.

41. Summers, *Michelaugelo*, 35. Baldassare da Castiglione, *Il libro del Cortegiano Baldesare Castiglione:* a cura di Walter Barberis (Venice, 1528; Torino: Einaudi, 1998). See also J. Shearman, *Mannerism* (New York: Penguin Books, 1967), 21.

42. Shearman, *Mannerism*, 63, 177–85.

43. Barasch, *Theories of Art*, 226.
44. Barasch, *Theories of Art*, 226.
45. Shearman, *Mannerism*, 21.
46. C. Sorte, *Osservazioni della pittura: con l'aggionta d'una cronichetta dell'origine della magnifica città di Verona* (Venice: Gio. Ant. Rampazetto, 1580); P. Barocchi, ed., *Trattati d'arte del cinquecento fra manierismo e controriforma* (Bari: Laterza, 1959); and Barasch, *Light and Color*, 97–8.
47. P. Pino, *Dialogo di Pittura* (Venice: Rampazetto, 1548). See too, M. Pardo, *Paolo Pino's "Dialogo di Pittura": A Translation with Commentary*. Dissertation, University of Pittsburgh, Pittsburgh 1984 (Ann Arbor: UMI, 1985); and R. Klein and H. Zerner, *Italian Art 1500–1600: Sources and Documents* (Evanston, Ill.: Northwestern University Press, 1966), 58–60.
48. Summers, *Michelangelo*, 63; Wölfflin, *Albrecht Dürer: Handzeichnungen*, 150, borrowed the notion of effortlessness as an attribute of artistic skill from Vasari and other Renaissance writers and criticized Dürer's emulation of the Venetians because his attempts to attain an Italian form of expression showed too much exertion on his part. He described the problem as follows: "everywhere [in the *Feast of the Rose Garlands*] the striving after too much affect stands in the way." Ideal painterly vision was an innate characteristic of the Venetians that could not be imitated, no matter how diligently and industriously it was sought.
49. Much more attention has been given to the iconographic meaning of the *Twelve Year Old Christ* and the sources Dürer tapped in its production than to its technique and method of execution. Primary bibliography concerning the iconography of the painting includes O. Chomentovskaja, "Le Comput digital dans l'art Italien," *Gazette des Beaux-Arts* 80, no. 2 (1938), 157 ff.; Panofsky, 1943, 114–16; J. Białostocki, "Opus Quinque Dierum: Dürer's 'Christ Among the Doctors' and Its Sources," *JWCI* 22 (1959): 17–34; Anzelewsky, 1971, 202–5; and A. Boesten-Stengel, "Albrecht Dürers zwölfjähriger Jesus unter den Schriftgelehrter der Sammlung Thyssen-Bornemisza, Lugano," *Idea* 9 (1990): 43–66.
50. Most scholars have accepted the inscription on the painting as accurate, with the caveat that Dürer could not have included the time he spent on the preparatory drawings in the five months mentioned.
 The time spent by Dürer in the production of paintings has received little attention. Using the documentary evidence found in the diary kept by Dürer on his journey to the Netherlands in 1520–1, Siegfried Czerny-Heidelberg attempted to reconstruct the amount of time expended by Dürer in painting the now-lost portrait of Christian of Denmark. Czerny-Heidelberg suggested that Dürer spent approximately eight days in the production of this portrait. However, he made no attempt to tie the investigation of the time expended by Dürer in painting the portrait to notions of virtuosity or technical prowess. See S. Czerny-Heidelberg, "Wie lange hat Dürer an einem Bildnis gemalt?," *Technische Mitteilungen für Malerei* 46, no. 15 (August 1, 1930): 174–5.
51. Dürer mentioned another painting in the letter of September 23, 1506, in conjunction with the *Feast of the Rose Garlands*. He called this "another painting the like of which I have never painted before," Rupprich, *Nachlass* I: 57. The reference

to this other picture, called a "quar" by Dürer, is found between two references to Dürer's satisfaction with and completion of the *Feast of the Rose Garlands*. "Quar" was interpreted by Panofsky as a shortening of the Italian word "quadro." Dürer used such pigeon Italian in his letters to Pirckheimer more and more often over the course of the year, perhaps to show off his acquisition of the Italian language, perhaps to prove to Pirckheimer that he was capable of conversing in the language of scholarship. See Panofsky, 1943, 108–9, for a discussion of Dürer's use of a "Maccharonian mixture of Venetian Italian and Latin" in these letters.

Many scholars have asserted that this painting must be the *Christ Among the Doctors*, (Figure 70) in the Thyssen Collection in Lugano, and that Dürer might have painted it for Giovanni Bellini. Thausing, *Dürer*, first made this argument, and it has been widely, although not universally, accepted since then. Panofsky, 1943, 114–15, agreed that the "quar" must refer to the Lugano painting. Other scholars have disagreed with this position. The arguments and literature about this painting were collected by Lübbecke, *Early German Painting*, 218–40. See also Boesten-Stengel, "Albrecht Dürers Zwölfjähriger Jesus," 43–66.

52. J. Białostocki, "Opus Quinque Dierum," 34. Białostocki suggested that the similarity of the inscriptions must have signified to Dürer that the two paintings represented two stylistic poles as well as "two modes of artistic and spiritual conception."

However, the critical reception of the *Christ Among the Doctors* has not been positive. Wölfflin, 1905, for example, dismissed the *Christ Among the Doctors* as a "mere curiosity' ("bloßes kuriosum"), and Białostocki, "Opus Quinque Dierum," asserted that the *Feast of the Rose Garlands* was superior to it.

53. Rupprich, *Nachlass* I: 44. In his letter, Dürer referred to Bellini as "Sambelling." "Aber Sambelling der hett mich vor vill czentillhomen fast ser globt. Er wolt geren ettwas von mir haben und ist selber zw mir kumen und hat mich gepetten, jch solt jhm etwas machen, er wols wol czalen. Und sagen mir dÿ lewt alle, wy es so frumer man seÿ, daz jch jm gleich günstig pin." Thausing, *Dürer*, first suggested that Dürer had painted the *Christ Among the Doctors* for Bellini, although neither he nor later scholars have been able to offer more than speculations about the link between the two artists.

54. Thausing, II: 356–7. Thausing asserted that Lorenzo Lotto could have seen the painting while it was in Bellini's possession and borrowed from it the motif of the Pharisee on the left for use in his depiction of St. Onuphrius in his painting of the *Virgin and Saints* in the Borghese gallery.

55. Rupprich, *Nachlass* I: 42. Dürer calls the Germans in Venice "den Tewczschen."

56. Rupprich, *Nachlass* I: 42. Dürer's German reads: "Wan sy mus, ob gott will, ein monett nach Ostern awff dem altar sten."

57. Rupprich, *Nachlass* I: 45. "Wist awch, . . . daz jch flux erbet. Aber vor Pfingsten getraw jch nitt fertig zw werden."

58. Rupprich, *Nachlass* I: 49. The first glimmer of anxiety about the completion of the panel reads: "Aber es jst ein grosse erbet doran und ich kan sy vor Pfingsten nit woll aws machen." Dürer later complained about the financial hardship due to

the cost of living and the various purchases he had made: "Wan die thafell, dy awff Pfingsten bereitt wirt, gett alle awff tzerung, Kawffen und tzalung."

59. Rupprich, *Nachlass* I: 50–4. It is also possible that Dürer was so anxious about his tardiness in completing the altarpiece that he avoided any mention of it.

60. Rupprich, *Nachlass* I: 55.

61. Conway, 56; Rupprich *Nachlass* I: 57. "Auch wist, daz mein tafell fertig ist, awch ein ander quar, des gleichen jch noch nie gemacht hab. Und wie jr ewch selbs wol gefalt, also gib jch mir hÿ mit awch zu fersten, daz pessers Maria pild jm land nit seÿ, wan all künstner loben daz, wy ewch dy herschaft. Sÿ sagen, daz sy erhabner leblicher gemell nie gesehenn haben." See Chapter 3 for my discussion of the meaning of "erhaben" to Dürer.

62. Koschatzky and Strobl, *Die Dürer Zeichnungen der Albertina*, 232, 238, noted that the original large folio sheets must have been cut in half sometime after 1822, since they were listed in the 1822 inventory of Duke Albert of Saxony-Teschen as single sheets. See also Strauss, *Complete Drawings of Albrecht Dürer*, II: 934, 952.

63. Lübbecke, *Early German Painting*, 224, reproduces these two drawings as if reunited. Unfortunately, the two photographs used by Lübbecke differ in contrast. This makes the connection of the two drawings seem less convincing than it is in reality. Further, there seems to be a small strip missing from the edge of one or both of the drawings. Because of this, the curly hairs of the angel that continue on the abutting page with the head of Christ do not continue smoothly, but are slightly out of kilter with one another.

64. Koschatzky and Strobl, *Die Dürer Zeichnungen der Albertina*, 232.

65. Panofsky, 1943, 110.

Chapter 5. After Venice

1. M. J. Friedländer called the painting of flesh the essential part of the composition, "the principal work" of painting. In Kühn et al., *Reclams Handbuch der Künstlerischen Techniken*, 224.

2. For the literature about this painting prior to 1971, see Mende, *Dürer Bibliographie*, and Anzelewsky, 1971, 45, 71, 227, 231, 272.

3. E. Heidrich, *Geschichte des Dürerschen Marienbildes* (Leipzig: K. W. Hiersemann, 1906), 93–4. Heidrich was troubled by the formal qualities of the painting, and wrote: "Das Bild ist vollig ungenießbar, wenn man es in seinem formalen Bewegungsinhalt aufnehmen will."

4. E. Heidrich, in *Die altdeutsche Malerei. 200 Nachbildungen mit geschichtlicher Einführung und Erläuterungen* (Jena: E. Diederich, 1909), 36, contrasted the *Virgin with the Pear* to the *Small Madonna* in Vienna to show the influence of the Italian trip on Dürer.

5. Panofsky, 1943, 132. Ironically, the Christ Child is based upon a sculptural model by Verrocchio.

6. See W. Bode, "Die Italienischen Skulpturen der Renaissance in den königlichen Museen II. Bildwerke des Andrea del Verrocchio," *Pr.Jb* 3 (1882): 91–105; W. Heil, "A Marble Putto by Verrocchio," *Pantheon* 27, no. 4 (July/August

1969): 271–82; and most recently, Andrew Butterfield, *Andrea del Verrocchio* (New Haven, London: Yale University Press, 1997).

7. I thank Lisa Farber for her help in making me see this important connection.

8. Notable examples of Bellini's use of this motif include the *Madonna Greca* in the Brera in Milan and the *Morelli Madonna* in the Gallerie dell'Accademia Carrarra, Bergamo.

9. I am grateful to Dr. Karl Schütz of the Kunsthistorisches Museum, Vienna, for his permission to investigate this painting. The investigations were carried out in the conservation laboratories of the Kunsthistorisches Museum on September 20, 1988, with the assistance of Professor Gerald Kaspar, Elke Oberthaler, and Monika Strolz.

10. Thausing, 34, noticed the contrast between the flesh tones of the Christ Child and the Virgin, although he attributed the difference to the play of light and shadow rather than to technique directly. He noted that the "uncommonly fluent and delicately blended flesh is tinted rosily in the light and with gray in the shadows."

11. Even though the paint in the Christ Child is less penetrable than that in the figure of the Virgin, it is still possible to distinguish the very summary, even scant underdrawing in the infrared reflectogram assemblies. I do not believe that the paint layers conceal a more complete underdrawing.

12. *The Infant Christ Child*, brush, heightened with white on blue Venetian paper, Paris, Bibliothèque Nationale, 1506. Heidrich thought Dürer went back to this study for the *Feast of the Rose Garlands* while painting the *Virgin with the Pear*. See Heidrich, *Geschichte des Durerschen Marienbildes*, 93. On the other hand, H. Th. Musper did not believe that the drawing from the *Feast of the Rose Garlands* was reused for the Christ Child in the *Virgin with the Pear*. See H. Th. Musper, *Albrecht Dürer* (New York: Abrams, 1965), 108.

13. For a discussion of the terms of the patronage of the *Martyrdom of the 10,000* and the *Adoration of the Trinity and the All Saints*, see F. Klauner, "Gedanken zu Dürer's Allerheiligenbild," *JKSW* 39 (1979): 57–92.

14. It is perhaps because of the modeling of these figures and their importance in the painted composition, that Carel van Mander described this painting as a "crucifixion" when he saw it in the collection of Rudolf the II in Prague just after the turn of the seventeenth century. See C. van Mander, *Het schilderboeck* (Haarlem: Paschier van Wesbusch, 1604). For a modern translation, see C. van Mander, *The Dutch and Flemish Painters*, trans. C. van de Wall (New York: McFarlane, 1936).

15. For the most convincing discussion of the iconography and patronage of this painting, see C. M. Carty, "Albrecht Dürer's *Adoration of the Trinity*: A Reinterpretation." *Art Bulletin* 67, no. 1 (1985): 146–53.

For discussion of the supposed portrait heads in the painting, see A. Gümbel, "Die Stifterbildnisse auf Dürers Allerheiligenaltar," *Rep* 46 (1925): 225–30. Gümbel identified both Matthäus Landauer, but with little convincing supporting evidence.

16. The underdrawing in some of the smaller, more "minor" figures in the *Adoration of the Trinity and the All Saints* is looser, and less controlled. This looser underdrawing occurs in the ring of angels surrounding the dove of the Holy Ghost at the top center of the painting. The looseness of the underdrawing here strongly

suggests that Dürer was working directly on the panel, inventing the details of the composition as he worked. Some of the faces in the bottom tier in the right half of the painting show a similarly loose and free execution in the infrared reflectogram assemblies, which suggests that Dürer was composing directly on the panel here as well.

17. It is of interest to note that the harp of King David shows one of the few areas in the entire painting where Dürer altered his original conception of the form planned in the underdrawing. In the infrared reflectogram assembly, the under-drawn depiction of King David's harp is different, and slightly larger, than it was ultimately painted. The base originally extended lower down into the cloud bank. This alteration was executed in the paint layers and is also visible in the X-radiograph of this area.

18. It is also worth noting that the body of the Christ Child in the *Haller Madonna* in the National Gallery of Art in Washington, D.C., is modeled with a thick gray paint that was impervious to infrared reflectography. Only the contours of the body of Christ were visible in my technical examination. See Figure 27.

19. Kühn et al., *Reclams Handbuch*, 224–6. See too, Hills, *The Light of Early Italian Painting*, 56–7.

20. The *Kahn Madonna* of about 1280 in the National Gallery of Art in Washington, D.C., is an early example. For technical information about this paint-ing, see H. Belting, "The 'Byzantine' Madonnas: New Facts About Their Italian Origin and Some Observations on Duccio," *Studies in the History of Art* 12, (1982): 7–24; and A. Hoenigswald, "The "Byzantine Madonna: Technical Investigation," *Studies in the History of Art* 12, (1982): 25–32.

21. Kühn et al., *Reclams Handbuch*, 224–6. Also, W. Felicetti-Liebenfels, *Geschichte der byzantinische Ikonenmalerei* (Lausanne, Olten: Urs Graf Verlag, 1956), 90; M. B. Fiorin, "Giovanni Permeniate pittore greque a Venezia e una tavola del Mu-seum Nazionale di Ravenna," *Bolletino d'Arte* 11 (1981): 85–8; M. B. Fiorin, "Pit-tori Cretesi-Veneziani e "maddoneri." Nuove indagini ed attribuzioni," *Bollettino d'Arte* 73, no. 47 (January/February 1988): 71–84; M. Acheimastou-Potomianou *From Byzantium to El Greco: Greek Frescoes and Icons* (London and Athens: Greek Ministry of Culture: Byzantine Museum of Athens, 1987); V. Lasareff, "Saggi sulla pittura veneziana dei secolo XIII–XIV, La maniera greca e il problema della scuola cretese (I–II)," *Arte Veneta* 19 (1965–6): 43–61; and G. Fedalto, "Stranieri a Venezia e a Padova," *Storia della Cultura Veneta: Dal primo Quattrocento al Concilio di Trento*, ed. G. Arnaldi and M. P. Stocchi (Vicenza: Neri Pozza Editore, 1980): 499–535.

22. Fedalto, "Stranieri a Venezia e a Padova," 512.

23. Cennini, 46–47, 49, 58, 94–96. See also D. Gordon et al., "Nardo di Cione's 'Altarpiece: Three Saints,'" *National Gallery Technical Bulletin* 9 (1985): 33–7.

24. In the last decades of the fifteenth century, Foppa was commissioned to paint an altarpiece for the Spinola Chapel in the Church of San Domenico in Genoa. Un-til 1477, that altar had been occupied by a Byzantine Madonna colloquially known as "La Mora." See W. Suida, "Two Unknown Pictures by Vincenzo Foppa," *BM* 45 (November 1924), 210–15. The earliest monograph on Foppa was written by

Ffoulkes and Majocchi, *Vincenzo Foppa of Brescia*. See the review of this publication as well: F. M. Valeri, "Il Foppa in una recente publicazione," *Rassegna d'Arte* 9, no. 5 (May 1909): 84–8. Recent interest in Foppa's career has spurred many new publications, most recently, Balzarini, *Vincenzo Foppa*; Mauro Natale planned a monographic exhibition of Foppa's paintings in Brescia in 2,000, which was to be accompanied by a comprehensive catalogue.

For a more recent discussion of Foppa's pigments and technique, see T. A. Lignelli and B. Price, "The History and Technique of Foppa Paintings in the Philadelphia Museum of Art," paper delivered at Yale University Symposium on Conservation of Early Italian Painting, April 2002.

25. Bull and Plesters, *The Feast of the Gods*, 80.

26. For a discussion of the literature concerning this drawing, see Rowlands with Bartrum, *The Age of Dürer and Holbein*, 99.

27. Lomazzo reported that Dürer was aware of a treatise written by Foppa on atmospheric perspective, and that Dürer made use of a number of drawings by Foppa in his own work. Ffoulkes and Majocchi, *Vincenzo Foppa of Brescia*, 243–4.

28. C. I. Scofield, ed. Holy Bible: The New Scofield Reference Bible, Authorized King James Version (New York: Oxford University Press, 1967), 1320.

29. G. Ladner, "The Concept of the Image in the Greek Fathers and the Byzantine Iconoclastic Controversy," *Dumbarton Oaks Papers* 7 (1953): 1–34. See also G. Ladner's *Ad Imaginem Dei: The Image of Man in Medieval Art* (Latrobe, PA: The Archabbey Press, 1962). H. L. Kessler's paper, delivered at the Princeton Symposium in March 1990 appeared in B. Cassidy, ed., *Iconography at the Crossroads* (Princeton: Princeton University Press, 1993).

30. Chrysostom's gloss of Hebrews 10:1 occurs in the Seventeenth Homily on the Epistle to the Hebrews of St. John Chrysostom. See Ladner, "The Concept of the Image," 19.

31. D. J. Geanakoplos, *Interaction of the "Sibling" Byzantine and Western Cultures in the Middle Ages and Italian Renaissance (330–1600)* (New Haven: Yale University Press, 1976), 57–9.

32. This text is found in *Saint Cyril of Alexandria Letters 1–50*, trans. J. I. McEnerny (Washington, D.C.: The Catholic University of America Press, 1987), letter 41.21. (Ladner translates the word "skíagraphía" as silhouette; Kessler translates it, I believe more properly in this context, as underdrawing.)

33. The gloss begins with: "Therefore the Law is called shadow, but Grace truth, and that which is to come is called things [reality – "pragmata"]." It continues with a line that reads: "Thus, the old dispensation is a figure of a figure, and the new a figure of real things." See Ladner, "The Concept of Image," 19. In Genesis 14:18, Melchizedek, King of Salem, presents bread and wine, clear typological references to the Eucharist. He is also called the "Priest of the most high God," another typological reference to Christ.

34. A similar connection between patristic writing and artistic practice was noticed by Geanakoplos, *Interaction*, 76. He wrote that the Byzantine influence in Western art left a lexical trace in the term "matizare," to shade. This word came from the Byzantine "lamma," meaning a gradation or shading of color. Andrew of

Crete, an eighth century archbishop used this term to compare the creative process of the Byzantine painter with the creative acts of God.

35. The writings of the Western medieval patristic writers are gathered in the *Patrologia Cursus Completa Latina*, edited in multiple volumes by J. P. Migne in Paris. For Alcuin, see Vol. 100 (1851), p. 1076; for Rabanus Maurus, see Vol. 112 (1852), p. 779; and for Walafrid Strabus, see Vol. 114 (1852), p. 660.

F. Hartt has introduced an interesting iconographic reading of Mantegna's *Madonna of the Rocks* based upon readings from the *Allegoriae in Sacram Scripturam* written by Rabanus Maurus. See F. Hartt, "Mantegna's *Madonna of the Rocks*," *Essays in Honor of Hans Tietze 1880–1954*, ed. E. Gombrich, J. Held, and O. Kurz (Paris: Gazette des Beaux Arts, 1950–8), 81–94. If Mantegna had access to Rabanus Maurus, it is likely that Dürer had access to a similar text as well.

36. For a discussion of Strabo's putative authorship of the "*glossa ordinaria*" (and the role of Anselm of Laon), see C. F. R. De Hamel, *Glossed Books of the Bible and the Origins of the Paris Book Trade* (Dover, N.H.: D. S. Brewer, an Imprint of Boydell and Brewer, 1984), xiii, 1–9. De Hamel notes the lack of a standard history of the "glossa ordinaria" as well as the wide popularity of the "*glossa ordinaria*" (a best seller of the twelfth century), which was widely available in libraries across Europe. For a discussion of the "glossa ordinaria" as a whole, see B. Smalley, *The Study of the Bible in the Middle Ages*, 2nd ed. (Notre Dame, IN: Notre Dame University Press, 1964), 46–66. For a more recent discussion of glosses, see A. E. Matter, *The Voice of My Beloved: The Song of Songs in Western Medieval Christianity* (Philadelphia: University of Pennsylvania Press, 1990).

37. *Biblia cum glossa ordinaria Walafridi Strabonis et interlineari Anselmi Laudunensis Straßburg*, 1480, in four volumes, printed at Straßburg by Adolf Rusch, ca. 1480–1 for Anton Koberger, the printer at Nuremberg.

38. P. Lombard, *Patrologia Cursus Completus series Latina*, Vol. 192, *Peter Lombard, II*, ed. J. P. Migne, (Paris: Lutetia Parisiarum, 1855), 192, 478.

39. I am grateful to Dale Kinney for sharing this information with me.

40. For information about the publication and prevalence of Latin and Greek titles during the Renaissance in Italy, see V. Massena, Prince d'Essling, *Les livres à figures Vénitiens de la fin du XVe siècle et du commencement duXVIe* (Florence: Olschki, 1914) and M. Sander, *Le livre à figures italiens depuis 1467 jusqu'à 1530* (New York: G. E. Stechert and Co., 1941), in six volumes. For more information about Pirckheimer's library, see K. Pilz, "Willibald Pirckheimer's Kunstsammlung und Bibliothek," *Willibald Pirckheimer 1470/1970* (Nuremberg: Glock und Lutz, 1970), 93–110; and K. B. Glock, "Willibald-Pirckheimer-Bibliographie," *Willibald Pirckheimer 1470/1970* (Nuremberg: Glock und Lutz, 1970), 111–26.

41. See my discussion of Vasari's' passage in relationship to Dürer's preparatory drawings for the *Feast of the Rose Garlands* in Chapter 3.

Chapter 6. Repetition and the Manipulation of Meaning

1. Examples include the *Saint Jerome* in Lisbon, the *Lucretia* in Munich, and the *Saint Anna Selbdritt* in The Metropolitan Museum of Art. Examination of the *Saint Anna Selbdritt* with infrared reflectography revealed relatively little underdrawing,

limited primarily to the definition of contours. It was investigated in the conservation studios of The Metropolitan Museum of Art. Besides myself, many members of the Conservation staff were on hand for this investigation, including D. Mahon, G. Bisacca, G. Helmkampf, J. Brealy, and M. Ainsworth. Penetration was not good; most of the contours appear to have been indicated in a grainy substance, possibly chalk or charcoal; in some places, like the hand of Anne resting on the Virgin"s shoulder and in the contours of the Virgin's face, these lines seem to have been subtly shifted. Also noted were a few areas of hatching in what appeared to be brush in the robe of St. Anne. This underdrawing was quite faint, and it is possible that much of this was not visible because of the thickness of the white layer of paint in these areas.

It has also been reported in the literature that this painting was transferred from wood to canvas at some point. This was clearly not the case, but there remained some doubt as to whether it had been transferred from wood to wood. George Bisacca, Wood Conservator at the Metropolitan Museum of Art, took a sample from the side, cutting away the strips added on all sides and discovered that the panel was not transferred at all, but was still on its original lindenwood support. The original support has been thinned and then mounted on a complex support system consisting of a walnut board, a layer of plywood and a thick cradle, evidently the work of the restorer Pichetto.

Close examination of the surface of the painting with the microscope reveals that the monogram is spurious. This calls into question the long accepted dating of the painting.

2. Panofsky, 1943, 193.

3. Rupprich, Nachlass I: 173, 176.

4. H. Stegmann, "Albrecht Dürers Maximiliansbildnisse," *Mitteilungen aus dem Germanischen Nationalmuseum* (1901): 132–45. Stegmann also asserted that the more costly materials used in the lindenwood panel as opposed to the Nuremburg tuchlein were indicative of a developmental progression utilizing first less and then more costly materials. This obscures the question of function, which, I believe, is more pertinent here. For further information regarding the use of linen as a support, see E. Bosshard, "Tuchleinmalerei – Eine billige Ersatztechnik?" *ZfKg* 45, no. 1 (1982): 31–42; and D. Wolfthal, *The Beginnings of Early Netherlandish Canvas Painting 1400–1530* (Cambridge: Cambridge University Press, 1989).

5. Thausing, II: 152. Thausing noted that the lines in the drawing and woodcut were identical, "Strich für Strich." Most recently, Larry Silver asserted that Maximilian's features were of different sizes in the two paintings. See L. Silver, "Prints for a Prince: Maximilian, Nuremberg and the Woodcut," *New Perspectives on the Art of Renaissance Nuremberg. Five Essays*, ed. J. C. Smith (Austin: University of Texas Press, 1985), 8.

6. I was able to make a tracing of the *Maximilian* in the Germanisches Nationalmuseum in Nuremberg on April 5, 1989, with the permission and assistance of Dr. Thomas Brachert and Joseph Pröll.

7. I was able to examine this painting with the kind and generous permission and assistance of Dr. Karl Schütz, Professor Gerald Kaspar, and Elke Oberthaler all of the Kunsthistorisches Museum, Vienna.

8. I would like to thank Dr. Fritz Koreny and Dr. Barbara Dossi of the Graphische Sammlung at the Albertina; with their permission and assistance, I was able to examine the *Head of Maximilian* and the *Hands of Maximilian*.

9. It is possible that Dürer made another, working, copy of the drawing, which was used for actual transfer onto the surfaces prepared for painting and carving. If this were not the case, I believe the drawing would appear to be much more worn from repeated incision than it is.

10. Vasari, *Vasari on Technique*, 215, 231. See also G. B. Armenini, *On the True Precepts of the Art of Painting*, ed. and trans. E. J. Olszewski (New York: Franklin, 1977), 147–8; and H. Kühn et al., *Reclams Handbuch*, 160–1. It is possible that the back of the drawing was coated with a carbon substance to transfer the design directly. Unfortunately, like so many of the drawings in the collection of Prince Albert of Sachsen-Teschen, now the essential collection at the Albertina, the head of Maximilian has been mounted, making the back of the drawing inaccessible and leaving conclusions about the method of transfer open to speculation.

Two further versions of the portrait of Maximilian survive, both likely by imitators or followers of Dürer. A portrait drawing of the *Head of Emperor Maximilian I*, attributed to Hans Sebald Beham was offered at Auction A100 at Galerie Koller in Zurich in September 1996; this drawing is very close to Dürer's portrait in the Albertina. I have not had the opportunity to actually examine this drawing, but it is such a close copy that it appears to me that Beham (if the attribution is correct) must have had access to either Dürer's drawing or a second cartoon of it. The painting in the Ponce Museum in Ponce, Puerto Rico, also reflects an intimate familiarity with the Vienna painting, although it must have been copied from the painting itself and not from the cartoon drawing. See J. Held, *Catalogue: Paintings and Sculpture of the European and American Schools* (Ponce, P. R.: Museo de Arte, 1984).

11. The size of the canvas in Nuremberg is 0.83 m × 0.65 m; the panel in Vienna measures 0.73 m × 0.615 m.

12. My investigation of the Nuremberg *Maximilian* was made possible by the permission and assistance of Dr. Kurt Löcher and Dr. Thomas Brachert. They allowed me the use of their infrared vidicon camera without which the results of this investigation would have been impossible.

13. The other imperial propaganda projects Dürer worked on included the *Great Triumphal Arch and Procession* and the *Prayerbook*.

14. Maximilian's first wife, Mary of Burgundy, and their son, Philip, are depicted here in posthumous portraits. Also represented are Maximilian's grandsons, Ludwig, Ferdinand, and Charles V. Strigel made the alterations at the request of the humanist Johannes Cuspinian, who wanted to transform the royal portrait into an altarpiece for private use.

15. The inscription reads: "Cleophas Frater Carnalis Iosephi Mariti Divae Virginis Mariae"; Maximilian is identified as Cleophas, the brother of Joseph and the Virgin's brother-in-law. Notably, Cleophas appears in the Gospel of Saint Luke as one of the pilgrims on the road to Emmaus, who, like St. Luke, had a mystical vision. St. Luke saw the Virgin, of course, and Cleophas saw the risen Christ.

Chapter 7. Conclusion

1. The next step in continuing this study would call for investigation of a number of Dürer's earlier paintings. These would ideally include *Self-Portrait with Eryngium* of ca. 1492–3 in the Louvre; *Portrait of Frederick the Wise* of 1495–7 in Berlin; *Dresden Altarpiece* of 1496–7 in Dresden; *Self-Portrait* of 1498 in Madrid; *Christ in the Sepulchre* of 1498–9 in Karlsruhe; *Adoration of the Magi* of 1504 in Florence; and *the Portrait of Burkard of Speyer* of 1505–6 in the Queen's Collection in London.

It would also be useful to examine several of the more problematic paintings associated with Dürer's oeuvre, including the *St. Jerome* in the National Gallery, London; the *Bagnacavallo Madonna* in Bagnacavallo, Italy; and the *Madonna of the Alps* in the Schäfer Collection in Schweinfürt. Finally, it would be of interest to examine a sampling of Dürer's later portraits, including the *Portrait of a Gentleman* of 1524 in Madrid; the *Portrait of Jacob Muffel* of 1526 in Berlin; and the *Portrait of Hieronymous Holzschuber* of 1526 in Berlin.

2. It would be useful to have comparative technical material about several paintings by Bellini, including, of course, the *San Zaccaria Altarpiece* of 1505. It would also be interesting to investigate other major works attributed to Bellini, including the earlier *Frari Triptych*, the *San Giobbe Altarpiece*, and the *Votive Picture of Doge Agostino Barbarigo*, all in Venice. Devotional pictures that would provide useful and interesting comparative material include the *Brera Madonna* and *Madonna Greca*, both in Milan; the *Madonna and Child with Two Female Saints* and the *Madonna degli Alberetti*, both in Venice; and lastly, the *Morelli Madonna* in Bergamo.

Appendix 1. The History of the Condition of the *Feast of the Rose Garlands*

1. Tietze and Tietze-Conrat, *KV* II: 27–30. The Tietzes asserted that, despite all the damages sustained by the painting, it remains the greatest painted composition of Dürer. "Es bleibt trotz allem die großartigste Bildkomposition Dürers." Olga Kotková, "'The Feast of the Rose Garlands': What Remains of Dürer?" *The Burlington Magazine*, 144, no. 1186, (2002): 4–13 appeared as this manuscript was being prepared.

2. J. von Sandrart, *Academie der Bau-, Bild, und Mahlerey-Künst von 1675*, ed. A. R. Peltzer (Munich: G. Hirth, 1925), 62–72. According to this account, Rudolf ordered the painting to be swaddled in layers of cotton and rugs, wrapped in waxed cloths, and carried by strong men from Venice to the Imperial Palace in Prague, so that the painting would not be jarred and damaged in transit. Sandrart's account reads as follows: "gegen so hoher Bezahlung, als man malen mit Teppichen und vielfältiger Baumwoll eingewickelt, in ein gewixtes Tuch eingeballt und damit es auf dem Wagen nicht hart gestoßen, gerüttelt und verletzt würde, auf ergangnen Käyserlichen Befehl von starken Männern an Stangen den ganzen Weg biß in die Käyserliche Residenz zu Prag getragen worden."

3. O. Benesch, "Zu Dürer's Rosenkranzfest," *Belvedere* 16 (1930): 81–5.

4. Koschatzky and Strobl, *Die Dürer Zeichnungen der Albertina*, 221.

5. Tietze and Tietze-Conrat, *KV* II: 28.

6. Tietze and Tietze-Conrat, *KV* II: 28.

7. Dunkerton et al. asserted that at times during the Renaissance up to half the cost of an altarpiece lay in the construction of the frame. Dunkerton et al., *Giotto to Dürer*, 156. An evaluation of the frame at four times the value of the painting itself is indicative of the degree of damage sustained by the painting. For further discussions of frames, see H. Verougstraete-Marcq and R. Van Schoute, *Cadres et supports dans la peinture flamande aux 15e et 16e siècles* (Heure-le-Romaine: H. Verougstraete Marcq, 1989) and T. J. Newbery, G. Bisacca, and L. B. Kanter, *Italian Renaissance Frames* (New York: Metropolitan Museum of Art, 1990). There have been no specific studies of German frames, or Dürer's frames, even though Dürer designed the frame for the *Adoration of the Trinity and the All Saints*, which survives in the collection of the Germanisches Nationalmuseum in Nuremberg. For a discussion of that frame, which Dürer designed in a style corresponding to Italian Renaissance ideals, but which was constructed more in keeping with Northern, gothic ones, see J. Meder, "Neue Beiträge zur Dürer-Forschung III. Zur Umrahmung des Allerheiligenbildes," *JKSAK* : 30 (1912) 223–7.

8. Graf Brühl was the director of the organization founded to acquire works of art for the new museum in Berlin.

9. Waagen was the director of the newly established Gemäldegalerie in Berlin.

10. P. O. Rave published a collection of letters and expert opinions written by a variety of art professionals and connoisseurs. See P. O. Rave, "Dürers Rosenkranzbild und die Berliner Museen 1836/1837. Ein Briefwechsel," *Pr. Jb* 58 (1937): 267–83.

11. The other experts involved in this process of evaluation continuously downplayed Schlesinger's opinion of the painting with the explanation that he was concerned about the difficulty of the restoration, but that his fears were unfounded.

12. Rave, *"Dürers Rosenkranzbild und die Berliner Museen."* Rave published a drawing made by Waagen in Prague in 1837 that recorded those areas of the painting that were most damaged as well as those areas that survived more or less intact (p. 281).

13. Tietze and Tietze-Conrat, *KV* II: 28.

14. For discussions of the specific areas of damage in the painting see Rave, *"Dürers Rosenkranzbild und die Berliner Museen,"* 267–83; Waagen, "Albrecht Dürer in Venedig," 112–17; and Benesch, "Zu Dürer's Rosenkranzfist," 81–5. Benesch found that the mantle of the Pope was still in good condition, but that his face, hands, and breast (along vertical crack) were completely new. Further, he described the Madonna as largely overpainted but wrote that the head of Maximilian was largely intact.

15. Private communication from Hubert von Sonnenburg, Director of Paintings Conservation at the Metropolitan Museum of Art. An extreme example of this method of conservation can be seen in Philipp Otto Runge's *Der große Morgen* in the Hamburger Kunsthalle.

16. In the course of six years, between 1928 and 1934, more than thirty articles concerning the fate of the *Feast of the Rose Garlands* filled German papers. For a complete listing of these articles, see Mende, *Dürer Bibliographie*, 179–80.

17. See A. Roeper, "Dürer's größtes Bild geht nach Amerika. Eine Million Dollar f.d. 'Rosenkranzfest,'" *Der Kunsthandel* 24, no. 12 (1932): 97–8, 100; and "Millionenangebot für Dürers Rosenkranzfest," *Kunst und Antiquitäten Rundschau* No. 23, Vol. 39 (1931): 264.

Bibliography

"A French Poet in Imperial Berlin (Editorial)." *Apollo* 106, no. 186 (August 1977): 88–97.

A. M. "Ein neuer Dürer." *Kunstchronik* N.F. 28, no. 17 (1916–17): 167.

Acheimastou-Potomianou, Myrtali. *From Byzantium to El Greco: Greek Frescoes and Icons.* London and Athens: Greek Ministry of Culture: Byzantine Museum of Athens, 1987.

Ackerman, Gerald M. "Lomazzo's Treatise on Painting." *Art Bulletin* 49, no. 4 (December 1967):317–26.

Ackerman, James. "Dürer's Crab." In *Ars Auro Prior: Studien Joanni Białostocki Sexagenaria Dicata.* Warszawa: Panstwowe Wydawnictwo Naukowe, 1981, pp. 291–5.

Ackroyd, Paul, Susan Foister, et al. "A Virgin and Child from the Workshop of Albrecht Dürer?" *National Gallery Technical Bulletin* 21 (2000): 28–42.

Aikema, Bernard and Beverly Louise Brown, eds. *Renaissance Venice and the North: Crosscurrents in the Time of Bellini, Dürer, and Titian.* Milan: Bompani, 1999.

Ainsworth, Maryan. "Underdrawings in Paintings by Joos Van Cleve at the Metropolitan Museum of Art." In *Le dessin sous-jacent dans la peinture*, Colloque IV, edited by Rogier Van Schoute and Dominique Hollanders-Favart. Louvain-la-Neuve, 1982.

"New Insights Into Joos Van Cleve as a Draughtsman." In *Essays in Northern Art Presented to Egbert Haverkamp-Begeman on His Sixtieth Birthday.* Doornspijk: Davaco, 1983, pp. 15–17.

"Schäufelein as Painter and Graphic Artist in the *Visitation.*" *Metropolitan Museum Journal* 22 (1987): 135–40.

"Northern Renaissance Drawings and Underdrawings: A Proposed Method of Study." *Master Drawings* 27, no. 1 (Spring 1989): 5–38.

" 'Paternes for Phiosioneamyes': Holbein's Portraiture Reconsidered." *Burlington Magazine* 132, no. 1044 (March 1990): 173–86.

"Implications of Revised Attributions in Netherlandish Painting." *Journal of the Metropolitan Museum of Art* 27 (1992): 59–76.

Petrus Christus: Renaissance Master of Bruges. New York: Metropolitan Museum of Art, 1994.

Gerard David: Purity of Vision in an Age of Transition. New York: Metropolitan Museum of Art and Ludion Press, 1998.

van Eyck to Breughel: Early Netherlandish Paintings in the Metropolitan Museum of Art. New York: Metropolitan Museum of Art, 1998.

Ainsworth, Maryan, and Molly Faries. "Northern Renaissance Paintings: The Discovery of Invention." *The Saint Louis Art Museum Bulletin* 18, no. 1 (Summer 1986): 4–97.

Alberti, Leon Battista. *On Painting*. Translated and edited by John R. Spencer. New Haven: Yale University Press, 1956.

Alcuin. *Patrologia Completa Cursus Latina, Vol. 100. Alcuin 1*. Edited by J. P. Migne. Paris: J. P. Migne, 1851, p. 1076.

Ames-Lewis, Francis. *Drawing in Early Renaissance Italy*. New Haven: Yale University Press, 1981.

Drawing in the Italian Renaissance Workshop. Exhibition Catalogue. London, Victoria and Albert Museum, 1983.

"Painters in Padua and Netherlandish Art, 1435–1455." In *Italienische Frührenaissance und nordeuropäisches Spätmittelalter: Kunst der frühen Neuzeit im europäischen Zusammenhang*, edited by Joachim Poeschke. Munich: Hirmer, 1993, pp. 179–202.

Anders, Otto. "Nürnberg um die Mitte des 15. Jahrhunderts im Spiegel ausländischer Betrachtung." *Mitteilungen des Vereins für Geschichte der Stadt Nürnberg* 50 (1960): 100–12.

Anzelewsky, Fedja. *Albrecht Dürer: Das malerische Werk*. Berlin: Deutsche Verein für Kunstwissenschaft, 1971.

Dürer Werk und Wirkung. Stuttgart: Elekta/Klett-Cotta. 1980.

Dürer's Selbstbildnis aus dem Jahre 1500. Warszawa: Panstwowe Wydawnictwo Naukowe, 1981, pp. 287 ff.

Dürer: His Art and Life. London: Alpine 1982.

Albrecht Dürer: Das malerische Werk, 2nd ed. Berlin: Deutsche Verein für Kunstwissenschaft, 1991.

Armenini, G. B. *On the True Precepts of the Art of Painting*. Edited and translated by E. J. Olszewski. New York: Franklin, 1977.

Arndt, Karl. "1471 Albrecht Dürer 1971 Zur Ausstellung des Germanischen Nationalmuseum im Nürnberg." *Kunstchronik* (1971).

Arnolds, G. "Opus Quinque Dierum." In *Festschrift Friedrich Winkler*, edited by Hans Mohle. Berlin: Mann, 1959, pp. 187–90.

Asperen de Boer, J. R. J. van. "Underdrawings in Paintings of the Rogier van der Weyden and Master of Flémalle Groups." *Nederlands Kunsthistorisch Jaarboek* 41 (1990): 7–328.

Asperen de Boer, J. R. J. van. *Infrared Reflectography. A Contribution to the Examination of Earlier European Paintings*. Thesis, University of Amsterdam. Amsterdam, 1970.

"An Introduction to the Scientific Examination of Paintings." *Nederlands Kunsthistorisch Jaarboek* 26 (1975).

Scientific Examination of Early Netherlandish Painting Applications in Art History.
Bussum: Fibula-Van Dishoeck 1975.
"Examination by Infrared Radiation." *Scientific Examination of Easel Paintings.*
*Published on the Occasion of the Xth Anniversary Meeting of the Pact Group at
Louvain-la-Neuve*, edited by Roger Van Schoute and Hélène Verougstraete-
Marcq. Strasbourg: Council of Europe, 1986, pp. 109–30 [Pact, 13, 1986].
Atkinson, Agnes D. "Albert Dürer's *Feast of the Rose Garlands.*" *Art Journal* N.S. 12
(1873): 17–18.
Aulmann, Hans. *Gemäldeuntersuchungen mit Röntgen-, Ultraviolett- und Infrarot-
strahlen zum Werk des Konrad Witz.* Basel: Holbein Verlag, 1958.
Balzarini, M. G. *Vincenzo Foppa.* Milan: Jacca Verlag, 1997.
Barasch, Moshe. *Light and Color in the Italian Renaissance Theory of Art.* New York:
New York University Press, 1978.
Theories of Art: From Plato to Winckelmann. New York: New York University Press,
1985.
Barocchi, Paola, ed. *Trattati d'arte del cinquecento fra manierismo e controriforma.* Bari:
Laterza, 1960/62.
Bartsch, Johann Adam Ritter von, Sixteenth Century German Artists: Albrecht
Dürer, ed. by Walter Strauss, New York: Abaris Books, 1980.
Bätschman, O., and Griener, P. *Hans Holbein.* Princeton: Princeton University Press,
1997.
Bauch, Kurt. "Albert Dürer et les artists." In *La gloire de Dürer Colloque organisée par
la Faculté des lettres et des sciences humaines de l'université de Nice*, edited by Jean
Richier. Paris: Editions Klincksieck, 1974, pp. 89 ff.
Baxandall, Michael. *The Limewood Sculptors of Renaissance Germany.* New Haven:
Yale University Press, 1980.
"Bartholomeus Facius on Painting. A Fifteenth-Century Manuscript of the *De
Viris Illustribus.*" *Journal of the Warburg and Courtauld Institutes* 27 (1964): 91–
107.
Shadows and Enlightenment. New Haven and London: Yale University Press,
1995.
Beck, James. "Leon Battista Alberti and the 'Night Sky' at San Lorenzo." *Artibus et
Historiae* 19 (1989): 9–36.
Beenken, H. "Zu Dürer's Italienreise im Jahre 1505." *Zeitschrift des deutschen Vereins
für Kunstwissenschaft* 3 (1936): 111–25.
Beenken, Hermann. "Dürers Kunsturteil und die Struktur des Renaissance-
Individualismus." In *Festschrift Heinrich Wölfflin*, Munich: H. Schmidt, 1924,
pp. 183–93.
Belting, Hans. "The "Byzantine" Madonnas: New Facts About Their Italian Origin
and Some Observations on Duccio." *Studies in the History of Art* 12 (1982): 7–
24.
Benesch, Otto. "Zu Dürer's Rosenkranzfest." *Belvedere* 16 (1930): 81–5.
The Art of the Renaissance in Northern Europe. Cambridge: Harvard University
Press, 1945.
German Painting from Dürer to Holbein. Translated by H. S. B. Harrison. Geneva:
Skira, 1966.

Berenson, Bernard. "Les dessins de Signorelli." *GBA*, Series 6 7 (1932): 173–210.

Berger, Ernst, ed. *Beiträge zur Entwicklungs-Geschichte der Maltechnik: Quellen für Maltechnik während der Renaissance und deren Folgezeit.* München: Georg D. W. Callwey, 1901.

Bettini, Sergio. *La Pittura di Icone Cretese-Veneziana e I Madonneri*, Florence: Olschki, 1932.

 Pitture cretesi-veneziane, slave e italiane del Museo Nazionale di Ravenna. Ravenna, 1940. Pubblicato a cura della cassa di risparmio di Ravenna nel primo centenario della sua fondazion.

Białostocki, Jan. "Opus Quinque Dierum. Dürer's 'Christ Among the Doctors' and Its Sources." *Journal of the Warburg and the Courtauld Institutes* 22 (1959): 17–34.

 "The Eye and the Window. Realism and Symbolism of Light-Reflections in the Art of Albrecht Dürer and his Predecessors." In *Festschrift für Gert von der Osten.* Cologne: M. Dumont Schauberg, 1970, pp. 159–64.

 Dürer and IIis Critics 1500–1971: Chapters in the History of Ideas Including a Collection of Texts. Baden-Baden: Valentin Koerner, 1986.

 "Dürer and the Humanists." *Bulletin of the Society for Renaissance Studies* 4, no. 2 (1986–7): 16–29.

Billinge, Rachel, Hélène Verougstraete, and Roger Van Schoute. "The Saint Barbara." In: *Investigating Jan Van Eyck.* Turnhout: Brepols, 2000, pp. 41–8.

Blunt, Anthony. *Artistic Theory in Italy 1450–1600.* Oxford: Clarendon, 1940.

Bock, Elfried. *Die Zeichnungen in der Universitätsbibliothek Erlangen.* Frankfurt am Main: Prestel, 1929.

Bode, Wilhelm. "Die Italienischen Skulpturen der Renaissance in den königlichen Museen II. Bildwerke des Andrea del Verrocchio." Jahrbuch der Preussischen *Kunstsammlung* 3 (1882): 91–105.

Boesten-Stengel, Albert. "Albrecht Dürers zwölfjähriger Jesus unter den Schriftgelehrter der Sammlung Thyssen-Bornemisza, Lugano." *Idea* 9 (1990): 43–66.

Bora, Giulio. "La prospettiva della figura humana – gli scurti – nella teoria e nella pratica pittorica lombarda del Cinquecento." In *Prospettiva Rinascimentale: Codificazioni e Trasgressioni.* Florence: Centro Di, 1980, pp. 295–317.

Boschini, Marco. *Le Minere della pittura. Compendiosa informazione non solo delle pitture publiche di Venezia: ma dell Isole ancora circonuicine.* Venezia: F. Nicolini, 1664.

 Descrizione di tutte le pubbliche pitture della città di Venezia e isole circonvicine. Venice: P. Bassaglia, 1733.

Bosshard, Emil. "Tuchleinmalerei – Eine billige Ersatztechnik?" *Zeitschrift für Kunstgeschichte* 45, no. 1 (1982): 31–42.

 "Die Unterzeichnung der Gemälde von Niklaus Manuel Deutsch." *Maltechnik Restauro* 89 (July 1983): 158–68.

Brachert, Thomas. "Neues zu Dürer's Madrider Selbst Porträt." *Restauro* 3 (September 1990): 175.

Brachert, Thomas, and Adelheid Brachert. "Neues zu Dürer's Kaiserbildern." *Restauro* 1 (January 1989): 22–39.

Brautigam, G., and M. Mendes. "Mähen mit Dürer; Literatur und Ereignisse im Umkreis des Dürer Jahres." *Mitteilungen des Vereins für Geschichte der Stadt Nürnberg* 61 (1974): 204–82.

Breydenbach, Bernhard von. *Die Reise ins Heilige Land.* Facsimile of 1483 ed. Edited and translated by Elisabeth Geck. Wiesbaden: Guido Pressler, 1961.

Brown, Clifford M. "An Art Auction in Venice in 1506." *L'Arte* N.S. 18–19/20 (1972): 121 ff.

Brown, David Alan. "Bellini and Titian." In *Titian, Prince of Painters.* Venice: Marsilio Editori, 1990, pp. 57–67.

Brown, Marguerite L. "The Subject Matter of Duerer's Jabach Altar." *Marsyas* 1 (1941): 55–68.

Buchner, Ernst. "Dürer's hl. Familie von 1509." *Pantheon 3* (1929): 38–42.

"Die sieben Schmerzen Mariä. Eine Tafel aus der Werkstatt des jungen Dürer." *Münchner Jahrbuch der bildenden Kunst* N.F. 11 (1934/1936): 250 ff.

Bull, David, and Joyce Plesters. *The Feast of the Gods: Conservation, Examination, and Interpretation. Studies in the History of Art* Monograph Series II, Vol. 40. Washington, D.C.: National Gallery of Art, 1990.

Burckhardt, Daniel. *Albrecht Dürer's Aufenthalt in Basel 1492–1494.* Munich and Leipzig: G. Hirth, 1892.

Burckhardt, Jacob. *Der Cicerone: Eine Anleitung zum Genuss der Kunstwerke Italiens.* Basel: Schweighauser, 1855.

The Civilization of the Renaissance in Italy. 1860.

The Cicerone: An Art Guide to Painting in Italy for the Use of Travellers and Students. Translated by A. H. Clough. London: F. W. Laurie, 1908.

Beiträge zur Kunstgeschichte von Italien. Berlin: W. Spemann, 1911.

The Civilization of the Renaissance in Italy. With an introduction by Hajo Holborn. New York: Random House/The Modern Library, 1954.

The Altarpiece in Renaissance Italy. Edited and translated by Peter Humfrey. Cambridge: Cambridge University Press, 1988.

Burmester, Andreas. "Dürer Durchleuchtet." In *Albrecht Dürer: Die Gemälde der Alten Pinakothek.* Edited by G. Goldberg, B. Heimberg, and M. Schawe. Munich: Braus, 1998.

Burmester, Andreas, and Johann Koller. "Säureanschlag auf drei Dürer-Werke in der Alten Pinakothek München. Schadenbeschreibung und Wege zur Konservierung aus naturwissenschaftlicher Sicht." *Restauro* 2 (April 1990): 89–95.

Burroughs, Alan. *Art Criticism from a Laboratory.* Boston: Little, Brown and Co., 1938.

Burroughs, B., and H. B. Wehle. *The Metropolitan Museum of Art Bulletin* 27, section II (November, 1932): 29 ff.

Bushart, Bruno, ed. *Altdeutsche Bilder der Sammlung Georg Schäfer Schweinfurt.* In collaboration with Isolde Lübbeke. Schweinfurt: Weppert GmbH, 1985.

Butterfield, Andrew. *Andrea del Verrochio.* New Haven and London: Yale University Press, 1997.

Canditto, A. -E. Cte. de [pseud.]. *Jacopo de Barbari et Albert Durer; La vie et l'oeuvre du maître au caducée, ses élèves Durer, Titian, Marc-Antoine, Mabuse, Marguerite d'Autriche. Catalogue et prix de ses 43 gravures.* 1881.

Canova, Giordana Mariani. "Rifflessioni su Jacopo Bellini e sul libro dei disegni del Louvre." *Arte Veneta* 26 (1972): 9–30.

Carr, Dawson W., and Mark Leonard. *Looking at Paintings: A Guide to Technical Terms.* Malibu, CA: J. Paul Getty Museum, 1992.

Carrit, David. "Dürer's St. Jerome in the Wilderness." *Burlington Magazine* 9 (1957): 363 ff.

Carty, Carolyn M. "Albrecht Dürer's *Adoration of the Trinity*: A Reinterpretation." *Art Bulletin* 67, no. 1 (1985): 146–53.

Cast, David. *The Calumny of Apelles: A Study in the Humanist Tradition.* New Haven and London: Yale University Press, 1981.

Castiglione, Baldassare da. *Il libro del Cortegiano Baldesar Castiglione: acura di Walter Barberis 1528.* Torino: Einaudi, 1998.

Cennini, Cennino d'Andrea. *The Craftsman's Handbook "Il Libro dell' Arte".* Translated by Daniel V. Thompson, Jr. New York: Dover, 1960.

Cetto, Anna Maria. *Watercolours by Albrecht Dürer.* Translated by Glyn T. Hughes. New York: MacMillan Co., 1954.

Chapuis, Julien. *German and French Paintings: Fifteenth and Sixteenth Centuries.* Rotterdam: Museum Boymans-van Beuningen, 1995, pp. 55–63.

Chastel, André. "Les Auto-portraits d'Albert Dürer." In *La gloire de Dürer. Colloque organisée par la faculté des lettres et des sciences humaines de l'université de Nice,* edited by Jean Richer. Paris: Editions Klincksieck, 1974, pp. 43–4.

"Dürer à Venise en 1506." In *Giorgione e la Cultura Figurativa del Suo Tempo,* Vol. 1 of *Giorgione e l'umanesimo veneziano,* edited by Rodolfo Pallucchini. Florence: L. Olschki, 1981, pp. 459–63.

Chomentovskaja, O. "Le Comput digital dans l'art Italien." *Gazette des Beaux-Arts* 80, no. 2 (1938): 157 ff.

Christensen, Carl C. *Art and the Reformation in Germany.* Athens, Ohio and Detroit: Ohio University Press and Wayne State University Press, 1979.

Christiansen, Keith. "Venetian Painting of the Early Quattrocento." *Apollo* 75, no. 301 (March 1987): 166–77.

Comblen-Sonkes, Micheline. "Le dessin sous-jacent chez Roger van der Weyden et le problème de la personnalité du Maitre de Flémalle." *Bulletin de l'Institute royal du Patrimoine artistique* 13 (1971/1972): 161–206.

Conway, William Martin. *Literary Remains of Albrecht Dürer.* Cambridge: Cambridge University Press, 1889.

Coremans, Paul B. *L'agneau mystique au laboratoire, examen et traitement sous la direction de Paul Coremans.* Antwerp: De Sikkel, 1953.

Cyril of Alexandria, Saint. *Letters 1–50.* Washington, D.C.: The Catholic University of America Press, 1987.

Czerny-Heidelberg, Siegfried. "Wie lange hat Dürer an einem Bildnis gemalt?" *Technische Mitteilungen für Malerei* 46, no. 15 (August 1, 1930): 174–5.

Dackerman, Susan. *Painted Prints: The Revelation of Color.* The Baltimore Museum of Art: The Pennsylvania State University Press, 2002.

Dackerman, Susan, William Neil, and Bett Miller. *Book Arts in the Age of Dürer.* Baltimore: Baltimore Museum of Art, 2000.

Dante, Vincenzo. *Il primo libro del trattato delle perfette proporzioni,* 1567.

De Hamel, C. F. R. *Glossed Books of the Bible and the Origins of the Paris Book Trade.* Dover, N. H.: D. S. Brewer, an Imprint of Boydell and Brewer, 1984.

Diemer, Peter. "Zur Restaurierung der beschädigten Münchner Dürer-Gemälde." *Kunstchronik* 43, no. 4 (April 1990): 147–8.

Dottin-Orsini, Mireille. "Jules Laforgue et Charles Ephrussi: Le "jeune Homme si Simple" et le "bénédictin Dandy" de la Gazette Des Beaux-Arts." *Gazette Des Beaux-Arts* 117, no. 1468–9 (May–June 1991): 233–40.

Dunkerton, Jill, and Ashok Roy. "The Technique and Restoration of Cima's 'The Incredulity of S. Thomas.'" *National Gallery Technical Bulletin* 10 (1986): 4–27.

Dunkerton, Jill, Susan Foister, Dillian Gordon, and Nicholas Penny. *Giotto to Dürer: Early Renaissance Painting in the National Gallery.* New Haven and London: Yale University Press, 1991.

Eastlake, Sir Charles Lock. *Methods and Materials of Painting of the Great Schools and Masters.* London: 1847. repr. New York: Dover, 1960.

Edgerton, Samuel, Jr. "Alberti's Color Theory: A Medieval Bottle Without Renaissance Wine." *Journal of the Warburg and Courtauld Institutes* 32 (1969): 109–34.

Eichberger, D. *Naturalia* and *Artefacts*: Dürer's Nature Drawings and Early Collecting." In *Dürer and His Culture,* edited by Dagmar Eichberger, and Charles Zika. New York and Cambridge: Cambridge University Press, 1998, pp. 13–37.

Einem, Herbert von, *Goethe und Dürer/Goethes Kunstphilosophie.* Hamburg: Marion von Schröder, 1947.

Goethe-Studien. Munich: Wilhelm Fink, 1972.

Eisler, Colin. *Paintings from the Samuel H. Kress Collection: European Schools Excluding Italian.* Oxford: Phaidon Press for the Samuel H. Kress Foundation, 1977.

The Genius of Jacopo Bellini: The Complete Paintings and Drawings. New York: Abrams, 1989.

Elkins, J. *The Poetics of Perspective.* Ithaca, NY: Cornell University Press, 1994.

Ephrussi, Charles. *Etude sur le Triptyque d'Albert Durer dit le Tableau d'autel de Heller.* Nuremberg: Sigmund Soldan, 1877.

Albert Dürer et ses dessins. Paris: A. Quantin, 1882.

Erasmus, Desiderius. *Dialogus de recta latina graecique sermonis pronunciatione.* Rotterdam: n.p., 1528.

Erb, Georg, *Die Landschaftsdarstellungen in der Deutschen Druckgraphik vor Albrecht Dürer.* Frankfurt am Main: Peter Lang, 1997.

Essling, Victor Massena (Prince d'). *Les Livres à Figures Vénitiens de la Fin Du XVe Siècle et Du Commencement Du XVIe.* Florence L. S. Olschki: Paris H. Leclere, 1907–14.

Facius, Bartholomeus. *De Viris Illustribus.* Published by L. Mehus, Florence, 1745.

Fara, Giovanni Maria. "Sul secondo soggiorno di Albrecht Dürer in Italia e sulla sua amicizia con Giovanni Bellini." *Prospettiva* 85 (January 1997): 91–6.

Albrecht Dürer. Teorico Dell' architettura: Una Storia Italiana. Florence: Olschki, 1999.

Faries, Molly. "Underdrawings in the Workshop Production of Jan van Scorel – A Study with Infrared Reflectography." *Nederlands Kunsthistorisch Jaarboek* 26 (1975): 98–228.

Fedalto, G. "Stranieri a Venezia e a Padova." In *Storia della Cultura Veneta: Dal primo Quattrocento al Concilio di Trento*, edited by Girolamo Arnaldi and Manlio Pastor Stocchi. Vicenza: Neri Pozza Editore, 1980, pp. 499–535.

Felicetti-Liebenfels, W. *Geschichte der byzantinische Ikonenmalerei.* Lausanne & Olten: Urs Graf Verlag, 1956.

Ffoulkes, Constance Jocelyn, and Rodolfo Majocchi. *Vincenzo Foppa of Brescia, Founder of the Lombard School. His Life and Work.* London and New York: Lane, 1909.

Filedt-Kok, J. P. "Underdrawing and Drawing in the Work of Hieronymus Bosch: A Provisional Survey in Connection with the Paintings by Him in Rotterdam." *Simiolus* 6 (1973/74): 133–62.

"Underdrawings and Other Technical Aspects in the Paintings of Lucas van Leyden." *Nederlands Kunsthistorisch Jaarboek* 29 (1978): 1–184.

Filipczak, Zirka Zaremba. *Picturing Art in Antwerp 1550–1700.* Princeton: Princeton University Press, 1987.

Fiore-Hermann, Kristina. "Das Problem der Datierung bei Dürers Landschaftsaquarellen." *Anzeiger des Germanischen Nationalmuseums* (1971–2): 122–42.

Fiorin, M[arisa] Bianco. "Giovanni Permeniate pittore greque a Venezia e una tavola del Museum Nazionale di Ravenna." *Bolletino d'Arte* 11 (1981): 85–8.

"Zafuri Nicola, cretese del quattrocento, e una sua inedita madonna." *Arte Veneta* (1983): 164–9.

"L'attività dei pittori Angelo e Donato Bizamano: Precisazioni ed aggiunte." *Bolletino d'Arte* 27 (September-October 1984): 89–94.

"Pittori Cretesi-Veneziani e 'maddoneri.' Nuove indagini ed attribuzioni." *Bolletino d'Arte* 73, no. 47 (January/February 1988): 71–84.

Flechsig, Eduard. *Albrecht Dürer: Sein Leben und Sein Künstlerische Entwicklung.* Berlin: G. Grote'sche, 1928.

"Zu Dürer's erster Reise nach Venedig." In *Cicerone Albrecht Dürer Festschrift der Internationalen Dürer-Forschungen*, edited by Georg Biermann. Leipzig-Berlin: Klinkhardt & Biermann, 1928, pp. 54–8.

Fletcher, Shelly. "A Preliminary Study of the Use of IRR in the Examination of Works of Art on Paper." Preprint. *ICOM Committee for Conservation. 7th Triennial Meeting. Copenhagen, September 10–14, 1984* (1984): 84.14.24.

Fogg Art Museum. *Style and Technique. Their Interrelationship in Western European Painting.* Cambridge: Harvard University, 1936.

Freedberg, J. Sydney. "*Disegno* Versus *Colore* in Florentine and Venetian Painting of the Cinquecento." In *Florence and Venice: Comparisons and Relations.* Acts of Two

Conferences at Villa I Tatti in 1976–1977. Florence: La Nuova Italia Editrice, 1980, pp. 309–22.

Painting in Italy 1500–1600. Harmondsworth, Middlesex: Penguin Books, 1971.

Friedländer, Max J. "Dürer's erste italienische Reise. Report on *Sitzung der Berliner kunstgeschichtlichen Gesellschaft* on 24 February, 1893." *Kunstchronik* N.F. 4, no. 18 (16 March 1892–3): 298.

"Dürers Bilder von 1505 und 1506 in der Berliner Galerie." *Jahrbuch der königlich preussischen Kunstsammlung* 20 (1899): 263–70.

"Die Ausstellung altdeutscher Kunst im Burlington Fine Arts Club zu London Sommer 1906." *Repertorium für Kunstwissenschaft* 29 (1906): 586.

"Ein neuer Dürer." *Kunst und Künstler* 15 (1916–7): 286.

"Ein neuer Dürer." *Zeitschrift für bildende Kunst* 52, no. N.F. 28 (1917): 131.

Albrecht Dürer. Leipzig: Insel-Verlag, 1921.

"Eine unbekannte Dürer-Madonna." *Pantheon* 14 (1934): 321–4.

Friend, A. M., Jr. "Dürer and the Hercules Borghese-Piccolomini." *Art Bulletin* 25 (1943): 40–9.

Fries, Walter. "Dürer in Italia." *La Bibliofilia* 30, (1928) no. 7/8: 249–55.

From Byzantium to El Greco: Greek Frescoes and Icons. London: Royal Academy of Arts, 1987.

Fry, Roger, ed. *Dürers Record of Journeys to Venice and the Low Countries*. New York: Dover, 1995.

Fusco, Laurie. "The Use of Sculptural Models by Painters in 15th Century Italy." *Art Bulletin* 64, no. 2 (June 1982): 175–94.

Gage, John. *Goethe on Art*. Berkeley, Los Angeles: University of California Press, 1980.

Garrido, Maria del Carmen, "Albert Dürer: Deux manières différentes de travailler." *Le Dessin sous-jacent et la technologie dans la peinture "perspectives."* Colloque XI, Louvain-la-Neuve, 1997, pp. 61–6.

Garrido, Maria del Carmen, and Dominique Hollanders-Favart. "The Paintings of the Memling-Group in the Prado – The Underlying Design and Other Technical Aspects." *Boletin del Museo del Prado* 5, no. 15 (1984): 151–71.

Gavel, Jonas. *Colour: A Study of Its Position in the Art Theory of the Quattro and Cinquecento*. In *Stockholm Studies in the History of Art*. Stockholm: Almquist & Wiksell International, 1979.

Geanakoplos, Deno John. *Byzantine East and Latin West: Two Worlds of Christendom in the Middle Ages and Renaissance. Studies in Ecclesiastical and Cultural History.* Oxford: Oxford University Press, 1966.

Interaction of the "Sibling" Byzantine and Western Cultures in the Middle Ages and Italian Renaissance (330–1600). New Haven: Yale University Press, 1976.

Gere, J. A. *Drawings by Raphael and His Circle from British and North American Collections.* New York: Pierpont Morgan Library, 1987.

Gettens, R. J., and M. E. Mrose. "Calcium Sulphate Minerals in the Grounds of Italian Paintings." *Studies in Conservation* 1, no. 4 (1954): 174–89.

Gettens, Rutherford J., and George L. Stout. *Painting Materials: A Short Encyclopedia*. New York: D. van Nostrand, 1942.

Gibbons, Felton. "Practices in Giovanni Bellini's Workshop." *Pantheon* 23 (1965): 146–55.

Gilbert, Creighton. "Antique Frameworks for Renaissance Art Theory: Alberti and Pino." *Marsyas* 3 (1943–5): 87–106.

Glare, P. G. W., ed. *Oxford Latin Dictionary*. Oxford: Clarendon Press, 1982.

Glock, Karl Borromäus. "Willibald-Pirckheimer-Bibliographie." In *Willibald Pirck-heimer 1470/1970*. Nuremberg: Glock und Lutz, 1970, pp. 111–26.

Glück, Gustav. "Zu Dürer's Anbetung der Könige im Florenz." *Jahrbuch der Preussischen Kunstsammlungen* 29 (1908): 119 ff.

Goffen, Rona. "Icon and Vision: Giovanni Bellini's Half-length Madonnas." *Art Bulletin* 57, no. 4 (December 1975): 487–514.

Giovanni Bellini. New Haven and London: Yale University Press, 1989.

Goldberg, Gisela. "A Technical Analysis of Albrecht Dürer's 'Four Apostles'." In *Albrecht Dürer, Paintings, Prints, Drawings*, edited by Peter Strieder and translated by Nancy M. Gordon and W. L. Strauss. New York: Abaris, 1982, pp. 333–46.

"Early German Paintings in the Alte Pinakothek, Munich." *Apollo* (October 1982): 210–62.

Goldberg, Gisela, Bruno Heimberg, and Martin Schawe. *Albrecht Dürer: Die Gemälde der Alten Pinakothek*. Munich: Braus, 1998.

Gombrich, E. H. *Art and Illusion: A Study in the Psychology of Pictorial Representation*. Bollingen Series, vol. 35. Princeton, N.J.: Princeton University Press, 1969.

"Light Form and Texture in Fifteenth Century Painting North and South of the Alps." In *The Heritage of Apelles: Studies in the Art of the Renaissance*, edited by E. H. Gombrich. Ithaca, N.Y.: Cornell University Press, 1976, pp. 19–38.

"The Pride of Apelles: Vives, Dürer and Breughel." In *The Heritage of Apelles: Studies in the Art of the Renaissance*, edited by E. H. Gombrich. Ithaca, N.Y.: Cornell University Press, 1976, pp. 132–4.

Gordon, Dillian, David Bomford, Joyce Plesters, and Ashok Roy. "Nardo di Cione's 'Altarpiece: Three Saints.'" *National Gallery Technical Bulletin* 9 (1985): 21–37.

Gould, Cecil. "On Dürer's Graphic and Italian Painting." *Gazette des Beaux-Arts* (February 1970): 103–16.

Gravenkamp, Curt. "Das Marienbild bei Dürer und Mantegna." *Die Kunst für Alle* 46 (1930–1): 117–21.

Grimm, Hermann. *Über Künstler und Kunstwerke*. Berlin: Ferd. Dümmler's Verlags buchhandlung, 1865.

Grimm, Jacob, and Wilhelm Grimm. *Deutsches Wörterbuch*. Leipzig: Verlag von S. Hirzel, 1860.

Gross-Anders, Hertha. "Dürer's Dresdner Altar und seine Rettung." *Maltechnik* 67 (1961): 68–81.

Grote, Ludwig. "Hier bin ich ein Herr," *Dürer in Venice*. Munich: Prestel, 1956.

Dürer. Geneva: Skira, 1965.

"Albrecht Dürer's Anna Selbdritt – ein Auftrag von Linhart Tucher." Anzeiger des Germanischen National museums (1969): 83–8.

Albrecht Dürer: Reisen Nach Venedig. Munich, New York: Prestel, 1998.

Grote, Ludwig. *Dürer. A Biographical and Critical Study*, translated by Helga Harrison. Geneva: Skira, 1965.

Gümbel, A. "Die Stifterbildnisse auf Dürers Allerheiligenaltar." *Repertorium* 46 (1925): 225–30.

Dürer's Rosenkranzfest und die Fugger. Konrad Peutinger der Begleiter Dürers. In *Studien Zur Deutschen Kunstgeschichte.* 234. Straßburg: J. H. ED. Heitz, 1926.

Hadeln, D. von. *Venezianische Zeichnungen des Quattrocentos.* Berlin: P. Cassirer, 1925.

Haendke, Berthold. "Dürer's Beziehungen zu Jacopo de' Barbari, Pollaiuolo und Bellini." *Jahrbuch der köNiglich Preussischen Kunstsammlungen* 19 (1898): 161–70.

Die Chronologie der Landschaften Albrecht Dürer's. Straßburg: Heitz and Mündel, 1899.

Hagen, Oskar. "'Dürer und Bramantino' Ein Beitrag zum Problem der ersten Italienischen Reise." *Kunstchronik* N.F. 26, no. 20 (1914–15): 267–72.

"War Dürer in Rom?" *Zeitschrift für bildende Kunst* 52 (1917): 255–65.

"Das Dürerische in der italienische Malerei." *Zeitschrift für bildende Kunst* N.F. 29 (1917–8).

Hambly, Maya. *Drawing Instruments: 1580–1980.* London: Sotheby's Publications, 1988.

Hammerschmied, Ilse. *Albrecht Dürers Kunsttheoretische Schriften.* Egelsbach: Fouqué, 1997.

Hampe, D. von. "Beobachtungen und Erfahrungen bei den Restaurierungsarbeiten am Dresdner Dürer Altar." *Forschungen und Berichte* 3/4 (1961): 109.

Hamsik, Mojmir. "Durers Rosenkranzfest: Zustand und Technik: Mit einer Laboruntersuchung von Jindrich Tomek als Beilag." *Bulletin of the National Gallery in Prague* 2 (1992): 128–31.

Hand, John O. *German Paintings of the Fifteenth Through Seventeenth Centuries.* Washington, D.C., Cambridge: National Gallery of Art, 1993.

Hand, John O., J. Richard Judson, William W. Robinson, and Martha Wolff. *The Age of Breughel: Netherlandish Drawings in the Sixteenth Century.* National Gallery of Art, Washington D.C.: Cambridge University Press, 1986.

Hand, John O., and Martha Wolff. *Early Netherlandish Painting. The Collections of the National Gallery of Art Systematic Catalogue.* Washington, D.C.: National Gallery of Art, 1986.

Hartt, Frederick. "Mantegna's Madonna of the Rocks." In *Essays in Honor of Hans Tietze 1880–1954.* Edited by Ernst Gombrich, Julius Held, and Otto Kurz. Paris: Gazette Des Beaux Arts, 1950–8, pp. 81–94.

Hausmann, B. *Albrecht Dürer's Kupferstiche, Radirungen, Holzschnitte und Zeichnungen, unter besonderer Berücksichtigung der dazu verwandten Papiere und deren Wasserzeichen.* Würzburg: J. Frank, 1922.

Heaton, Mary Margaret Keymer. *The History of the Life of Albrecht Dürer*. London: Macmillan, 1870.

Heckscher, W. S. "Melancholla (1541): An Essay in the Rhetoric of Description by Joachim Camerarius." In *Beiträge zur Geschichte des Humanismus im Zeitalter der Reformation*, edited by F. Baron. Munich: Wilhelm Fink, 1978, pp. 31–120.

Heidrich, Ernst. *Geschichte des Dürerschen Marienbildes*. Leipzig: K.W. Hiersemann, 1906.

 Die altdeutsche Malerei. 200 Nachbildungen mit geschichtlicher Einführung und Erläuterungen. Jena: E. Diederich, 1909.

Heil, Walter. "A Marble Putto by Verrocchio." *Pantheon* 27, no. 4 (July/August 1969): 271–82.

Heimberg, Bruno. "Zur Maltachnik Albrecht Dürers." In *Albrecht Dürer: Die Gemälde der Alten Pinakothek*, edited by Gisela Goldberg et al. Munich: Braus, 1998, pp. 34–42.

Heimberg, Bruno, and Hubertus von Sonnenburg. "Säureanschlag auf drei Dürer-Werke in der Alten Pinakothek in München." *Restauro* 1 (January 1990): 13–21.

Heimbürger, Minna. *Dürer a Venezia: Influssi di Albrecht Dürer sulla pittura Veneziana del primo cinquecento*. Rome: Ugo Bozzi, 1999.

Heise, Carl Georg. "Albrecht Dürer: Die Madonna mit der Birnenschnitte – Wien." In *Die goldene Palette. 1000 Jahre Malerei in Deutschland, Österreich u.d. Schweiz*. Stuttgart: Hamburg, 1968, pp. 198–9.

Heitz, P., ed. *Neujahrswünsche des 15. Jahrhunderts*. Straßburg: JHE Heity, 1900.

Held, Julius. *Catalogue: Paintings and Sculpture of the European and American Schools*. Ponce, P.R.: Museo de Arte, 1984.

Heller, Joseph. *Das Leben und die Werke Albrecht Dürer's*. Bamberg: Wallraf-Richartz-Museum, 1827.

Hendy, Philip, and Ludwig Goldscheider. *Giovanni Bellini*. Oxford: Phaidon, 1945.

Hendy, Philip, and A. S. Lucas (with Joyce Plesters). "The Ground in Pictures." *Museum* 21, no. 4 (1968): 245–76.

Hermann-Fiore, Kristina. *Dürers Landschaftsaquarelle*. In *Kieler Kunsthistorisches Studien*, edited by Erich Hubala. Frankfurt/M: Peter Lang, 1972.

Hevesy, André de. "Jacopo de Barbari's German Pupils." *Burlington Magazine* 45 (1924): 143–4.

 "The Drawings of Jacopo de Barbari." *Burlington Magazine* 44 (1924): 76–83.

 Jacopo de Barbari: Le maître au caducée. Edited by G. van Oest. Paris, Bruxelles: Librairie national d'art et d'histoire, 1925.

 "Albrecht Dürer und Jacopo de Barbari." In *Cicerone Festschrift der internationalen Dürer-Forschung*, edited by Georg Biermann. Leipzig and Berlin: Klinkardt & Biermann, 1928, pp. 32–41.

Hiller, Irmgard, and Horst Vey, *Katalog der deutschen und niederländischen Gemälde bis 1550 (mit Ausnahme der Kölner Malerei) im Wallraf-Richartz-Museum und im Kunstgewerbemuseum der Stadt Köln* Mit Vorarb. von Tilman Falk. Köln: Wallraf-Richartz-Museum, 1969.

Hills, Paul. *The Light of Early Italian Painting*. New Haven: Yale University Press, 1987.

Hirst, Michael. *Michelangelo Draftsman*. Milan: Olivetti, 1988.

Hoenigswald, Ann. "The "Byzantine" Madonna: Technical Investigation." *Studies in the History of Art* 12 (1982): 25–32.

Hoffmann, Walter Jurgen. *Über Dürer's Farbe*. Nürnberg: Hans Carl, 1971.

Holly, Michael Ann. *Panofsky and the Foundations of Art History*. Ithaca, N.Y.: Cornell University Press, 1984.

Homolka, Jaromír. *Albrecht Dürer: The Feast of the Rose Garlands*. Translated by Till Gottheiner. London: Spring Art Books, 1961.

Humfrey, Peter. *Cima de Conegliano*. Cambridge: Cambridge University Press, 1983.

———. "Dürer's *Feast of the Rose Garlands*." *The Bulletin of the Society for Renaissance Studies* 4 (1986): 29–39.

———. "La festa del Rosario di Albrecht Dürer." *Eidos* 2 (June 1988): 4–15.

———. "Dürer's *Feast of the Rose Garlands*: A Venetian Altarpiece." *Bulletin of the National Gallery in Prague* 1 (1991): 21–33.

Hutchison, Jane Campbell. *Albrecht Dürer: A Biography*. Princeton: Princeton University Press, 1990.

Huth, Hans. *Kunstler und Werkstatt der Spätgotik*, 2d ed. Darmstadt: Wissenschaftliche Buchgesellschaft, 1967.

Hutter, Heribert. *Drawing: History and Technique*. New York: McGraw-Hill, 1968.

Jacobs, Frederika H. "An Assessment of Contour Lines: Vasari, Cellini and the *Paragone*." *Artibus et Historiae* 18 (1988): 139–50.

Jacobsen, Michael A., and Paula Burdell Thurman. "Dürer's Johannes Kleberger." *Source* 10, no. 2 (Winter 1991): 16–21.

Janitsch, J. "Dürer's Türkenzeichnungen." *Jahrbuch der Preussischen Kunstsammlungen* 4 (1883): 61–2.

Janitschek, Hubert. *Geschichte der deutschen Malerei*. Berlin, 1890.

Jennings, J. "Infrared Visibility of Underdrawing Techniques and Media." *Le Dessin sous-jacent dans la peinture* (1993), 241–52. Collected papers of Colloque IX, *Louvain-la-Neuve: Université Catholique de Louvain, Institut Supérieur d'Archéologie et d'Historie de l'Art, September 1991* (1993), pp. 241–52.

Justi, Ludwig. "Jacopo de Barbari und Albrecht Dürer." *Repertorium für Kunstwissenschaft* 21 (1898): 346–74.

Kanter, L. B. *Italian Renaissance Frames*. New York: Metropolitan Museum of Art, 1990.

Kauffman, Hans. "Albrecht Dürer's Dreikönig-Altar." *Wallraf-Richartz Jahrbuch* 10 (1938): 166–78.

———. "Dürer in der Kunst und im Kunsturteil um 1600." *Anzeiger des germanischen Nationalmuseums* (1940–54): 18–60.

Kaufmann, Thomas Da Costa. "The Perspective of Shadows: The History of the Theory of Shadow Projection." *Journal of the Warburg and Courtauld Institutes* (1975): 258–87.

Kemp, Martin, ed. *Leonardo on Painting*. New Haven: Yale University Press, 1989.

"'Equal Excellences': Lomazzo and the Explanation of Individual Style in the Visual Arts." *Renaissance Studies* 1, no. 1 (March 1987): 1–26.

The Science of Art: Optical Themes in Western Art from Brunelleschi to Seurat. New Haven, London: Yale University Press, 1990.

Kessler, Herbert L. "Medieval Art as Argument." In *Iconography at the Crossroads: Papers from the Colloquium Sponsored by the Index of Christian Art*, edited by Brendan Cassidy. Princeton: Princeton University Press, 1993, pp. 59–73.

Klauner, Friderike. "Gedanken zu Dürer's Allerheiligenbild." *Jahrbuch der Kunsthistorischen Sammlungen in Wien* 39 (1979): 57–92.

Klebs, Luise. "Dürers Landschaften. Ein Versuch, die uns erhaltenen Naturstudien Dürers, chronologisch zu ordnen." *Repertorium für Kunstwissenschaft* 30 (1907): 399–420.

Klein, Robert, and Henri Zerner. *Italian Art 1500–1600: Sources and Documents*. Evanston, IL: Northwestern University Press, 1966.

Knackfuss, H. *Dürer*. Bielefeld, Leipzig: Velhagen & Klasing, 1908.

Knappe, Karl-Adolf. *Dürer: Das graphische Werk*. Vienna, Munich: Anton Schroll, 1964.

Koerner, Joseph Leo. "Albrecht Dürer and the Moment of Self-Portraiture." *Daphnis: Zeitschrift für mittlere deutsche Literatur* 15, no. 2–3 (1986): 409–39.

The Moment of Self-portraiture in German Renaissance Art. Chicago: University of Chicago Press, 1993.

"The Shock of the View: *Perspective as Symbolic Form* by Erwin Panofsky, Translated by Christopher S. Wood." *The New Republic*, no. 4,084 (26 April 1993): 32–7.

Koetser, Leonard. "Dürer or not Dürer?" *The Connoisseur* 141 (1958): 567.

Kolb, Philippe, and Jean Adhémar. "Charles Ephrussi, 1849–1905: Ses Secrétaires: Laforgue, A. Renan, Proust, 'sa' Gazette Des Beaux-Arts." *Gazette Des Beaux-Arts* CIII (January 1984): 29–41.

Koreny, Fritz. *Albrecht Dürer und die Tier- und Pflanzenstudien der Renaissance*. München: Prestel, 1985.

Koschatzky, Walter. *Albrecht Dürer: The Landscape Watercolors*. Translated by Philippa McDermott. New York: St. Martin's Press, 1973.

Koschatzky, Walter, and Alice Strobl. *Die Dürer Zeichnungen der Albertina*. Vienna: Residenz, 1971.

Kosegarten, Antje Middeldorf. "The Origins of Artistic Competitions in Italy (Forms of Competition Between Artists Before the Contest for the Florence Baptistry Doors Won by Ghiberti in 1401)." In *Lorenzo Ghiberti nel suo tempo. Atti del convegno internazionale di studi*. Florence: L. S. Olschki, 1980, 167–86.

Kotková, Olga. "'The Feast of the Rose Garlands': What Remains of Dürer?" Burlington Magazine 144, no. 1186 (2002): 4–13.

Kristeller, Paul Oskar. *Das Werk des Jacopo de Barbari*. Berlin: Internationale Chalcographische Gesellschaft, 1896.

Kuhn, Charles. *A Catalogue of German Paintings of the Middle Ages and Renaissance in American Collections*. Cambridge: Harvard University Press, 1936.

Kutschbach, Doris. *Durer: Die Altäre*. Stuttgart, Zurich: Besler, 1995.

Kühn, Hermann, Heinz Roosen-Runge, Rolf E. Straub, and Manfred Koller. *Reclams Handbuch der Künstlerischen Techniken. Vol. 1. Farbmittel, Buchmalerei, Tafel- und Leinwandmalerei*. Stuttgart: Philipp, 1984.

Ladner, Gerhard. "The Concept of the Image in the Greek Fathers and the Byzantine Iconoclastic Controversy." *Dumbarton Oaks Papers* 7 (1953): 1–34.

——— *Ad Imaginem Dei: The Image of Man in Medieval Art*. Latrobe, PA: The Archabbey Press, 1962.

Lasareff, Victor (Lazarev). "Saggi sulla pittura veneziana dei secolo XIII–XIV, la maniera greca e il problema della scuola cretese (I–II)." *Arte Veneta* 19 (1965–6): 43–61.

——— "Saggi sulla pittura veneziana dei sec. XIII-XIV, La maniera greca e il problema della scuola cretese (II)." *Arte Veneta* 20 (1966): 43–61.

Lauer, Rolf, Christa Schulze-Senger, and Wilfried Hansmann. "'Der Altar der Stadtpatrone ins Kölner Dom.'" *Kölner Domblatt Jahrbuch des Zentral-Dombau-Vereins* 52 (1987): 9–80.

Laws, Frederick. "Ein Dürer in England entdeckt?" *Die Weltkunst* 27 (1957): 19.

Lazzarini, Lorenzo. "Il colore nei pittore Veneziani tra il 1480 e il 1580." *Studi Veneziani, Suppliemento n.5 del Bolletino d'Arte* (1983): 138.

Lebcr, Hermann. *Albrecht Dürers Landschaftsaquarelle: Topographie und Genese*. Hildesheim, Zürich, New York: Georg Olms, 1988.

Levenson, J. A. *Jacopo De'Barbari and Northern Art of the Early 16th Century*. New York: Garland, 1978.

Levey, Michael. "The German School." In *London: National Gallery Catalogue*: The National Gallery, London 1959–60, pp. 28–31.

——— "Minor Aspects of Dürer's Interest in Venetian Art." *Burlington Magazine* 103, no. 705 (1961): 511–13.

——— *Dürer*. New York: W. W. Norton, 1964.

Levey, Michael, Cecil Gould, and Joyce Plesters. *Michelangelo's Entombment of Christ. Some New Hypotheses and Some New Facts*. London: National Gallery of Art, 1970.

Levey, Michael, and Christopher White. "The German Exhibition at Manchester." *Burlington Magazine* 103, no. 705 (December 1961): 485–88.

Lieb, Norbert. *Studien zur Fuggergeschichte. Vol. 10. Die Fugger und die Kunst Im Zeitalter der Spätgotik und frühen Renaissance*. Munich: Schnell and Steiner, 1952.

Lightbown, Ronald. *Mantegna: With a Complete Catalogue of the Paintings, Drawings and Prints*. Oxford: Phaidon, 1986.

Limmert, Erich. "Lautenspielender Engel." *Nürnberger Hefte* 1, no. 12 (1949): 21–2.

Lippmann, Friedrich. *Zeichnungen von Albrecht Dürer in Nachbildungen*. Berlin: G. Grote, 1883–96.

Löcher, Kurt, ed. *Germanisches Nationalmuseum, Nürnberg: Die Gemälde des 16. Jahrhunderts*. Ostfildern-Ruit: Gerd Hatje, 1997.

Lomazzo, Giovanni Paolo. *Trattato dell'arte della pittura, scultura, ed archittetura.* Milan: P.G. Pontio, 1585.

Lombard, Peter. *Patrologia Cursus Completus Latina, Vol. 192 Pierre Lombard, II.* Edited by J. P. Migne. Paris: J. P. Migne, 1855, p. 478.

London, Royal Academy of Arts. *From Byzantium to El Greco: Greek Frescoes and Icons.* Exhibition Catalogue. London, 1980.

Longhi, Roberto. "Una Madonna del Dürer a Bagnacavallo." *Paragone* 139 (July 1961): 3–9.

Loomie, Albert J. "New Light on the Spanish Ambassador's Purchases from Charles I's Collection 1649–1653." *Journal of the Warburg and Courtauld Institutes* 52 (1989): 257–66.

Lorenz, L. *Die Mariendarstellungen Albrecht Dürers.* Straßburg: Heitz, 1904.

Lowry, Martin. "Venetian Capital, German Technology and Renaissance Culture in the Later Fifteenth Century." *Renaissance Studies* 2, no. 1 (March 1988): 1–13.

Luber, Katherine Crawford. "The Maximilian Portraits of Albrecht Dürer: An Investigation of Versions." *Master Drawings* 29, no. 1 (Spring 1991): 30–47.

Ludwig, G. "Antonello da Messina und deutsche und niederländische Künstler in Venedig." *Jahrbuch der Königlich preuszischen Kunstsammlungen* 23 (1902): 43 ff.

Lübbeke, Isolde. *Early German Painting: 1350–1550. The Thyssen-Bornemisza Collection.* Translated by Margaret Thomas Will. London: Sotheby's Publications, 1991.

Lüdecke, Heinz. "Albrecht Dürer und Italien." *Bildende Kunst* 2 (1964): 74–80.

Mander, Carel van. *Dutch and Flemish Painters.* Translated by Constant van de Wall. New York: McFarlane, 1936.

"Many Offers for Important Dürer." *The Art News,* 28 November 1931.

Matter, Ann E. *The Voice of My Beloved: The Song of Songs in Western Medieval Christianity.* Philadelphia: University of Pennsylvania Press, 1990.

Mayer, August L. "Zwei venezianer Frauenbildnisse Dürers." *Pantheon* 3 (1929): 249–50.

Mazzariol, Giuseppe. "Venise à l'époque de Dürer d'après le plan de Barbari." In *La gloire de Dürer. Colloque organisée par la faculté des lettres et des sciences humaines de l'université de Nice,* edited by Jean Richer. Paris: Editions Klincksieck, 1974, pp. 37–41.

McKim-Smith, Gridley, Greta Andersen-Bergdoll, and Richard Newman. *Examining Velazquez.* New Haven: Yale University Press, 1988.

Meder, Joseph. "Neue Beiträge Zur Dürer-Forschung I. Zur Reise Dürers Nach dem Westen Deutschlands 1490–1494. II. Zur Ersten Reise Nach Venedig (1494–1495). III. Zur Umrahmung des Allerheiligenbildes." *Jahrbuch des kunsthistorischen Sammlungen des allerhöchsten Kaiserhauses* 30 (1912): I: 181–97; II: 197–222; III: 223–7.

Die Handzeichnung. Ihre Technik und Entwicklung. Vienna: Kunstverlag Anton Schroll, 1919.

"Eine Dürer Zeichnungen." *Mitteilungen der Gesellschaft für vervielfältigende Kunst. Beilag der "Graphische Künste"* 52, no. 4 (1929): 66.

Medica, Massimo. "Quattro tavole per un polittico di Vicenzo Foppa." *Paragone* 37 (January–March 1986): 11–17.

Meiss, Millard. "Light as Form and Symbol in Some Fifteenth Century Paintings." *Art Bulletin* 27 (1945): 175 ff.

Mende, Matthias. *Dürer Bibliographie*. Wiesbaden: O. Harrasowitz, 1971.

Albrecht Dürer. Das Fruhwerk bis 1500. Herrsching: Pawlak, 1976.

"From Writings About Dürer." In *Albrecht Dürer: Paintings, Prints, Drawings*, edited by Peter Strieder. New York: Abaris Books, 1983, pp. 366–72.

Merrifield, M. P. *Original Treatises on the Art of Painting*. London, 1849; reprint New York: Dover, 1967.

Merrill, Ross. "A Technical Study: Birth and Naming of St. John the Baptist." *Bulletin of the Cleveland Museum of Art* 63, no. 5 (1976): 136–45.

Metropolitan Museum of Art. *Gothic and Renaissance Art in Nuremburg*. New York, 1986.

Mantegna, edited by Keith Christiansen. New York: Metropolitan Museum of Art, 1992.

VanEyck to Breughel: Early Netherlandish Paintings in the Metropolitan Museum of Art. New York: Metropolitan Museum of Art, 1998.

Meyer, Hellmuth. "Anleihen in alten Zeiten. Eine Dürerbeobachtung." *Zeitschrift für Bildende Kunst* 60 (1926–7): 244.

Michelet, Jules. *Histoire de France*. Paris: E. Flammarion, 1855.

"Millionenangebot für Dürer's Rosenkranzfest." *Kunst und Antiquitäten Rundschau* 39, no. 23 (1931): 352.

Mirollo, James V. *Mannerism and Renaissance Poetry: Concept, Mode, Inner Design*. New Haven: Yale University Press, 1984.

Mulazzani, Germano. "Raphael and Venice: Giovanni Bellini, Dürer, and Bosch." *Studies in the History of Art* 17 (1986).

Musper, H. Th. *Albrecht Dürer. Der gegenwärtige Stand der Forschung*. Stuttgart: Europäischer Buchklub, 1953, p. 224.

Albrecht Dürer. New York: Abrams, 1965.

Dürer's Kaiserbildnisse. Cologne: M. Dumont Schauberg, 1969.

Musée de Louvre. *Dessins de Dürer et de la Renaissance germanique*. Paris: Réunion des Musées Nationaux, 1991.

Müller, Max. "Bamberger Ansichten aus dem XV. Jahrhunderten." *Jahrbuch der königlich preussischen Kunstsammlungen* 58 (1937): 241–57.

Neuwirth, Joseph. "Zur zweiten Reise Dürer's nach Italien." *Zeitschrift für bildende Kunst* 21 (1886): 87, 120, 170, 260.

"Ein Nachtrag zu den Kopien des Dürer'schen Rosenkranzfestes." *Repertorium für Kunstwissenschaft* 19 (1896): 346–8.

Nürmburg Germanisches Nationalmuseum. *1471 Albrecht Dürer 1971*. Nürmburg, 1971.

Oberhammer, V. "Die Vier Bildnisse Kaiser Maximilians I von Albrecht Dürer." *Alte und Moderne Kunst* 14, no. 105 (1969): 2–14.

Ochenkowski, H. "Albrecht Dürer's Pfeiffer und Trommler. Ein Beiträge zur Konstruktion d. Figuren und zur Datierung des Bildes." *Repertorium für Kunstwissenschaft* 35 (1912): 363–78.

Oehler, Lisa. "Das Dürermonogramm auf Werken der Dürerzeit." *Städel Jahrbuch* N.F. 3 (1971): 79–108.

"Das Dürermonogram auf Werken der Dürerschule." *Städel-Jahrbuch* N.F. 4 (1973).

Olds, Clifton C., Egon Verheyen, and Warren Tresidder. *Dürer's Cities: Nuremberg and Venice*, edited by Robert A. Yassin. Ann Arbor: The University of Michigan Museum of Art, 1971.

Os, H. W. van, J. R. J. van Asperen de Boer, C. E. de Jong-Jansen, and C. Wiethoff, eds. *The Early Venetian Paintings in Holland*. Transl. Michael Hoyle. Maarssen: Gary Schwartz, 1978.

Oudendijk Pieterse, F. H. A. van den. *Dürer's Rosenkranzfest en die ikonografie der Duitse rosenkransgroepen van de XVe en het begin des XVIe eeuw*. Amsterdam: De Spieghel, 1939.

Ozment, Steven. *The Reformation in the Cities: The Appeal of Protestantism to Sixteenth-Century Germany and Switzerland*. New Haven: Yale University Press, 1980.

Magdalena and Balthasar: An Intimate Portrait of Life in 16th Century Germany Revealed in the Letters of a Nuremberg Husband and Wife. New Haven, London: Yale University Press, 1989.

Three Behaim Boys: Growing Up in Early Modern Germany: A Chronicle of Their Lives. New Haven, London: Yale University Press, 1990.

Panofsky, Erwin. *Dürer's Kunsttheorie, vornehmlich in ihrem Verhältnis zur Kunsttheorie der Italiener*. Berlin: G. Reimer, 1915.

Idea: Ein Beitrag zur Begriffsgeschichte der älteren Kunsttheorie. Leipzig, Berlin, 1924.

"Die Perspektive als 'symbolische Form.'" *Vorträge der Bibliothek Warburg* (1924–5).

"Zwei Dürerprobleme (Der sogenannte 'Traum des Doktors' und die sogenannten 'vier Aposteln')." *Münchner Jahrbuch der Bildenden Kunst* N.S. 8 (1931): 18–48.

The Life and Art of Albrecht Dürer (with Handlist), 1st ed. Princeton: Princeton University Press, 1943.

"Dürer's Last Picture?" *Burlington Magazine* 89 (January 1947): 55.

Early Netherlandish Painting. Cambridge: Harvard University Press, 1953.

Renaissance and Renascences in Western Art. Stockholm: Almquist & Wiksell, 1960.

Idea: A Concept in Art Theory. Translated by J. J. S. Peake. New York: Harper & Row, 1968.

"Albrecht Dürer and Classical Antiquity." In *Meaning in the Visual Arts*. Chicago: University of Chicago Press, 1982, pp. 236–94.

Perspective as Symbolic Form. Translated by Christopher S. Wood. New York: Zone Books, 1991.

Pardo, Mary. *Paolo Pino's "Dialogo di Pittura": A Translation with Commentary*. Dissertation, University of Pittsburgh, Pittsburgh, 1984. Ann Arbor: University Microfilms International, 1985.

Parshall, Peter. "Camerarius on Dürer: Humanist Biography as Art Criticism." In *Beiträge zur Geschichte des Humanismus im Zeitalter der Reformation*, edited by F. Baron. Munich: Wilhelm Fink, 1978, pp. 11–29.

Pauli, Gustav. "Ein Naturstudie Albrecht Dürers." *Zeitschrift für Bildende Kunst* 23 (1912): 109–20.

———. "Dürer's Monogramm." In *Festschrift für Max. J. Friedländer zum 60. Geburtstag.* Leipzig: E. A. Seemann, 1927, pp. 34–40.

Philip, Lotte Brand. "The Portrait Diptych of Dürer's Parents." *Simiolus* 10, no. 1 (1978–9): 5–18.

———. "Das Neu Entdeckte Bildnis von Dürers Mutter." *Renaissance Vorträge* 7 (1981): 3–34.

Pieh, Gerhard. "Aspekte einer Dürer-Restaurierung." *Maltechnik Restauro* 2 (April 1985): 22–33.

Pigman, G. W., III. "Versions of Imitation in the Renaissance." *Renaissance Quarterly* 33 (1980): 1–32.

Pignatti, Terisio. "The Relationship Between German and Venetian Painting in the Late Quattrocento and Early Cinquecento." In *Renaissance Venice*, edited by J. P. Hale. London: Faber, 1973, pp. 244–73.

———. "Albert Dürer à Venise." In *La Gloire de Dürer. Colloque organisé par la faculté des lettres et des sciences humaines de l'université de Nice*, edited by Jean Richer. Paris: Editions Klincksieck, 1974, pp. 41–2.

Pilz, Kurt. "Willibald Pirckheimer's Kunstsammlung und Bibliothek." In *Willibald Pirckheimer 1470/1970*. Nuremberg: Glock und Lutz, 1970, 107 ff.

Pino, Paolo. *Dialogo di Pittura*. Edited by Rodolfo Pallucchini and Anna Pallucchini. Venice: Edizioni D. Guarnati, 1946.

Pizzetti, Simona Tosini, ed. *Masterpieces from the Magnani-Rocca Foundation Collection.* Bologna: Nuova Alfa Editoriale, 1990, p. 15.

Pliny the Elder. *Natural History: The Elder Pliny's Chapters on the History of Art.* Translated by K. Jex-Blake with an introduction by E. Sellers. Chicago: Argonaut, 1968.

Ploß, Emil. "Lasur." *Zeitschrift für deutsche Philologie* 74 (1955): 286–95.

———. "Die Fachsprache der deutschen Maler im Spätmittelalter." *Zeitschrift für deutsche Philologie* 79, no. 1 (1960): 70–83, 315 ff.

———. *Ein Buch von alten Farben.* 1967.

Podro, Michael. *The Critical Historians of Art*. New Haven: Yale University Press, 1982.

Poeschke, Joachim, ed. *Italienische Frührenaissance und nordeuropäisches Spätmittelalter: Kunst der frühen Neuzeit im europäischen Zusammenhang.* Munich: Hirmer, 1993.

Pogány-Balas, E. "On the Problems of an Antique Archetype of Mantegna's and Dürer's." *Acta Historiae Artium* XVII (1971–2): 77 ff.

Poirier, Maurice George. *Studies in the Concepts of Disegno, Invenzione and Colore in 16th and 17th C. Italian Art and Theory*. Dissertation, directed by Craig Hugh Smythe, New York University, New York, 1976. Ann Arbor: University Microfilms International, 1977.

Pollitt, J. J. *The Ancient View of Greek Art: Criticism, History, and Terminology.* New Haven: Yale University Press, 1974.

Popper, Kurt. "Einige Randbemerkungen zu Dürer's Rosenkranzfest." *Speculum Artis* 16, no. 2 (1964): 44–50.

Price, Beth A., Teresa A. Lignelli, and Janice H. Carlson. "Investigating Foppa: Painting Materials and Structures." *Techne.* Forthcoming.

Queen's Gallery, Buckingham Palace. *Treasures from the Royal Collection: The Queen's Gallery.* London. The Gallery, 1988.

Rabanus Maurus. *Patrologia Cursus Completus Latina Vol. 112. Rabanus Maurus, VI.* Edited by J. P. Migne. Paris, 1852: J. P. Migne: p. 779.
 Patrologia Completa Cursus Latina Vol. 112. Allegoriae in Sacram Scripturam. Edited by J. P. Migne. Paris: J. P. Migne, 1879.

Raby, Julian. *Venice, Dürer and the Oriental Mode.* The Hans Huth Memorial Studies. Vol. 1. London: Islamic Art Publications, 1982.

Rasmussen, Jörg. "Zu Dürer's unvollendeten Kupferstich 'Die grosse Kreuzigung.'" *Anzeiger des Germanischen Nationalmuseums* (1981): 56–79.

Rathbone, Eliza E. "Renoir's Luncheon of the Boating Party: Tradition and the New." In *Impressionists on the Seine: A Celebration of Renoir's Luncheon of the Boating Party.* Washington D.C.: The Phillips Collection, 1996.

Rave, P. O. "Dürers Rosenkranzbild und die Berliner Museen 1836/1837. Ein Briefwechsel." *Jahrbuch der königlich preuszischen Kunstsammlungen* 58 (1937): 267–83.

Real, William A. "Exploring New Applications for Infrared Reflectography." *Bulletin of the Cleveland Museum of Art* (December 1985): 389–412.

Richier, Jean, ed. *La Gloire de Dürer: Colloque organisée par la Faculté des lettres et des sciences humaines de l'université de Nice.* Paris: Editions Klinksieck, 1974.

Ricketts, C. "Antonello, Cima and Barbari." *Burlington Magazine* 9 (1906): 267.

Roberts, Jane. *Master Drawings in the Royal Collection: From Leonardo da Vinci to the Present Day.* London: Collins Harvill, 1986.

Robertson, Giles. *Giovanni Bellini.* Oxford: At the Clarendon Press, 1968.

Roeper, Adalbert. "Dürer's größtes Bild geht nach Amerika. Eine Million Dollar f.d. 'Rosenkranzfest.'" *Der Kunsthandel* 24, no. 12 (1932): 97–98, 100.

Rowlands, John. *Holbein: The Paintings of Hans Holbein the Younger,* complete edition. Oxford: Phaidon, 1985.

Rowlands, John, with Giulia Bartrum. *The Age of Dürer and Holbein: German Drawings 1400–1550.* London: British Museum Publications, 1988.

Ruhemann, Helmut, and Joyce Plesters. "The Technique of Painting in a 'Madonna' Attributed to Michelangelo." *Burlington Magazine* 106, no. 741 (December 1964): 546–53.

Rupprich, Hans, ed. *Albrecht Dürer. Der Schriftlicher Nachlass.* Berlin: Deutschen Verein für Kunstwissenschaft, 3 vols., 1956–69.
 Wilibald Pirckheimer und die erste Reise Dürers nach Italien. Vienna: Anton Schroll & Co., 1930.
 "Die Kunsttheoretischen Schriften Leoni Battista Alberti's und ihre Nachwirkung bei Dürer." *Schweizer Beiträge zur allgemeinen Geschichte* 18/19 (1960–1): 219 ff.

Saffrey, H. "Albrecht Dürer, Jean Cuno, O. P. et la confrérie du Rosaire à Venise." In *Philophronema: Festschrift für Martin Sicherl zum 75. Geburtstag*, edited by Dieter Harlfinger. Paderborn: F. Schöningh, 1990.

Saliger, Arthur. "Aspekte zur künstlerischen Autorschaft des *Ober St. Veiter Altares*." In *Hans Schäufelein, Vorträge, gehalten anläßlich des Nördlinger Symposiums im Rahmen der 7. Rieser Kulturtage in der Zeit vom 14. Mai bis 15. Mai 1988.* Nördlingen: C. H. Beck'sche Buchdruckerei, 1990, pp. 171–82.

Salvini, Roberto. "Il compianto di Albrecht Dürer." *Antichita Viva* (May/June 1979).

Sander, Jochen. *Hugo van der Goes: Stilentwicklung und Chronologie*. Mainz: P. von Zabern, 1992.

 Niederländische Gemälde im Städel 1400–1550. Mainz am Rhein: Philipp von Zabern, 1993.

Sander, Max. *Le livre à figures Italiens depuis 1467 jusqu'à 1530*. New York: G. E. Stechert and Co., 1941.

Sandner, I. "Unterzeichnungen auf Gemälden Nürnberger Meister, Dürer und sein Kreis." In *Unsichtbare Meister zeichningen auf dem Malgrund. Cranach und seine Zeitgenossen*. Regensburg: Wartburg-Stiftung Eisenach, 1998, pp. 260–76 and 277–91.

Sandrart, Joachim von. *Academie der Bau-, Bild- und Mahlerey-Künste von 1675*. Edited by A. R. Peltzer. Munich: G. Hirth, 1925, pp. 62–72.

Sansovino, Francesco. *Venetia Città Nobilissima et Singolare, Descritti in 14 Libri* ... Venetia: J. Sansovino, 1581.

Schedel, Hartman. *Liber cronicarum* ... Nuremberg: Anton Koberger, 1493. "See the facsimile edition of the Weltchronik, 'Die Schedelsche Weltchronik von 1493.' Kommentiert von Rudolf Pörtner Dortmund, Harenberg Kommunikation: 1978."

Scherer, Valentin. *Klassiker der Kunst in Gesamtausgabe. Vol. 4. Dürer: Des Meisters Gemälde, Kupferstiche, und Holzschnitte*. Stuttgart: Deutsche Verlags-Anstalt, 1908.

Scheurl, Christoph. *Libellus de laudibus Germaniae et ducum Saxoniae*. Leipzig: Martin Landsberg, 1508.

 Oratio attingens litterarum prestantiam necnon laudem Ecclesie Collegiate Vittenburgensis. Leipzig: Martin Landsberg, 1509.

 Vita Reverendi patris Domini Anthonii Kressen ... Nürnberg. Nuremberg: Friedrich Peypus, 1515.

Schiferl, Ellen. "Corporate Identity and Equality: Confraternity Members in Italian Paintings, Ca. 1340–1510." *Source* 8, no. 2 (Winter 1989): 12–18.

Schilling, Edmund. "Dürer's Tafelchen mit dem hl. Hieronymus." *Zeitschrift für Kunstwissenschaft* 11 (1957): 175–84.

 "Additional Notes on Dürer's Painting *St. Jerome*." *Burlington Magazine* 100 (1958): 130.

 "Dürer's 'Pupila Augusta.'" *Zeitschrift des deutschen Vereins für Kunstwissenschaft* 22 (1968): 1–9.

Schmidt, J. Heinrich. "Zu Stefan Lochners Farbiger Gestaltung." *Wallraf-Richartz Jahrbuch* 10 (1938): 132–8.

Schoute, Roger van. "Le dessin de peintre chez Hugo van der Goes." *Revue des Archéologues et Historiens d'Art de Louvain* 5 (1972): 59–66.

Schulte, Alfred. "Dürerforschung und Wasserzeichen." *Der Papier-Fabrikant* 13 (1938): 110.

Schulz, J. "Jacopo de' 'Barbari's View of Venice: Map Making, City Views and Moralized Geography Before the Year 1500." *Art Bulletin* 60 (1978): 425–74.

Schweikhart, Gunter. "Novita e Belleza. Zur frühen Durer-Rezeption in Italien." In *Festschrift Herbert Siebenhühner*. Würzburg: F. Schöningh, 1978, pp. 111–36.

Schütz, Karl. "Der Sebastiansaltar Altdorfers und seine Vorzeichnungen – Stilistische und technische Aspekte." *Kunsthistoriker Mitteilungen des Österreichischen Kunsthistorikerverbandes* 8 (1991): 91–5.

Albrecht Dürer im Kunsthistorisches Museum. Vienna: Electa, 1994.

Sciré, G. N. "La Pala Barbarigo *el' "attramentum"* di Apelle." *Quaderni della Soprintendenza ai beni artistici e storici di Venezia*, 41–3.

Scofield, C. I., ed. *Holy Bible: The New Scofield Reference Bible*: Authorized King James version. New York: Oxford University Press, 1967.

Secker, Hans. "Zwei neue Dürerzeichnungen." *Zeitschrift für bildende Kunst* N.F. 29 (1917–18): 177.

"Beiträge zur Dürer-forschung. 1. Dürer and Mantegna's Fresken in Padua." *Zeitschrift für Bildende Kunst* N.F. 29, 53 (1918): 133.

Seidel, Linda. "Jan Van Eyck's Arnolfini Portrait: Business As Usual?" *Critical Inquiry* 16, no. 1 (Autumn 1989): 54–86.

Jan Van Eyck's Arnolfini Portrait: Stories of an Icon. Cambridge: Cambridge University Press, 1993.

Sgarbi, Vittorio. *Fondazione Magnani-Rocca: Capolavori della pittura antica*. Milan: Mondadori, 1984, pp. 71–5.

Shaw, James Byam. "Drawing in Venice." In *The Genius of Venice 1500–1600*, edited by Jane Martineau and Charles Hope. New York: Harry Abrams, 1984, pp. 243–5.

Shearman, John. "Leonardo's Color and Chiaroscuro." *Zeitschrift für Kunstgeschichte* 25, no. 1 (1962): 13–47.

Mannerism. New York: Penguin Books, 1967.

"A Note on the Early History of Cartoons." *Master Drawings* 30, no. 1 (1992): 5–8.

Silver, Larry. "Prints for a Prince: Maximilian, Nuremburg and the Woodcut." In *New Perspectives on the Art of Renaissance Nuremburg. Five Essays*. Edited by J. C. Smith. Austin: University of Texas Press, 1985.

Simonsfeld, Henry. *Der Fondaco dei Tedeschi in Venedig und die deutsch-venetianischen Handelsbeziehungen*. Stuttgart: J. G. Cotta, 1887.

Smallery, Beryl. *The Study of the Bible in the Middle Ages*, 2nd ed. Notre Dame, Indiana: Notre Dame University Press, 1964.

Smith, Alastair. "Dürer and Bellini, Apelles and Protogenes." *Burlington Magazine* 114, no. 830 (1972): 326–9.

"Germania and Italia: Albrecht Dürer and Venetian Art." *Royal Society of Arts Journal* 28, no. 5,273 (April 1979): 273–90.

Smith, Alastair, and Angela Ottino della Chiesa, eds. *The Complete Paintings of Dürer*. New York: Harry Abrams, 1968.

Smith, Graham. "Bronzino and Dürer." *Burlington Magazine* 119, no. 895 (October 1977): 709–10.

"Netherlandish Artists and Art in Renaissance Nuremberg." *Simiolus* 20, no. 2/3 (1990–1): 153–67.

Nuremburg: A Renaissance City. Austin: University of Texas Press, 1983.

Smith, Jeffrey Chipps, ed. *New Perspectives on the Art of Renaissance Nuremburg: Five Essays*. Austin: University of Texas Press, 1985.

Smith, N. K. *Here I Stand: Perspective from Another Point of View*. New York: Columbia University Press, 1994.

Sorte, Cristoforo. *Osservazioni della pittura: con l'aggionta d'una cronichetta dell'origine della magnifica città di Verona*. Venice: Gio. Ant. Rampazetto, 1580.

Spronk, Ron. "Art History, Science, and the 'Mongrel Pup That Had Crawled Through the Academic Fence': The First Two Decades of Conservation at the Fogg Art Museum." Unpublished Paper, forthcoming.

"The Early Years of Conservation at the Fogg Art Museum: Four Pioneers," *Harvard University Art Museums Review*, 6, no. 1, (Fall 1996): 1–12.

"More Than Meets the Eye: An Introduction to Technical Examination of Early Netherlandish Paintings at the Fogg Art Museum." *Harvard University Art Museums Bulletin* 5 no. 1 (Fall 1996).

Städelsches Kunstinstitut. *Albrecht Dürer: Das Graphische Werk*. Frankfurt am Main: Maindruck, 1971.

Stange, Alfred. "Zwei neuentdeckte Kaiserbildnisse Albrecht Dürer's." *Zeitschrift für Kunstgeschichte* 20 (1957): 1 ff.

Schwaben in der Zeit von 1450–1500, Vol. 8. Deutsche Malerei der Gotik. Munich, Berlin: Deutscher Kunstverlag, 1957.

"Ein Gemälde aus Dürers Wanderzeit?" In *Studien zur Kunst des Oberrheins. Festschrift für Werner Noack*, 116. Constance and Freiburg: Rombach, 1959.

Kritisches Verzeichnis der deutschen Tafelbilder vor Dürer. Munich: Bruckmann, 1967.

Stechow, Wolfgang. "Dürers bologneser Lehrer." *Kunstchronik und Kunstmarkt*. N.F. 33, 57 (1921–2): 251–2.

"Alberti Dureri Praecepta." *Studies in the History of Art*. (1971–2).

"Recent Dürer Studies." State of the Research. *Art Bulletin* 56, no. 2 (June 1974): 259–70.

Stegmann, Hans. "Albrecht Dürers Maximiliansbildnisse." *Mitteilungen aus dem germanischen Nationalmuseum* (1901), 132–45.

Stoichita, Victor I. "Nomi in Cornice." In *Künstler über sich in seinem Werk: Internationales Symposium der Bibliotheca Herziana*, edited by Matthias Winner. Weinheim: VCH Acta humanora, 1992, pp. 293–315.

Strabus, Walafrid. *Walafrid Strabus, II*. In *Patrologia Completus Cursus Latina*, edited by J. P. Migne. Paris: J. P. Migne, 1852, p. 660.

Strauss, Ernst. "Review of Herrmann-Fiore, K." *Pantheon* 32 no. 1 (January–March 1974): 111–12.

"Untersuchungen zur Kolorit der spätgotischen deutschen Malerei." In *Koloritgeschichtliche Untersuchungen zur Malerei seit Giotto und andere Studien*, edited by Lorenz Dittmann. Munich: Deutscher Kunstverlag, 1983.

Strauss, Walter. "Dürer in Vienna?!" *Drawing* 7, no. 3 (September–October 1985): 61–3.

Strauss, Walter L., ed. *The Complete Drawings of Albrecht Dürer Volume 2 1500–1509*. New York: Abaris Books, 1974.

Albrecht Dürer: Woodcuts and Wood Blocks. New York: Abaris Books, 1980.

Strehlke, Carl Brandon. *Italian Paintings in the John G. Johnson Collection and the Philadelphia Museum of Art*. Phildelphia: Philadelphia Museum of Art, forthcoming.

Strehlke, Carl Brandon, and Mark Tucker. "The *Santa Maria Maggiore Altarpiece*: New Observations." *Arte Cristiana* 75, no. 719 (March–April 1987): 105–24.

Strieder, Peter. "Literaturbericht: Die Malerei und Graphik der Dürerzeit in Franken." *Zeitschrift für Kunstgeschichte* 26 (1963): 171–2.

"La signification du portrait chez Albert Dürer." In *La gloire de Dürer. Colloque organisée par la faculté des lettres et des sciences humaines de l'université de Nice*, edited by Jean Richer. Paris: Editions Klincksieck, 1974, pp. 45–56.

Dürer. Milan: A. Mondadori, 1976.

"Noch einmal zu Albrecht Dürer's Kaiserbildern." *Anzeiger des germanischen Nationalmuseums* (1979): 111–15.

Albrecht Dürer:, Paintings, Prints, Drawings. Translated by Nancy M. Gordon and Walter L. Strauss. New York: Abaris Books, 1982.

"Review of *Albrecht Dürer: Kritischer Katalog der Zeichnung* (Berlin)." *Master Drawings* 23–4, no. 2 (Summer 1986): 175–90.

Communio sanctorum: Albrecht Dürers Anbetung der heiligen Dreifaltigkeit für die Kapelle im Zwölfbruderhaus des Matthäus Landauer. Nuremberg: H. Carl, 1992.

Strzygowski, Josef. "Dürer's Madonna vom Jahre 1519, sein und Holbein's Verhältnis zu Leonardo." *Zeitschrift für bildende Kunst* 12 (1901): 235–8.

Stumpel, Jeroen, and Jolein van Kragten. "Albrecht Dürer's Self Portrait of 1493." *Burlington Magazine*, no. 1186, (2002): 14–18.

Suida, W. "Two Unknown Pictures by Vincenzo Foppa." Burlington Magazine 45, no. 160 (November 1924): 210–15.

Summers, David. *Michelangelo and the Language of Art*. Princeton: Princeton University Press, 1981.

Talbot, Charles, ed. *Dürer in America: His Graphic Work*. Washington, D.C.: National Gallery of Art, 1971.

Talley, M. Kirby, and K. Green. "Thomas Bardwell and His Practice of Painting: A Comparative Investigation Between Described and Actual Painting Technique." *Studies in Conservation* 20, no. 2 (1975): 44–108.

Térey, Gabriel von. *Albrecht Dürer's Venetianischer Aufenthalt 1494–1495*. Straßburg: J. H. Ed. Heitz (Heitz and Mündel), 1892.

Thausing, Moritz. *Dürer: Geschichte seines Lebens und seiner Kunst*. Leipzig: E. A. Seemann, 1875.

The Life and Art of Albrecht Dürer, English ed. London: John Murray, 1882.

Thode, Henry. "Drei Porträts von Albrecht Dürer." *Jahrbuch der königlich preussischen Kunstsammlungen* 14 (1893): 210.

Thompson, Daniel V. *The Materials of Medieval Painting*. With a foreword by Bernard Berenson. New Haven: Yale University Press, 1936.

Thorndike, Lynn. *A History of Magic and Experimental Science*. New York: Columbia University Press, 1934.

Tietze-Conrat, Erica. "Beitrag zu Italien und Dürer." *Mitteilung der Gesellschaft für vervielfältigende Kunst* 52 (1929).

"Two Dürer Woodcuts and an Italian Model." *Burlington Magazine* 62, no. 362 (1933): 241–2.

"An Unpublished Madonna by Giovanni Bellini and the Problem of Replicas in His Shop." *Gazette Des Beaux-Arts* 33 (1948): 379–82.

Mantegna: Paintings, Drawings, Engravings. Complete Edition. London: Phaidon, 1955.

Tietze, Hans. "Der Verkauf von Dürer's Rosenkranzfest." *Der Kunstwanderer* 9 (1927–8): 373–4.

"Dürer's Portrait of a Young Man at Hampton Court." *Burlington Magazine* 52 (1928): 143.

"Dürerliteratur und Dürerprobleme in Jübiläumsjahr." *Wiener Jahrbuch für Kunstgeschichte* 7 (1930): 232 ff.

"Dürer in Amerika." *Anzeiger des Germanischen Nationalmuseums* (1932–3): 84–108.

"Dürer's Rosenkranzfest: Anläßlich seines Übergangs in d. Besitz d. tschechoslowakischen Staats." *Die Kunst für Alle* 48 (1932–3): 306–9.

"Dürer in America." *Art Bulletin* 15 (1933): 263.

"Ein neuer Dürer." *Technische Mitteilungen für Malerei* 50 (1934): 115–16.

Dürer als Zeichner und Aquarellist. Vienna: Anton Schroll, 1951.

Tietze, Hans, and Erica Tietze-Conrat. *Kritisches Verzeichnis der Werk Albrecht Dürers Vol. I: Der junge Dürer*; Vol. II: *Der reife Dürer*. Augsburg: Dr. Benno Filser, 1928.

"Neue Beiträge zur Dürer Forschung." *Jahrbuch der kunsthistorischen Sammlungen des allerhöchsten Kaiserhauses* N.F. 6 (1932): 115–40.

Der Reife Dürer. Vol. II of *Kritisches Verzeichnis der Werk Albrecht Dürers*. Basel & Leipzig: Holbein AG, 1937.

Tietze, Hans, Erica Tietze-Conrat, Otto Benesch, and Karl Garzarolli-Thurnlackh. *Beschreibender Katalog der Handzeichnungen in der Graphischen Sammlung Albertina. Vols. 4 & 5. Die Zeichnungen der deutschen Schulen bis zum Beginn des Klassizismus*. Edited by Alfred Stiz. Vienna: Anton Schroll, 1933.

The Drawings of the Venetian Painters. 2nd ed. New York: J. J. Augustin, 1969.

Treasures from the Royal Collection. London: The Queen's Gallery, 1988.

Tresidder, Warren. "Dürer's Influence on Venetian Art in the Early Sixteenth Century." In *Dürer's Cities Nuremberg and Venice*, edited by Robert A. Yassin. Ann Arbor, MI: University of Michigan Art Museum, 1971, pp. 28–31.

Trevelyan, Humphry. *Goethe and the Greeks*. Cambridge: At the University Press, 1941.

Urbach, Susanne. "Ein Burgkmairbildnis von Albrecht Dürer?" *Anzeiger des germanischen Nationalmuseums* (1985): 73–90.

Valeri, Francesco Malagrizzi. "Il Foppa in una recente publicazione." *Rassegna d'Arte* 9, no. 5 (May 1909): 84–8.

van de Waal, H. "The *Linae Summae Tenuitas* of Apelles; Pliny's Phrase and Its Interpreters." *Zeitschrift für Aesthetik und allgemeine Kunstwissenschaft* 12 (1967): 5–32.

van Schoute, Roger, and Hélène Verougstraete-Marcq. "Radiography." *Scientific Examination of Easel Paintings. Published on the Occasion of the Xth Anniversary Meeting of the Pact Group at Louvain-la-Neuve*, edited by Roger van Schoute and Héléne Verougstraete-Marcq, Strasbourg: Council of Europe, 1986, pp. 131–54 [Pact, 13, 1986].

Vasari, Giorgio. *Vasari on Technique*. Translated by L. S. Maclehose. New York: Dutton, 1907.

"Life of Marc' Antonio Bolognese and of Other Engravers of Prints." *Lives of the Most Eminent Painters, Sculptors and Architects*. Translated by G. du C. de Vere. London: The Medici Society, 1913.

Lives of the Artists. Harmondsworth, Middlesex, England: Penguin, 1965.

Le vite di più eccellenti pittori, scultori e architettori nelle redazioni del 1550 e 1568. Edited by R. Bettarini and commentary by P. Barocchi. Florence: Sansoni, 1966–76.

Le vite de' piu eccellenti pittori scultori e architettori. Edited by Gaetano Milanese. Florence: Sansoni, 1981.

Venezia, Palazzo Ducale. *Venezia e Bisanzio*. Edited by Sergio Bettini. Venice: Electa, 1974.

Venturi, Lionello. "La critique d'art en Italie à l'époque de la renaissance. III: Pierre Arétin, Paul Pino, Louis Dolce." *Gazette des Beaux-Arts* 66 (January 1924): 39–48.

Verougstraete-Marcq, Hélène, and Roger van Schoute. *Cadres et supports dans la peinture flamande aux 15e et 16e siècles*. Heures-le-Romaine: H. Verougstraete Marcq, 1989.

Vincent, R. "Une copie de la fete de Rosaire d'Albert Dürer." *Bulletin des Musées et Monuments Lyonais* 4 (1969–71): 165–70.

Voll, Karl. "Zur Enstehungsgeschichte von Dürers vier Aposteln." *Süddeutsche Monatshefte* 3 (1906): 73–80.

"Dürer's Madonna mit der Birne." In *Entwicklungsgeschichte der Malerei in Einzeldarstellungen. Vol. 1. Altniederländische und Altdeutsche Meister*. Munich: Suddentsdie Monatshefte, 1913, pp. 154–8.

Waagen, G. F. "Albrecht Dürer in Venedig." *Zeitschrift für bildende Kunst* 1 (1866): 112–17.

Warnke, Martin. *Hofkünstler: Zur Vorgeschichte des modernen Künstlers*. Cologne: DuMont, 1985.

Washington, D.C. The National Gallery of Art. *From Schongauer to Holbein: Master Drawings from Basel and Berlin*. Washington, D.C.: National Gallery of Art, 1999.

Watrous, James. *The Craft of Old-Master Drawings*. Madison: University of Wisconsin Press, 1957.

Wehle, Harry B. "Preparatory Drawing on a Panel by Dürer." *The Metropolitan Museum of Art Bulletin* N.S. 1, no. 4 (1942–3): 156–64.

Wehle, H. B., and M. Salinger. *A Catalogue of Early Flemish, Dutch and German Paintings*. New York: Metropolitan Museum of Art, 1947.

Wehlte, Kurt. *Werkstoffe und Techniken der Malerei: Ein Fachbuch*. Ravensburg: Otto Maier, 1967.

Weiss, Roberto. "The Medals of Pope Julius II (1503–1513)." *Journal of the Warburg and Courtauld Institutes* 28 (1965): 163–82.

Weixlgärtner, Arpad. "Zu Dürer's Anbetung der Könige in den Uffizien." *Jahrbuch der Kunsthistorischen Sammlungen des allerhöchsten Kaiserhauses* 28 (1909–10): 27–30.

"Alberto Duro." In *Festschrift für Julius Schlosser zum 60. Geburtstag*, edited by Arpad Weixlgärtner and Leo Planiscig. Zurich, Leipzig, Wien: Amalthea Verlag, 1927, pp. 162–86.

"Die Fliege auf dem Rosenkranzfest." *Mitt. d. Ges. f.v.K.* 51 (1928): 20–2.

Wheelock, Arthur. *A Collector's Cabinet*. Washington D. C.: National Gallery of Art, 1998.

White, John. *The Birth and Rebirth of Pictorial Space*. London: Faber and Faber, 1957.

Wickhoff, Franz. *Mitteilungen des Instituts für österreichische Geschichtsforschung* (1880), 413 ff.

Winkler, Friedrich. "Dürer als Maler." *Der Kunstwanderer*, 1/2 (April 1928): 326–30.

"Dürerstudien 1. Dürer's Zeichnungen von Seiner ersten italienischen Reise (1494–1495)." *Jahrbuch der preuzsischen Kunstsammlungen* 50 (1929): 148–66.

"Dürerstudien 2. Dürer und der Ober St. Veiter Altar." *Jahrbuch der preuzsischen Kunstsammlungen* 50 (1929): 123–47.

"Dürers Studie zum Kopf des Papstes im Rosenkranzbild." *Jahrbuch der preussischen Kunstsammlungen* 56 (1935): 1–5.

Die Zeichnungen Albrecht Dürers. Berlin: Deutscher Verein für Kunstwissenschaft, 1936–9.

"Hans Wechtlins 'Schöne Maria.'" *Berliner Museen* N.F. 1 (1951): 9–11.

Albrecht Dürer: Leben und Werk. Berlin: Verlag Gebr. Mann, 1957.

"Eine Pergamentmalerei von Dürer." *Pantheon* 18 (1960): 12–16.

Winzinger, Franz. "Albrecht Dürer in Rom." *Pantheon* 24, no. 5 (September/October 1966): 283–7.

"Dürer and Leonardo." *Pantheon* 29, no. 1 (1971): 3–21.

Dürer. Reinbek bei Hamburg: Rowohlt, 1982.

Wölfflin, Heinrich. *Die Kunst Albrecht Dürers*. Munich: F. Bruckmann, A. G., 1905.
Albrecht Dürer: Handzeichnungen. Munich: R. Piper, 1914.
The Art of Albrecht Dürer. Translated by Alastair Grieve and Heidi Grieve. London: Phaidon, 1971.

Wolfthal, Diane. *The Beginnings of Netherlandish Canvas Painting 1400–1530*. Cambridge: Cambridge University Press, 1989.

Wolk-Simon, Linda. "Fame, *Paragone*, and the Cartoon: The Case of Perino del Vaga." *Master Drawings* 1 (1992): 61–82.

Wollheim, Richard. *Painting as an Art*. Princeton: Princeton University Press, 1987.

Wolters, Christian. *Die Bedeutung der Gemäldedurchleuchtung mit Röntgenstrahlen für die Kunstgeschichte*. Frankfurt am Main: Prestel, 1938.

Wright, Joanne. "Antonello Da Messina: The Origins of His Style and Technique." *Art History* 3 no. 1 (March 1980): 41–60.

Index